THE ARAB IMAGO

The Arab Imago

**A SOCIAL HISTORY
OF PORTRAIT PHOTOGRAPHY,
1860–1910**

Stephen Sheehi

Princeton University Press
Princeton and Oxford

Copyright © 2016 by Princeton University Press
Published by Princeton University Press,
41 William Street, Princeton, New Jersey 08540
In the United Kingdom: Princeton University Press,
6 Oxford Street, Woodstock, Oxfordshire OX20 1TW
press.princeton.edu

Jacket illustrations: (*front*) left to right: Abdullah Frères, Garabed Effendi Yassayian, Istanbul, undated carte de visite, 10.4 × 6.4 cm.; Shoucair, Ra'uf 'Abd al-Hadi, "With fond memory to my dear friend [illegible name], Sincerely Ra'uf 'Abd al-Hadi," October 20, 1917, postcard, 13.8 × 9.8 cm.; Massaoud Frères, Kassab and unidentified woman, Port Said, May 16, 1904, 12.4 × 8.2 cm.; unknown photographer, Faridah Habib, Cairo, ca. 1900–1910, fragment, print on paper; and portrait of Wahib Sheehi, courtesy of Stephen Sheehi; (*spine*) G. Saboungi, anonymous portrait, Beirut, cabinet card, 16.3 × 10.8 cm.; (*back*) left to right: G. Saboungi, unidentified European with medals, 1893, cabinet card, 16.3 × 10.8 cm.; G. Saboungi and G. Krikorian, anonymous portrait, Beirut, 1880–90, carte de visite, 10.5 × 6.3 cm.; Khalil Hawie, portrait of a young man named Kassab, Alexandria, 10.8 × 6.7 cm.; Alexandre and Joseph Kova, anonymous bridal portrait, Beirut, ca. 1900, carte de visite; and unknown photographer, Masis Bedrossian, 1920, portrait postcard, 13.9 × 8.9 cm.

All Rights Reserved
ISBN 978-0-691-15132-8
Library of Congress Cataloging-in-Publication Data
Sheehi, Stephen, 1967– author.
The Arab imago : a social history of portrait photography, 1860–1910 / Stephen Sheehi.
pages cm
Includes bibliographical references and index.
ISBN 978-0-691-15132-8 (hardback : acid-free paper)
1. Portrait photography—Middle East—History—19th century.
2. Photography—Social aspects—Middle East—History—
19th century. 3. Portrait photography—Middle East—History—20th century.
4. Photography—Social aspects—Middle East—History—20th century. I. Title.
TR113.5.S54 2016
770.956—dc23
2015030517
British Library Cataloging-in-Publication Data is available

Designed and composed by Yve Ludwig
This book has been composed in Mercury and Benton Sans
Printed on acid-free paper.
Printed in Canada
10 9 8 7 6 5 4 3 2 1

For You
Who have given me this book
With your love and faith.

Photography [*fotografia*]—"the writing of light," or otherwise
known as *al-taswir al-shamsi* [sun-imaging]—is a modern
craft that has reached in these recent years a level of
unsurpassed credibility. Many of *al-Muqtataf*'s honorable
readers like to approach its secrets through naked, theoretical
science; others want to learn how to do the work itself.
We wrote this article to fulfill both obligations.

SHAHIN MAKARIUS, "AL-FOTOGRAFIA," *al-Muqtataf* 7 (1882–83)

Contents ix

Acknowledgments xi

Note on Translations
and Transliterations xv

ACKNOWLEDGMENTS

I am struck by how this project has enacted a projective identification with the topic itself. Like the portrait, the research holds so much history; it contains so many layers; it speaks and it remains silent of its own production. The book operates on multiple levels of identification and ideology and expresses both a personal interiority and a collective subjectivity. Yet, also like the portrait, multitudes lie outside of this manuscript; so much has not made its way in, so much sits adjacent to it staring from the outside. The project, let alone the book, holds a dear amount of emotional energy that lies far beyond its eccéité. One thing that is certain undergirds the mass of material collected for this book and brings together the thousands of hours and tens of thousands of miles between four continents and numerous libraries, archives, and collections. This is the aid, friendship, generosity, patience, care, and love of so many people.

I could not have dared to start the Promethean task of excavating the vast uncharted terrain of Ottoman Arab photography without the help of archivists and librarians in Europe, North America, and the Middle East. I offer profound thanks to Yasmine Chamali and the Fouad Debbas Collection in Beirut, and Jeanette Sarouphim at the Institute of Palestine Studies in Beirut; Debbie Usher at Oxford's St. Antony's College Middle East Centre Archive; Joanne Bloom and Andras Riedlmayer at Harvard's Fine Arts Library; Zeina Arida and the staff at the Arab Image Foundation; Tracy Schuster at the Getty

Research Institute; Muhannad Salhi at the Library of Congress's African and Middle East Division; Jan Just Witkam in Leiden and Claude Sui at Reiss-Engelhorn-Museen in Mannheim. All of these archivists share an intricate and intimate knowledge of their collections, compounded with a generous spirit and eagerness to help. Likewise, I thank the staff at the American University of Beirut, the Lebanese National Archives in Beirut, Institut du Monde Arabe in Paris, the Mohammed Ali Foundation and Abbas Hilmi Collection at Durham University, and Dar al-Kalima in Bethlehem, along with Rachel Alma Lev and Paul Vester at the American Colony of Jerusalem, Constantia Nicolaides at the National Portrait Gallery in London, and Jesse Peers and Joe Struble at the George Eastman Legacy Collection at George Eastman House. Special thanks are due to Sura and Saeb Salam, His Excellency Prime Minister Tammam Salam, and Mr. Hallaq, the archivist for the Salam family collection, for facilitating several visits to their family archive. I would also like to thank my editors Lisa Hacken and Beth Gianfagna, who were professional, pleasant, thorough, and gentle. Particular thanks go to Princeton University Press, especially to Hanna Winarsky and Michelle Komie, who have been kind, responsive, helpful, and immeasurably patient, considering that completion of this book was interrupted by the loss of two hard drives, the publication of my book *Islamophobia*, and many more tribulations and blessings.

A massive number of photographs from institutional and personal collections in the Middle East and Europe did not make their way into this book, partially because copyright permissions were not given. For this reason, it is even more important to acknowledge that the images in this book have been reproduced with the permission of the Sadek, Saddic, Salem, and Rebeiz families in Ottawa, Philadelphia, and Beirut, respectively. Institutions that have permitted me to reproduce photographs in their collections are, in Lebanon, the Fouad Debbas Collection, the Institute of Palestine Studies, the Arab Image Foundation, the American University of Beirut, and the Lebanese National Archives; in Great Britain, the Middle East Centre Archive at St. Antony's College, University of Oxford, the National Portrait Gallery and the Mohamed Ali Foundation in London, and the Abbas Hilmi Collection at Durham University Library; in Cairo, the American University of Cairo; in Amman, the Khaled Shouman Foundation and Darat al-Funun; in Mannheim, Germany, the Reiss-Engelhorn-Museen; and in the United States, Harvard University Library—especially the Fine Arts Library, the Getty Research Institute in Los Angeles, the Zaidan Foundation in Bethesda, and the Library of Congress.

This book is indebted to the time and generosity of Muhammad Alwan, Isis Sadek, Gamil Sadek, and George Zaidan of the Zaidan Foundation, who generously shared their personal collections with me along with their invaluable knowledge. Richard Milosh in Australia was lavish in supplying me with an oral and written history of the

fascinating Arakel Artinian and Studio Venus. A very special thanks goes to the tireless and unrecognized research on Louis Saboungi by Özcan Geçer in Istanbul, whose generosity, sincerity, and friendship have been overwhelming, and whose work on Louis Saboungi needs public recognition. Also, I thank Rogier Visser for access to his wonderful dissertation. My respects and thanks to the late and legendary Kemal Rebeiz for many early morning meetings and for providing me access to his archive as well as a volume of anecdotal information. Ola Seif, curator of the Photography Collection at the American University of Cairo, deserves an exceptional thanks and acknowledgment. She is not only the most helpful, informed, untapped resource on photography in Egypt, but also, her generosity, kindness, and friendship have taught me much personally and professionally and undoubtedly have enriched this book.

Ahmad Dallal, Patrick McGreevy, Robert Myers, Waleed Hazbun, Samir Seikaly, and Nadia El Cheikh graciously facilitated a research faculty affiliation at the American University of Beirut through the Center for Arab and Middle East Studies and the Center for American Studies and Research in the fall of 2013 and summers of 2010 and 2012, which permitted me access to Jaffet Library, which served as an anchor and "go-to" for this book's research. Similarly, Zeina Arida and the staff not only provided me with regular access to the unparalleled collection at the Arab Image Foundation in Beirut since the earliest days of its inception, but also, most recently, aided the completion of my research when I was a Fellow in the fall of 2014.

My colleagues and the administrations at the American University of Beirut, University of South Carolina, and the College of William and Mary have been an unwavering source of financial and collegial support. It has also been a pleasure and honor to be appointed as the Sultan Qaboos bin Said Professor of Middle East Studies at the College of William and Mary. The chair is a consequence of a generous endowment by the Sultan Qaboos Higher Center for Culture and the Sciences in Oman. The provosts' and dean's offices at the College of William and Mary, American University of Beirut, and University of South Carolina, along with a summer grant from the National Endowment for the Humanities, underwrote much of my travel and research. Equally important, the intellectual sustenance and friendship that my colleagues provided at these institutions fueled completion of this work. In addition to my stellar colleagues and friends at the American University of Beirut; the Language, Literature, and Cultures Department at the University of South Carolina; and the Modern Language and Literature Department at William and Mary, my main man, Michael Gibbs Hill, and dear friends Nicholas Vazsonyi, Agnes Mueller, Paul Allen Miller, *akhi al-ʿaziz* Wadie Said, *rifaqayni* Daniel Drennan, Rami Zurayq, John Eisele, Kate Conley, Lu Ann Hamza, Bill Fairchild, Lara Ducate, Maryse Fauvel, Francie Cate-Arries, Mona Harb, Jonathan Glasser, Yvonne Ivory, Nina Moreno, Robert Myers,

Isis Sadek, Robert Smith, Sibel Zandi-Sayek, and Chitralekha Zutshi deserve particular thanks.

No doubt, the list of friends, colleagues, and staff that warrant my gratitude outstretches the limitations of these acknowledgments. However, the quality and scope of this book would have been significantly diminished without the friendship, feedback, guidance, support, and scholarly advice of my blood, George Azar and Mariam Shahin; my admired friend, chef, and scholar Ali Behdad; *Ustadhi al-awal* Peter Gran; my sister-in-arms Michelle Hartman; West Coast comrade Akira Mizuta Lippit; *rafiqi al-ʿaziz* Issam Nassar; *ahabb sahabi* Walid Raad; *sadiq tufulati* Walid Sadek; my truest brother, Ara Sarafian; my beloved mentor, Peter Sluglett; and *atyab sadiqati*, Eve Trout Powell. Also, heartfelt thanks go to Salim Tamari, Margot Badran, Elizabeth Frierson, Jens Hanssen, Anneka Lenssen, Nancy Micklewright, Afsaneh Najmabadi, Christopher Pinney, Sarah Rogers Qutbi, Lucie Ryzova, Nada Shabout, and Ella Shohat for the critical discussions, suggestions, conversations, comments, and support over the years of this project.

Finally, the journey of this book has been completed only through the love, support, friendship, kindness, generosity, and humor of my family. Thank you to my loving parents, Patricia and Wade Cameron, who have always been supportive and understanding of my scholarship and overcommitted schedule but also continue to be a source of love. To my beloved in-laws, Wajdi and Rima Masri and my sweet yet stylish brother-in-law, Ziad Masri, whose love for me, my wife, and our children have been the bedrock upon which we all continue to rely. Most of all, I thank my loving wife, Lara Sheehi, and our two effervescent and luminous children, Jad and Shadee. My children's friendship, humor, and energy kept me intellectually sharp and buoyant while dashing between kitchen, desk, and airports. On the most practical level, my soul mate, confidante, and best friend Lara remains my most diligent editor and sounding board, tireless, boundless, and nurturing. Without her, this project, along with my soul, would never have seen the sunlight of day. On the level of sublimity, Lara's, Jad's, and Shadee's love, individually and jointly, fueled me during many long hours and inspired me to navigate, if not complete, long geographic as well as emotional journeys and battles. This book is a by-product of the rich life that they have given me. On the shelf, I pray that it looks back at them and assures them that their love, sacrifice, and support made this book possible and my life worth living.

NOTE ON TRANSLATIONS AND TRANSLITERATIONS

This book employs the Library of Congress transliteration system. I note differences in *ʿayn* (ʿ) and *hamza* (ʾ) and also transliterate the *ta-marbutah* as -*ah* unless it is in an *idafa*, in which case it is -*at*. For feminine *nisbah* adjectives, for example, the book uses -*iyah* not -*iyya* as in the *International Journal of Middle East Studies* (IJMES) transliteration system. I do not include macrons to differentiate between long and short vowels in Arabic, nor do I distinguish between *qamari* and *shamsi* letters. I contract the definite article (*al-*) when conjoined with a connector (e.g., *wa* + *al* = *wal-*, *fi* + *al* = *fil-*). Most transliterations are clear to readers with an even rudimentary level of Arabic. However, I also try to make indications if ambiguities exist (e.g., *adab* singular and *adab* plural).

The book deviates from this transliteration system for place names and proper names, which are given as presented in other sources. For example, Beirut, Cairo, Alexandria, and Jerusalem remain Anglophonic, and concerning proper names, Sabunji is Saboungi; Jawhariyah is Jawhariyyeh; Abdullah Frères is not ʿAbd al-Allah; and the sultans ʿAbd al-Hamid and ʿAbd al-ʿAziz are Abdülhamid and Abdülaziz. That said, many Ottoman Turkish names remain arabicized, such as Midhat Pasha.

All translations are my own unless otherwise indicated.

Proem to *Indigenista* Photography

The structure of representation … is intimately
implicated in the reproduction of ideology.
VICTOR BURGIN

Introduction to a Perspective

In February 1861, Muhammad Sadiq Bey (1832–1902) set off to survey
the geography and pilgrimage route to Medina in the Hijaz (Hejaz). In
his trunk full of new scientific equipment was a camera. In the blurry
history of indigenous "Arab" photography, one thing seems certain.
Sadiq Bey was the first person ever, Arab or foreign, to photograph the
populace, pilgrims, officials, and holy sites of Medina and Mecca.[1] By
any account, 1861 was an early time for anyone, let alone an Egyptian
amateur photographer, to take photographs of the provincial capitals
and cities in the Arab East, let alone the hinterland. Sadiq Bey's carto-
graphic journey was the first to use modern methods and equipment
to survey the Hijaz. He spent two winter months measuring, charting,
and photographing terrain, cities, holy sites, and roads between the
Red Sea port of al-Wajh and Medina, the city of the Prophet's refuge
and burial place. The Egyptian mission mapped and registered the
topography of the Hijaz and the pilgrimage route. Sadiq Bey's precise
recordings and diagrams were the first drafts of sites, saints' shrines,
and sacred buildings in and on the way to Medina, which were cata-
logued and published by the Egyptian court and European engineers
and geographers. These accomplishments were a part of larger Otto-
man Egyptian and imperial Ottoman projects that instituted new
disciplinary regimes of organizing and controlling populations, land,
and commerce throughout their rural, as well as urban, domains.

Sadiq Bey was fully cognizant of his role as the first photographer of the Hijaz. In a handful of fleeting self-reflections found in his four publications, he acknowledges that he was "the first to have ever photographed such images by using a camera."[2] His accounts provide interesting clues to the place of photography in Arab Ottoman society by 1860. His most noteworthy account remains in *Nabdhah fi iktishaf tariq al-ard al-hijaziyah* (Window to the exploration of the Hijaz land route), published in 1877, where he relates his experience of photographing the Prophet's Mosque in "the Radiant City":

> *I had taken a position on top of the Haram with a detailed and precise view [manzhar] and recorded its image down to the centimeter. I also took a picture [rasam] of Medina al-Munawwarah, the Radiant Medina, using a camera in order to take photographs of the honorable mosque's dome and courtyard, choosing the armory [tubkhanah] as a focal point so that the view of the city gives perspective in relation to the neighborhood of al-Manakhah [in the background]. As for the view of the holy dome, I took it from within the Haram with the instrument, the camera, as well. No one had ever preceded me in taking these images [rasumat] with this apparatus, the camera.[3]*

Sadiq Bey's account of photographing the Prophet's Mosque and Medina for the first time titillates the imagination, inviting us to consider how the previously unrepresented would be narrated in an account by a man concerned with the modern representation of space. Rather than the camera intruding into a virgin space, Sadiq Bey's account tells us how Medina had entered into the cartographer's *manzhar* or "perspective"—into the visual framework that already existed within his mind and social "view." He produced a number of panoramas and cityscapes taken from the vantage point of walls, buildings, and mosque roofs. They show a deep tonal range, with the foreground densely populated by architectural structures but only scant people, framed by mountains or disappearing horizons (fig. 1). In the most literal terms, he was a functionary of that perspective, charged with "recording" the panoramas of cityscapes, holy sites, and portraits of mosque officials within a new visual hierarchy most faithfully represented by his two technical specializations, the camera and the map.

This *manzhar* as "perspective" should not be confused with the Renaissance's "perfect perspective," collapsing the camera with a "European" vision of balance and symmetry. Sadiq Bey's and his contemporary's use of *manzhar* is not the same as centuries of Arabo-Islamic writings on "vision," optics, perspective, perception, and representation in science and the arts since al-Kindi and Ibn Haytham.[4] While his *manzhar* does not lie outside his own historical memory of the Arabo-Islamic sciences, Sadiq Bey's *manzhar* was as much an ideological as a visual position. To borrow from Christian Metz, it

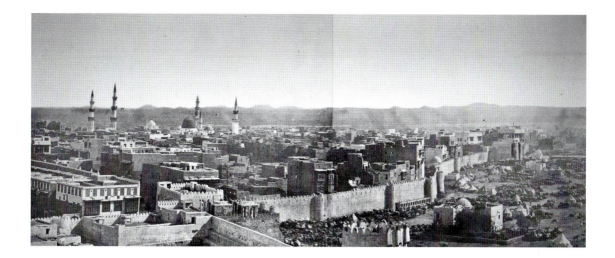

Figure 1.
Muhammad Sadiq Bey, Photographic panorama of Medina.

referred to a "scopic regime" where the "focal point" waited to be the anchor of the photograph's frame. The photographer and the camera captured a "view" (*manzhar*) that was already organized "down to the centimeter" by the cartographer's instruments. This capturing of a perspective that was waiting to be scientifically registered was part of not only a project financially and ideologically endorsed by Egypt's Wali Saʾid's own modernizing agenda, but also of the nineteenth-century Arab "Renaissance," or *al-nahdah al-ʿarabiyah*.

As Sadiq was an engineer and cartographer, his "perspective" led him to photograph the landscapes, cityscapes, panoramas, shrines, and monuments in the Hijaz's cities, towns, and ports. Claude Sui hypothesizes that Sadiq's training as an engineer predisposed his eye to a keen photographic sensibility because he commanded a knowledge of three-dimensional uses of space, lines, and vectors as well as the spatial interrelationship of objects.[5] Sadiq's training was not only an individual accomplishment that speaks to the genius, skill, and courage of the photographer. Sui's astute observation directs us toward Sadiq Bey's education as part of a larger historical construct that informed the existence, use, and value of photography, namely, *al-nahdah al-ʿarabiyah*.

Sadiq Bey's cartographic and photographic perspective arose from a vision produced by an archipelago of new schools and national institutions in Ottoman Egypt. This cultural and ideological infrastructure reproduced and disseminated new forms of knowledge, new regimes of "seeing," organizing, measuring, and categorizing the physical and metaphysical world. As a functionary of the Egyptian state and a product of new forms of education, Sadiq Bey was a product of this very social order and the perspective or scopic regime, cribbing Jonathan Crary, that formed the "background of a normative vision" of, what I will term in this book, *Osmanlilik* modernity and

nahdah ideology.[6] A history of early "Arab photography" cannot be separated from a history of that perspective.

Contre Orientalism: Toward *Indigenista* Photography

Sadiq Bey will reappear later in this study, but he opens this book because his early activities contrast with the familiar story of Middle Eastern photography that we are traditionally told. Only two years after the 1839 announcement of the invention of the daguerreotype, Noël Paymal Lerebours exhibited images of Beirut, Damascus, and Egypt in his monumental world-travel survey, *Excursions daguerriennes*.[7] Gustave Le Gray improved on Henry Fox Talbot's primitive paper negative process by adding wax to significantly increase the sharpness of the photographic image and taught many notable French photographers, not the least of whom was Nadar. Le Gray was one of the first architectural photographers in Europe who was nominated, along with Hippolyte Bayard and Henri Le Secq, among others, to participate on the Mission Héliographique in 1851.[8] After traveling as a photographer for ten years around the Mediterranean, he settled and died in Cairo, having established a photographic studio in the city for two decades, which served, among other clients, Khedive Isma'il Pasha. There is little information about Le Gray, but his life seems to be representative of many early photographers, at a time when they were avatars of art, science, adventure, and opportunism. In photographic historiography, which understands photography as a Western import into Eastern lands, he is demoted in its master narrative after he settled in Cairo, banished to serve invisibly as a portraitist and draftsman for the Egyptian aristocracy.

Like Le Gray, Maxim Du Camp and Auguste Salzmann were educated in draftsmanship and painting. They, along with Louis LeClerq, secured official state funding, particularly from the Académie des Inscriptions et Belles Lettres and the Ministry of Public Education, to underwrite their expeditions to the Middle East.[9] That Du Camp traveled with Gustave Flaubert and Le Gray with Alexandre Dumas gives us a hint that these photographers believed that their photographs were more than the "conclusive brute facts."[10] The canonical images of Egyptian antiquities and ruins by Le Gray, Du Camp, and Salzmann reified a photographic syntax for the millions of photographs of Pharaonic Egypt and the Holy Land.[11] Whatever their philosophical, artistic, or political worldviews might have been, "the photographic imaginary" of these photographers, as Derek Gregory notes, "rendered the remains of Egypt as a transparent space that could be fully 'known' by the colonial gaze."[12] It is well known, then, that the photographic missions to and European studios in the Ottoman East during the Second Empire and the Victorian era produced character-types, landscapes, architectural photography, and tableau vivant genre

scenes that were particularly useful for postcards, stereoscopes, and exotic tablature. This production of imagery was inextricable from the "period of rapid colonial expansion and imperialist adventures" and, as such, "the discourse of the Second Empire imperialism was couched in terms either of a *mission civilisatrice* or, more conspicuously in the case of Palestine, in a systematic denial of the existence of native inhabitants."[13] Their "photographic rejection of contemporary Middle Eastern life" was "undeniable" and served a poignant ideological function in France's rise as the preeminent colonial power in North Africa and the Levant.[14]

The legacy of this historiography lingers, powerfully overshadowing the quotidian role of indigenous photography. In addition to Le Gray, Du Camp, and Salzmann, the works of Tancrède Dumas, Francis Frith, Felice Beato, Emile Béchard, Hippolyte Arnoux, and Alexandre Leroux, as well as Maison Bonfils, Maison Lehnert & Landrock, Maison Garrigues, Photoglob Zurich, and Underwood & Underwood still define the imagery and historical narrative of photography of the Middle East. The colonial and imperious ability to compose the Oriental object and its locale within a changing pictorial syntax of Orientalism constituted a visual act of power. It persists even in well-meaning art history and curatorial discourses that continue to ask "how is Arab photography *really* different?" The question itself only promises to reinscribe the binaries of the dominant historical narrative of Middle Eastern photography. If the "Eastern" photographic image is distinct from the Western master-image, cultural difference is safely maintained, keeping intact Orientalism's asymmetries of power. If we are told that the "Eastern" image looks the same, all indigenous photographic production is ascribed to mimicry of the European master-text, and indigenous photography is just a derivative variation of the Western original.

Post-Saidian studies of Middle Eastern photography have largely avoided indigenous photography but have concentrated on the Othering representations produced by "Western" photographers.[15] *The Arab Imago* shares with this critical research on Orientalist photography an interest in the ideologically laden act of looking, representation, and image production. The book, however, offers an explicit riposte to the master narratives of the "history of Middle Eastern photography" by bypassing photography's history of service to the *colonisateurs* in favor of interrogating the history of "native" photography of the late Ottoman Arab world, or, in Deborah Poole's words, *indigenista* photography.[16] Poole's examination of photography in South America is instructive and helps tease out the similarities of indigenous photography in the global South. Riffing on the liberatory tradition of *indigenismo* in Latin America, Poole shows how the social practice of photography was a globalized phenomenon of *embourgeoisement* but simultaneously informed by the political, social, and ideological particularities of turn-of-the-century Peru. This is the global story of

photography, where formalistic patterns and social practices repeat themselves and even accompany the camera as part of the apparatus itself, but that formalism and those technical and social practices act within or toward their own ideological ends. This is not to say that such formalist practices that accompany the camera preclude the existence of vernacular forms of photography studied by those such as Christopher Pinney and others.[17]

In the case of the Arab world, *Arab Imago* redresses the dearth of critical attention to *indigenista* photography, excavating the production, discourse, performance (or what I term, following contemporary Freudian and object relations theory, as "enactment"), exchange, circulation, and display of photography in Ottoman Egypt, Lebanon, and Palestine between 1860 and 1910. Portraiture, in particular, the *carte de visite* (visiting card), provides a guiding thread in the complex labyrinth of a vast and uncharted history of *indigenista* photography.[18] This study attempts to engage photographic portraiture as a social practice, a technological act, an ideological enactment, and a condensation of shifts in political economy that express as well as displace the history of the contexts of its production. *The Arab Imago* aims to "look through" and "look at" portraits in order to read them, in Geoffrey Batchen's words, "as sensual and creative artifacts but also as thoughtful, even provocative meditations on the *nature of photography* in general."[19]

This phrase, "the nature of photography," will continually reemerge in this search to excavate the largely unearthed sites of indigenous photography in the Ottoman Arab world, drawing on a combination of Arabic sources, a variety of archives, and photography and critical theory. The use of this theory does not vacate the specificities of "Arab photography." It is not meant to, nor should it be read as, a retrenchment of that imperious European master-narrative. Quite to the contrary, this work seeks to "provincialize" the history and "nature" of photography, probing the ways photography works within certain conditions without ascribing those practices, functions, and effects to an original site, that is, Europe.[20] This book does not dismiss critical and logical questions such as "What does Arab photography really look like?" It reveals that these questions are a part of a master-narrative that disenfranchises Arabs from proprietorship of the universalizing power of photography to which they subjugated their own subalterns and were subjugated in the colonial encounter.

Whether in Europe, the Middle East, or South America, the "nature of photography" is multivalent, contradictory, and holds its own limitations alongside its possibilities. This is the case even in photography's most formalistic genres and formats such as the carte de visite. Abigail Solomon-Godeau warns us that "proposing an art history of photography, in which photography is understood as a history of distinct genres and styles, supposes that one can distill the cultural solution from which discrete images will precipitate out."[21] The challenge, then, is to navigate between liberating the por-

trait from the master narratives of European photography without fetishizing it, between remarking on the formalism of the portrait and looking at and through its indexical content without succumbing to its headlock on "truth-value." The challenge is to understand the physicality, materiality, and social history of the portrait along with an ideologically inflected signification system in order to resurrect not its essential meaning, but its relevance and force in naturalizing and perpetuating how social constructs of power enlisted and relied on the complicity and participation of its subject.

Within the formality, morphologies, semiotics, and ideology of the photograph and amidst the mass of known and anonymous photographers, studios, practices, formats, exchanges, social histories, and "paths" of the portrait, *The Arab Imago* asserts that the "nature of photography" of the late Ottoman Arab world is underscored by a few fundamental principles. First and foremost, *all photography expresses social relations*. Second, photography in the Ottoman Arab world is an *afterimage*, not producer, of the massive transformations in political economy, class structure, nationalism, and subject formation. Finally, as afterimage, the portrait is a material object that operates on multiple and coterminous levels, the manifest level of its ideological and representational life and the latent level, signifying histories that were excluded from the manifest. The photographic object is, as we will see, an "image-screen," a *point de capiton* through which multiple vectors of political economy, subjectivity, signification systems, and social discourses meet in order to create a legible surface and an object of trenchant social value. These principles forcefully recenter indigenous photography production to the "history of Middle Eastern photography," "provincializing," in turn, the master narrative of the European arrival of the craft and its craftsmen to Arab shores.

Defining Modernity, *Osmanlilik* and *al-Nahdah*

In his book *Each Wild Idea*, Geoffrey Batchen poses the question, "How can photography be restored to its own history? And how can we ensure this history will be both materially grounded and conceptually expansive, just like the medium itself?"[22] In hopes of offering a preliminary answer, I suggest that the Ottoman Arab photographic portrait was the copula where signification meets material practice, and where ideology meets representation and sociability. But also, the medium itself is structured by the tension and contradictions of its own promises, and, by its own "nature," works to push away the "alterity" of its own surface. More specifically, the portrait pushes away those social practices, economic organizations, self-conceptions, experiences, and social hierarchies that have been displaced by the disciplinary regimes of *al-nahdah al-'arabiyah* and Ottoman modernity, what Ottomans termed as *Osmanlilik*. This copula of forces is an

expression of a series of social formations among a *collective* of actors, classes, and ideological formations. When I speak of a collective of actors, I imply a social group, and in turn, class. While invoking the Grasmscian concept of social group, I heed Gayatri Spivak's call for breaking with a Eurocentric concept of social organization without disowning the political and social economies of regions and microregions that were shaped by interlocking global and local forces.[23]

To begin to restore lost photographic histories of the Middle East, I consciously move away from a Eurocentric imagining of orthodox class structure just as I move away from a Eurocentric master narrative of photography. This is not because Arab Ottoman society and economy did not undergo a radical restratification and reorganization. As in the case of Gramsci's Italy, the social structures were nuanced in ways that might escape an orthodox European developmentalist template. This is not to exoticize the Middle East. Rather, it recognizes the centrality of class formation to capitalist, "modernizing," and "civilizing" processes, which occurred in virtually every location where natives held the camera. If the social history of photography and capitalism, indeed their natures, intertwine, this study also seeks to track how social, economic, and ideological formations within the Ottoman Arab world—namely, the *effendiyah* middle class—fostered specific sorts of *identification* between new subjects and classes that were instantiated through the portrait and its exchange.

While *The Arab Imago* breaks with the predominant tendency to focus on Western photographic history as a hegemonic lens through which to approach "photography in the Middle East," it finds the practice of indigenous photography in the complex epistemological, capital, subjective, and temporal matrix of "modernity." Modernity is perceived as a European phenomenon. To borrow from Dipesh Chakrabarty, this book studies a photography produced and a society ruled "by modern institutions of the state, bureaucracy, and capitalist enterprise" coupled with "concepts such as citizenship, the state, civil society, public sphere, human rights, equality before the law, the individual, distinction between public and private, the idea of the subject, democracy, popular sovereignty, social justice, scientific rationality, and so on ..." all of which "bear the burden of European thought and history." By the grace of colonialism and world capitalism, "modernity is now global," whereas non-Western societies and intellectuals have "warmly embraced the themes of rationalism, science, equality, and human rights that the European Enlightenment promulgated."[24]

Samir Amin reminds us that "the emergence of capitalism and the emergence of modernity constitute two facets of one and the same reality."[25] The Ottoman Empire's own history cannot be disentangled from its immersion in the world capitalist system, which invited native collusion and participation at every social level to work in concert and compete with colonialist, imperialist, and capitalist forces. Arab intellectuals consistently argued that capitalism "was a system geared

at improving people's lives and decreasing the gap between rich and poor." In the words of Y'aqub Sarruf, "prosperity" (*tharwah*) was an essential result of progress and civilization, and wealth was "not taken from the poor but from the wealth of the earth."[26] Capitalist development and processes, including the formation of new classes who would produce and patronize the portrait, is a principal component of Ottoman and Arab modernity. In this regard, "modernity" serves as a useful organizing rubric that encompasses a variety of common factors and ideological precepts that underwrote ruptures and shifts in political economy, social hierarchies, and worldviews in a variety of localities under the universalizing schema of "civilization and progress."

The concept of modernity, then, is not a contrivance imported into the analysis of this book. Just as the term "perspective" is taken from the prevalence of *manzhar* in Arabic writing, the Ottoman term *Osmanlilik* (or *Osmanlicilik*) derives from Turkish writing about the reform movement. It localizes modernity, arising directly from the juridical, social, economic, and political program of "Ottoman modernity" and the reorganization of the empire, known as the Tanzimat (or Reorganization). In the case of the Arab world, *al-nahdah al-ʿarabiyah*, or what is commonly translated as the "Arab Renaissance," was the civilization project working in tandem with the Ottoman Tanzimat's empirewide establishment of *Osmanlilik* modernity. Within the context of the Tanzimat, Arab intellectuals in Beirut, Alexandria, and Cairo were formulating the role and reform of Arab society and identity in this "new era," or *al-ʿasr al-jadid*.[27] If any idiom represented the ethos of Ottoman modernity and *al-nahdah*, it was "civilization and progress" (*al-tamaddun wal-taqaddum*). This phrase and these goals structured virtually every cultural production of the era, mobilizing cultural acts in the cause of "reform" (*islah*), unity, and social betterment. Although what I term *nahdah* ideology shared with *Osmanlilik* ideology a common nomenclature of and formula for reform, it referred specifically to Arab identity, Arab culture, Arab history, and Arab societies. While *nahdah* writing was marked by a variety of competing, often opposing *political* positions, they all shared a concern with the local, thinking out Syrian or Egyptian identity in contrast to Turkish Ottoman identity. "Arab photography," like all cultural productions, must be understood within the context of *al-nahdah*, itself contingent on *Osmanlilik* modernity. It must be understood as a product of its own history.

Nineteenth-Century History and the Meaning of Social Relations

That this book focuses on the social history of indigenous photography between 1860 and 1910 is not arbitrary. Those two dates roughly bookend the rise of the Tanzimat and *nahdah* in the Arab world and the demise of the *Osmanlilik* project with the Turkish nationalist coup of the Committee for Union in Progress. These events mirror the

popularization of photography in the Arab world and the rise, albeit not introduction, of the Brownie and Kodak cameras. Social organizations, urban and rural spaces, technologies, gender roles, education, cultural institutions and practices, religious *doxa*, and commercial and agricultural practices and populations shifted, grew, and transformed in a half century—more quickly than they had in centuries past. The empire witnessed legal and regulatory writs, codes, laws, and edicts issued and implemented by Sultans Abdülmecid and Abdülaziz. Although Sultan Abdülhamid abrogated the Ottoman constitution and dissolved the parliament, he continued the economic, social, and political reorganization under his recentralization of sultanic power. Rural and village space was completely reconceptualized, reevaluated (in terms of value-added vis-à-vis market exchange), and commodified under the new Ottoman Land Code of 1858.[28] New merchant and intellectual classes—called the *effendiyah* in Arabic—arose, and traditional urban elites were transformed (or destroyed) by accumulating new levels of wealth, consolidating ownership of unprecedented amounts of land, and leveraging this wealth to negotiate with the new system of provincial Ottoman administration, including the khedives of Egypt.[29]

The economy of the Arab world was becoming linked to the world economy, and the demand for raw materials in Europe, nineteenth-century Lebanon, Syria, and Egypt saw the role of owners, workers, peasants, and functionaries change in the cotton, silk, sugar, wheat, and tobacco sectors. With this, the traditional communal, religious, and legal practices and judgments that previously regulated the profits that local elites and *multazim* tax-farmers earned from landholdings were replaced by the Ottoman codes, permitting unprecedented accumulation of capital and legal claims on land that restructured relations between those on it and those who now "owned" it.[30]

As a result, space and its relationship to subjects and the state were changing. Istanbul, Beirut, Cairo, Alexandria, and Haifa were being parceled, organized, and rationalized. ʿAli Mubarak, legendary Egyptian reformer, litterateur, and the minister of public works, wrote his twenty-volume magnum opus, *al-Khitat al-tawfiqiyah al-jadidah* (The new Tawfiq plans), which recorded the history, monuments, and geography of Cairo and mapped and organized its new streets and development under the massive urban plan of Khedive Tawfiq.[31] Eventually, architects and urban planners such as Habib Ayrout and his son Charles compartmentalized the city into old and new quarters, including New Cairo (*Misr al-Jadid*), or Heliopolis, to accommodate the lives of Egypt's economic elite and the ascendant *effendiyah*.[32] Beirut had its own indigenous engineers such as Yusuf Aftimus. Aftimus's "civic and commercial landmark constructions blended Ottoman revivalism with local materials, vernacular styles, and his personal tastes," contributing to Beirut's transformation into "a place of order, sobriety, and rationality."[33] This history of urban design was governed by in the local rulers and elites, foreign interest and capital, and Otto-

man precedence. Grand Vizier Rashid Pasha, along with Ottoman elites, "parceled" and "regularized" the urban space of Istanbul as early as 1832, after the city's cataclysmic fire.[34]

Architecture, urban planning, and photography were the effect of these changes in political economy and shifts in social relations. Egypt witnessed the massive reorganization of its economy, especially around the internationalization of its cotton sector. Between 1860 and 1910, Egypt's "governors" (khedives) became a dynastic royal family, which cultivated power by their alliances with France and Great Britain but also through the rise of bureaucratic and *effendiyah* classes, groups of middle strata, intellectuals, technocrats, professionals, and entrepreneurs who spearheaded the civilizational, nationalist, and anticolonialist projects. The country's transformations in the nineteenth century were exemplified by the concession of land for, and construction of, the Suez Canal, to be completed eventually in 1869.[35] Massive state debt, owing to infrastructural investment, the reorganization of urban spaces, and vanity projects resulted in the ʿUrabi Revolt of 1881, which itself was crushed by direct British military intervention, effectively making Egypt a British colony.

In Lebanon, the 1860s started with bloody, intersectarian violence that was the result of the massive reorganization of the political economy and social hierarchy that developed out of the cultivation of the silk industry, which was solely dependent on the European market.[36] The influx of capital around sericulture, along with Beirut's naturally deep harbor transformed this minor coastal city into a major port, economic hub, and cultural center. The Ottoman Bank opened in Beirut with French capital in 1856, and Crédit Lyonnais opened a branch in 1875. The Beirut–Damascus Road was built in 1857, and the Beirut–Damascus Railroad followed in 1895, funneling goods through Beirut into the hinterland that were previously imported from other Levantine ports, including those in Palestine. Tobacco became a cash crop in southern Lebanon, replacing silk; the Compagnie du Port des Quais et des Entrepôts de Beyrouth gained the concession from Ottoman authorities in 1886 to finally open a fully modern port, with customs duties, in 1894. Jens Hanssen shows how noncompliant workers, local notables, the powerful new bourgeoisie and *latafundia*, Ottoman bureaucrats, native intelligentsia, and foreign officials, missionaries, and compradors interacted, infusing the seaport with new capital and rearranging its "physical spaces" and "mental places."[37]

Scholars such as Salim Tamari, Beshara Doumani, Mark LeVine, Gershon Shafir, and Michelle Campos have shown similar transformations in Palestine.[38] Traditional trade entrepôts were transformed, and craftsmen and tradesmen were enfranchised or dispossessed. Not unlike in Egypt and Lebanon, notable families reconsolidated their political importance and jockeyed with secular administration and upstart families. New forms of citizenship and sociability were created. All of these archetypal Ottoman transformations were

transpiring at the same time that Zionist colonial settlers began to arrive from Europe, whose designs on land acquisition had considerable impact on Palestine's political economy.

While this overview has left out far more than it includes, this study understands photography's advent and participation within the larger system of political, economic, cultural, and social changes that were occurring in the Ottoman Arab world. Alongside understanding the photograph as a representational and ideological space of enactment, this book identifies photography as a social practice as well as a technological act and examines how its social currency was intertwined intimately with these changes. Indigenous photographers such as Abdullah Frères, Pascal Sébah and his son Jean, Jurji and Louis Saboungi, the Kova Frères, Garabed and Johannes Krikorian, Khalil Raad, and many others thrived because they were involved in reproducing the economic and social transformations in their localities.

By locating early Arab photography within a matrix of capitalism, representation and ideology, social transformations, class formations, and state programs, we may then understand the photograph as an expression of "social relations." Marx elucidates that "social relations within which individuals produce, the social relations of production, are altered, transformed, with the change and development of the material means of production, of the forces of production. The relations of production in their totality constitute what is called the social relations, society, and, moreover, a society at a definite stage of historic development, a society with peculiarly distinguished character. … Capital also is a social relation of production. It is a bourgeois relation of production, a relation of production of bourgeois society."[39] This theoretical definition should recall that the effendi classes in Istanbul, Beirut, and Cairo patronized native studios as dutifully as royalty, high-ranking Ottoman and khedival officials, and economic elites. As we will see, Arab intellectuals, writers, and photographers saw the craft as a product of material, modern knowledge and social labor. This recalls Marx's observation that "the means of subsistence, the instruments of labor, the raw materials, of which capital consists" have been "produced and accumulated under given social conditions, within definite social relations."[40]

Claiming that, "all photography expresses social relations" is not intended to assign photography as some slavish factotum to native elites and those who dominate the means of production. Photography and the photograph were *enmeshed* in the shifting and multilayered social networks of the Ottoman Empire. They participated in facilitating social relations among new individuals, classes, and institutions and ideologically "hailed" the subjects who found themselves so clearly represented in the portrait. Some readers may ask, "Where is the photograph" in the social history of photography? To which this book replies that such a question poses a false dichotomy, where history stands in competition with reading the compositional formality of a photograph.

Photography was a practice that produced a material object that held social and ideological roles, including expressing, naturalizing, and reproducing particular social relations. The surface of the photograph is critical. It must be read and engaged. However, this surface, the portrait's content, formalism, composition, and format, are equal to its visible and invisible histories of production and contexts.

Lacunae and Gender

This project was born out of the abject absence of critical research on indigenously produced photography in the "Arab East." The "nature of photography" is precisely its abundance, its visual truth and excess that coexist to prevent us from defining its borders or even genres. This book is not a comprehensive history of "Arab" photography or even portraiture between 1860 and 1910. Far too many wonderful subgenres of portraiture fell by the wayside in composing this study: portraits of subjects dressed in theatrical costumes, self-Orientalizing portraits, amateur-produced intimate portraits, and playful pictures of fantasy such as subjects posing in and on cardboard trains and bicycles. I do not engage candid photography, for example, leaving out those many amateurs who toward the turn of the century produced the most intimate, even erotic, humorous, playful, personal, evocative, and emotional images of the era.[41] Portraits of faculty and students of new colleges and professional schools, along with group portraits of college staff, governmental bureaus, hospitals, companies, and banks, such as the Ottoman Bank, sports teams and social clubs similar to the Boy Scouts, literary and scientific associations, philanthropic organizations, and so on are found throughout the Arab world and the Ottoman Empire. While I will present some group portraits, this book is unable to flesh out group portraiture systematically as a subgenre or institutional practice, although it dominated publications and institutional and private albums of Ottoman southwest Asia and Egypt.

In terms of geography, my focus on Istanbul, Beirut, Jerusalem, and Egypt should not be understood as a choice of hierarchy. These were highly visible and active Ottoman provincial centers and representative of many trends that were occurring throughout the empire. Studios, professional and amateur photographers, and the Ottoman and early-twentieth-century histories of photography in Syria, Jordan, the Gulf, the Maghreb, and Iraq remain uncharted and deserving of serious scholarly attention. The photographic histories of Cairo and Alexandria remain incomplete because of the number of these cities' studios that were co-owned by non-Arab, often non–Middle Eastern, expatriates, who partnered with Arab Christian émigrés and Armenians, leaving little evidence of their lives except their names on scattered cardboard mounts.

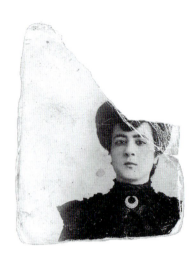

Figure 2.
Unknown
photographer,
Faridah
Habib, Cairo,
ca. 1900–1910,
fragment,
print on paper.

While the limits of this research are circumscribed by scope, scale, and economy, I most regret that it falls far short on fully considering photography's relationships with gender politics, class formation, and print media.[42] The photograph of Hoda Shaarawi and Saiza Nabarawi's unveiling at the Cairo train station in 1923 relates the centrality of photography in the formations of gendered identity politics in the Arab world and the interplay between activism, print, and the visual medium. Margot Badran tells us that Shaarawi's photograph and staged unveiling appeared immediately thereafter in *al-Lataʾif al-musawwarah*, and *Le Journal de Caire* on June 4, 1923, then in the *Egyptian Gazette* on June 16, and even in Jeddah's newspaper, *al-Qiblah*, albeit without the image.[43] The scope of this book was unable to accommodate the need to address questions of how gender intertwined with processes of social, familial, and class individuation as enigmatically evoked by photographs such as Faridah Habib's ripped portrait (fig. 2). This tattered fragment of Faridah Habib draws out the gendered space of a photographic frame even if it clearly is "incomplete." The *nahdah* discourses of gender and domesticity impose themselves on us as much as on the production of the image. Faridah's posture and proximity to the image's border encourages homo-normative conjecture, where she is likely standing next to and/or behind a family, a husband, a sister, a child.

What we know of Faridah comes to us from sources exterior to the image itself—through oral, family history, passed to her grandson then his daughter, Isis Sadek. Faridah was a Coptic Egyptian woman, a mother, and the wife of a man who scandalously converted from Islam to marry her. Despite the scandal, her gendered role in reproducing an "in-tact family" operated along common lines of Coptic, Egyptian sociability and middle-class ideology, which are powerfully evoked when matching the photographic shard to the oral family history. This is certainly the case when national and subjective ideals were represented in metaphors of domesticity and maternity.[44]

This study has largely neglected gender not because its lack of importance but precisely because of the enormity of its complexity. Providing a space for the representation of women does not preclude the dangers of also flattening out processes of gender individuation across class, community, and geography. The striking bourgeois matriarch Faridah contrasts, for example, with a highly gendered portrait of the Israel family (fig. 3). The young girl with her arm around her brother and flowers in her hand is my great-grandmother, Philomena. She poses with the matriarchs of the family, widows whose husbands had died. My great-great grandmother, Hannah Azar Israel, sits firmly protecting her newly married son and his bride, Fouz. The portrait of the Israel sisters is almost like a Rorschach inkblot in its symmetrical doubling of two related and interconnected families.

But such symmetry does not give balance, a balance that is assumed in Faridah's original, untorn portrait. Rather, it communi-

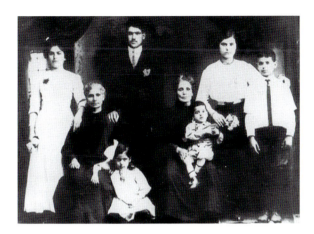

cates a compositional irregularity that tilts the clean analysis of the formalistic new Arab family. Family portraiture, Arab and non-Arab, is formalistically structured around a male figure, usually the father, flanked by children and, frequently, a spouse (fig. 4). These family images are often pyramids where the father is the center, the base, or the pinnacle. The family portrait of Garabed Krikorian, a pioneer Armenian photographer in Jerusalem, is heavy with the vectors of patriarchy, despite his being a practitioner of the consummate modern technological practice, who also passed the craft along to his wife and daughter, Najla. His arms almost seem to envelop the women and children of his family, who, despite their air of modern domesticity, are under the protection of the *sayyid al-bayt* (master of the house). The gender dynamics, vectors, and placement of bodies of Hannah Azar Israel's family portrait are different. The male head, George Israel, is relegated to standing behind his mother. The symmetrical image of the Israel sisters and their families hints at a different set of networks of sociability that lead beyond the social history of these women and children.

These two stern, matriarchal widows from rural, northern Lebanon, forced to emigrate to Philadelphia with their children, chimes with the narratives of early Arabic novels that invariably involved widows, orphans, despots, villains, and Horatio Alger characters. This overdetermined, Rorschacian symmetry ushers women into the master ideological schema of *al-nahdah*, only to pose them outside class ideals but securely within a moralistic ideal of class ideology. The image—to me, a scion of the girl with her arm around her brother—demonstrates that the volumes photography speaks to about social hierarchy and ideology are matched by an ineffaceable silence about them, silences so powerfully contained in the image's gendered history. Despite this lacunae, *The Arab Imago* offers a theoretical apparatus that can engage in dialogue with a more nuanced and integrated gen-

Figure 3.
Unknown photographer, Israel family portrait. *Standing, back row* (*left to right*): Fouz Israel and husband, George Israel; Fula (Philomena) Israel, with arm around her brother, Israel "John" Israel. *Seated* (*left*): Hannah Azar Israel; *right*, her sister, Isis Azar Israel. Mary Israel is on the floor; the boy in Isis's lap is perhaps Almozo Abdullah or George Israel Jr. Tripoli, Lebanon.

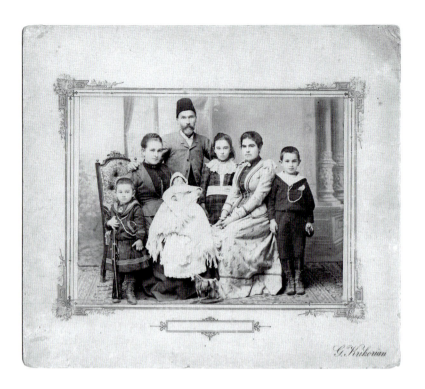

Figure 4.
G. Krikorian,
Garabed
Krikorian
and family,
Jerusalem,
1910.

dered history of photography. Such a gendered history could flesh out further how the portrait functioned as a stabilizing medium to enact new forms of subjectivity and to reconfigure patriarchy within modern Arab societies subject to capitalist transformations.

Finally, scholarship cannot avoid the materiality of photography or its own production; the mundane and frustrating administrative, financial, and legal realities inevitably shape scholarship. On the most banal level, the choice of portraits in this study is often limited to issues of copyright and accessibility. Apart from tracking down collections and "original" images, acquiring copyright releases to publish private portraits offers further challenges. In a region that suffered colonial brutalization and mutilation, the surveillance of police states, and that demonstrates credible paranoia owing to decades of foreign spying and machinations, one can hardly blame individuals and families for holding on to their photographs so as to protect their loved ones from the denuding and "wrecking effects" of mass dissemination.[45] While this caution makes publishing and writing about images all the more challenging, I am sympathetic to the photo owners' justifiable distrust of losing control and proprietorship of their own personal heritage and experience. In this regard, I hope that this research offers a conceptual, theoretical, and methodological framework to engage in further inquiry into and discussion of the fecundity of *indigenista* photography of the Middle East.

"Arab Photography": Arabs and Armenians

So much is lost to us about the "nature" of Ottoman Arab photography. The repetitious representation of the portrait can be ferreted out through the writing of *nahdah* intellectuals, commentators, technocrats, and functionaries. The practice and sociability of photographers, studios, and their clients is less easy to retrieve. They have been lost in the tumultuous history of Lebanon and Palestine. Remnants erratically emerge in institutional archives, through family connections, in Cairo's *Suq al-guma* (Friday flea market), or a small legendary bookshop in Beirut, where we find names and traces such as Shoucair's in Cairo (fig. 5). One wonders how long such a studio with a likely Lebanese Christian name was open, considering its prominent address on Nubar Street. One can also imagine that the studio had a relation to the atelier by the same name in turn-of-the-century Beirut.[46] As we will see, the inscriptions and stamps on photographs are breaches through which the repetitive and generic representation of the portrait communicate to us the social history of the photograph. In the

Figure 5.
Shoucair, Ra'uf 'Abd al-Hadi, "With fond memory to my dear friend [illegible name], Sincerely Ra'uf 'Abd al-Hadi," October 20, 1917, postcard, 13.8 × 9.8 cm.

case of this postcard portrait, a popular format during the first quarter of the twentieth century, the sitter was Ra'uf 'Abd al-Hadi, an Ottoman officer from a prominent Palestinian family who was captured by the British and, in turn, enlisted to join the Amir Faisal's "Arab Army."[47] The double inscription on the back of his portrait, written in two different hands with two different pens, is exemplary of the "social networks" that we will examine in this study. But also, the image, inscriptions, and stamp provide us a composite image-screen that suggests how the meanings of identity markers and the photographic representation itself have their own histories that appear, already legible, in the portrait.

Foremost among these markers is "Arab." I use "Arab" with self-consciousness and self-awareness. It is, simply, used as a cultural designation, particular to those who speak Arabic and identify themselves with what would become articulated as "Arab" identity at the time Ra'uf 'Abd al-Hadi was posing in Cairo. As articulated by Arabism, "Arab" is not a racial category but one that involves a shared history and language that often includes non-Arab ethnicities and non-Muslim minorities. This is not an apology for the Arab nationalist regime's often dreadful history in "absorbing" or erasing ethnic minorities such as the Amazigh or Kurdish peoples, let alone 'Abd al-Nasser's expulsion of Armenians, Jews, Greeks, and Italians, most of whom spoke Arabic.

Photography's earliest production in Egypt, Palestine, and Lebanon (as well as Ottoman Anatolia) emerged, largely but not exclusively, from established religious and ethnic minorities such as Armenians, Syriac Catholics, Italians, Greeks, and *shamiyin* (Syrian, Lebanese, and Palestinian Christian émigrés and expatriates in Egypt). The considerable presence of minorities in photography has been erroneously explained as a result of Eastern Christians' "natural" inclination for and historic ties to the West and Western knowledge as well as Muslim prohibitions on image production. One might ask whether the photographer's Greek ethnicity contributed to the success of the G. M. Georgoulas Pyramids tourist photography business, which was centered on tourism at Giza. The lion's portion of his surviving images are foreigners in front of the pyramids, most noteworthy a group photograph that includes T. E. Lawrence, Winston Churchill, and Gertrude Bell. A sparse number of existing photographs show his portraits of native Egyptians or Arabs. His work shows a characteristic diversity of photographic production, from institutional group portraits to tourist photographs to portraits of Egypt's *effendiyah*. One such rare image shows a man posing for a portrait, most likely in the gardens of the famous Mena House near the pyramids outside Cairo, where the Italian photographer Fasani had his studio (fig. 6). The cracked and liquidized emulsions and tatters of photographs are a reminder of the material history of the photograph's production, information that is now lost to us. The full-bodied effendi sits confi-

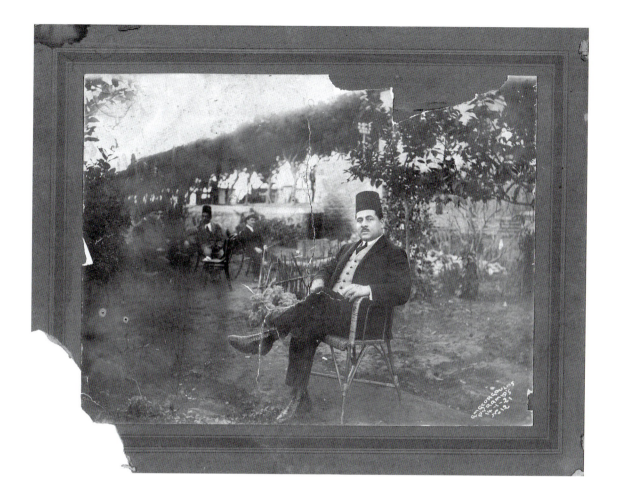

Figure 6.
G. M. Georgoulas
Pyramids,
anonymous
portrait, Cairo,
January 14, 1921,
28.8 × 22.3 cm.

dently and relaxed in the light of the foreground, while more effendis sit in the background of the garden in the receding darkness at one side of the portrait, balanced by the column of trees, itself marking a special boundary in the frame and in the garden. We can surmise that G. M. Georgoulas's Greek ethnicity provided him access to develop certain social relationships, which positioned him advantageously over his Muslim-Egyptian counterparts such as court photographer Riad Shehata. While we might not fully understand why, one thing that is empirically obvious is that ethnic and religious minorities played a central role in the early decades of photography in the Arab world, most importantly the Armenians.

Armenians, including the Abdullah Frères and the Krikorians, were a critical lynchpin in the production and distribution of photography throughout the Ottoman Empire in the nineteenth century. In the twentieth century, ethnic Armenians came to further dominate the studio scenes of virtually every major provincial capital from Beirut to Baghdad.[48] The role of Armenians cannot be overemphasized

in the history of Ottoman photography.[49] Their predominance in the profession of photography is often attributed to the massive diaspora caused by the Armenian genocide and the destruction of Armenian communities in Istanbul and historic Anatolian Armenia in 1915. Skilled Armenians, including photographers, are said to have arrived in the Arab world after the Hamidian massacres and deprivations of 1894–96. The Middle East's most prodigious postcard studio of the twentieth century was owned by Abraham (ca. 1873–1925), Boghos (1876–1934), and Samuel (1884–1941) Sarrafian, otherwise known as the Sarrafian Brothers.[50] They arrived in Beirut from Diyarbekir to open their studio in 1895 in Bab Idriss, likely because of anti-Armenian pogroms.[51]

Armenian social and economic connections to the Arab world predated the Hamidian massacres and the genocide by centuries. Long-standing Armenian communities in Arab cities such as Aleppo, Beirut, Jerusalem, Cairo, and Alexandria, some existing for centuries, were similar to but far more established than other minority communities such as the Greek, Italian, and Syro-Lebanese Christian communities in Alexandria and Cairo. These communities facilitated the geographic *mobility* of Armenian photographers from all parts of the empire. Armenian technicians and professionals could move between provincial centers to nest in similar ethnic communities in order to build their commercial practices. This study is not equipped to delve into the history of Armenian photography, a topic that sorely needs investigation through Armenian sources. However, pertinent to this study, Armenians' ability to transplant to various parts of the eastern Mediterranean reveals the flows of sociability that informed the production, exchange, circulation, and social network of the carte de visite in the late Ottoman age.

Overview

The Arab Imago is a social history of indigenous photography in the Ottoman Arab world. The book does not develop a theory around a kitchy subgenre of portraiture nor does it frequently "unpack" individual images as if each contained an indexical cipher that can be decrypted. To the contrary, the images in this book are consciously chosen for their formalism and, perhaps, even for their banality and accessibility. This is not coincidental or accidental, but rather, is intended to reflect the "nature of photography," or, at least, the nature of portraiture itself. Whether a particular image or collection should or should not be included in this study is less important than the fact that many of these images are interchangeable with a plethora of similar photographs. With this in mind, this study travels between what I will call the "manifest content," the surface, of the image that contains formalistic representation that "enacts" the ideals of *nahdah* ideology

and the photograph's "latent content," which references the alternative life-worlds displaced by the hegemony of the manifest.

In this regard, the terms "enact" or "enactment" are not meant to supplant the concept of "performance" and "performativity," as theorized in speech-act theory and later in the work of Judith Butler. I borrow enactment from contemporary Freudian and object relations psychoanalytic theory because it elicits a dynamic of performance that is not merely reproductive of, for example, certain subjective discourses and ego-ideals, which in turn produce, resist, or calibrate them into producing new discourses and subjectivities.[52] Rather, an "enactment," in the analytic dyad, creates, performs, or "enacts" the unconscious relationship that the patient has with the analyst. This enactment is not only an importation of overdetermined historical objects and events from the patient's past, it is a co-creation of the patient's transference and the analyst's own countertransference to that "fantasy" relationship. The enactment in therapy is a "re-living" of the past and the repetitious manifestation of the patient's relations to objects and others. I use this concept because it precisely draws the manifest and latent into a particular act of nonverbal representation, the portrait. "Enactment" allows us to understand the image as both an afterimage of ideology and one that participates in it. Contrary to the classical Freudian psychoanalytic theory, this book understands enactments as ideologically conditioned by social relations and history. The portrait therefore is an enactment of the conditions of its production, its intelligibility, its politics of representation, and the object relations within it and between which it circulates. In the case of the portrait, it is an *actualization* of modernity, but an actualization is different from an enactment, which seeks, simultaneously, to hide and make visible the latent history of the subject's history.[53] The Ottoman portrait as an enactment, in other words, might dissociate its subject from its material history in order to enact an ideological statement of who the sitter is (that is, a member of the new middle class that dissociates itself from its peasant origins). In doing so, an enactment demands legibility for its viewer. It demands production and knowledge of the photographer; it presumes a circuit of intelligibility, of reception, and of circulation in hopes of eliciting some social value. In thinking of the portrait as an enactment, I import the concept of enactment from the analytic dyad into the social setting in order to uncover the social relations that bind the portrait's history, ideology, and materiality together.

The Arab Imago is organized into two parts and eight chapters, which commute between two distinct but interlocking poles: the empirical history of *indigenista* photography in the Ottoman Arab world and a complex theorization of the multivalent levels of photography as a social practice and ideological act. The structure of this book is composed in movements, alternating between an unpacking of previously unexamined written texts (journal articles, guides, autobiographies, and so forth) and a crescendo of "case studies."

In order to restore the history of Ottoman Arab photography, *The Arab Imago* asserts that the social character of the portrait made it a synapse of intersecting "manifest" and "latent" planes and vectors: materialist, social, discursive, semiotic, and historic. Photography's truth-value, indexicality, its *studium* and intelligible references, and its expressed ideology remained in tension with the photographic image, its ambivalence, its alterity, and its *punctum*.[54] The exchange value, social value, and discursive effects work in tandem with photography as a social practice. Combined, these vectors synthesize into the image-screen that *reproduced* the social relations that they represented. The bipartite organization of this book is not meant to reify a binary between manifest and latent, surface and hidden, representation and history. It is intended, rather, to bring them together into the unity of the material object of the portrait.

Part 1 examines the histories of *indigenista* photographers and defines what the *nahdah* portrait looked like, its ideological content, its representation, its social relations, and the material history. Just as I locate *nahdah* within *Osmanlilik* modernity, I begin this examination of Arab photography with the work of the Ottoman Empire's most renowned studio. Chapter 1 reveals how the repetitious formalism of portraiture, exemplified in the work of Abdullah Frères, represented, enacted, and reproduced Ottoman modernity, imprinting on the photograph's surface the "optical unconscious" of *Osmanlilik* ideology. From this larger Ottoman framework, chapter 2 offers a discussion of pioneer *indigenista* "Arab" photographers Jurji Saboungi, Louis Saboungi, and the Kova Frères in order to understand how their work imprinted the "Arab imago," a condensation of the ego-ideals of *nahdah* selfhood. Chapter 3's exposition of the carte de visite shows us how the social currency and import of the portrait emerges from a new sense of sociability that accompanied these shifts and was essential to the naturalization of social and political reorganization in the Ottoman Arab world. More specifically, the visiting card was an interpellation of *nahdah* ideology but also interpolated its subject into a social vision of *al-nahdah al-ʿarabiyah*. Chapter 4 focuses on the consolidation of a photographic discourse in the Arab print media, particularly the journal *al-Muqtataf*. "*Nahdah* photography writing" reveals an awareness of what Christopher Pinney terms the "technomateriality" of photography, recognizing how it is both a material object and a product of scientific knowledge and labor that also carries a keen ideological message. The photograph was seen by Arab writers as a *verum factum*, in Giambattista Vico's words, of the *nahdah* "perspective," that was at one time an objective and positivist representation of reality and at the same time an expression of experience of that reality.

In part 2, I offer a series of "case studies," focusing on particular photographs and practices that allow us to theoretically unpack the histories and framework that were laid out in part 1. Chapter 5, for example, juxtaposes Wasif Jawhariyyeh's unpublished photographic

albums against the production of the Krikorian and Raad studios of Jerusalem that fill their pages in order to map out how these circuits of sociability look. Jawhariyyeh's albums allow us to think beyond the exclusivity of "national" Palestinian identity to place it within the larger Ottoman context of reorganizing social relations in the Levant without abrogating or negating modern Palestinian subjectivity itself.

Chapter 6 begins to unpack how the portrait's "manifest" content, the hegemonic *nahdah* and *Osmanlilik* civilizational representation discussed in part 1, stabilized and mediated the profound social and economic transformations of the day. The carte de visite, then, offers "object constancy" for the "new men and women" of the era. It offers "jointness" to bind their new sociability and economic transformations to the representational set that gives them ideological meaning. Against this process of stabilization, chapter 7 is the only chapter to fully explore the latent content of the portrait. It examines Jurji Saboungi's portrait of Midhat Pasha to explore the alterity of the image, its latent content, that has been displaced by the representational, formalistic, and ideological hegemony of the manifest surface. Finally, chapter 8 veers from formal, metropolitan studio photography to examine a form of *indigenista* photography largely ignored, namely, the narratives of the first Egyptian officials, such as Muhammad Sadiq Bey, who photographed the Hajj between 1860 and 1902.

No doubt, *The Arab Imago* has embarked on a complicated endeavor. On the one hand, it is charged to excavate and map as much empirical information about the history of indigenously produced photography as possible. Such an enterprise is epic considering the dearth of research on the topic, let alone the weight of the Orientalist master narrative. On the other hand, this book is consigned to name what the "Arab portrait" looked like. What forms do this "imago" take when imprinted onto the surface of the photograph? The answer must be formalistic, yet it must engage what Zahid Chaudhary calls the "aesthetic imagination" in order to determine whether or why such photographs seem to derive from, mimic, or resemble the European master-image.[55] In the venture to grapple with photography and cultural theory, I run the risk of either sounding too abstract or vacating Arab photography of its own locality. Considering this minefield of dilemmas, I proceed intrepidly and start, not with a strict art history, but with a study of the social history of Arab photography. In offering a social history, this book hopes to engage the representational and formalistic content of the portrait in order to answer "what Arab portraiture looks like during the nineteenth and early twentieth centuries." But also, we seek together the history of the portrait's social life and probe the processes, social currency, ideological effect, and, indeed, anxieties and alterity of portraiture.

Histories and Practice

An Empire of Photographs

ABDULLAH FRÈRES AND THE *OSMANLILIK* IDEOLOGY

The invention of the daguerreotype was announced in the Ottoman press as soon as François Arago presented it to the Académie des Sciences in Paris in 1839. The state organ *Takvim-I Vekayi* wrote, "The talented Frenchman, Daguerre has reproduced an object through the reflection of the sun's rays onto a shiny surface. One can understand the importance of this invention when one realizes that in this way certain things, which should be preserved, may be captured."[1] Very soon after, the royal court developed a keen interest in the craft. Sultan Abdülaziz, like his nephew Sultan Abdülhamid and Shah Nasir al-din of Iran, were trained as amateur painters and, subsequently, learned photography.[2] Information about the royal interest in photography dovetails with a foundational story related by Kevork Abdullah, one of three brothers who became the Ottoman Empire's most famous photographers, the Abdullah Frères.

As the story goes, Sultan Abdülaziz was displeased with a French photographer to whom he granted the privilege of taking the royal portrait. Fuʾad Pasha, his grand vizier and later the legendary mutasarrif of Mount Lebanon, recommended to the sultan that Istanbul's own Abdullah Frères be commissioned for the task. In this age of Ottoman reform and nationalism, Fuʾad Pasha found little difficulty in convincing this modernizing and enlightened sultan that an Ottoman photographer should photograph an Ottoman sultan. His Highness was so pleased with the result that he ordered his portrait to be

Figure 7.
Abdullah Frères, Sultan Abdülaziz, Istanbul, undated carte de visite, albumen.

"widely distributed" in a variety of forms among foreign dignitaries and his people.[3] Consequently, the Sultan Abdülaziz appointed the Abdullah Frères as court photographers in 1863.[4]

This anecdote does not mark the beginning of the history of the photographic portrait in the Ottoman Empire, but it does illustrate Abdülaziz's interest in photography during the earliest years of his reign. Fatma Müge Göçek reminds us that the sultan's portrait was not only circulated abroad but was hung in military and civil bureaus throughout the empire.[5] At the same time, however, the "formation and reception" of these royal portraits were "imbricated within the field of Orientalist photography."[6] The royal use of photography also suggests something more profound. The sultan knew what his portrait *should* look like. Abdülaziz had ascended to the throne in 1861 and implemented the administrative, legal, and economic Tanzimat (Risorgimento) reforms, which were started previously by his father, Sultan Mahmud II, and his brother, Sultan Abdülmecid. Unlike Abdülmecid and his successor, Abdülhamid, he posed for a number of cartes de visite, including vignette busts, full-body shots, and even a profile produced by Abdullah Frères (fig. 7), which were disseminated throughout personal, official, and international circles. Although we cannot be certain that the minimalist profile shown here is the product of the Abdullahs' first meeting with Abdülaziz, this portrait shares the representational qualities of all of the sultan's extant portraits. The monarch's portraits are always solitary, projecting a strong and steadfast, yet unpretentious, ruler who was not only the supreme political and spiritual leader, but also the first citizen of the Ottoman Empire.

In 1867, Abdülaziz was the first Ottoman sultan to visit Europe. Accompanied by his nephew Abdülhamid, the royal visit intentionally coincided with Napoleon III's Exposition Universelle in Paris, where the Ottomans maintained a pavilion robustly populated with photographs by court photographers Abdullah Frères, Pascal Sébah, Gülmez Frères, and Basili Kargopoulo. The competency of these indigenous photographers did not dissuade the sultan and the young Abdülhamid from participating in a common photographic practice, getting one's carte-de-visite picture taken while traveling, in this case by W. & D. Downey, Britain's photographs of royalty. W. & D. Downey produced at least two portraits of Abdülaziz and Abdülhamid, taken either at Balmoral Castle in Scotland or Buckingham Palace.[7] The full-body representations of the Ottoman statesmen show the sultan, in the understated dress of the *effendiyah*, standing with his hand on a desk in front of a leather couch (fig. 8) and, in the same studio, Abdülhamid sits with a sword in an embroidered Ottoman military uniform (fig. 9). The disagreement as to the location is important only inasmuch as it relates the indeterminate nature of photography and the generic quality of the portrait's indexical content. Giving no indication of the specific locale other than photographer's name, these portraits could have as easily been taken in Abdullah Frères' studio in Istanbul as in

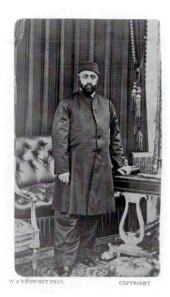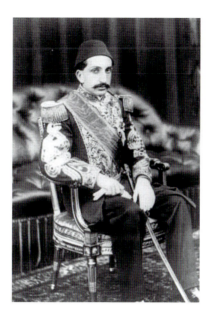

England or Scotland. This generic quality speaks to the universalist claims of the cartes de visite and the representation of "civilization" (*mediniyat*) and "progress" (*terakki*) that they invoked.

This chapter discusses those "generic" qualities as "genetic patterns" that mobilized the Ottoman ideology of reform and modernization upon which Abdülaziz and Abdülhamid claimed authority. Nancy Micklewright's work on Ottoman photography shows us that Abdülaziz, Abdülhamid, and their "advisors were perfectly aware of the subtleties of photographs as a means of communication" and power.[8] Against this backdrop of royal portraiture and their use of photography, this chapter begins to explore the social history of *indigenista* "Arab" photography within its historical, social, and ideological context of the late Ottoman Empire. The photography of the Abdullah Frères proffers an example of how *indigenista* photography served to represent Ottoman modernity as well as imprinted the "optical unconscious" of *Osmanlilik* ideology. Although active in Cairo and perhaps foundational for Egyptian indigenous studio production, the Abdullah Frères were neither Arab nor from the Arab world. As Ottoman citizens, however, they allow us to situate local photography within a larger Ottoman experience and provide us with an entrée into the complexities of Ottoman photography in which "Arab" photography is inlaid. Even as an elite and highly privileged practice, the Abdullah Frères' studio offers a model to explore how Ottoman photography was an expression of and facilitated by the new social relations of the nineteenth century. Their photography reproduced a particular "perspective" that expressed the reorganization of the empire within a normative scopic regime of Ottoman modernity. We

Figure 8.
W. & D. Downey, Sultan Abdülaziz, London, 1867, albumen, 9.2 × 5.4 cm.

Figure 9.
W. & D. Downey, Abdülhamid II, London, ca. 1867, carte de visite, albumen, 8.3 × 5.3 cm.

discover that the work of the Abdullah Frères was legible not because that representation was exclusively a state project, as John Scott notes, but because this legibility was an *effect* of discourses of "civilization and progress" that served to naturalize the universalizing dimensions of the Tanzimat and *al-nahdah al-ʿarabiyah*.[9]

Defining the Tanzimat

John Tagg tells us that photography and image making were used in tandem with "institutional practices central to the governmental strategy of capitalist states whose consolidation demanded the establishment of a new 'regime of truth' and a new 'regime of sense.'"[10] The observation is as applicable to Istanbul as to London, Paris, or colonial India. He also shows that image production is an ideological endeavor that bisects state or official institutions, commercial ventures, and communal and individual social practices. The birth of photography accompanied the capitalist restructuring of markets and modes of governance in both Europe and the Middle East. Photography arrived in the Weberian wake of the Ottoman modernizing project that was enmeshed in a struggle between the rationalizing impulse to disenchant governance, society, and economy and the desire to maintain cultural authenticity. I, therefore, delink or "deprovincialize" the history of photography in the Ottoman Arab world from the European master-narrative by locating that history as embedded in the Tanzimat and of the *Osmanlilik* project of the nineteenth century.

Sultan Mahmud II, who set out to modernize the state and its institutions through legal, social, and institutional reform, instituted the Tanzimat in 1839, the same year that Arago announced the invention of the daguerreotype. The Tanzimat was a massive and multivalent Ottoman reform movement, officially starting with Sultan Abdülmecid's *Hatt-i-Şerif*, or the Gulhane Edict, that decreed equal access to property and government offices to all Ottoman subjects, including non-Muslims. This decree was the result of changes in political economy and social hierarchy in previous decades, leading to the abolishment of tax farming and establishment of new *Mecelle* civil codes and their secular *nizamiye* courts.[11] The new Ottoman Land Code of 1858 legalized private property and determined land value through market forces. New merchant classes arose alongside the new *effendiyah*, a new, educated class of bureaucrats, functionaries, and professionals that staffed the growing number of new secular state and private institutions throughout the empire, including schools, universities, hospitals, public services, and so forth.[12] Suraiya Faroqhi asserts that photography was an expression of the "self-image and aspirations" of this new Ottoman *effendiyah* middle class.[13]

This sweeping overview of the Tanzimat allows us to fathom the undergirding ideology of "Ottoman modernity," otherwise known as

Ottomanism or *Osmanlilik* (or *Osmanlicilik*). I use the term *Osman-lilik* because it was more than a state policy; it was an ethos that cut across the reign of a number of sultans, whose strategies for modernization and vision of citizenship differed. As the litany of political assassinations, coups, and exiles within the highest echelon of Ottoman government attests, many diverse and competing political actors and factions shared *Osmanlilik* ideology. That it was unevenly implemented throughout the empire does not detract from the force of the Tanzimat's *Osmanlilik* ideology. *Al-nahdah al-ʿarabiyah* in the Arab provinces was inexorably connected to the Tanzimat although separate from it. *Al-nahdah*'s civilizational formula came from the nomenclature of Ottoman reform but aimed at the reform of Arab societies, at least in Greater Syria (Lebanon, Palestine, and Syria) and Egypt. In Egypt, for example, Hussein Marsafi's *al-Kalim al-thamin* identified eight key words that came out of reformist Ottoman and khedival policies. Terms such as *watan* (nation), *hukumah* (government), *ʿadil* (justice), *hurriyah* (freedom), *siyasah* (politics), and *tarbiyah* (education) could be found in Turkish or Armenian as easily as in Arabic.[14] But more important, if they were not necessarily the virtues exhibited in the sultans' and khedives' portraits, they were, as we will see, virtues exhibited by the "ideal" Arab subject who was also different, but not necessarily superior or inferior to, its Turkish Ottoman counterpart.

The civilizational ideals of *Osmanlilik* and *nahdah* ideology, like patriotism (*wataniyah*), unity (*ittihad*), and progress (*taqaddum*), were not descriptive goals to achieve but functioned to interpellate, mediate, and facilitate the radical restructuring of the political economy of the empire and its reengineering of social and political hierarchies. The camera was the exemplary instrument to exhibit the new ideological vision that reorganized "secular" space, society, and selfhood in order to facilitate new modes of production, governance, and capital accumulation. Photography was the perfect space for their representation.

The reason that Middle Eastern photographic history seems similar to European photographic history is not because one is derivative of the other but because the two are enmeshed. In this regard, the prominence of technological modernization and the rationalization of governance and political economy within *Osmanlilik* ideology has misled scholars to fold the history of Ottoman modernity into the master-narrative of European modernity. Art historian Wendy Shaw, for example, claims that the ensuing photographs, paintings, and frescos were the result of the Ottoman fascination with technological modernization and did not represent an epistemological shift in Ottoman society and visual production. "Divorced from its links to pictorial tradition," she states, "the absence of a perspective construction and the non-mimetic realism of manuscript painting, the primary form of illustration in the Ottoman Empire before photography, made the realism of the new medium entirely new in the

empire."[15] Nineteenth-century Ottoman photography, art, design, and architecture were, therefore, technocratic and derivative of Western forms. The functionaries who reproduced these media and forms, she states, had little concept of subject-centered perspective because late Ottoman artistic production was in the service of the state, not an expression of any artistic or social shift as in the West.[16] Scholars from Nissan Perez to Sarah Graham-Brown concur that "styles of photography remained largely derivative, taking the norms of composition and styles of portraiture almost entirely form European models."[17]

The view that Ottoman Turkish, Arab, and Armenian visual production was based on a mimicry and technological fetishism implies that these social actors, functionaries, and artists were not fully conscious of the aesthetic, intellectual, and political ramifications of the medium they used and the *form* it produced. The anecdotes surrounding Abdullah Frères and the sultans, however, suggest the contrary. While reformers, bureaucrats, and the sultans looked to Western models to reform Ottoman society, economy, and governance, they did so with a profound degree of self-awareness and ideological intent.

Mary Roberts confirms this when she locates the sultans' use of photography squarely within the explicit court agenda to produce a royal image that represents a modern and powerful state and its equally modern ruler. "Royal portraiture," she states, "formed a hinge between the long-standing tradition of representing the Ottoman sultans through painting and the current sultan's embrace of the modern medium."[18] The technology of photography might have included generic representation, but that representation, no matter how banal, was not without ideological effect. Transferred into a new political and cultural geography, the medium might have repetitiously reproduced the genetic patterns of that representation. However, that representation and the physical image itself were deployed with ideological intents and motivations that served the reproduction of social relations *within* the Ottoman lands where they were produced. Ottoman photography was an Ottoman phenomenon.

Ottoman Photographers

Just as *indigenista nahdah* photography was nestled within Ottoman photography, the Abdullah Frères were nuzzled within a community of Istanbul photographers, a community they helped to create. Basili (Vassilaki) Kargopoulo (1826–86), an ethnic Greek resident of Istanbul, is considered their most prominent forerunner. He was the first photographer to have opened a studio in Beyoğlu (Pera) as early as 1850. He and Abdullah Frères are credited with creating a community of young Ottoman photographers outside the new state school system. They trained Greeks and Armenians who populated Istanbul and provincial capitals. These photographers include Nikolai Andriomenos

(1850–1927); Alkibiades Nikolaidis, the owner of Photographie Stamboul; Atelier Apollon's Achilleas "Asil" Samanci; Gülmez Frères; and Photographie Phébus, owned by Bogos Tarkulian.[19]

Among these successful commercial photographers, Kargopoulo was likely to have been the first photographer to the Ottoman court, awarded the position by Abdülaziz's brother, Sultan Abdülmecid. Later, his son became court photographer to Sultan Abdülhamid in 1879 after the Abdullah Frères fell out of his favor. Wendy Shaw credits Kargopoulo for the "introduction of photography to the royal eye," which "laid the groundwork for the profound change in the use of photographic images under Sultan Abdülhamid II."[20] Despite this misattribution, Shaw's comment highlights the presence of Kargopoulo within royal circles.

His work stretches from landscapes, character-types, and vistas targeting European markets and was bound in albums and displayed in exhibitions alongside his more famous contemporaries Abdullah Frères, Pascal Sébah, and Sébah et Joaillier.[21] While Carlo Naya's studio might have been the first in Pera in 1845, Kargopoulo's studio successfully marketed small-format landscapes, cityscapes, and character-types to Istanbul's tourists and also ran a thriving portrait studio where "his customers could pose in a wide variety of Eastern costumes he kept on hand."[22] His commercial success among Istanbul's minority communities and the new effendi, middle classes grew with the expansion of the carte de visite market.

Despite his prominence, Kargopoulo did not have the stature and pull of the Abdullah Frères. Their only true rival was Pascal Sébah, (1823–86). Sébah opened his studio El-Chark, Arabic for "The East," in 1857. El-Chark moved to Istanbul's fashionable Pera district, now BeyoÐlu, where the Abdullah Frères and Kargopoulo had also opened studios alongside their European counterparts. Sébah was, most likely, a Syrian Catholic who made his way to Istanbul as a youth, and his probably Levantine Arab origin deserves noting in a study on "Arab photography." More than a decade before Abdullah Frères' branch debuted in Cairo, Sébah opened a studio with his French technician Larouche in the city's celebrated Shepheard's Hotel in 1873.

On the verso of Sébah's cartes de visite, the mount displayed his Istanbul and Cairo addresses along with etchings representing the medals he had won from international expositions in Paris (1870), Vienna (1873), Philadelphia (1877), and Naples. As was the standard practice, the mount advertised that he was a member of the Société Francaise de Photographie.[23] Adjacent to these merits, his ornate logo appeared as "El-Chark: The amazing flashlight picture, so that loved ones do not depart."

Sébah's photography empire was taken over by his son, Jean, and brother Cosmi after his death in 1886. Jean partnered with Policarpe Joaillier in 1888 to create the renowned Sébah et Joaillier brand, which was expanded even further when the studio acquired the

Abdullah Frères' archive in 1900.[24] Jean Sébah also partnered with Fettel et Bernard, a prolific portrait studio in Alexandria, to form Fettel, Sébah, et Bernard around the turn of the century. The Sébah name lasted for some time, becoming Foto Sabah in 1934 until eventually closing in 1953.

Sébah is known for his massive oeuvre that contributed to internationalizing the Hamidian photographic project, to which the Abdullah Frères and Kargopoulo also contributed. Pascal's photographs span the empire, from mosque interiors to tableaux vivants in provincial towns. Sébah is remembered most for his character-types. At the charge of Sultan Abdülhamid, he collaborated with Osman Hamdi Bey (1842–1910), the famous archeologist, founder of museums, and painter who trained under Gérôme. Sébah produced the photographic illustrations for Osman Hamdi's *Costumes populaires de la Turquie en 1873*, which was created especially for the International Exposition of Vienna.[25] While Sébah and Kargopoulo deserve more attention, their work and oeuvre in this study function as counterpart and complement to the work of Abdullah Frères and demonstrate the vitality of indigenous photography not only in the court but also in the Ottoman street.

Abdullah Frères

It seems symbolically relevant that Abdullah Frères displaced Kargopoulo and became court photographers by 1863, as they would become a tour de force in the empire equaled only by the Sébah legacy. Their Armenian surname was Aliksan and, in 1858, the Abdullah brothers took over the photographic studio of an expatriate German chemist-photographer named Rabach. The eldest brother, Vichen (d. 1902), previously worked in Rabach's studio, while his younger brother, Kevork (d. 1918), had completed his studies in art at Murad Raphaelian, the Armenian Catholic school on the island of San Lazzaro in Venice. Along with their brother Hovsep (d. 1900), they purchased Rabach's studio upon his return to Europe. Ten years later, after becoming court photographers, their stature was further enhanced by an imperial decree that protected their copyright.[26] By the 1870s, they clearly had become Istanbul's highest-prestige studio, accommodating not only the new bureaucratic and *askari* (military) elite but also Egyptian elites and *effendiyah* classes.[27]

Ever since the Sultan Abdülaziz was photographed by Abdullah Frères, every sultan and grand vizier until the fall of the empire had his portrait taken, including several for cartes de visite of the reform-minded Fu'ad Pasha. In addition to prized portraits of Abdülhamid and Abdülaziz, the Abdullah Frères photographed the sultan's daughter, Saliha Sultan, in 1873 and established a special room in their atelier just for the elite and royal women of Istanbul and Cairo, their

entourages, consorts, governesses, sisters, and daughters.[28] More profound than the number of high-profile sitters they attracted was the fact that the Abdullah Frères were central to image production for a network of new bureaucratic and administrative elites. Mary Roberts places Fu'ad Pasha himself as the "lynchpin of this network" who was "instrumental" in creating "the image of the modern sultanate."[29]

The association with the court served the Abdullah Frères well and positioned them to be the choice photographers for the Ottoman elite and the empire's new rising classes. In many ways, Abdullah Frères were ideal Ottoman subjects, serving the ruling class and the sultan by fashioning the royal image as modern and powerful. But also, their success serves as a riposte to the presence of European expatriate photographers in Ottoman elite circles. Just as Abdülaziz visited W. & D. Downey, foreign aristocracy and luminaries visited the Abdullahs. They photographed Prince of Wales Albert Edward (later King Edward VII) when he and his wife toured Egypt, the Holy Land, Istanbul, and Greece accompanied by the British photographer Francis Bedford in 1862.[30] Their high-profile clientele included foreign dignitaries, aristocracy, and celebrities, including Emperor Napoleon III and his wife Eugénie, Emperor Franz Joseph of Austria, and Mark Twain.[31] Augusta, the kaiser of Germany's wife, requested a picture of Abdülaziz in 1863, which was taken then by Abdullah Frères and reproduced by the German empress, imprinted in a medallion emblazed with the sultan's image. The portrait became the sultan's favorite and was used as the model of the minted royal image.[32]

The brothers' political intimacy with the court cut both ways. During an official visit to Istanbul in 1875, Khedive Isma'il had his portrait taken by the Abdullah Frères.[33] Some have attributed the opening of an Abdullah Frères studio in Cairo to their relationship with the viceroys of Egypt, opening a branch at the behest of and "grant" from Khedive Tawfiq Pasha in 1885.[34] Perhaps more telling is that, in 1878, the Abdullah Frères accepted a commission for a large group portrait by Grand Duke Nicolas, a Russian aristocrat and general who had led Russian forces to defeat the Ottomans at San Stefano (now the Istanbul suburb Yeşilköy). Considering the humiliation imposed on the Ottoman Empire by the subsequent Treaty of San Stefano, the Abdullahs' concurrence with the portrait request offended Sultan Abdülhamid. He revoked their copyright protection and prohibited them from using the royal monogram, the *tughra*, on their photographs. Kargopoulo and his son were renamed court photographers and Abdullah Frères' photographs of the court and their negatives were confiscated.

After the brothers repatriated to Istanbul from Cairo, their firm was re-granted the royal monogram in 1890.[35] Two years later, however, Sultan Abdülhamid ordered the seizure of their studio, claiming that "Armenians photographed women dressed in various clothes offending Muslims." Esra Akcan provides a translation of this decree,

which claimed that the Abdullah Frères' photographs "raise suspicion in Muslims' minds."[36] The vacillating favor of the court was not a result of royal capriciousness. By 1894, the sultan was orchestrating the mass and indiscriminate murder of Armenian civilians throughout the Armenian provinces in eastern Anatolia by Ottoman troops, Kurdish tribesmen, and local irregulars. The "Hamidian massacres" were a prescient indication of the genocide that would befall the Ottoman Armenian community two decades later.

At the same time, Kevork wrote articles in the Armenian press not only about photographic technique and composition but also about social and political issues.[37] These events draw attention to the relationship between photography, photographers, and their societies. For the purposes of this book, the rise, fall, resurrection, and afterlife of Abdullah Frères communicates the complexities of being an Armenian involved in image making in the Ottoman Empire, especially when they were so deeply ensconced in many of the same social networks of the Ottoman elites who would lead the Turkish nationalist takeover of the empire in 1913. As Armenians, they must have had to negotiate a very treacherous political economy of social and political relations in the imperial capital and the empire. One can only speculate as to the quotidian existence of these minority photographer-impresarios without access to their lives, voices, and social practices as articulated in their own language sources. To this end, a critical history of the Abdullah Frères involving Armenian, as well as Turkish and, potentially, Greek, sources is needed. Such a mining of sources would provide us a fuller understanding of Armenian, if not Greek, photographers of the empire.[38] Their lives and work are relevant to this study precisely because their photographic practice shows us how their success rested on their social and commercial network as much as the quality of their composition. The social relations around the photograph and the photographer outstretched the confines of a minority community in the imperial capital. It is that "reach" that imbided their portraiture with such a social currency.

Mimetic Ideology and the Ottoman Perspective

Opening this chapter with a discussion of Abdullah Frères' portrait of the Sultan Abdülaziz allows me to posit a counternarrative to the dominant Orientalist narratives of "Middle Eastern photography" that assert Ottoman Arab, Turkish, and Armenian photography was derivative of European photography. This is not to say Ottoman photography compositionally "looked different" from European photography; rather, the repetitious photographic formalism was imbued with specific meaning and ideological roles within their own contexts. Scholars who study the photography of the global South recognize how the politics of representation within *indigenista* photography

shared ideological, social, and economic processes akin to, if not intertwined with, Europe.

In reflecting on the history of family photographs, Julia Hirsch remarks that recurrent "patterns" in American and European individual and family portraits seem to have been "grafted onto alien cultures."[39] Christopher Pinney notes the difficulty in distinguishing native- from foreign-produced images because "early Indian photographic practitioners were part of an elite that mimicked key colonial aesthetic forms." What differentiated the Indian from the British and the personal from the official portrait was not form but "the field of power around the camera."[40] Zahid Chaudhary further adds that nineteenth-century Indian photography was inevitably engaged with a process of a colonially informed aesthetic mimesis, stating that because "aesthetic forms contain rhetorical contents," we should consider "formal elements of the image as one among other registers of mimetic practice."[41]

In his discussion of the use of portraits in the colonial Philippines, Vincent Raphael uncovers that the form of the middle-class portrait may have appeared the same but "the function" of indigenous portraits "differs from the needs of colonial authority. Rather than serve as receptacles for colonial intentions," indigenous portraits were imbricated with colonial representation, but, simultaneously, middle-class Filipino portraits "unhinge identities from their received contexts, expanding the terrain of possible identifications beyond what could be surveyed and disciplined" by Spanish colonial interest.[42] As Pinney, Chaudhary, Raphael, Deborah Poole, and Karen Strassler show how indigenous photographic practice presents potential alternative modernities, modalities of selfhood, economy, and sociability that were themselves products of indigenous, and certainly repressive, elite class formations.[43]

Therefore, the history of *indigenista* photography in the colonial world does not lie in compositional or aesthetic difference or similarity with Western photography. In the case of the Ottoman world, Abdullah Frères and W. & D. Downey offer stately and balanced portraits of imperial rulers no different from those of the monarchs of Europe whom they photographed. W. & D. Downey's portrait does not depict an elaborate Oriental potentate but a full-bodied presentation of a political leader. The Frères' profile proffers nothing to suggest that the royal portrait, initially botched by a European photographer, was specifically an indigenously produced portrait of the most powerful man in the empire. What defines indigenous production is less form than context, the field of power along with the field of desire around the camera, as W.J.T. Mitchell and Geoffrey Batchen note.[44] The truth value and verisimilitude of the photograph suggests not blind imitation but that the Ottoman Empire, via the Tanzimat and its concomitant economic transformations, had already experienced the social and ideological shifts that have given a social value to photography.

It is not coincidental that photography emerged as the first global visual cultural phenomenon at the same time when new striations of classes were being formed throughout the world. Nor is it coincidental that it surfaced most prominently in Istanbul and the new metropoles of capital accumulation like Izmir, Beirut, and Alexandria. The processes of *embourgeoisement* and the practice of photography are interlocked within the character and logic of capital, which was in tension with competing forms of "lived experience" in each locality. As a result, the photographic histories in the global South may look similar to those of Europe, but they contain "alternative" social, technological, and social sagas, as Nancy Micklewright, Ayshe Erdogdu, and Suraiya Faroqhi have explored in the context of Ottoman Empire.[45] These scholars demonstrate how "official photography" was an organic outgrowth of normalizing discourses of *Osmanlilik* modernity. While Ottoman photographic forms mimicked European representational templates, templates that accompany that apparatus itself, these scholars show how photography played a role in new consumerist practices and new gender roles, connecting those social practices to larger discourses, which defined Turkish Ottoman cosmopolitanism.[46]

The sociohistorical and political context of mimetic photography compels us to examine the *effects* of what Paul De Man, in his discussion of literature, calls "genetic patterns." The adoption of foreign practices and technologies was not a passive act but transpired within "semiological and rhetorical terms" of *Osmanlilik* ideology and the Tanzimat, terms that simultaneously distinguished the new, ideal Ottoman subjects (new bourgeois *effendiyah*) from the "backward" subaltern classes and from their European counterparts.[47] The act of "imitation" was an ideological and aesthetic act in a social space. Through representational and social enactments, non-Western subjects *actualized* modernity, claiming ownership of technology, social practices, concepts, and ideological principles within what was presented as a universalized civilizational formula for progress and "modernity." They asserted proprietorship over the intellectual, economic, and social capital they held in order to lay claim to their own national sovereignty and subjective worth in a world dominated by European cultural and economic hegemony.

Although deeply entrenched within asymmetrical relations to power and capital, the sharing of cultural forms and social practice between Europe and "the East" so vividly depicted in Ottoman era photography is a complex formula of mimesis. Mimesis, then, is not a blind imitation and monkeying of standardized visual forms imported, *prêt à porter*, into the empire. European and Ottoman portraits may have shared a representational index but, as we will see throughout this book, that index was an imprint of a modern civilizational ideology of new social classes and individuals. Not only an ideological representation, the portrait was an imprint of these new classes, showing that they had arrived to lead the local cultures to "progress"

and their civilizational potential but also to parry European civilizational claims and imperialist designs.

The new social classes of the late Ottoman Empire were not homogenous. They collaborated with Europeans more often than resisting them. They interacted and collaborated with official state elites in instituting public policy and learned from and taught them in the new schools of the empire. They struggled with the state for control of power, governance, juridical authority, and control of local means of production (raw materials and agricultural products such as cotton, tobacco, silk, and grain, as well as services and ancillary production around ports, the development of economic and civic infrastructure, and so forth). Regardless of their rivalries and alliances and differing *political* positions vis-à-vis each other and foreign powers, the "new men and women" of the Ottoman Empire, including the Arab provinces, shared a common ideological *manzhar,* or "perspective," of the world, their countries, and their selfhood.

In order to excavate the mimetic composition and continue the process of "provincializing" the Orientalist master-narrative, the photograph should not be seen as a site for the *production* of social classes and identities, just as it should not be seen as a site that produced a new visual aesthetic *ipso facto.* To the contrary, the surface of the photograph was a site for the ideological reproduction and expression of the new *social relations* within the empire. It was a site of imprinting a particular *perspective* that organized Ottoman society.

Art historical methodologies cannot be faulted for misunderstanding the imprint of this perspective as derivative from Western forms. But those like Micklewright, Mary Roberts, and Esra Akcan demonstrated that Ottoman photographers, like the Abdullah Frères, "transformed and adapted [various European] visual legacies ... for their own purposes, making use of the new medium's possibilities." *Indigenista* Ottoman photographers "did indeed construct the 'artful' convention of photography especially the Abdullah Frères panoramic city albums" that distinguished themselves from Orientalist photography despite their compositional similarity.[48] For example, Abdullah Frères' photograph of Tophane and the Nusretiye Mosque places a rower crossing the Bosporus in the foreground and uses the actual "subject" of the picture, the famous Istanbul neighborhood and modern ships, as a backdrop (fig. 10). The image is as artistic as it is formal and speaks to a representational repertoire that is rooted in the subject-centered perspective of the photograph.

Akcan's reading of the Abdullah Frères directs us toward the politics of representation in exploring Ottoman photography. She asks us to interrogate the aesthetic choices of Ottoman photographers, choices defined by the rationalizing principles of Tanzimat reform. The subjects who appeared in Abdullah Frères' portraits were the same subjects who were looking at the landscapes from the camera's perspective. Ottoman photography shared with the West the appearance

Figure 10.
Abdullah
Frères, View of
Tophane from
the sea, photo-
graphic print,
albumen.

of a "new kind of observer" who was "inseparable from a massive reor-ganization of knowledge and social practices that modified in myriad ways the productive, cognitive, and desiring capacities of the human subject."[49] To say that the Middle East and Europe shared the rise of "new kind of observer" is not to say that these observers were the same. The *Osmanlilik* perspective was imprinted in photography and reflected the perspective of a new, modern Ottoman subject just as the portrait of Abdülaziz represented a new, modern Ottoman ruler.

The Abdullah Frères provide us with a site of inquiry into this perspective. In mapping the empire's blue-chip photographers, we can identify the ideological "boundaries" that structured a normative "perspective," or, to riff on Martin Jay, on a scopic regime of *Osman-lilik* modernity.[50] Tanzimat and *Osmanlilik* perspective organized a social, spatial, and subjective vision that undergirds class, gender, individualist, and national formation in the late-nineteenth-century Ottoman Arab world. The photograph was inevitably an imprint of this perspective and its production irrevocably a part and by-prod-uct of the same social and economic relations that gave its ideological content meaning.

Repetition and the Optical Unconscious

Rather than focus on compositional differences between Orien-talist and Ottoman photography, we may inquire into how the photograph's "realism" appeared as legible and ideologically relevant

to the empire's rulers and subjects. Mary Roberts suggests that the Abdullah Frères not be understood within art historical categories of Orientalist and Ottoman photography. They should be examined through their "precise historical contexts in order to map their movement between categories and trace the processes of boundary formation" between these traditions.[51] The most striking quality of the Ottoman and early Arab portrait may be its generic quality, for example. The images recall Walter Benjamin's remarks regarding the carte de visite, deriding how individuals and families posed with "the pedestals and balustrades and little oval tables. … This was the period of those studios—with their draperies and palm trees, their tapestries and easels."[52] Benjamin speaks of the balustrades and bucolic backdrops as an uncanny index that stubbornly defined studio portraiture well after their utility expired. Early photography's long exposure times required one to lean "against the polished door jamb," a table, or chair for support, but the accessories also matched the technology, matched the relationship between the photographer, the photographed, and the photograph. With the development of photographic technology and the death of the photographer as artisan, the technology of mass mechanical reproduction stripped these objects and postures of relevance as tools in a relationship between the photographer, his skill, studio, and sitter. The persistence of these props and poses after their utility had expired may have made them "absurd," but their persistence served an ideological purpose in Europe. They were "reminiscent" of an age and reproduced an "aura" of a social relationship between sitter and craftsman that the age of mechanical reproduction had eviscerated.[53]

While the Ottoman portrait's formalism might seem derivative from Western forms, the repetition of these props, accessories, backdrops, and poses served alternative ideological ends. Suren Lalvani notes that the appearance of Hellenic statuary, baroque chairs, books, reading tables, and "Grecian columns and voluminous drapes" in the cartes de visite "exude a civilizing and civilized air."[54] This "civilizing air" took on particular ideological salience and political imperative in portraits produced during the Tanzimat and *al-nahdah al-ʿarabiyah*, when the Arab East was assailed by foreign and self-criticisms about its own "backwardness" and the empire was pursuing a modernization agenda. These props possessed ideological gravity in the context of Ottoman modernity because they drew from a semiotic register within Tanzimat, *Osmanlilik*, and *nahdah* reform discourses that signified *universalized* progress and civilization. The appearance of these mundane civilizational signs in the portraits of Abdülaziz, Abdülhamid, their grand viziers, generals, ministers, and provincial governors affirms that these quotidian accessories were not benign decoration or technological necessities but visual markers of Ottoman progress and cultural presence on a world stage dominated by European military and economic supremacy.

This is not to suggest that the sultan's portrait defined the indexical meaning of the Ottoman portrait, which citizens then imitated. The royal template did not define the "genetic patterns" in Ottoman portraiture. To the contrary, even the sultan's portrait took part in and derived meaning from the "genetic patterns" that the Abdullah Frères reproduced throughout their visiting cards. Rather than focus on the "genetic patterns" themselves, I focus on the repetition of the portrait's formulaic poses, its accessories, props and backdrops, and the format sizes of the carte de visite and cabinet card as serving a very striking ideological function.

Elizabeth Edwards notes that the repetitious uniformity of the carte de visite suggested "a beguiling uniformity of function."[55] Within Europe, the carte de visite, John Tagg shows us, was "made to a formula. Posing was standardized and quick."[56] He shows that "the history of photography had been a history of an industry. The impetus for its development came from a vast expansion of the market for reproductions—especially portraits—which both necessitated and depended on a mechanization of production."[57] While the "formula" in Europe may have been replicated formalistically in the Ottoman world, its ideological effect and purpose were not the same. The repetition of form and content overdetermined the portrait's "civilizing" message within the protean era of *Osmanlilik* modernity.

The civilizational underpinnings of Ottoman photography are related to its own social relations vis-à-vis social reform, class formations, and disciplinary power within the empire as much as with Orientalism and European expansionism. The overwhelming nature of repetition as a constitutive form of photography alerts us to a process: namely, to borrow Benjamin's phrase, *Osmanlilik* modernity's "optical unconscious."[58] The repetition compulsion of the portrait—deploying ornate chairs, tables, books, pens, pedestals, bucolic fences, arched bridges over faux-streams, backdrops of Roman and Hellenic ruins, and a "conventional set of conventional poses" —represents the Ottoman "image world."[59] It imprints the "perspective" of the Tanzimat and its new subject. But the photograph represents these image worlds "enlarged and capable of formulation," as Benjamin states.[60] Yet, this imprint of the "optical unconscious" is not just a one-dimensional representation of desires and wishes of imagined communities and subjects. Rather, the formalistic repetition alerts us that this "enlarged" imprint of the Ottoman optical unconscious was an enactment of ideological identifications. But also, this repetition was an instantiation of that very *Osmanlilik* ideology and its subjective ideals.

The "optical unconscious" of the Ottoman portrait lies beneath the surface in the larger discourses of science, knowledge, art, craft, society, reform, education, gender, domesticity, and industry. The repetition of the props, format, and indexicality of the studio portrait, its very claim to universality, was an enactment of *Osmanlilik* modernity in order to reaffirm the ideological certainty of the new social and

economic order being played out in localities such as Istanbul, Beirut, and Cairo. This repetition in form and content suggest a similarity in social processes in Europe and the Ottoman Empire but constitute different ideological ends. In order to excavate the Ottoman "optical unconscious," the Abdullah Frères oeuvre is instrumental, allowing us to see how the repetition of genetic patterns cuts across official and commercial portraiture, yielding different ideological effects.

Two particular photographs by the Abdullah Frères illustrate the "optical unconscious" of the Ottoman "image world." They are portraits of a young Abdülhamid, taken in 1868, eight years before he ascended to the throne through a coup. He was seen to be sympathetic to the reform and constitutional movement. His coronation in 1876, where he was invested with the *kılıç kuşanmak*, the Sword of the Prophet, contrasted with his unassuming arrival for the event.[61] An Abdullah portrait of a man called Arif Pasha (fig. 11) is virtually identical to a three-quarter-length portrait of a young Abdülhamid, likely taken by the Abdullah Frères and now housed in the archive of the Topkapi Palace in Istanbul, displaying then Prince Abdülhamid in the dress of what was thought to be his ideological cohorts, the progressive and educated Istanbul *effendiyah* (fig. 12). Arif Pasha's and Abdülhamid's portraits portray an Ottoman notable in the long frock coat and tarboosh of the Ottoman effendi bureaucrat. The sultan's hand on a table mirrors Arif's elbow on a high vanity bureau, and their clothes are virtually identical. If the sultan's smartly pressed and crisp black frock coat, frontal pose, and eye contact assert a photographic presence, his figure is also more rigid than Arif Pasha's leaning casualness. We are not certain of Arif Pasha's identity. He could have been a field

Figure 11.
Abdullah Frères, Arif Pasha, Istanbul, 1870s, carte de visite, 10.4 × 6.4 cm.

Figure 12.
Unknown photographer, Abdülhamid, carte de visite, Topkapi Palace.

marshal or a minister. The representation of his portrait communicates an ideological message, identifying with *Osmanlilik* ideals that Abdülhamid would years later suppress and appropriate. The representation of the portrait and its ideological message are recognizable because they were repeated in the genetic patterns of the portraits of high-ranking functionaries and the effendi class since the Abdullah Frères had opened their first studio.

The repetition of these patterns does only necessarily *represent* the desires of *Osmanlilik* ideology. It *enacts* them. It imports them into the materiality of representation and relies on them for stable meaning that assumes to be as transparent and unquestionable as the truth-claims of the portrait itself. Repetition reveals that the ideals of Ottoman modernity have already arrived and its ideal subjects already existed. The portrait of Arif Pasha and the sultan do not provide a template that is defined by Tanzimat principles such as nation, government, justice, politics, and education. The portrait and its repetition instantiate these principles, confirming them as social facts already in play. The portrait performs these principles both in the portrait and in their lives (which they bring to the portrait), proving that they are not abstract goals but social reality. The paired image of a frock-coated Abdülhamid, then, does not define a template to be imitated by his subjects. It enacts a subject enmeshed in the social, historical, political, and economic interplay of what modern Ottoman subjects *are* during the Tanzimat. The *Osmanlilik* ideology is so powerful that the sultan occupies the repetitious space of its visual and discursive nomenclature.

Repetition is a structural element in the economy of the image at all levels. It is structured along set "patterns" of composition, staging, and posture, all of which themselves coalesce in a handful of standardized dimensions and formats of the portrait. This repetition draws portraits into a shared ideological space. Abdullah Frères' photographic vignette of the young Abdülhamid is a more unassuming example, less laden by the obvious indexical language of the effendi portrait (fig. 13). Likely cropped from the sultan's three-quarter portrait, the image is understated and almost serene, exhibiting Abdülhamid in the same effendi garb that Abdülaziz sympathized with, tried to crush, and then appropriated during his reign. The minimalism and closeness of the portrait recalls Abdullah Frères' profile of Abdülaziz. This vignette portrait and W. & D. Downey's portrait of Abdülhamid, ornately dressed in Ottoman military regalia, are contemporaneous. The authority of the image is not in epaulettes, swords, embroidery, or the salon surroundings but in the face of the Ottoman prince. Ottoman subjects, especially the proponents of the constitutional and parliamentary movement, no doubt, searched in his face and eyes for a humanity with which they could identify. How different is the Abdullahs' vignette of Abdülhamid from a contemporaneous carte de visite taken at the Frères studio in Istanbul. The subject of that portrait is an Ottoman Armenian, Garabed Yassayian (fig. 14). The indexical differences in clothing may

communicate that Yassayian is not a government functionary or educated effendi. This difference does not preclude that the subjects of each vignette portrait are citizens of the Ottoman state, protected by the new civil codes passed in the preceding decade. If anything, Yassayian's confident and strong glance and subtle smile emits a charisma that Abdülhamid's visual presence seems to lack.

These two portraits of the young Abdülhamid are given meaning because they are imbricated with *Osmanlilik* ideology and enactments of a political economy of selfhood that already exists in Ottoman societies. The repetition of patterns, props, dress, and photographic formats and composition alert us to the regularity and legibility of a particular "perspective," an Ottoman perspective. This perspective is that of the viewer on the banks of the Bosporus looking across the water to the modern ships, buildings, and Nusretiye Mosque, built by the grandfather sultan of reform, Mehmet II. It is the "view" of the Ottoman subject, whether it be the young Abdülhamid, Arif Pasha, or Garabed Yassayian, who looks to the *Osmanlilik* architectural forms and urban space of Istanbul as a source of identity but also as a place to actualize modernity.

The repetitious formalism directs us to the relationship between repetition and *identification*.[62] Photography in the Ottoman world was couched in the overarching discourses of "civilization and progress," in *Osmanlilik* and, in the Arab world, *nahdah* ideology. The portrait imprinted the Ottoman "optical unconscious" because it expressed the new class and national subject's *identification* with the ideological tenets that organized the potentiality of Ottoman political economy and social order. In this regard, the optical unconscious girding

Figure 13.
Unknown photographer [Abdullah Frères], Abdülhamid II, Istanbul, 1860s, carte de visite, albumen, 8.3× 5.3 cm.

Figure 14.
Abdullah Frères, Garabed Effendi Yassayian, Istanbul, undated carte de visite, 10.4 × 6.4 cm.

Abdülhamid, Arif Pasha, and Garabed Yassayian's portraits is a shared and collective unconscious that understood the photograph as a clear representation of social desires, a clear representation of what reality looks like as it is undergoing the social and economic transformations of the Tanzimat. The massive oeuvre of Abdullah Frères lends itself to understanding the processes of identification and subjective constitution and reproduction. The repetition of the portrait visually affirms the "ascending consciousness" of the new Ottoman subject.[63]

The Abdullah Frères' photography poses a scenario of class-national-ideological identification in which photography materialized the *Osmanlilik* perspective as fully formed social and scientific narratives that served to regulate social transformations and regularize the ideologies that validated and made sense of those transformations. In other words, discourses and practices of Ottoman Arab photography were inextricably bound by certain ideological *immobiliers* of *Osmanlilik* modernity. The repetitious form and content of early photography were the symptom and effect of, in the words of Aijaz Ahmad, the "centralizing imperatives of the nation-state," but also the expressions of ideological identifications that made these imperatives natural, necessary, and logical.[64]

Flat Albums

We have explored how the Abdullah Frères were an exemplary *indigenista* studio in Orientalist and native image production, servicing a network of new effendi—bureaucratic and administrative elites, not the least of which was the Ottoman Court. Discussing a handful of official royal portraits provided an indication of how photography was legible because of *Osmanlilik* perspective, but also because it was an imprint of ideology in practice. The royal portrait was an enactment both of the new egalitarian *Osmanlilik* project, a project that still was girded by imperial, as well as state, power. Couched against the thousands of images that resemble those of Arif Pasha and Garabed Yassayian, the figures of Abdülaziz and Abdülhamid draw official and personal photography into an adjoining space. However, as potentates, Mary Roberts observes, they used "photographic portraiture as a tool of Ottoman statecraft."[65] Abdülhamid's agility in programmatically using photography was matched by his aversion to having himself photographed.

No doubt, Abdülhamid's portraits are generally unflattering. He likely recognized that his weak-chinned visage and slouching if not spindly frame could not project the same power and resolve of Abdülaziz's imposing stature and stern features. The contrast is notable when one juxtaposes W. & D. Downey's portrait of Abdülhamid (see fig. 9) and Abdullah Frères' famous portrait of Abdülaziz. The latter was promulgated quite extensively during his reign and served

as a model for oil paintings and caricatures of him in Europe and the empire. He is seated in uniform, with a sash, two medals of Ottoman orders, and the Sword of Osman resting between his legs. Similarly, Abdülhamid sits in the same pose in a more ornate Ottoman military uniform, and a ceremonial sword between his legs. Downey's shallow focus contains and even isolates Abdülhamid within the confines of a chair that is awkwardly positioned in front of a blurred leather couch. The crowding of the space contrasts the orderly compactness of the same room in Downey's portrait of Abdülaziz (see fig. 8). The three-quarters view of his face gives the effect that he is looking at, rather than into, the camera. As such, it fails to produce the same power projected by his uncle's direct eye contact with the viewer.

In an attempt to find compositional differences between Western and non-Western photography, one could infer that W. & D. Downey, as British photographers, imprinted Abdülhamid as an overly decorated yet ineffectual Ottoman royal, highlighting his slouching posture and watery glance against a shallow depth of field, disorganized space. Conversely, the Abdullah Frères captured the majesty and presence that the Sultan's sheer physical girth commanded. These readings, I would argue, are misplaced, not because Abdullah Frères' sensitive, almost humanizing, portraits of Abdülhamid contrast with Downey's portrait, but because their portrait of Abdülaziz is nearly identical to the British one.

Perhaps a more simple yet profound explanation of Abdülhamid's dislike of the personal portrait rises from his awareness of the power of photography and value of image production and image making. Perhaps, he knew that the ptosis of his eyelids reflected political flaccidity or communicated the shiftiness of a leader who sent an army of spies and secret police throughout the empire. This aversion is not a matter of vanity but has a political effect. It seems to have started only after his coronation. His change in willingness to have his portrait taken corresponds to shifts in his political positions that inevitably led him, in 1878, to dissolve the Ottoman parliament and abrogate the new constitution, which had politically enfranchised and represented all "citizens" equally throughout the empire. The shift provocatively suggests that Abdülhamid's abandonment of the Tanzimat convictions then made him suspicious of the ideological content and the "perspective" of the progressive *Osmanlilik* portrait, if not also suspicious of the social networks that circulated those images.

Abdülhamid's discerning use of the royal portrait did not dissuade him from using the craft adeptly to rule, however. Photography was taught in Ottoman schools, particularly the Imperial Engineering College, an institution that graduated under his rule a number of Ottoman Turkish photographers, Ali Sami and Ali Riza Pasha being the most famous. He integrated portraits into police, prison, and bank records. Suraiya Faroqhi shows that the sultan used photography and photographers in a variety of political ways, which "adapted and responded

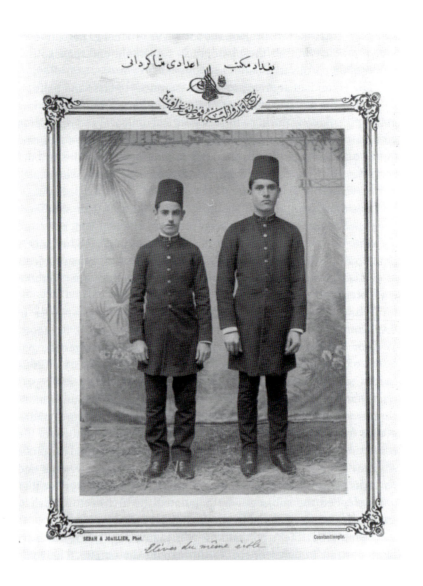

بغداد مكتب اعدادى شاكردان

SÉBAH & JOAILLIER, Phot. Élèves du même école Constantinople.

Figure 15.
Sébah et
Joaillier,
High school
students,
Baghdad,
albumen.

Sébah et Joaillier's subjects enacted, photographically and socially, modernity, while also administratively categorizing them either as Ottoman subjects within state institutions such as high schools or as character-types of tribal, religious, or ethnic communities within the Ottoman *millet* system.

The same uniformity defines portraits of pairs of schoolgirls, medical students, and military cadets, a uniformity that contrasts with the albums' many character-types. In the introduction to *Costumes populaires*, Osman Hamdi Bey notes that uniforms "efface not only all distinctions between diverse classes of society but also those between different nations which seemed otherwise to be permanently separated by natural and moral barriers."[71] Accompanied by Sébah's photographs, his book was sponsored by Abdülaziz and categorized

شآم مكتب اعدادئ شاكردان

Sébah & Joaillier, Phot. Constantinople.

Élèves du même école.

character-types of Ottoman citizens according to their *millet* (community), location, gender, and ethnicity. The character-types appear in diverse clusters: dissimilar high-ranking military officials and bureaucrats who pose alone, not in even in pairs, as do the schoolboys. Props and backdrops, such as anchors and seaside props, decorate the portraits, overdetermining, in these cases, that the portrait is of an admiral. The images of the officers, bureaucrats, and *effendiyah* offer to the uniformed schoolboys and cadets a promise of the visual, social, and political spaces that they may occupy as a result of their education. Of course, Abdülhamid did not account for the promises of *Osmanlilik* modernity that outstretched his own ability to manage. These figures and these institutions continued a social and economic project that preceded his ascension to the throne. Ironically, then,

Figure 16.
Sébah et Joaillier, High school students, Damascus, albumen.

the Hamidian albums registered the consolidation of a number of classes: the effendi class, a political class, and a military class. These classes would depose the sultan in 1908. In this regard, the ideological imprint of *Osmanlilik* ideology into the visual archive of the Hamidian albums was too powerful for the sultan to contain.

The effects of the genetic patterns in Abdülhamid's albums were similar to those of Abdullah Frères' portraits. They interpellated social and material practices into standardized visual indexes of the enacted and regularized social, institutional, and economic practices of modernity that were already defining reality. The carte de visite and the school portrait flattened differences between subjects in Damascus and Baghdad, Istanbul and Beirut. Abdullah Frères produced both official and private photography, images of people, places, and things. What brings this massive oeuvre together is that they share a flattening effect of *Osmanlilik* identity. The flattening effects of the portrait worked against the emergent nationalism that was pulling at the empire, but also they facilitated products, ideas, identities, and loyalties to circulate more evenly.

The representational overlay between Abdullah Freres' *effendiyah* portraits and Abdülhamid's portraits of functionaries and schoolchildren flattened regional, class, sectarian, and national differences in order to create *Osmanlilik* uniformity. The genetic patterns provided a common visual nomenclature to enact the ideological, social, and economic program of modernization. The effects of these patterns, too, were held in tension between the vision of the sultan and the perspective of the new effendi citizen, whose creation *preceded* Abdülhamid by a generation. Because they were the enactment of *Osmanlilik* ideology and the aftereffect of the social and economic transformations of the Tanzimat, the portraits also offered a class promise, one that disrupted not Ottomanism per se but certainly Abdülhamid's authoritarian and sectarian implementation of it. Neither the sultan nor Abdullah Frères devised the genetic patterns of the official and personal portraiture, just as they are not Eastern mimicry of European bourgeoisie.

The repetitive structural elements of the portrait, those that are representational, compositional, and formalistic, are *material* and ideological expressions of indigenous *embourgeoisement*, the *effendiyah*. The portrait was a material instantiation of *Osmanlilik*, a class act of the "new men" of the empire, as Peter Gran has called them.[72] We will see, however, that this did not simply mean that new subjects acted out their identities in photographs, only to come back to homes, streets, and social relations dominated by a premodern political economy. The portrait was a material instantiation of *Osmanlilik*, and *nahdah*, ideology because it also was a material object with social currency. It expressed social relations because it was a product and tool of them, exchanged throughout a network of class actors who were, themselves, leveling differences between localities in order to create a new form of sociability, class rule, and political economy.

The Arab Imago

**JURJI SABOUNGI AND THE *NAHDAH*
IMAGE-SCREEN**

In a stained, highly faded carte de visite, two men flank a young child (fig. 17). The informality of the image might be surprising considering the status of, at least, one of these men. A baby, sporting his own haphazardly placed fez, leans on what we assume is the father, or uncle. Despite the portrait's dwindling playfulness, the adult figures, especially the man on the left, are distinguished characters. As children of a visual culture, we search the image for codes: tarboosh, frock coat, facial hair, posture, body dynamics, props, and, lucky for us, inscriptions. The visiting card is marked in ink, indicating the sitters: Ziya Pasha, Misal Bey, and baby Zuhru Bey in the middle. Although the latter two remain unrenowned, Ziya Pasha (1829–1916) was quite a notable figure.

As his poised, dignified, yet relaxed composure suggests, Ziya Pasha was a high-ranking Ottoman functionary, a political activist, poet, translator of Rousseau, and cofounder of *al-Hurriyet*, Turkey's most prominent newspaper. Son of a mid-tier Istanbul bureaucrat, he was a product of the Tanzimat reforms and an ideologue of *Osmanlilik* modernity, championing radical political reforms and parliamentary order. He was a founding member of the Patriotic Alliance, otherwise known as the Young Ottomans, during the reign of Abdülaziz. As a part of the cadre of Young Ottomans, he, along with other notable names such as Namik Kemal, plotted to assassinate Ali Pasha (Mehmet Emin Ali Pasha), author of the *Islahat Hatt-i Hümayun*, the sultanate edict

Figure 17.
G. Saboungi,
Ziya Pasha,
Zuhru Bey,
and Misal Bey,
Beirut, carte
de visite,
10.5 × 6.3 cm.

granting equality in all realms to all citizens regardless of religious affiliation. Ali Pasha was a self-made man, educated in the Ottoman Empire's new, modern schools. He mastered French and climbed up the ladder through the diplomatic corps, attaining the title of Pasha. His effectiveness as an administrator in Cyprus and Bosnia-Herzegovina lead him to the empire's highest position, grand vizier, under two sultans. A leading advocate of the Tanzimat, he challenged the authority of the Sublime Porte but developed a political and ideological rivalry with the younger generation, especially the Patriotic Alliance.

Ziya Pasha was the eldest member of that group. Despite their adversarial rivalry, his biography resembles that of Ali Pasha. He taught himself French and was a career *fonctionnaire*. Yet, his political positions indicate more complex fault lines within *Osmanlilik* ideology beneath the uniformity and genetic patterns communicating progress, unity, and civilization within the standardized image of the effendi "new man." After the failed coup, he lived in exile in Paris for five years. He was eventually pardoned and returned to the empire, where he was appointed governor of a variety of localities, including Adana, Cyprus, and Aleppo.[1] His portrait tells us nothing other than that it was taken by the most renowned Arab photographer of the Ottoman Empire, Georges Saboungi, in his pioneering Beirut studio.

Ziya Pasha's portrait circulated within the same routes of sociability as the portraits by Abdullah Frères, and that of Arif Pasha—between Istanbul and provincial cities, between elites and nobles, between families and friends. Also like the work of the Abdullah Frères, the image itself was an ideological statement that embodied discourses of reform, modernity, and progress. Perhaps taken when he was governor of Aleppo, the portrait works on both official and unofficial planes. Ziya Pasha's posture does not have the insouciance of Misal Bey and Zuhru Bey. He is an Ottoman official, acting in an apparent role as father/uncle. Jurji Saboungi's portrait of Ziya Pasha embodies the many functions of photography, personal and official, private and public. On a representational level, *Osmanlilik* ideology structures its reception and discursive codes, enacting the social order that gives these subjects value. On the material level, the carte de visite's inscriptions imprint the social origins of the image, its circulation, its social life, and its political role.

This Ottoman portrait by an Arab photographer demonstrates how photographic portraiture in the Arab world enacted the ideological identifications of new social order, classes, and subjects of the Ottoman Empire, including Ottoman Syria. This chapter uses the life and work of pioneering Beirut photographer Jurji Saboungi as an example of how photography interpellated *Osmanlilik* modernity as Arab subjectivity during the nineteenth-century "Arab Renaissance." We will discover that the "Arab portrait" was a photographic "screen image" of a variety of social and ideological forces and expressed the "Arab imago"—the ego ideals and ideal ego of the new, reformed subject.

Jurji Saboungi

Theorists of photography, like language, have shown that the image functions on levels of signification, meaning, and semiotics and levels of the social. As a materialist object, Ziya's portrait demonstrates the intersection between the lives and social practices of Ottoman elites with those of Arab Ottoman subjects. On the level of representation, the portrait evinces the overlay of *Osmanlilik* modernity with the Arab world's practices and formula for social renewal. The carte de visite provides us with a shared visual nomenclature that linked *Osmanlilik* modernity and *al-nahdah al-ʿarabiyah*. The portraits taken by Abdullah Frères and Sébah differ little from those of Beirut's own blue-chip studios, including that of Jurji Sabunji (1840–1910). Jurji Saboungi, or "Georges Saboungi" on his mount, was photographer to the *nahdah* stars, and his portraits were a prominent fixture in the Beirut's elite, "middle stratum" *effendiyah* and intellectual scene.[2]

Born in Mardin or Diyarbekir, he emigrated to Lebanon in the 1850s for education. Some sources say that Saboungi opened his studio in Beirut in 1862, only two years after Trancrède Dumas, the first European to do so in Beirut. Fouad Debbas contends that Saboungi opened in 1878. He reports that after apprenticing for years at the hand of Félix Bonfils in the famed Beirut atelier Maison Bonfils, Saboungi assisted Bonfils during his expeditions to Egypt and Palestine between 1867 and 1874. Debbas also claims that Saboungi opened a studio in Sahat al-Qamh (Wheat Square) in Beirut after Bonfils returned to France because of health problems.[3] No matter the date, Jurji was the first "Arab" studio owner, learning photography, at least initially, from his famed brother Louis Saboungi upon his return from Rome. Consequently, Jurji, according to Carney Gavin, "effectively started the Lebanese photographic industry … an industry which solely relied on local photographers."[4] This claim resonates with a nationalist narrative of Lebanese cultural production. Its insights lie, however, in recognizing the transfer of technology and specialized knowledge among indigenous photographers involved in closer interaction with European expatriate photographers.

In contrast to Louis's adventurism, Jurji's name became an uncontroversial fixture in the Arab Ottoman provinces. While he maintained a thriving studio in Beirut, Jurji Saboungi was obviously mobile throughout the empire and, perhaps, in Europe. He married a Danish woman and opened a studio at Assour Square (Sahat al-Sour, named after the old city wall), next to the train station, which is now Sahat Riad al-Solh.[5] By the 1890s, his studio had moved to the Suq Sursock, in the shadow of the famous palatial *maison* of the Sursock family, built by Musa (Mousa) Sursock, a successful merchant, financier, and owner of *latifundia* throughout Syria. Saboungi moved to the corner of Rue Syrie and Rue Lazariah, in the center of the city.[6] His son, Philippe, joined him in 1908 and ran the studio until 1916, while

Dalil Beirut (1909) also mentions a studio called "Madame Philippe Saboungi."[7] To further complicate the story behind the Saboungi name, a photographic studio owned, at this time, by Philip J. Saboungi in North Star, an Ohio hamlet not far from the Indiana border, existed before World War I.

Daoud Saboungi, apparently the brother of Louis and Jurji, had a successful studio in Jaffa by 1892.[8] In addition to portrait photography, he serviced the Holy Land tourist trade and partnered with Palestine's most prominent photographers Garabed Krikorian and Khalil Raad. He is best known for being an official photographer, along with Krikorian, for the visit of Kaiser Wilhelm II and his wife, Augusta Victoria, to Palestine and Lebanon.[9] Contributing to mysteries surrounding the Saboungi-Sabunji-Sabounji-Sabongi family name, "M. Sabongi," likely a Saboungi sibling or relative, could be Manual Sabunji (b. 1872), who is listed in the National Evangelical Church baptismal records as being a photographer and resident of Beirut in 1891. Or, perhaps, it is Muna Saboungi, spouse of Louis.[10] In any event, it seems that M. Sabongi had a successful studio in Cairo, and perhaps also in Beirut and Jaffa. His signature adorns portraits of many prominent intellectuals and merchants such as Jurji Zaidan, the *nahdah*'s leading editor, writer, and author of historical fiction.[11] At the same time in Cairo, the name B. N. Sabungi appeared on the photographs, which he reproduced as halftones in many Cairo journals, including *al-Ajyal*, representing high-profile subjects such as Khedive Abbas in 1897.[12] Despite the mystery surrounding the Sabounji name, Jurji Saboungi had a respected reputation in Beirut and throughout the Ottoman Empire. Saboungi is responsible for landscapes and tourist photography used in Ottoman photography albums and sold in Europe. He produced a prolific number of portraits for Beirut's populace, elites, and intellectuals but also is known for his visiting cards and portraits of leading Ottoman officials. He held official roles in Beirut's municipality and was awarded imperial medals in 1892 and then a higher status (to Second Rank) in 1898. In 1902, he was appointed as a customs inspector in Beirut.[13] His official role as a municipal functionary and his close relationship with the Ottoman government illustrate the intimacy between photography and the state and the intermingling of intellectuals, technocrats, and functionaries, locally and regionally. Despite these connections, Istanbul denied Saboungi's petition to open a photographic society, which requested a "lottery" (*piyango*) to help fund developing photography in the empire.[14]

The work of the Beirut photographer was as diverse as that of Abdullah Frères; Saboungi produced photographic albums of sites such as Baalbek and the Cedars, Greece, and Palestine for tourist and European consumption.[15] His corpus of landscapes and monumental and architectural photographs of Greater Syria differs little formalistically from Maison Bonfils, Jurji's former employer. His cartes de visite vary in quality but are distinguished by a lush, bright red vel-

vet or green cardboard mount, and his cabinet cards were elegantly mounted on black cardboard with a gold border and monogram. In some of his larger-format, high-quality images, his photographs bear a gold stamp with raised red letters. Saboungi was, first and foremost, a studio photographer. Just as Abdullah Frères' had a relationship with the Ottoman bureaucratic network, the portrait of Ziya Pasha, Zuhru Bey, and Misal Bey is indicative of the Beirut photographer's intimate association with this same ruling elite, as well as the new bourgeoisie of Syria. Just as Abdullah Frères' connection with the court made them central to image production of Ottoman political and economic elites, Saboungi's affiliations with *nahdah* intellectuals and the reform-minded ruling class gave him a privileged position in replicating the visual codes of *nahdah* ideology.

His subjects were not exclusively male but included couples, women, and a considerable number of children. While images of the economic elite, Ottoman functionaries, and organic intellectuals survive as a visible part of his clientele, many portraits and cartes de visite portray what were aspirant class subjects. The atelier of Saboungi and other Beirut-based studios demonstrate the plasticity of what we imagine a native middle-class *effendiyah* to look like. The capital accumulated and ancillary services surrounding such an important entrepôt as Beirut generated finely striated and interlocked classes that all visited, at one time or another in their lives, photographic studios. The photographic studio and the surface of the portrait offered these new subjects a space to enact the ideology that mediated the transformations of their city and society.

Photography as Indigenous Knowledge Production

The oeuvre of Jurji Saboungi cannot be detached from the social transformations that were occurring in Ottoman Syria and Beirut during the nineteenth century, just as the portrait cannot be separated from the formation of modern Arab subjectivity as interpellated through *nahdah* and *Osmanlilik* discourses. Like the portraits by Abdullah Frères, Saboungi's studio portraits illustrate a civilizational ideology that undergirded the state and new social strata, namely, new *effendiyah*, the bourgeoisie, *petits fontionnaires*, and repurposed notable classes in Greater Syria. The photography served social and ideological purposes. It was the very instantiation of *nahdah* discourses.

Saboungi was not only an accomplished photographer; he also wrote a handful of technical articles on the craft in the Arab press. By the 1880s, he affably engaged in journalistic dialogues with readers, editors, and other contributors. The Beirut photographer wrote articles in *al-Muqtataf* explaining the "simplest and quickest way" to complete a number of elementary tasks (such as glossing photographs or preparing collodion glass plates).[16] In one article, Saboungi elab-

orates on a previously published article about glossing photographs, offering instructions on a better process that he claims to have discovered. At the end of the article, the editor interjects: "We laud the attention of the expert photographer Mr. Jurji Effendi Saboungi for this generous advice. Following the procedure that he discovered made the photographs gleam. The glossing was completed in less than a half hour and its process was considerably simpler for a student to learn with less practice."[17] The dialogue demonstrates that indigenous photography practitioners were not merely replicating Western photographic practices but innovating photographic technology and procedure. Saboungi's contribution to the formation of a discourse on photography in the pages of the Arab world's most popular journal, *al-Muqtataf*, highlights that, as was the case in India, native photographers were producers of technological knowledge, innovation, and practice essential to the craft, not just passive consumers of it.[18]

Just as he conversed with editors and readers in *al-Muqtataf*, Saboungi engaged with other Arab writers about photography, referring to books such as *al-Durr al-maknun fil-sinaʿah' wal-funun* (The unknown feat in the arts and crafts), written by the Lebanese pharmacist Jirjis Tannus ʿAwn and published in 1883. ʿAwn was playing off the title of Jabir ibn Hayyan's eighth-century classic, *Kitab al-Durrah al-maknunah* (The book of the created pearl), which is a treatise on the coloring of glass. *Al-Durr al-maknun* is the first technical manual published in Arabic to discuss photography, along with an array of other technical skills, from silver-smithing to dying wool to making soap. ʿAwn's technical manual declared that photography should be used not only as a means to document knowledge but also to "beautify" interiors and to capture the "special moments" of the photographer.[19] Saboungi's engagement with ʿAwn's work was a précis of a full-fledged discourse on photography as a technological act.[20]

Saboungi's engagement with the Arab press needs to be situated as a form of knowledge production in which Ottoman Arabs anchored their project of social reform. Native photographers, whether the Saboungi brothers, the Abdullah brothers, or Pascal and Jean Sébah, were innovators, inventors, and practitioners. They were proprietors of the knowledge and discourses that informed the craft and practice of photography. This simple but important observation about Saboungi's writing proves that *indigenista* photographers and sitters were producers of an organically native social practice. Concomitantly, their position as owners and masters of photographic knowledge and technique, rather than colonial recipients or beneficiaries, position them as cognizant reproducers of the representational and ideological systems of native modernity. Through their engagement with the knowledge production of photography, the civilizational formula was enacted and ideologically reproduced. In mastering photographic knowledge, local photographers did not only illustrate the representation of the new Ottoman Arab subject. This mastery was a social and

political act, whereby the new *effendiyah* owned the cultural capital necessary for the reform of Ottoman Arab societies.

Imprinting of the Arab Imago

The practice and discourse of photography matched *nahdah* ideals and kept pace with the social and economic transformations of the nineteenth-century Arab world. Simultaneously, the writings of *al-nahdah* intellectuals, including Khalil Khuri, founder of *Hadiqat al-Akhbar*, Syria's first independent newspaper, and owner of the prominent Syrian Press (Matba'at Suriya), were matched by his representation in photographic portraits. Khuri's definition of civilization [*al-tamaddun*] is founded on the efforts [*juhud*] of compatriots. These "sons of the nation … disseminate knowledge [*al-'ilm*] among the people. They spread the utility of personal, civil, and sociable [*ulfiyah*] customs, which create the sound judgment [*al-dhawq al-salim*] that directs countrymen to stir the goodness within individuals and the masses in order to elevate them to a level of human dignity not previously enjoyed."[21] Photography's pedigree was genealogically related to the *nahdah*-Tanzimat formula for civilization and social progress, defined by virtues such as perseverance [*sumud*], temperance [*i'tidal*], and ambition [*hamasah*] and values like "knowledge" and patriotism [*wataniyah*], which beget "unity and concord" [*ittihad* and *ulfah*]. Photography embodied Khuri's prescripts. Saboungi's portraits represent the men and women who embodied these virtues but also the practices that instituted progress.

The portrait of "Shaykh Effendi al-Khuri" is emblematic of a class of *effendiyah* men that populated Greater Syria (fig. 18). It is even possible that Khuri could be the grandfather of the Lebanese architect Pierre Elkhoury, father of the photographer, Fouad Elkhoury, whose collection houses the image. Saboungi's portrait is exemplary of ideological codes and indexes of the *nahdah* portrait that are repeated throughout the photographic archive of the nineteenth century. The portrait articulates an orthodox visual iconography of the successful and educated Beiruti effendi in native attire, gazing not into the camera but from right to left, like Arabic writing. His forward gaze past the frame stabilizes his body and posture, working in concert with the technology at hand to produce an image that looks into the "progress" that he enacts. If not slightly rigid, his stance and resting arm on a rococo chair exude the "human dignity" and "sound judgment" that come with the "personal, civil, and sociable [*ulfiyah*] customs" that he undoubtedly practiced.

The iconography was a visual standard for the reform intellectual, Arab Ottoman functionary, officer, civil servant, and modern comprador. The patterns of Khuri's portrait are repeated time after time in the nineteenth-century visual archive, but it was not limited to the

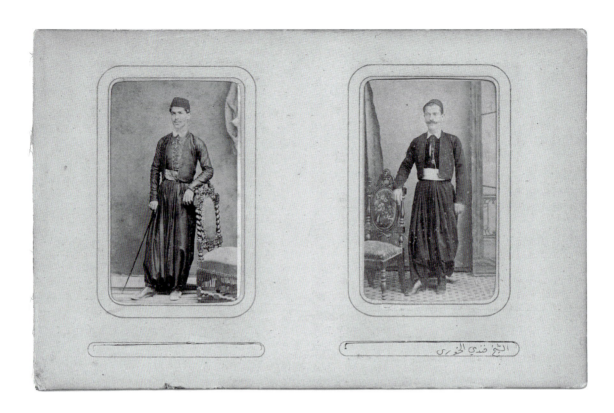

The Arabic caption below the right image reads: الشيخ ضني الخوري

Figure 18.
G. Saboungi, Shaykh Effendi al-Khuri (*right*), and anonymous sitter, black and white on paper.

uniform clothing and posture of Greater Syria and Egypt's *effendiyah*. The effendi in fez, sirwal pants, and *kubran* (waistcoat) standing with an arm on a parlor chair or a hand on a book is an ideological, social, and representational analogue to its counterparts, exhibiting the Arab provinces' new generations of reformers, entrepreneurs, and professionals in "Western" apparel. The late-nineteenth-century portrait, probably taken in Cairo, of a young Jurji Zaidan (fig. 19) matches Saboungi's portraits of Beirut's new citizens (fig. 20). The portrait of the *nahdah*'s most prolific writer resonates with the anonymous portrait taken by Saboungi at the same time, between 1890 and 1900. Zaidan poses with his hand on a chair, wearing a vest, blazer, and the checked pants common to that period. If his staid posture contrasts with the cocksure pose of Saboungi's subject, Zaidan's bow tie, the de rigueur fashion for the era's professors and professionals, assures the viewer that he is equally confident. Zaidan's position among the pantheon of Arab intellectuals collapses his massive archive of social commentaries, historical novels, and histories of the Arabo-Islamic world into his portrait. However, without the knowledge of his identity, Zaidan's image remains similar in ideological effect to Saboungi's self-assured client. If the traditionally attired effendi sitter projects a mastery of knowledge emblematic of *al-nahdah*, Saboungi's suited man emanates a mastery of means. Regaled in Western garb, his coat draped over his arm, relaxed on his walking cane, the subject is clearly confident in his urbanity.

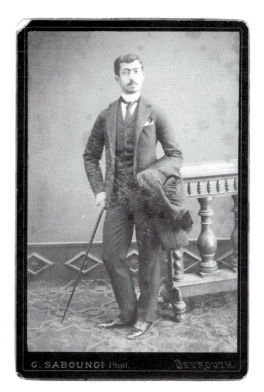

Saboungi's studio produced innumerable images that resemble those of Khuri, Zaidan, and his anonymous Beiruti counterpart, creating collectively an ideological anthology of the modern Arab imago. These portraits of Arab intellectuals, reformists, citizens, new fathers, new mothers, new children reproduced an image of the nineteenth-century Arab subject informed by *nahdah* discourses of selfhood and Arab societies' changes in political economy. Lacan's imago presents an analytical concept that takes into account how ideological ideals and social desires express themselves in repetitive formalism and visual modes of representation. The imago is neither exclusively an "imagined" self nor an image in a mirror. It allows us to understand the portrait as a place of mediation and reproduction, where the visual imaginary and imagery ideologically and culturally interpellate economic forces and social change. The imago expresses a set of ideological and social processes that are imprinted in and express themselves through the portrait.[22] The notion of the imago underscores the portrait as a surface that emits "ego-ideals" and an "ideal-ego," while also recognizing the multiple vectors at play within that ideal, including the realization that it has an ideological projection and configuration.

This is not to say that Zaidan and al-Shaykh Khuri walked politically, intellectually, and socially in step or shared the same circles. Nor is it to collapse Saboungi's studio with the anonymous portraitist

Figure 19.
Unknown photographer, Jurji Zaidan, black and white on paper.

Figure 20.
G. Saboungi, anonymous portrait, Beirut, cabinet card, 16.3 × 10.8 cm.

who photographed Zaidan. Saboungi's Khuri was rooted in a Beirut community struggling to define its national and class identity, caught between new sectarian and *Osmanlilik*-inflected Syro-Lebanese "patriotism." A supporter of the "Young Turk" revolution in 1906, Zaidan was in Egypt forging a secular Arab identity that was both a part and apart from Egypt's own national project. However, both sitters and both photographers share in the hegemony of a positivist, universalizing, normative vision that organized and justified a reconceptualization of self, society, governance, and economy. The repetition of the portrait's "genetic patterns" provided a language and representation to the ego ideals of the modern, secular, urban Arab, in *nahdah* thought and *Osmanlilik* practice. The standardization and repetition of the portrait reached beyond the ego-ideal into the material and social life of the ideal-egos, into the lives of those who sat for and exchanged these portraits. Khuri circulated his image among his compatriots, who surely were participating in Beirut's new economy. Zaidan's portrait made its way through a community of leading intellectuals, journalists, and political figures if not through consumers of his journal.

To understand Saboungi's images as an expression of the Arab imago uncovers the relationship between ideology, representation, and the acts of image making, exchanging, and deploying the image. The portrait as imago exposes photography as an intricate act of ideological identification within specific social, economic, and historical contexts.[23]

Sartorial Codes and Photographic Meaning

Saboungi's studio photography cogently represents how the portrait expressed the Arab imago, a visual condensation of the *nahdah* subjective and ideological ideals with which the new citizen, new class subject, new national subject, and new Arab individual could identify. Despite the ways its repetitious formalism resembles other studio portraits, reading "the content of a photographic message" is as indeterminate in Ottoman Syria as it was in Europe.[24] Saboungi's portraiture, like that of the Abdullah Frères and their European counterparts, is not distinguished by formalistic or compositional differences but rather by their ideological effect and their social role. The "photographic message" of the *nahdah* portrait is found concomitantly in its surface and its materiality, in its ideological representation that, in the words of Victor Burgin, created "the intelligibility of the photography" and the social and economic processes that gave the portrait value.[25] On the level of representation, Jurji Saboungi's portraits, like those of Abdullah Frères, illustrated the ego-ideals of new classes of Ottoman Syrian subjects. The ideal-egos of Saboungi's Shaykh Effendi Khuri and his Beiruti subject might have differed, but their ego-ideals, their

value in the *nahdah* criteria, their perspective of social progress surely corresponded. Likewise, the circulation of their portrait drew these individuals into networks of sociability that worked toward their class, economic, and political goals. The image's value dissolves when the social relations that give the portrait its meaning disappear. When the social context of the sitter is absent, Siegfried Kracauer notes, the "trappings" of costume, setting, backdrop, and props cannot be separated from the sitter and history.[26] In this regard, sartorial codes come to overdetermine early photographic portraiture.

The study of *indigenista* Middle Eastern photography inevitably involves searching for compositional differences in technique, lighting, and staging but, even more immediately, in self-fashioning, in dress and sartorial codes. Within the confines of repetitious poses and studio props, Saboungi's clientele displayed a range in dress between the effendi clothing of Khuri and *afranji*, or European, clothes. The assumption is made that Western dress equals Westernization and, inversely, "Eastern" costume reflects "tradition." To consider "Western" clothes as antithetical to "Ottoman" and urban *effendiyah* dress, or counter to the Arab ʿabaya, gambaz, hatta/kufiyah,ʿiqal, jubbah, and *thawb,* is a common error in reading photography of the nineteenth century.

Fashion was a dynamic *site* of ideological contention during the late Ottoman period. Unlike Orientalist photographers, Ottomans themselves, whether in Smyrna, Beirut, Aleppo, or Cairo, were able to note a difference between dress and costume, as Hamdi Bey makes clear in the introduction to his *Les costumes populaires de la Turquie.* The uniformity of bureaucratic dress started when Sultan Mahmud, who instituted the Tanzimat, introduced the fez as an emblem of reform in 1829 and banned the turban as a sign of social acridity after "auspiciously" crushing the *börk*-wearing Janissaries.[27] By the second half of the nineteenth century, the fez, sirwal pants (*salvar*), *kubran* and veil confirmed *normative reform* fashion as much as "Western" dress among Arabs, Greeks, and Turks. Charlotte Jirousek comments on how the fez and sirwal subsequently became the uniform for a reformed bureaucracy, while Palmira Brummett investigates how "traditional" clothes, symbolized both nationalism and backwardness, just as European dress signified both progress and immorality.[28] Elizabeth Frierson concludes that women domesticated European fashion even when rejecting it, "making deliberate choices about their costume, exercising personal taste and creating markers of social identification."[29]

Journals like *Fatat al-Sharq* (Demoiselles of the East), *al-Muqtataf*, and *al-Hilal* (The crescent) frequently carried articles on *aziyaʾ* (fashion/dress) for women, men, and children, not only telling the reader about the latest fashion but also instructing what was appropriate fashion for particular events, seasons, occasions, and social roles.[30] Ahmad Faris al-Shidyaq, noted for exclusively wearing Eastern garb, even when living for years in England and France, asks, "Why

would you buy from the westerners clothes and accessories and not buy science, wisdom and literature?"[31] Toufoul Abou-Hodeib quotes a contrary sentiment by thinker 'Isa Iskander Ma'luf, who "warned against 'adopting that which does not go with our taste and is not of the nature of our country,'" and asserted that adopting European clothes was a form of "false civilization."[32] European goods, from sewing machines to clothing, flooded Beirut's markets but were also sold in the city's first department store, Orosdi-Beck, in 1900. Subsequently, the debate surrounding fashion became prominent in civil society, especially regarding Europeanization (*tafarnuj*) and national costume. Jurji Zaidan provides a glimpse into the consumer world of sartorial commodities in his autobiography. He worked as a young apprentice making "European-style shoes" in 1870s Beirut. It was a craft that he preferred over the menial labor of his father's humble restaurant, where he met Ibrahim al-Yaziji. Son of Nasif al-Yaziji, the classical poet and doyen of Beirut literary circles, Ibrahim was the "founder" of modern Arabic linguistics and the journals *al-Bayan* and *al-Diya*. He is popularly considered one of the earliest Arab nationalist activists in Beirut. Ibrahim was kind to young Jurji, encouraging him to pursue the life of study, culture, and knowledge for which the young man had yearned. In his father's eatery, Zaidan admired how al-Yaziji proudly wore sirwal pants and a fez.[33]

Perhaps taken in the 1880s when he patronized the Zaidan restaurant, the youthful Ibrahim appears in a half-body vignette of a mustached man in Beiruti *effendiyah* dress, worn by his intellectual cohort. Wearing a fez and an unembroidered, simple black bolero jacket and waistcoat with an embroidered rope necklace, Ibrahim's determined demeanor communicates the will (*iradah*) that undergirded the reform project. Indeed, the portrait appears in Philippe de Tarrazi's biography of al-Yaziji.[34] In addition to its halftone reproduction, Daoud Corm used this photograph or a very similar one as a model for his oil painting of al-Yaziji for the Lebanese National Archive (fig. 21). Given that Corm died in 1930, Tarrazi probably commissioned Corm to paint al-Yaziji's portrait well before it was dedicated to the Republic of Lebanon in 1934. Corm's subtle use of black accentuates the Ottoman effendi dress, punctuated by a subdued but colorful cummerbund and a bright red fez. His soulful eyes invite the onlooker to a conversation, just like the ones he had with young Jurji Zaidan.

Corm's portraits of *nahdah* intellectuals were based on photographic portraits that are now lost. Except for the portrait of Ibrahim's father, Nasif, Butrus al-Bustani, Salim al-Bustani, Khalil Khuri, and Ibrahim al-Yaziji wear similar dress, just as does Shaykh Effendi Khuri, codifying a visual orthodoxy that defined the Beirut-based *nahdah* intellectual. But this sartorial orthodoxy did not preclude other modes of dress. The portrait of young Ibrahim and the effendi visual codes contrast with a more widely distributed portrait from his

Figure 21.
Daoud Corm,
*Ibrahim
al-Yaziji*, oil
on canvas.

later years (fig. 22). In it, he is a mustached elderly man with pince-nez, a jacket, white-collared shirt, and bow tie. The "Sabungi" name is etched on the front. It appeared in many publications during the twentieth century, including Zaidan's *al-Hilal*.

Neither of al-Yaziji's portraits is unique. Both reproduce genetic patterns that were reproduced throughout *al-nahdah* by Saboungi and other Beirut photographers. Just as the younger Ibrahim's portrait shares in the visual codes of the *effendiyah* portrait, the portrait of the elder al-Yaziji is virtually indistinguishable from numerous other images, including an anonymous carte de visite by Beirut's other marquee photographers, Alexander and Joseph Kova (fig. 23). Save the pince-nez, the "Sabungi" portrait of al-Yaziji and the Kovas' anonymous portrait are virtually identical in form and content. The sharpness of the Kovas' portrait allows the subject to peer out of the oval, unambiguously calling the viewer to recognize his presence. It recalls a review in *al-Muqtataf* that praised portraits by the "expert

painter" Salim Haddad, where the sitter's "face, his clothes and his posture all appear in the painting to indicate elegance, judgment and propriety of character."[35] We are left with two pairs of images: Ibrahim al-Yaziji's youthful effendi portrait that resembles that of Saboungi's portrait of Shaykh Effendi Khuri and Corm's photograph-based paintings of the *nahdah* pioneers, and al-Yaziji's older portrait resembling the Kovas' anonymous vignette. The images, when read adjacently, discourage us from thinking of dress as determinative, but rather to consider it as the result of ideological and historical choices made at particular moments. The portrait is not an image of clothes. It is a photograph of subjects. As such, it is a gestalt of the new Arab Ottoman subject, representing, as Suraiya Faroqhi suggests, the "self-image and aspirations" of the sitter.[36]

The younger Ibrahim's dress was as much a statement about an affiliation with a group of men and women as it was a nationalist statement. The *effendiyah* class was the vanguard of *nahdah* virtues and social values, and al-Yaziji's portrait, like Shaykh Effendi Khuri, depicted the effendi imago of cultural and social reform in Greater Syria. The older al-Yaziji's image is located within the repetition of "semiological and rhetorical" patterns that project men of modernity and means. By the time of the portrait, al-Yaziji, like Zaidan himself, owned the journal he edited. But more than their actual command of capital, these portraits, like Saboungi's anonymous subject or the Kovas' confident vignette, portray men of cultural capital, who depict "sound judgment" (*al-dhawq al-salim*), perseverance (*sumud*), temperance (*i'tidal*), and ambition (*hamasah*).

Sartorial codes may have offered, as Frierson suggests, a number of "deliberate choices" in projecting "social identification" and affiliation. Saboungi's portraits provided templates that imprinted social, class, and subjective formations, reproducing the ego ideals of modern Arab subjectivity. Rather than seeing sartorial choices as determinative of photographic meaning, the portrait's repetitious indexicality, including sartorial codes, expressed possibilities within *nahdah* ideology and reproduced the multitude of forms of the *imago*, which embodied Arab "civilization" and progress but also individual presence.

Kova and the Performative Surface

The portrait, especially as expressed in the carte de visite, was an imprint of the Arab imago, an ego-ideal of *nahdah* social formations and desires. Photographic meaning and photographic social roles were not organized or signified by dress but by the Arab imago itself, which was formed through the writing and social practices of reformers, thinkers, professionals, journalists, and literati throughout Egypt and the Ottoman Arab provinces. Whether portraits by Abdullah Frères or Saboungi, the dissemination of the representation of a

confident, worldly, and cultured Ottoman effendi, whether ethnically Arab, Armenian, Greek, or Turkish, was "relatively inconspicuous but all the more effective as a factor contributing to the process of secularization," social reform, and "modernization."[37]

Saboungi did not innovate the "genetic patterns" of the Arab imago, nor was he alone. Al-Yaziji's portrait was paired with the anonymous vignette taken by the now forgotten Kova Frères. Alexandre (Iskander) (d. 1911) and Joseph (d. ca. 1904) Khorshid, a.k.a. Kova, rivaled Saboungi's status, working comfortably between provincial capitals and the imperial center.[38] Like the Abdullah Frères, the Kova brothers were two experienced painters of icons, and like Saboungi, they were probably Syriac or Chaldean Christians from what is now southeastern Turkey who relocated to Beirut to paint in the Orthodox Cathedral of Mar Jirjis in the 1860s.[39] They were "famed in the craft of photography [*fotografia*] and skilled in painting [*taswir*]." An article in *al-Muqtataf* declared that the Kovas won ribbons at the Vienna World's Exhibition in 1873 and the International Centennial Exhibition in Philadelphia in 1876 for their images of Syrian landmarks and costumes.[40] Like Saboungi, Sébah, and Abdullah Frères, the Kovas publicized these awards on the backs of their photographs. The two brothers worked separately in the 1870s. Alexandre also promoted himself as a painter and a landscape photographer as well as a specialist in colorizing and enlarging photographs, phototype, photogravure, photochromie, and ferrotype. His monogram included printing in Arabic, French, and Greek.

Celebrated in the Arab press as one of Beirut's two blue-chip photographers, the Kovas, like so many prolific studios, slipped into anonymity. With the breakdown in their social relations and the currency of the carte de visite, little remains from studios like those of the Kovas, Nasr Aoun, Georges Tabet, S. Jureidini, and Spiridon Chaïb in Beirut; Daoud Saboungi in Jaffa; Suleiman Hakim and Habib Hawawini in Damascus; and countless others in Alexandria and Cairo. As the circuits of sociability and exchange changed, the social relations and photographic meaning of the Kovas' portraits become increasingly difficult to discern, making us reliant on the manifest, surface indexicality of their portraits. In this way, the standardized and repetitious patterns expressing the ego-ideals of the modern Arab subject define Kovas' portraits.

Brides, distinguished men, portrait vignettes, children, and families are anonymous but are legible due to the hegemony of the *nahdah* ideology and representation. These anonymous images, in the words of Nöel Burch, are ideologically intelligible through a shared "institutional mode of representation," which the Kovas and Saboungi spearheaded. The Kova Frères' portraits consistently produced dapper men in European clothes, like Saboungi's own images. Compositionally, there is no ideological difference between Kovas' cabinet card of a man in a fez and suit, leaning on a banister and Saboungi's

card with its subject holding a cane and folded coat. Kovas' subject is causal but demonstrative, suggesting the same professionalism and confidence of Saboungi's counterpart.

As we have seen in the case of the Abdullah Frères and *Osmanlilik* ideology, the more the image and formalistic content of photographic portraiture were repeated, the less ambiguous its effect, regardless of what the sitter was wearing or what prop formed the backdrop. The portraits are intelligible, semiotically and ideologically, through a cumulative process in which a portrait speaks with subjects, with portraits, with portrait spaces, with commodities, and with ateliers in order to reproduce meaning and ideology. This was the ideological work of the portrait, which was simultaneously a product of discourses on practical knowledge, science, and selfhood and a material object with a social function, social value, and social relations, discernable even when we do not know the identity of the photographic subjects.

The studio production of the Kovas is just one example of how the photographic portrait reproduced, by performing the discourses of national and class (we may call it bourgeois) subjectivity, the state power and market capitalism that were in play at the time.[41] On the most immediate surface, the photographic image does not produce but enacts or *performs*. It reproduced and naturalized social relations and ideological practices through its production, consumption, dissemination, and sociability. What little we know of the Kova Brothers, we know from the *nahdah* press. The *nahdah* inevitably mediates our introduction to the Kova Frères; it is our entrée into the image's social history. The *nahdah*'s ego-ideals, the networks of its sociability and exchanges, and the ideology of representation are what make the Kovas' images recognizable.

Their images are *nahdah* images, mediated by Beirut's new forms of sociability, new communal relations, and national identities. The sectarianism that marked Lebanon's modern history does not come through in these portraits because, as *nahdah* portraits, they project a social-subjective imago that performs *nahdawi* knowledge and ideology, and mediates the social relations that structured the new era. The *performative* nature of the portrait's surface reenacted the *nahdah doxa*, moral rectitude, gender decorum, work ethic, and nationalistic principles.

The Kovas' vignette of an anonymous woman resembles a similar vignette portrait of author Mariyana Marrash (1848–1919) that appeared in the Arab press, with "Sabungi" credited as photographer (fig. 24). Marrash was one of the earliest modern poets, *salonnière*, and sister of the famous intellectuals Francis and ʿAbd Allah Marrash. She regularly wrote articles and commentaries about women's education and advancement in the most visible Arabic journals, and her writing broached social and political panegyrics as much as lyric poetry. Her salon was noted as Aleppo's cultural and cross-sectarian hub, exemplary of "a particular kind of bourgeois sociability" characteristic of

her new intellectual class.[42] Mariyana Marrash's profile is no different from its anonymous counterpart mounted on the Kovas' recognizable mount (fig. 25).[43] While these women clearly were of the "modern age," they were not Gibson Girls. Their hair is controlled, kempt, and pulled-back in a half-bun with tightly wound ringlets, matching their dignified, focused, yet soft profile and gaze. In both cases, the portraits are organized by the semiotic genetic patterns of *al-nahdah*, which the portrait presented as an imago of the modern Arab woman. Assuming that these were Christian Arab women, based on the lack of a veil and the modern dress, replicates a sectarian mode of analysis that the *nahdah* specifically rejected.

Frierson has shown that European or Turkish dress was a conscious and complex ideological choice for Turkish women. While Istanbuli women may have availed themselves of these choices, the consistency of Saboungi's portraits of Beirut women in "European" dress suggests that their relationship to *nahdah* discourse was more regimented and dogmatic. If Arab men enacted their own modern national identities through donning embroidered Ottoman uniforms or local effendi waistcoats, frock coats, tarbooshes, and sirwal pants, women enacted the effects of women's education, mobility, and elevation, championed and instituted by *nahdah* discourses of women's liberation and "modern" practices of domesticity, about which Mariyana Marrash actively wrote.[44] The processes of portrait taking and making, circulation, and distribution, coupled with the representation of gendered ego-ideals, were an enactment or performance of the identifications that undergird *nahdah* ideology.

The Kovas' images are disconnected from their social contexts, but the manifest surface, the image's indexicality, is structured by the repetition of genetic patterns that communicate the ideology of *nahdah* and *Osmanlilik* modernity. The photographic portrait was performative of the ego-ideals of the Arab imago. We will see how this performance did not create national, class, or gendered identities. Rather, the portrait enacted the ideological values of *al-nahdah* in order to mediate the conflicts between *nahdah* discourses and political and economic realities.

Portrait as Image-Screen

The portrait enacted the *nahdah* Arab imago. This enactment of modern Arab class, gender, and national identities in the photographic space mediated the social changes that created that modern Arab subjectivity. Although perhaps less apparent in Kovas' and Saboungi's anonymous portraits, the portrait of Ziya Pasha suggests how the portrait was a "locus of mediation," the place where the subjective meets the social.[45] Saboungi's portrait was an object that bound ideology with materiality, history with semiotics, political economy with production,

Figure 24.
[Saboungi], Mariyana Marrash, halftone print.

Figure 25.
Alexandre Kova, anonymous portrait, Beirut, carte de visite, 10.5 × 6.5 cm.

subjectivities with social formations, groups, and networks. This portrait, like those by the Abdullah Frères, synthesized the Tanzimat's and *nahdah*'s discourses of self, class, and society into an intelligible and actualizing "image-screen." The image-screen, according to Lacan, is the meeting point between the subject's eye and the object of the gaze. It is a tangent plane where two inverted or mirrored prisms intersect.[46] It is the vinculum that fastens the photograph's index and ideology to material objects, social practices, and modes of economy. The image-screen is the place where "histories are not backdrops to set off the performance of images" but are "scored" through the intense fusing of social history and the discourses that enable it onto the material surface.[47]

Understanding the early Arab photograph as an image-screen allows us avoid the trappings of formalism or the determinism of sartorial codes that might make us attribute the Ottoman Arab portrait to European influence. Focusing on the discourses, practices, and social relations that enabled photography reveals its surface or "manifest" image as a "locus of mediation" and a site of ideological reproduction. The portrait is a composite synapse of social forces that displace and repress as readily as they condense representation, emanate ideology, and perform Ottoman Arab subjectivity. Conceptualizing the portrait as an image-screen shows that photography was a chiasmus where *manifest* social relations suppress *latent* histories and worldviews.

Ziya Pasha's portrait provokes us to consider the issues of production, circulation, and social networks of Ottoman sociability and how they intertwine with *Osmanlilik* ideology. We may conjure scenarios of how this portrait might have stabilized relationships that Ziya Pasha needed as a governor ruling provinces in the midst of challenges, intrigues, and battles with old notables, superstitious clerics, and embittered political rivals.[48] Understanding the portrait as an image-screen invites us to contemplate how the manifest content of Ziya Pasha's portrait validated *Osmanlilik* ideals while its latent content invokes imagining how histories were *displaced* by instituting those ideals.

Saboungi's portraits (or those attributed to him) of Ibrahim al-Yaziji and Mariyana Marrash demonstrate how the portrait was structured by *nahdah* ideology, while Ziya Pasha's image reveals the portrait as an image-screen where the social meets the ideological. Within this image-screen, Ziya Pasha's portrait suggests that photographic meaning was a manifold composite of social and economic forces that did not only produce but displaced ideologies and lived experiences.

Louis Saboungi: Fading of Social Currency

The power of Jurji Saboungi's oeuvre arose from his success in replicating the ego-ideals of *nahdah* discourses and *Osmanlilik* modernity. Photography is, however, by nature indeterminate. The life and work

of Jurji's brother, Father Louis Saboungi (1838–1931), provides us with a counterweight to the stability that the image-screen provided in the studio portrait.

We know far more about Louis than we do about his younger brother, Jurji. Louis was more than an amateur photographer and photography aficionado. Born in Diyarbakir or Mardin, he went to study at the seminary in the Syriac Catholic Patriarchate in Mount Lebanon in 1850, after which he was sent to the College of Pontifical Propaganda in Rome in 1853, where he remained for eight years and also learned photography. Returning as an ordained priest, he was among the first instructors at the newly established Syrian Protestant College, where he taught Turkish and Latin.[49] He established and directed *al-Madrasah al-siriyaniyah* (the Syriac Catholic School) in 1864.[50] In 1870, he founded his renowned journal, *al-Nahlah* (The bee), which was eventually moved to London, where it became a provocative anti-Hamidian organ.[51] Saboungi's life in Beirut was marked by rivalries with Lebanon's most renowned intellectuals and institutions, including both Butrus and Salim al-Bustani, Ahmad Faris al-Shidyaq, and the Maronite Patriarchate.[52] Ottoman authorities twice shut down his journal because it defamed these intellectuals and members of the religious communities in Beirut. This is likely to be the reason for his eventual departure from Lebanon. After traveling the world, he settled in Great Britain, where he was professor of Arabic at the Imperial Institute in London in the late 1880s.[53] Louis is best known for his association with British anti-imperialist Wilfred Blunt. The priest introduced Blunt to a myriad of dissident personalities in Egypt, including Muhammad ʿAbduh and Muhammad ʿUrabi, who led the Egyptian army against the British and the Khedive Tawfiq in 1882.[54] In addition to his anticolonialist activities, Louis distinguished himself from his *nahdah* peers by prominently questioning the sultan's claim to Islamic Caliphate. The shrewd Sultan Abdülhamid eventually coaxed him, like Ziya Pasha, to move to Istanbul, where he employed Louis until the Committee for Union and Progress (CUP) revolution in 1908. Using his Italian citizenship to escape the empire, he emigrated to the United States, where he wrote under his Italianized name, Giovanni Luigi Bari Sabounji. In addition to his travel account of Europe, *Rihalat al-nahlah* (The journey of the bee), he left an unpublished *Diwan* and his diary.[55]

Throughout his polymorphous life, Louis remained a dedicated amateur photographer. Tarrazi states that Louis was the first "to introduce the art of photography [*al-taswir al-shamsi*] to Beirut, which was virtually unknown in the city at that time."[56] Further supporting the claim that natives themselves possessed photographic knowledge, Louis invented two photographic apparatuses during his stay in Manchester; the patent of one was sold to the British "Stereoscopic Co.," while his "Authomatic [*sic*] Apparatus" received recognition from the French government.[57] His prodigious work conveys the understand-

ing that his public photography was inextricable from his dynamic life's journey.

Louis illustrated his *Diwan* with a number of photographs. The various incarnations of his journal *al-Nahlah* contained many photoengraved portraits and photographs as well as etchings of his own political illustrations. Rogier Visser shows that Louis was the consummate marketer, using photography to promote his publications. He sold two versions of the *Diwan*, the more expensive of which contained photographs.[58] His memoirs were discovered in Istanbul with a large number of photographs, many of which he produced. Before being published as *Yildiz Sarayi'inda Bari Papaz* (A priest in Yildiz Palace), these memoirs were partially serialized in 1929 and 1952 in the Turkish journal *Vakit*. His publications show that Louis was no dilettantish photographer. Rather, photography was integrated into his life and work.

Père Saboungi made a gift of his illustrated *Diwan* to Khedive Isma'il, who had funded *al-Nahlah*.[59] In turn, the khedive reciprocated by giving his own portrait to Saboungi. This relationship marked an exchange of writing and images, demonstrating how photographs were used to build networks between echelons of power and intellectuals, activists, entrepreneurs, and, even, clerics and adventurers. Michel Fani states, "The photograph is nothing but a supplement to the generalized *bricolage* of the self, lacking any real echo of society, or context, or respondent."[60] Contrarily, Jurji Saboungi's photography demonstrates an imago of a "real" subject of material society, and Louis's use of photography reveals that the portrait was not a rhetorical vehicle for the visual codes of Ottoman and *nahdah* civilizational discourses but currency in a social act of exchange that fortified new social, political, and economic relations. Hardly an "echo," Louis' photographs are a concrete *afterimage* of social relations that defined regional modernity and social transformations. They attest to these social forces not because they are compositionally different from those of his brother, the Abdullah Frères, or the Kovas, but because of where they are found and in what instances they were exchanged.

Beginning in 1891, Louis remained under the charge of the sultan and lived a comfortable life as educator, translator, and state intellectual. He leveraged his influence with the court to capitalize on previous relations for economic gain, including acting as an agent for a British company to win concessions to build ancillary railroad lines in Lebanon and Iraq.[61] After Abdülhamid was deposed by CUP officers in 1909, he returned to Lebanon some forty years after leaving it. His attacks on the Maronite Church and others in Beirut, let alone his close association with the now deposed sultan, made Lebanon an unwelcoming space in which to remain.

After spending World War I in Egypt, he emigrated to the United States via East Asia, leaving on a ship from Japan, and disembarking in Seattle. In the United States, Louis attempted to capitalize on Amer-

ica's Oriental and spiritualist craze, marketing his Eastern identity and writing on Eastern Christianity and spirituality. Detached from his previous social, political, and intellectual networks, he slid into anonymity, only to die ignominiously and in poverty a decade later, murdered by burglars in Los Angeles at age ninety-three. His body was found in his apartment with a number of his esoteric paintings, which few seemed to appreciate.[62] With no network to sustain his social value, Louis survived on his currency as an objectified, exoticized Oriental, quite different from the intellectual and political provocateur who pushed on the fault lines running between a number of powerful players who, despite marked political differences, all shared the same *nahdah* and *Osmanlilik* beliefs in progress and civilization. The meaning of the Ottoman Arab portrait "that carries the photograph into the domain of readability" is historically constituted within *nahdah* discourses of "progress" and "civilization" but also determined by the portrait's social relations and the trajectories by which it was exchanged, circulated, and displayed.[63] Louis Saboungi's nomadism questions the boundaries of the ideological hegemony of *nahdah* ego-ideals forged into an image-screen. Like Ahmad Faris al-Shidyaq, Louis moved between social networks rather than anchoring himself in one particular locality or set of social relations. Unlike al-Shidyaq, however, Louis's ideological oscillation between competing political camps confirms the contingency of the Arab imago as naturalized by the *nahdah* portrait.

Inscribing the *Punctum*

In approaching the portrait as a material image-screen that projects the hegemonic nahdah ideology and the Arab imago, we must be careful not to "reify" or confuse the portrait's "truth-value" with "illusions of transparency or opacity."[64] Christopher Pinney shows us that the displacement of lived worlds, social experiences, traditional hierarchies, and cultural practices are also scored into the photograph as much as the ideological hegemony of its indexicality and truth-value.[65] Louis Saboungi's photography, in the words of Roland Barthes, allows us to recognize how the image-screen of the portrait coterminously held "spatial immediacy and temporal anteriority."[66] The nineteenth-century Ottoman Arab photograph serves as material instantiation of shifts in economy of representation, subjectivity, social-political hierarchies, and commerce. While we read the portrait as an expression of the Arab, Louis Saboungi's *indigenista* portraits divulge how the photographic image-screen is a document of dueling social forces that are suppressed and displaced by the very semiotic and indexical representation that the photograph enacts.

Louis's life was marked by confrontation because his opportunism and passion pressed at the edges of the *nahdah* social reform theories

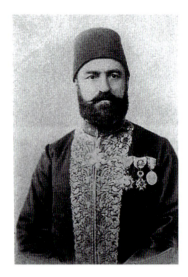

and vision. His writing and activism challenged the elasticity of *nahdah* political virtues, pushing the limits of concepts such as self-rule, self-governance, and political civility. The equanimity of Jurji's portraits, like those of Abdullah Frères, flattened out the religious, ethnic, and class differences of men and women throughout the empire under the common *Osmanlilik* ethos. Contrarily, Louis' life shows the frontiers of liberal political theory in action in the empire, as well as the malleability of subjective and political positions represented within photographs like those by Abdullah Frères and his own brother.

Louis's restlessness betrays the seam that binds the image-screen. His life communicates a movement between fixed positions that constitute the semiotics of the image and its ideological relevance. His fascinating career as a genuine *nahdah* intellectual-activist, photographer, inventor, painter, world-traveler, and political opportunist ossified when he entered the service of the sultan and perished when he emigrated. The photography in his *Diwan* provides some clue as to how these nomadic challenges to the fixities of *nahdah*, *Osmanlilik* ideology play out visually.

In a portrait from his *Diwan* dated 1893 reproduced in Debbas's *Des photographes à Beyrouth*, Louis dons a civil servant's uniform and the posture and air of a functionary (fig. 26).[67] No sign of his pedigree as Catholic priest, an Ottoman minority, or a former dissident exist. The portrait resembles Abdullah Frères' portraits of innumerable Ottoman officials. Debbas counterpoises portraits of Louis next to a self-portrait of his brother (fig. 27). Jurji stands with his hand on a banister that appears throughout his portraits, including behind the dapper Beiruti with a cane. His figure resembles Abdullah Frères' portraits of the young Abdülhamid and Arif Pasha. While his dress is different, he poses not as a photographer but as a recipient quite possibly of the Medal of Majid for loyalty and service as a bureaucrat. Louis, too, is decorated with Ottoman medals, recognizing his service to the sultan and the empire. His uniform is one that marks his employment at the Ottoman court. The image confirms that the threat to *Osmanlilik* reform discourse that he embodied had been neutralized, just as the Ottoman Constitution and Parliament had been in 1878.

Ottoman portraiture, like Abdülhamid's albums, flattens difference into an ideological coherence free of instability or ambiguity. The portraits of Louis and Jurji resemble a master genre of portraiture of Ottoman functionaries, *petit-fonctionnaires*, civil servants, and national-class organic intellectuals. The portrait offers us a space of ideological overlap, a shared sociability of these political actors and intellectuals despite their political differences. Louis's portrait when in the service of the sultan wipes away any semiotic or compositional trace of his past and the way he challenged the sultan's very legitimacy to rule Muslims as a non-Arab.

The ideological flattening of the portrait presents a challenge to traditional art historical methodologies in that it forces us to reach

beyond the portrait's composition. The photograph's claim to truth-value forces us to explore the ideological realm of representation but also the paths of sociability in which the image was circulated, displayed, exchanged, and even forgotten. This leveling legibility of the photographic portrait, especially those of Ottoman men, pushes us into the materiality of the image to look for inscriptions, marks, writing, stamps, or any sign to evince its exterior sociability. While repetition of the portrait's formalism displaced difference in order to establish *Osmanlilik* and *nahdah* normativity, the portrait as a social object bears the scars of its social life.

As was common practice, Louis sent portraits with his correspondence. On these images, he frequently wrote notes, dedications, and poetic verse on the portrait's mount or reverse side. In fact, just as the very raison d'être of the carte de visite was exchange, salutations and notes of affection were regularly written by the subject of the portrait to the recipient. We find that Louis and Jurji were bound by fraternal affection as much as by their interest in photography. Michel Fani reproduces a photographic profile of Georges, under which is an explanation that the portrait is "a representation [*timthal*] of my brother Jirjis." A poem in Arabic appears below this line:

> *Much time might have passed since our union*
> *The love of our friendship melted with my blazing love*
> *Perhaps, one day, the Lord will grant me His benevolence*
> *so that we will reunite in the goodness of our country.*[68]

The sentiment of poetry pours an interiorized world onto the flatness of a surface that holds seemingly uncontestable truth-value but still tells us so little. On the surface of this image-screen, the portrait represents multiple ideological and social significations; brother, photographer, and idealized "son of the nation." The sentiment speaks of love, friendship, and unity in a munificent homeland. Yet, on another level, the coupling of verse cracks the transparency of this image-screen, indicating a geographic and alienating distance between those who exchange the portrait and a history that eludes the portrait.

The verse offers a *punctum* to the self-evident truth-value of the portrait, where the alterity of personal experience, exclusive to individuals, appears alongside the fixity of *Osmanlilik* and positivist *nahdah* discourses. This is the nature of the portrait itself, whose strength of presenting the trueness of its subject also leads to the inevitable recognition of the limitations of the photograph's transparency. In other words, the coupling of poetic verse and photography remarks on the limits of photography and photographic meaning, which could not yet "speak a thousand words." The portrait, or likeness (*timthal*), is partnered with its writing, particularly a poetic form that consciously calls attention to itself, to the surface and density of language, as opposed to the transparency and unmediated claims of

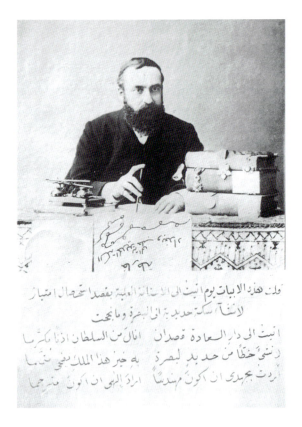 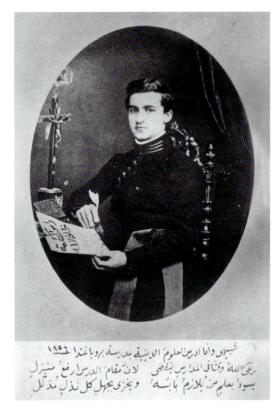

Figure 28.
Unknown
photographer,
Louis Saboungi.
From *Diwan
shi't al-Nahla
al-manzhum fi
khilal al-rihla.*

Figure 29.
Unknown
photographer,
Louis Saboungi,
black and
white on paper.

the photographic representation. This verse is a supplement to the image while also an inextricable part of it.

The cultural force of classical Arabic poetic language and the sentiment it elicits weaves back into the immediacy of the portrait. Poetic language animates the flatness to give it life, but also to buffer its transparency. Writing on the surface of the portrait provides both an opacity and transparency of the image, an interiority of meaning and an anteriority. However, writing is a part of the image's materiality and a part of its sociability. A later portrait of Louis was obviously a tool in his role as agent for a British railroad company (fig. 28). While these two images, the affectionate souvenir and an official portrait, are quite different, writing, quite literally, underwrites them but cannot be separated from their production, just as little as the writing of light could be separated from the photograph's surface.

Writing, coupled with the photograph, provides, in Barthes words, a *punctum* to the image's message, producing an "accident" of the photograph that divulges the image's alternative history.[69] Do sentiment and conspicuous language betray a trace through which to pursue the image's anteriority and its alterity, or might they be constituent of photography's own logic? The portrait of a young Louis, sitting by a cross and dressed in his seminarian costume, might show

precisely that the portrait operates on multiple levels (fig. 29). The writing is a part of its materiality that leads us both to the image's social currency, as well as to the history of its own production, the trajectories of its own circulation, the ideological work it performs in the service of class interests, and so forth. Writing reiterates the dominant enunciations and discourses of the photograph while also authorizing other sentiments and experiences to haunt and dodge hegemonic ideology. The complexity of the "nature of photography," however, is that its own *habitus* is constituted by these alterities that themselves are covalently bonded to the same logic of photographic seeing, the same perspective of capital, self, and affection.

Michel Fani reproduces a similar portrait of Louis as seminarian, dated 1865.[70] Perhaps it, too, was taken to commemorate his ordination in the same year, as Saboungi appears young and bearded, in a priest's vestments. However, in this image, the standard books, quill, and parchment in his hands mark Louis' self-identification as an intellectual, poet, and scholar-cleric. One cannot divine any connection between this portrait and that of the one that was taken while he was working in the Yildiz Palace. No clue exists in this portrait that relays the historical trajectory in front of him. That trajectory brought a Catholic priest into the service of a sultan who fostered loyalty through policies and rhetoric that intentionally induced religious fervor, especially against ethnic and Christian minorities in Saboungi's ancestral Anatolia. No sign exists portending that he will work for the same sultan whom he vocally criticized for usurping the Caliphate.

The portrait of a cleric is not rare. Orthodox patriarchs and Catholic clergy frequently had their portraits taken. An art historian might argue that if a formalistic tradition of portraiture existed in the Arab world, it came from two mutually exclusive traditions—that of the Ottoman court/bureaucracy and that of the Catholic and Orthodox churches. Apart from the Aleppan, Jerusalemite, and Coptic schools of iconography, Louis Saboungi, like Kevork Aliksan (from the Abdullah Frères) and the Kova Frères, was trained in painting in the Italian seminaries.[71] Religious indexes were not uncommon in *indigenista* photography. By the 1870s, Christian Arabs, Armenians, and Greeks in Lebanon, Palestine, and Egypt, as well as Istanbul, regularly visited photographic studios to commemorate not only weddings but also, particularly, First Holy Communion and baptism, if not the last rites.

What is secular about photography is not the literal index, but rather the perspective that it claims to be natural. Louis Saboungi's photography both relies on that perspective but, equally frequently, indicts it. In his seminarian portrait, he holds a parchment that reads, "The source of wisdom is in the safeguard of God" (*raʾs al-hikma fi khafirat Allah*). While it seems to have been taken in Rome, the image is framed on his brother's mounting, "G. Saboungi Photo." The photograph is marked belatedly with reflective sentiment, written about a bygone past. "My likeness [*shabhi*] when I was studying theology

[*al-'ulum al-diniyah*] at the College of Propaganda [in Rome], 1856." Under this, Louis pens in ink verse:

> *God's protection, temporally, is schools, we remain*
> *because the place of learning elevates the home.*
> *It marks with knowledge whoever comes upon its door*
> *and shames with ignorance all disgraceful turpitude.*

The certainty of this portrait, the commemoration of a young man's days in seminary, may be folded back into a sectarian discourse that might fit uncomfortably with politically secular *al-nahdah* discourses. But then, again, *al-nahdah* discourse always spoke of moral uprightness, faith in God, and, of course, the value of schools and learning in opposition to ignorance and depravity. The classical, somewhat stilted strophe written below his portrait contrasts with what should be the photograph as a space of ideological certitude and semiotic legibility. Louis Saboungi interspersed Arabic meter, as well as faith in and praise for God, into otherwise pared down Arabic prose. The juxtaposition of the transparency of the photography along with new forms of Arabic prose with the opacity of poetry is one more mark to suggest the alternative modes of belief, seeing, thought, and life that are contained within the surface and circuits of the photograph.

Louis's early political, religious, and social conflicts in Beirut arose out of the very particular sectarian stances that he held in regard to the Butrus and Salim al-Bustani, who were Protestant converts. He accused the Bustanis and their intellectual coterie of atheism, and alleged that the Maronites were heterodox. Such language or allegations were hardly welcomed at a time when Beirut's intellectuals were following Ottoman officials' calls for interconfessional unity. And while the nomenclature is derived from the *nahdah* vocabulary for social progress, national unity, and civilization, one can only ponder what sort of learning Louis imagines when he invokes "turpitude" (*nadhl*). That said, the language was resilient enough that it, too, could traverse political boundaries, between those *nahdawiyin*, activists, and reformers with whom he was allied and those he challenged. This verse, like the portrait, and as part of the portrait, could cross time and find meaning in its circulation and its effects. It could cross political lines and ideological registers because it was constituted by its own logic, even while it suggested alternative, competing logics.

The Carte de Visite

THE SOCIABILITY OF NEW MEN AND WOMEN

In describing the courtship of her "Aunt Nimet," Emine Foat Tugay, tells us that "the bride had the advantage of being shown a photograph of her intended husband, whereas, for a description of the girl, a man had to rely on the taste of his mother or sisters, who had seen her."[1] Aunt Nimet was no other than Nimetallah Hanim, the daughter of the Khedive Tawfiq. She courted and would marry Prince Kamal El-Din Hussein, the son of the Egyptian "Sultan" Hussein Kamal, who renounced claim to the throne as a protest to British occupation. Emine Foat Tugay was the granddaughter of Tawfiq's father, Khedive Isma'il, and daughter of a well-connected, high-ranking Ottoman military official (fig. 30). Her autobiography provides an intimate and detailed account of the private lives of the Ottoman and khedival aristocratic elites, especially within women's spaces, at the turn of the century.[2] She also explains how the mothers, sisters, and courtesans from the royal harems within the ruling elites arranged marriages between capitals such as Istanbul and Cairo. Photographs had a special place in this process, traveling across great distances into spaces otherwise inaccessible to the suitor.

Faroqhi confirms that during the late Ottoman Empire, Muslim upper-class family portraits "were already a part of everyday life. Women, particularly younger women, of that class, including the Sultan's daughters, liked to be photographed without veils and in European dress ... pictured at the grand piano or holding a violin."[3] Similar

Figure 30.
Phébus
(retouched),
Her Royal
Highness
Princess
Eminé Hanim
(a.k.a. Umm
al-Muhsinin),
Istanbul, 1880,
albumen,
30 × 24 cm.

vignettes are repeated in a variety of memoirs, including that of Sultan Abdülhamid's own daughter, Ayse. She "recalled choosing her prospective husband from the photographs her father sent her, testifying to the new medium's diffusion into the lives of the royal elite."[4] Likewise, Ellen Chennells, the governess of Princess Zeyneb, the daughter of Khedive Isma'il, relays how photographs were also the means by which royalty would meet their imminent brides.[5] More interesting, she relates how the Princess Zeyneb wanted her portrait taken. The khedive would not allow photographers access to the harem. He was concerned, even more than he was about propriety, that he would have no control over the image's circulation and display, since a European photographer would likely sell the portrait abroad. As a solution, a photographer from the realm, an Egyptian, was hired, and portraits were to be taken outside in the palace garden. The conditions were punishing. The sun was unrelenting and the garden had little shade. By order of the khedive, the photographer was not permitted an assistant, completing single-handedly the arduous task of photographing multiple images of the princess and her full entourage over two days. The final product was not to the liking of the princess, who "tore her own likeness into the smallest fragments but laughed heartily at the caricatures of her friends." The poor quality of the images, Chennells assures us, was not due to the Egyptian photographer's lack of skill but because of the insurmountable challenges put upon him. From the palace garden shoot, one "fair photograph was produced"—a full-length portrait that was sent to Paris and reproduced as a large oil painting.[6] Chennells confirms how portraits would not only travel horizontally between members of the same class but, indeed, vertically. Although she destroyed her own images, the princess gave the botched portrait of the governess to a slave, who, the author tells us, was quite fond of the Englishwoman. Chennells, however, was able to gain "possession of it by ruse, destroyed the atrocious thing, and presented her instead with a very good likeness, which had been taken by Abdullah [Frères] on my last visit to Constantinople."[7] While telling us that portraits traveled between vast class chasms, as represented by the circulation of the image between a princess, a slave, and a governess, the vignette also demonstrates the brand-recognition of "Abdullah" and the geographic distances the image would travel.

These and Emine Foat Tugay's stories tell us much about the technical, social, and political implications and conditions surrounding photographic production at the turn of the century. Her anecdote about the photograph's trajectory across the Mediterranean and into the protected space of the harem and elite circles shows that it is a *social product* explicitly intended for circulation, exchange, and display among friends, acquaintances, potential suitors. Photographs played a role in business and official relationships, not to mention in state security services, institutions, and organizations. Tugay's narrative, like that of the more famous autobiography of Hoda al-Shaarawi,

confirms that she was "not only the daughter of an immensely privileged family but also a figure who bridged" the social and class transitions "from the multiethnic Ottoman-Egyptian household" to new national bourgeoisies and secular elites—the generation of "new men and women," along with their modern concepts of monogamy, family, child-rearing, and what it meant to be a spouse as well as a liberated and productive citizen.[8]

Photographs had a social role, and photographs traveled. Among the plethora of gender issues, harem stories convey hints of the social life of the photographic portrait and the geographic, spatial, and social boundaries it traversed and mapped. Hasan Rasim Hijazi, photographer from Tanta, reminds *al-Muqtataf* readers to include a nice gloss on the photograph because "many [photographs] circulate around especially during the holidays" and a nice, glossy sheen will make the photograph more attractive when you "present it to a friend."[9] Hijazi's technical articles still reveal that exchange and viewing was the photograph's raison d'être. The trajectories of portraits, whether horizontally within, or vertically between elite circles and "middling" classes, recalls Oliver Wendell Holmes's observation that "a photographic intimacy between two persons who never saw each other's faces … is a new form of friendship."[10] This was as true in the Ottoman Empire as in North America. The photograph operated as a radically new mediating object of these "new forms of friendship." It expressed those relationships in ways that were previously technologically, economically, and socially unthinkable.

Reading photography theory against studies of Ottoman Arab social history yields more than the fact that nineteenth-century portraiture, "in functioning to bring the body of ordinary experience to visibility and to think it into a normative order, became a disciplinary practice essential to the cultural reproduction of the individual and the family."[11] This chapter engages how photographic portraiture was a text of sociability, social relations, and exchange. The portrait, especially exhibited by the carte de visite, was an object with social currency and a social role, expressing, creating, and reinforcing a new sociability in the Ottoman Arab East, the "new forms of friendship" of Ottoman modernity.

This chapter reveals the social relations at the heart of the portrait. It demonstrates that the portrait was a social product, created by an array of new scientific knowledge and accessible chemicals and photographic hardware, imbibed with a social currency through exchange and circulation within new networks of sociability, commerce, and power. Through the process of discussing a small handful of studios in Istanbul and Palestine, we can begin to understand the portrait—whether a carte de visite, cabinet card, portrait postcard, or other larger format media—not only as a composite of an array of social forces, but also as an effect of these forces. To claim that the Ottoman Arab portrait is an image-screen that conjoins planes of

historical and material forces with their ideological justification and instantiation, this chapter builds on the discourses that were articulated in the Arab press and also focuses on the portrait's surface, the materiality of the portrait, and its mode of circulation and articulation as a mediating and stabilizing ideological object.

Carte de Visite

The carte de visite was patented by André Adolphe Eugène Disdéri in 1854, although previous forms of its technology had been used expressly for administrative and institutional, that is, disciplinary, functions.[12] A camera equipped with four lenses would simultaneously expose a wet-collodion glass negative, placed on a moving plate holder. This single exposure would create eight identical photographs, roughly five by eight centimeters each. Cut to size, each portrait was individually mounted on a cardboard backing, about the size of a "calling card."

By 1860, Disdéri had opened studios in several European cities, and the production of the carte de visite exploded, blossoming into hundreds of privately owned "portrait factories" worldwide.[13] The production of the carte de visite was a new form of photographic mass production, whose low price made it accessible to virtually every class. In the words of Max Kazloff, "like the Gatling gun of 1862, its aim was to decrease the ratio of effort to output by mechanizing the product. Poses could be standardized, droves of assistants could be hired, sales volume could be increased."[14] This accessibility was counterbalanced by "prestige portraiture," where celebrities and notables patronized particular photographers known for their artistry—Nadar being the best European example.[15] As we have seen in the work of Saboungi, Kova Frères, Abdullah Frères, and Sébah, the prestigious and commonplace were bound by a repetitive "formula" of content and dimension, creating a template in which "posing was standardized and quick."[16] In addition to private use, cartes de visite of rulers, foreign and domestic, circulated in the market, importing the image of the leader into people's homes, work, and public spaces. Ottoman Arab lands were no different from England, where seventy thousand portraits of the Prince Consort, Albert, were sold the week of his death in 1861 or, where John Mayall, renowned for his portrait of Queen Victoria and the royal family in 1860, is said to have had an "output over 500,000 *cartes* annually."[17]

While Sultans Abdülhamid and Abdülaziz were both photophiles, the khedives of Egypt effectively disseminated their images, and the images of their families, among its population. As the calling cards circulated among friends, family, state institutions, and print media, the carte de visite compressed the distance, if not alienation, between ruled and ruler. In Egypt, for example, the propagation of portraits of the khedives served an essential political function to draw

together the new middle *effendiyah* classes, traditional peasantry, and the khedival aristocracy, who, as Emine Foat Tugay's narrative confirms, continued to marry within Turkic ethnicities while also invoking parochial nationalism. The "calling card" format was used for multiple purposes—personal pictures, official portraits, and exotic character-types. This versatility, as well as its affordability, expanded its market exponentially. Simply stated in the words of Helmut Gernsheim, and expounded on by scholars like Deborah Poole, "'cartomania' was truly international."[18]

While each locality maintained its own historically and culturally informed pedigree, the photographic representation and "genetic pattern" of the carte de visite replicated itself across borders. The visiting card was a process of flattening. Its sameness accompanied the standardized props, equipment, and chemicals one had to use to produce it. The portrait's iconography was a world of disenchantment, of leveling, speaking to the ideology of "modernity" as it was experienced throughout the globe. Europe's concept of "civilization," the Bengal's version of *bhadra samaj*, the Chinese's *wenming*, Meiji Japan's *bunmei kaika*, and the familiar Ottoman and Arab variant of *tamaddun* of *al-nahdah al-ʿarabiyah* are repetitively articulated as the imagery of the carte de visite itself.[19]

This efficiency and naturalness of the mechanization of portrait production is the reason why the history of Arab photography is so difficult to excavate. While the traces of prestige photographers and successful studios in Beirut, Jerusalem, Cairo, and Alexandria exist, the Middle East is awash in anonymous cartes de visite whose origins are erased and whose photographers' names seem inconsequential because they were rarely celebrated outside local quotidian life. The semiotics of the carte de visite carried the portrait and displaced its own material history. The hegemony of its codes and ideology, like the repetition of its production, made the social origins of the studio irrelevant. Haunting the collections and archives in the Middle East, these prestige photographers and studios, however, have so far provided us with a launching point to recover the complex material history that photography presents.

Lost Native Studios: Beirut and Palestine

The host of studio and photographers' names in Lebanon, Syria, Palestine, and Egypt suggests that the popularity and success of the carte de visite and later cabinet card market reached beyond Abdullah Frères, Pascal Sébah, Sébah et Joaillier, Saboungi, and the Kovas. These blue-chip ateliers were examples of larger photographic and studio practices in the empire. The demand for the prestige studios by foreign and domestic elites reflects the currency of and demand for carte de visite in the Middle East, which outlasted the domestic

market in Europe, where it was displaced by other popular photographic formats.[20] The longevity of the carte de visite and its sister cabinet card in the Ottoman East could be attributed to the fact that it accommodated a series of markets. *Indigènes*, expatriates, and tourists patronized local studios that also serviced the foreign market's reliable demand for a steady flow of character-types and biblical figures, the negatives of which also could be repurposed for postcards. Just as Malavika Karlekar, Christopher Pinney, and Zahid Chaudhary suggest in the case of Indian photography, native-owned studios in Beirut, Cairo, Alexandria, Damascus, and Jerusalem attended to Americans and Europeans as frequently as they served locals.[21] The same can be argued for expatriate studios, especially in Cairo and Alexandria, arguably the Mediterranean's most ethnically diverse and vibrant city at that time.

The dozens of editions of the *Baedeker Guide* to the Holy Land and Egypt relate how studios in the urban centers crossed markets, clientele, and genre. While providing an extremely restricted sample of studios in Beirut, Jerusalem, Cairo, and Alexandria, *Baedeker* offers names of largely expatriate-owned photographic studios, postcard dealers, and photographic equipment with limited information other than directions and street addresses. Comments regarding the quality and price of the product are provided, along with an occasional remark about the trustworthiness of the haggling, native dealer.

Jules Lind, for example, was an expatriate resident in Beirut, about whom we know very little except through his extant photographs, which range from studio portraits to landscapes. He was, however, successful among the *indigene* market, notably for the iconic image of al-Shaykh Nasif al-Yaziji reproduced in *al-Hilal, al-Muqtataf*, and Tarrazi's *Tarikh al-sahafah al-ʿarabiyah* (History of Arab Press).[22] Assad Dakouny and his brother Frédéric eventually purchased and divided Lind's studio and collection. Dakouny was a successful Beirut photographer who capitalized on Lind's name but certainly surpassed him in production and popularity.[23] They apprenticed with Costi, a Beirut Greek Orthodox photographer and the associate of Octavia Covas, perhaps the first Arab woman to own her own studio between 1905 and 1937.[24] While Assad kept the Lind monogram, Frédéric opened Photo-Paris, and their cousin Antoine Dakouny maintained a studio under the family name. Although their careers exceed the time frame of this study, it is important to note that all three would have various degrees of success in producing "portraits of politicians and the rich" for French Mandate Lebanon's high society and political elite.[25]

Baedeker Guide states in 1906 that Lind's studio was "near the barracks" in Beirut, where "portraits" and "photographic requirements are also on sale."[26] Fani, however, says that Lind, a German who left Lebanon on the eve of World War I, established a studio in 1894 near Assour Square, which would have been near Saboungi's atelier.[27] Clearly, the *Baedeker Guide* does not represent a comprehensive por-

trayal of commercial photography in the urban centers of the eastern Mediterranean. The same guides were reprinted year after year under various titles, noting only a small number of the same European studios for years, with the exception of marquee establishments such as those of Garabed Krikorian and Khalil Raad in Jerusalem and Suleiman Hakim in Damascus's Asruniyah neighborhood.[28]

The lacunae of the *Baedeker Guide* were not coincidental or innocent. As Maria Antonella Pelizzari and Kathleen Stewart Howe show, respectively, the photographic narrative that accompanied the written text, in the West, produced an "imaginative geography" that reflected the colonial ideological nature of tourism, photography, and these guides in general.[29] The *Baedeker Guide*'s neglect of the wealth of native activity served very unambiguous ideological and commercial ends. It was not because of any language barrier that tourists were directed to European-expatriate establishments; most native photographers were likely to be proficient in at least one European language, notably French. Considering the tenure of the *Baedeker Guide*, which repeatedly warned of being overcharged and cheated, native studios were expunged because they were seen as less reliable and untrustworthy. That said, the glaring oversight of native studios in the *Baedeker Guide* was replicated for decades in the study of photography in the Middle East, most prominently reflected in works such as Nissan Perez's canonical *Focus East* or Ken Jacobson's more recent *Odalisques and Arabesques*.[30] Recent works by scholars such as Issam Nassar, Badr el-Hage, and Michel Fani have begun to redress this ideologically laden lacuna, revealing much about native photographers and photographic studios, as well as their close commercial and social relationships with expatriate studios, as exhibited by the Lind-Dakouny connection.

Family albums, institutional collections, and archives in the region are peppered with cartes de visite, cabinet cards, postcards, and medium-format portraits from Beirut photographers and studios like the Kova Brothers, Nasr Aoun, Georges Tabet, M. Thabit's Photo Empire, Atelier Phébus, Sa'id Jureidini, Spiridon Chaïb, and Michel Covas, an elder relative of Octavia and photographer in the 1880s, who might have had a studio in Egypt. Few of these names appear in the *Baedeker Guide*, as their clientele perhaps existed outside the networks involved with foreign tourism. The prodigious number of cartes de visite produced in Beirut was not a consequence of foreign clientele. Beirut had a booming portrait studio culture by the turn of the century (a culture that would expand even more by the 1920s and 1930s) owing to its growth as the commercial and cultural center of the Levant, even though Cairo and Alexandria dwarfed its photographic production and flourishing portrait business. An important caveat is that the division between native and expatriate studios and clientele is problematic. While foreign studios did entirely cater to the foreign and tourist markets (as did some high-profile native photographers like

Jurji Saboungi), native photographers shared clientele, resources, and collections with foreign-owned studios such as Jules Lind, Edouard Aubin, and A. D. Reiser, together evincing the craft's integration in Beiruti society.

Ottoman Arab *cartomania* was not a center-to-periphery occurrence, however, but a mass, albeit uneven, social practice. While studios appeared, disappeared, and reemerged in various incarnations, Iskander Makarius tells us that, by the turn of the century, "the number of photographers have increased" among the general population, "so the number of photographs of people has increased."[31] Some may contend that these photographs and studios were urban phenomena and that, in rural areas and impoverished urban neighborhoods, photographs were a highly valued but rare luxury item, despite their affordable price to the aspirant classes. This prevalent assumption, however, overlooks a variety of empirical facts and theoretical conclusions that surround early Arab photography. If the circulation of photographic portraits maps the contours of growing class and social relations, the alleged absence of the carte de visite among peasants may attest to the fact that these social groups were outside of the social networks of exchange. This paucity also may indicate the low social currency that the portrait might have had within a class culture that values other forms of sentimentality and sociability, forms that were not invested in the representation of orthodoxy or in the semiotic system of Ottoman modernity. The assumption is rooted in an anachronistic understanding of what the photograph was in a culture not yet awash in visual images. That is, the shards of history come to us in the form of individual photographs bearing studio names now forgotten. The prevalence of *cartomania* does not necessarily mean the new subjects of the era were producing an inordinate number of portraits of themselves, however. Despite the multiple images of leaders, dignitaries, and functionaries throughout their lives, one image in a lifetime might have sufficed for the private citizen, which itself speaks to our historical and cultural conceptualization of selfhood and its relationship to photography.

Not until recently have we learned about Issa Sawabini and Karimah Abboud (Karimeh Abbud), thanks to Issam Nassar's vital research on the history of photography in Palestine.[32] We know, however, very little about photographers such as Daoud Saboungi in Jaffa or Krikor Missirlian in Aleppo, of whom we are aware because of their carte de visite production. Daoud Saboungi's activity is known because he partnered with Issa Sawabini to open a popular studio in Jaffa, and also with Garabed Krikorian to document the visit of Kaiser Wilhelm II to Palestine in 1898.[33] Despite these efforts, we still know little about the biographies, histories, clientele, and trajectories of Octavia Covas, Costi, Madame P. Saboungi, Habib Hawawini, Savides, Toumayan, Sam'an al-Sahar, Abu 'Issa Freij, and Kevork Kahvedjian's Elia Photo in Palestine, Lebanon, and Egypt.

The carte de visite is the only clue to untold studios in small towns and secondary cities, such as Soubhi S. et Muni Aita and Chouha Frères in Aleppo or Habib Hawawini in Damascus. While the Lekégian Brothers were most famous for establishing a studio in Port Said, the studio of G. Massaoud et Frères on Rue Said 27 successfully produced "photographie artistique" by the turn of the century. Hasan Rasim Hijazi was writing about photography by the 1890s from Tanta, and his work was followed by studios such as Melik Photographie and the atelier of Soleiman Akle in Minieh. In Lebanon, Badr el-Hage has recently published a book on the studios and photography in a small Orthodox town, including a nineteenth-century studio run by Nasib Khonaysir. This is not to mention Wadiʾ Nawfal or *photographes ambulante* such as Camille El-Kareh (al-Qarah) in Zgharta.[34]

Market Share

The history of indigenously produced photography has yet to be fully written. Beirut, Jerusalem, Cairo, and Alexandria, let alone Damascus, Aleppo, and Baghdad, are all cities with rich and complex modern histories as regional metropolises. For all of Beirut's intellectual dynamism, economic power, and social vitality, it was no Cairo. Egypt's cultural magnitude, however, makes it virtually impossible to excavate, because so many studios in Alexandria and Cairo before the turn of the century were owned by non-Arab, often non–Middle Eastern, expatriates, who also tended to partner with Christian Arabs and Armenians. Perhaps this was the result of British control after 1882, or perhaps the sheer number of foreign tourists made it too lucrative an economic opportunity for foreign photographers to pass up, especially with the extraterritorial privileges that they held.

Native ownership of studios, particularly by Armenian Egyptians, skyrocketed after World War I and Egyptian independence, which might have been a result of Britain's departure or perhaps the influx of skilled photographers following the Armenian Genocide and dissolution of the Ottoman Empire. While narratives such as Emine Foat Tugay's give us evidence of the prevalence of Egyptian photographers, the earliest studios are known to be European. In 1850, Anton Schranz, a Maltese, opened the first studio in Cairo, followed by the successful W. Hamerschmidt, both of whom accommodated the tourist more than the domestic market.[35] Not only did Abdullah Frères and Sébah open studios, but so, too, did many prominent Europeans, such as Gustave Le Gray, Beato, and Henri Béchard, who also partnered with Sébah.

Levantine, Armenian, and Greek photographers, most often in Alexandria, partnered with expatriate photographers. Aziz Bandarli and Umberto Dorès co-owned a studio, Aziz & Dorès, which predated their cooperation making Egypt's pioneer films and co-owning

Figure 31.
Fettel, Sébah, and Bernard, anonymous portrait, Alexandria, ca. 1900, cabinet card, 8 × 3.6 cm.

a cinema and production studio, which trained one of Egypt's most important cinematographers, Alvise Orfanelli.[36] Jean Sébah provides a good example of how blue-chip studios capitalized on name recognition, frequently partnering with indigenous and expatriate-owned studios, as attested to by amalgamated mounts such as those of Fettel, Sébah, and Bernard (fig. 31).

Such "branding" reinforces our understanding of studio practice as a commercial undertaking. These hybridized studios of indigenous, expatriate, and "transnational" photographers accommodated the local markets as much as they did Egypt's tourism industry. They produced cartes de visite and cabinet cards of the "new men and women," as well as children, of khedival Egypt, which differed little from those of the expatriate residents of Egypt. While few of these portraits portrayed men in "native attire," the difficulty in determining the ethnicity and identity of these multiethnically owned studios is telling. Their subjects pose in generic fashion, sharing qualities that project affluence, education, and presence. The impossibility of identifying these subjects is due precisely to the *formalistic* character and the standardizing "genetic patterns" that allowed Ottomans, whether Arab, Armenian, Turkish, or Greek, to lay claim to the universality of "civilization and progress" that the British used as a justification to rule Egypt.

Cross-pollination and interactive cooperation between studios and photographers was the rule rather than the exception. Their portraits often shared common "universal," standard "genetic patterns" that linked Beirut, Cairo, Alexandria, Jerusalem, and Istanbul. But also, if we parse out vernacular inflections of the indigenous portrait, the locality of partnerships may yield more fruitful results than a comparison of "Arab" with "Western" photography. Garabed Krikorian teamed up with a number of Beiruti and Palestinian photographers, including Jurji Saboungi, Daoud Saboungi, and, of course, Khalil Raad. Comparing regional partnerships such as Saboungi and Krikorian with Sébah, Fettel and Bernard confirms some of the compositional differences between studios in Greater Syria and Egypt (fig. 32). The *effendiyah* in the cartes de visite of G. Saboungi & G. Krikorian more frequently asserted their locality, wearing their Beiruti effendi dress as opposed to the consistent appearance of *afranji* apparel in hybridized and expatriate studios such as Fettel, Sébah, and Bernard. The woman, whom we assume to be the wife, in G. Saboungi & G. Krikorian's portrait of a couple assures the viewer that the subjects do not reject *afranji* dress. The generic pattern image, if not Saboungi's characteristic red velvet mount, locates the couple in Ottoman Syrian cosmopolitan culture, in Beirut's own pedigree of *nahdah* discourse. The cabinet card format confirms that a decade or two separates it from the Fettel, Sébah, and Bernard portrait. The differences between the format and the content, the *afranji* Alexandrian against the native Levantine effendi couple, allows us to think about how Ottoman studios (considering Sébah and, potentially, Fettel as Ottoman *indigènes*)

imprinted the particularities of their own locale (Alexandria and, say, Beirut or Haifa) into the portrait, how they projected their own version of cosmopolitan Arab modernity, and how the portrait was an interpellation of each city's own "new men and women."

Expatriate studios in Cairo produced a substantial number of cartes de visite and family portraits for Egyptians as well as Levantine (Shami), Armenian, Greek, and Italian minority communities. The backing of B. Edelstein's photographs was printed in Arabic as well as English, providing his address on Mousky Street over Mssr. Kramers & Cy's Shops. Italian-, German-, and French-owned studios such as Royer & Aufière and Délie & Co., A. (Alessandro?) Brignoli, and Schieb & Schueff produced a considerable number of cartes de visite starting as early as the 1860s, suggesting that this was a prime source of income along with their usual tourist fare. Studios in Cairo, such as Fasani and Grivas, produced a considerable array of portraits but also cityscapes and architectural photographs of new Cairo's urban growth, which seems more relevant to Egyptians than tourists.

The Mediterranean port city of Alexandria was a hub of hybridized studio ownership at the turn of the century. Many of its studios marketed to the ethnic and expatriate communities of the city: Greek, Italian, mostly Levantine-Arab, and Armenian, not to mention other Europeans. The sentiments found on these cartes de visite were written in Italian, Greek, English, and Armenian and often confirm that they were circulated either among community members or sent to the "homeland." Equally frequently, French served as a koine, which further complicates the origins and paths of these portraits.

Turn-of-the-century studios like F. Prisco (1900s), Anagnostis (1890s), and Atelier Lassave in Alexandria were just as popular as those of Fettel & Bernard, Stromeyer & Heyman, Arno, Pellegrino, Caruana, and Photo Constantinople. They remain mysterious, however, other than what we can deduce from the juxtapositions of various ethnicities of names. The fluid clustering of expatriate, Ottoman, and local photographers suggests that these studios were less competitors than entrepreneurial ventures that cooperated in developing a native market. Photographic studios seemed to be lucrative but ephemeral and risky enterprises, resulting in much turnover and the selling negatives among themselves. The monogram on the back of cartes de visite shows us that Luzzato, the "artistic photographic studio," was not alone when it bought the well-established expatriate studios of Scheir and Schoefft, which it continued to advertise on its own products. As Dakouny's acquisition of Jules Lind's name and archive shows, native photographers and ethnic minorities often purchased lock, stock, and barrel the brand name, equipment, and archives of expatriate-owned studios. Most famously, for example, Abraham Guiragossian in Beirut purchased the Bonfils studio, where he once apprenticed. The economics of buying a recognized studio rather than creating one's own was a sound business choice, or some-

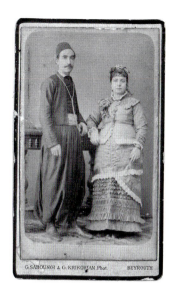

Figure 32.
G. Saboungi and G. Krikorian, anonymous portrait, Beirut, 1880–90, carte de visite, 10.5 × 6.3 cm.

times selling it was just a good way to retire, as was the case when the elder Abdullah Frères sold their archive to Jean Sébah at the turn of the century.

When they were not purchasing and writing their own names on negatives acquired from other studios, larger ateliers, like Bonfils and the American Colony, enlisted smaller studios, local photographers, and expatriates to take photographs for them, contracting them for projects or employing them for a period of time. This confirms Nancy Micklewright's speculation that large studios used a variety of photographers in the centers and provinces.[37] Considering the enormous territory that these studios covered, the diverse genres they produced, and the various markets they accommodated, the critical mass of photographic production reveals the degree to which natives and expatriates cooperated to cultivate the market.

Many of these studios are not mentioned in the standard histories, let alone in the *Baedeker Guide*. Their portraits pepper the region's family albums, archives, and private collections. Rather, what little information we know of prolific studios like Nasr Aoun in Beirut or Studio Venus in Cairo is largely gleaned from fleeting mention in the written record or oral histories related from one generation to another. No doubt, the cataclysmic history of Lebanon's civil war, the expulsion of minority communities from Alexandria, and the mass dispossession of Palestinians resulted in the destruction and loss of countless photographic studios and collections. These historical realties should not impede our understanding of indigenous photography but confirms the relationship between the materiality of the photograph and the history, politics, and social forces of its locality. Less dramatic, the disappearance of these studios kept pace with the devaluation of the carte de visite's currency and the social network of exchange in which it was invested. As in the case of other cultural productions, the cross-communal exchanges that characterized Ottoman Arab society, instantiated in the *production* of cartes de visite, would be displaced, suppressed, and recoded throughout the Arab world with the rise of various forms of nationalism, parochialism, confessionalism, and regionalism.[38]

Atelier as Hub of "Interactive Emergence"

While we know few details about Alexandrian, Cairene, Jerusalemite, Jaffan, and Beiruti studios, collectively we can discern how they negotiated the ideology of the Ottoman Empire's changing social, class, and cultural landscape. These studios, whether blue-chip or pedestrian, nurtured relationships at every possible echelon of local society, from the Ottoman and khedival courts and the expansive bureaucratic and functionary classes, to the urban bourgeoisie and middle classes, not to mention the steady revenue from the tourist market. We have

seen how the coalescence of a photographic *habitus* of photography provided yet one more space for ideological and performative enactments to commit new subjects to a citizen/individual–nation/ state nexus that served particular elite interests. The myriad of photographic ateliers in the Ottoman Empire, including Egypt, serviced and inhabited an instrumental space in the "interactive emergence" of class and ideological interests.

The concept of "interactive emergence" was initiated by John Wills in regard to South Asia and deployed by Peter Gran, albeit all too briefly, to understand the mutual interests, cooperation, and collusion between colonialists and indigenous merchants, minorities, elites, aristocracies, and bureaucracies in accumulating, if not "liberating," capital through their joint commercial enterprises.[39] The analytical concept of interactive emergence invalidates that understanding of the colonial encounter as a unidirectional extraction of surplus capital and resources from colonized and protocolonized lands or the encounter with "modernity" as a simplex catastrophe causing "shock" in "traditional" zones.

Local economic elites and *effendiyah* shared and competed with the interests of Ottoman and khedival bureaucracies but also European political and economic players. While these classes were often jockeying for preeminence, they all drew legitimacy and inspiration from a common "perspective" structured by the *nahdah* master-narratives of "civilization and progress." On the most empirical level, the matrix of photographic studios from Georges Tabet in Beirut to Issa Sawabini in Jaffa to Aziz et Dorès in Alexandria was a material and quite literal space for the interactive emergence of a subsector of economic production, whose social currency arose, partially, from their command of "modern," specialized, technical know-how and, partially, from their ability to mass-produce a commodity with great social utility.

At the height of their success, the Abdullah Frères, Saboungi, Krikorian, and various manifestations of Sébah's Cairo and Istanbul studios were probably not quaint, artisanal studios run by an individual, tinkering craftsman. While they likely did not operate on the scale of Disdéri's "Temple of Photography," they certainly were the very sort of ateliers that were otherwise represented in Abdülhamid's albums.[40] On a higher level, the network of studios and critical mass of photographic production produced a materialist *habitus* of photography, a social and physical *space* and *product* of interactive emergence of multiple class subjects, locally and transnationally, nationally and regionally. As Bourdieu explains, his analytical concept of *habitus* contains and conceptualizes a myriad of social, cultural, economic, and psychological forces that can unpack the practices surrounding photography because it is "conceived in three distinct sets of relations: to the conditions under which it was formed, to the immediate situation of action, and to the practices it produces." *Habitus* is a "system of

lasting, transposable dispositions which, integrating past experiences, functions at every moment as a matrix of perceptions, appreciations, and actions," and makes possible an array of social tasks in order to regulate social challenges, problems, and development.[41]

This theory helps us begin to define the variety of elements at play within photography's production, how history, "dispositions," "experiences," "perceptions, appreciations, and actions" are also organized, made productive, regularized, and socialized. The *habitus* affords manifold "tasks" and spaces: namely, the semiotic representation and language that give the image ideological salience; the material required to produce the portrait; the knowledge, skill set, and cultural and social infrastructure behind the photographic establishments, their workers, and owners; the sources of wage-capital exchanged in order to circulate the portrait; and the circuits of sociability in which the portrait was exchanged and maintained social currency.

Christopher Pinney interestingly remarks that, in India, "the changing technological base of photography," much of which we have seen in Arabic writing about photography itself, "propelled a disengagement from the colonial *habitus*."[42] The tasks and "dispositions" that unfold in the space of indigenous photography are clearly rooted within an autogenetic modernity that operated through a system of economic and social exchange between multiple tiers, social groups, institutions, and figures throughout the empire, in Beirut, Cairo, Alexandria, Jerusalem, and Istanbul, for example. Marx reminds us that "it is only by being exchanged that the products of labour acquire, as values, one uniform social status, distinct from their varied forms of existence as objects of utility."[43] If social and economic exchange is at the center of the production of photography, the concept of interactive emergence forces us to approach photographic studios as production and distribution facilities as much as ideological clearinghouses. The host of names of photographers that we come across in the shards of history, knowing so little about them, their clientele, their lives, and their social milieus are recuperated when we understand them collectively as a *habitus* of production of objects that *reproduced* ideologies (and perhaps counter-ideologies), allowing them to be performed and circulated.

When the Abdullah Frères opted to photograph the Russian Grand Duke Nicholas, they misread the boundaries of this photographic *habitus*, thinking that they operated within a particular "interactive emergence" of photography as an elite class practice. Just as in nineteenth-century France, where the new bourgeoisie found the anciens régimes of Europe a lucrative clientele, the Frères operated on a vertical plane that serviced a range of clients, from the aspiring *effendiyah* to aristocrats and officials regardless of ethnicity and nationality (that is, Turkish, Egyptian, British, French, Italian, English, Armenian, Levantine etc.). Overplaying the sociability of these relationships at the expense of their political nature, they transgressed the boundaries

of their most important social relation, that of the relationship with the sultan. We could surmise that cooperation and alliances between photographers and the state was not rife with tension. Indeed, many of Jurji Saboungi's clients seem to be high-ranking but extremely controversial political Ottoman officials such as Ziya Pasha and, as we will see, Midhat Pasha. The cachet of these relationships and its dividends must have paid off, as Saboungi accrued a highly visible clientele among the Levant's, Egypt's, and the empire's reformist circles. Yet, also, while being a low level functionary himself, he failed in his own struggle with the Ottoman administration to establish officially and legally a photographic society in Beirut.

Despite these setbacks, Saboungi and the Abdullah Frères were able to recuperate not only because they could fall back on their elite relationships with the khedives of Egypt, but also because they relied equally on social and commercial relationships among the new social formations of their milieu. In other words, the brothers' cachet, for example, was transportable, allowing them to be transplanted in Cairo. Their cultural capital, like their wealth, was infused by the currency of their social relations and network of exchange of their product among, most visibly, but not exclusively, the elite. Their "brand" relied on and drew its value from networks of social, political, and commercial alliances and relationships that were not singularly built but that were produced through collective energies that drew together individuals, communities, social groups, and institutions throughout the empire.

"New Men and Women" in the Arab Provinces

We have seen how repetition was a structural element of portraiture, especially the cartes de visite, which functioned as an enactment of ideological identifications that secured a fixity of visual and social codes, enframed within interlocking class, national, gender, and individualist narratives of civilization and progress. The repetitive social and semiotic practices of the portrait reproduced, in the words of Pinney, an ideological "tacit system of codes," an index of life, material reality, and a vision of social order "that quietly encode a life-world—which photography was able to mobilise but which also came to define in certain respects the proper use of photography."[44] The endless, repetitious cortège of standardized, formulaic, formalistic visiting cards reproduced an index, or set of representations, that naturalizes and enforces the ideology of the empire: order, education, citizenry, loyalty, patriotism, and civility. This index is the representational set of what Peter Gran calls the "New Men" of capital accumulation, found concurrently in a variety of global localities during the world's conversion into a global capitalist order. These New Men "are a group of people across the planet more attuned to the laws of the market and

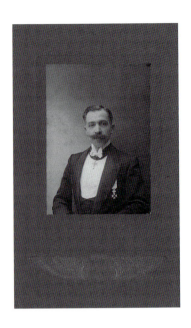

Figure 33.
Cairo Studio,
anonymous
portrait,
undated
cabinet card,
18.8 × 11.4 cm.

less so to the traditional laws and moralities of nation-states."[45] The carte de visite as the first global phenomenon of mass visual culture speaks to this simultaneous "rise of the rich" where, in the words of Deborah Poole, the carte de visite represented "the shared desire and sentiments of what was rapidly becoming a global class."[46]

While I will investigate alterity as a consequence of the arrival, implementation, and covalence of *Osmanlilik* and *nahdah* modernity, I recognize within Peter Gran's scheme of New Men a universalizing trait of capital that, in Marx's words, compels "men" to "enter into definite relations that are indispensable and independent of their will" in order to establish "relations of production" that constitute the economic structure of society—the real foundation on which legal and political superstructures rise and "to which correspond definite forms of social consciousness."[47] The new men and *women* of the empire were constituted within an "interactive emergence" of a complex array of social relations mediated by their access to the knowledge-education matrix, capital production, and legal relations to each other and the state that was so adeptly, cleanly, and transparently represented in the portrait.[48]

In the wash of photographs without names of their sitters or photographers, we are struck by a realization that no portrait started out anonymously. Those images were produced, disseminated among, and displayed by men and women who maintained relationships with the sitter. To reclaim the anonymous image, we can invert Max Kozloff's claim that the carte de visite acted as a "fashion plate" for the bourgeoisie, "where everyone was simply leveled, more or less interchangeably, to the role of actors in a charade" (fig. 33).[49] But the charade is not a lie; it is an ideological enactment. The anonymous portrait of a distinguished gentlemen and with a medal, probably is later than the scope of this book. Its "Cairo Studio" stamp, a studio of which we know nothing, is less interesting that the sloppiness of the mount. We know that photographs were often framed on studio mounts that did not take the portrait. We are left then only with genetic patterns and the indexicality of the image, which serve as an interpellation of Cairo's society of men who were restructuring the political economy of Egypt, into an "Egypt for the Egyptians," as the slogan of nationalist men and women proclaimed. While juridically conceptualized as individuals, in Gramsci's words, these subjects acted collectively in concert as new "social groups" (or classes), giving "homogeneity and a consciousness of [their] own function" to a shifting political economy and social sphere.[50] They were Egypt's new *effendiyah* that fought for independence and simultaneously wrestled with khedival power.

Egypt's new individuals found their representation ready-made for them in the portrait. Or perhaps better, they found in the portrait a preexisting *habitus*—a manicured extension of social space—in which they could choose from a number of ideologically inflected genetic

patterns for self-representation. Just as the props, backdrops, and staging were *prêt à porter*, the representation and ideological identifications waited to be enacted by the sitter. The cartes de visite waited to be occupied by new subjects and to express their social relations. From Aleppo, Alexandria, Beirut, Cairo, Damascus, and Haifa to Izmir and Istanbul, the transformations under way in the Ottoman Empire were creating "new men and women" not only in some sort of "informal," esoteric abstract way, where individuals began to see themselves through a liberal and Enlightenment prism based on inalienable rights, but, as Sibel Zandi-Sayek shows in her precise study of nineteenth-century Izmir (Smyrna), "formal dimensions of citizenship" were "governed by institutional categories." The process by which the "new men and women" of the empire emerged involved the meshing of new juridical uses of power (changes in political representation, legal codes, land-tenure, and taxation) and civilizational and national narratives by *nahdah* intellectuals, literati, reformers, and a new phalanx of professionals that gave them meaning. New urban Ottoman citizenship, then, "was a complex interplay of legal norms and daily practices as evidenced through property transactions" involving foreign and native subjects, premised equally on legislative and legal means (through shifts in taxation and land-tenure policies) and "active participation in and appropriation of the city's economic, social, and cultural spheres by virtue of residing in an urban territory."[51]

The "new men and women" of the Ottoman Empire posing in the cartes de visite of the era were officials, judges, administrators, and intellectuals of these "legal and political superstructures." Lest we portray these actors, reformers, and functionaries deterministically as thoughtless agents of capital's ideology or as tools of the elite, we understand these "new men and women" as archetypes, a synthesis of material forces of production, products of the discourses of knowledge, which they calibrated, articulated, and disseminated. Within the mundane formalistic repetition and production of their images, these ideologues and functionaries of new Ottoman governmentality are revealed as inseparable from the reorganization of the nature of capital accumulation, the forces of production, and the nature of property in the empire. This is most blatantly evinced in the reform of the Ottoman Land Code of 1856, not to mention the legal enfranchisement of all Ottoman citizens, regardless of faith, established by the Hatt-i-Hamiyun, an imperial firman in 1856.

The works of Abdullah Frères, Sébah, Saboungi, Kova Frères, and others are, then, an indexical template for the "new men and women" of the Ottoman Empire. This template, like Kozloff's "fashion plate," is a class, discursive, social, and commercial schematic. The carte de visite was an extension of social space, where that template offered ideological positions to be occupied and enacted. The imprint of that enactment, the portrait itself, was then circulated among individuals, elites, functionaries, classes, and ethnic communities between Ottoman

provincial capitals and ancillary towns, between Western and Middle Eastern cities, to shore up their social relations within the tussles, ruptures, and sedimentations of economic and political changes.

Social Network

Dyala Hamzah remarks that "by reading the thought of the intellectuals within the emerging public sphere, that is, with the context that moved and shaped them, one is able to map the web of their relations, the spaces of their experiences, the horizon of their expectations, the ideational matrix in which they evolved, in their sustained endeavors to plot the coordinates of selfhood as against the coordinates of statehood."[52] The same sets of complex relations existed not only between intellectuals, but also between larger social groups, between minorities and majorities, elites and middlemen, guilds, merchants, and officials, notable families, religious clerics, and bureaucrats. These social groups, communities, and networks expanded, shifted, and contracted for centuries. By the last quarter of the nineteenth century, however, unprecedented groups such as the *effendiyah* appeared alongside reconstituted groups that would define themselves in ways particular to the modern era: in terms of national identity, ethnicity, sectarianism (in Lebanon), and classes apart from their regional and local communalism. These individuals collectively came together in concert with state elites and colonial powers to rewire new commercial, social, and economic networks in the late Ottoman period. The Abdullah Frères, Sébah, Saboungi, and Garabed Krikorian, along with a legion of local studios, worked within and served these networks to form an Ottoman sociability that linked the "new men and women" of the Arab provinces with each other and with imperial centers in Istanbul and Europe.

After their emblematic panoramic, architectural, and industrial images of the empire, Abdullah Frères, Sébah, Saboungi, and Krikorian are known for their portraits of high-ranking Ottoman bureaucrats, including a large number of senior military officials, governors and ministers, and grand viziers such as Fu'ad Pasha and Daoud Pasha, both of whom were appointed to rule Mount Lebanon in their illustrious careers. The portrait was not limited to enacting ideological positions within a representational space that was an extension of societal realities. The template of genetic patterns connected classes and individuals to each other and to ideological, class, and social formations, such as the *effendiyah* and the nation. But also, as a material object, the portrait enacted the social relationship that it represented. It was a *souvenir d'amitié*, a "souvenir of friendship," that bound economic elites; it bound individuals within and across class and social formations.

Saboungi's portrait of a highly decorated European acquaintance of G. M. Sursock and his wife is evidence of this enactment (figs. 34, 35). George Musa Sursock was the son of Musa, the grand patriarch

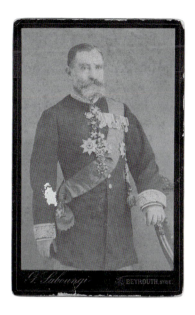

of the wealthy Beiruti Sursock (Sursuq) family, whose wealth came from cotton mills and agricultural lands in Lebanon and Palestine. He and his brothers were latifundists, whose landholdings grew with the change in Ottoman land laws, and their wealth exponentially increased with the monetization of crops such as wheat and cotton, which they also processed in textile mills they owned. While the Sursocks are known for selling many of their landholdings in Palestine to Zionist settlers (and with that, the land rights of their Palestinian tenant farmers), they were still economic players in the Ottoman Levant, securing rights to development projects from Mardin to Palestine.[53] Saboungi's cabinet card brings to visibility the social relations necessary for the Sursock economic empire to succeed. The portrait gives us access to a model network of social relations between the new Ottoman administrative, political, and economic elites. The cabinet card and cartes de visite enacted the class identities through their surface representation, but this representation itself, though its imprinting of the material object of the photography, served to enact and secure relations between men and women, making the photograph a social and representational practice.

These photographic enactments were only a symptom of larger geographic and social movements. Syria's, Mount Lebanon's, and Palestine's highest-ranking *wali*s and mutassarifs filtered through the same Ottoman network of civil and military offices, moving between Istanbul, the Palace, and provincial capitals, and linking them even more intimately with like-minded new local economic and political elites as well as the old notable classes. These networks were regional and imperial, cultural, personal, administrative, and economic. Notables from Mecca

Figure 34.
G. Saboungi, unidentified European with medals, 1893, cabinet card, 16.3 × 10.8 cm.

Figure 35.
Reverse side of the same card: "A Monsieur & Madame G.elb. Sursock. Souvenir d'amitié. [Unidentifiable signature] Beyrouth le 5 Avril 1893" (To Mr. and Mrs. George Sursock. Memory of a friendship. Beirut, April 5, 1893), cabinet card, 16.3 × 10.8 cm.

to Cairo to Damascus would send their young sons to Istanbul and provincial capitals and cities for civil and military education, only to return to their counties of origins to become local, if not later, national leaders.[54] The fact that Hussein bin Ali (1854–1931), sharif of Mecca, and his son Faisal (1885–1933), later the Hashemite king of Iraq, were born in Istanbul and educated in the schools represented by Abdullah Frères in the Hamidian albums speaks not only to the interconnectedness of these elites, but also to the historic fact that no town was too remote to have intimate contact and relations with Istanbul and other Ottoman cities. I would argue, as an extension, no town was too remote for the production, exchange, and display of the portrait.

It is not my intention to reduce the networks of sociability in the late Ottoman Empire to a formalistic template of circulating elites, subcultures of organic intellectuals, or even the undifferentiated bourgeoisie. The social and commercial networks, traversing religious affiliation, geography, ethnicity, and social hierarchy and status, were a common feature of Ottoman political, intellectual, and economic life for hundreds of years, but they transitioned into the basis of new relationships in the nineteenth century, as Christine Philliou has shown in her biography of Stefanous "Istefanaki Bey" Vogoridis and his Phanar-Ottoman elite network.[55] The networks of sociability facilitated transfers of capital and commodities but also cultural practices and ideas. Cem Emrence adeptly shows how the Ottoman Empire was "characterized by three regional trajectories" (coast, interior, and frontier)—zones that were constituted by their own sociocultural and economic particularities that informed their relation to the Ottoman state, capital and economic development, and modernity in general.[56] The crux of Emrence's study is to highlight the centrality of social, political, and economic networks in the development of various forms of modernity and rival forms of social and political order. While schematic geography of economy marks Emrence's work, it reminds us of the inter-regional networks and zones of economic and cultural exchange that Janet Abu Lughod tracked back to the thirteenth century, later reorganized with shifts in transportation technology, commercial routes, agricultural commodities, and political alliances and rivalries.[57]

Within this history of political economy, we remember that material culture, like the carte de visite, both shadows and runs throughout the recoded networks of Ottoman sociability. The anecdotes of Ellen Chennells hint at the complex social crossings essential to the production of the carte de visite, which extended beyond transgressing the imaginary Manichean divides of *afranji* photographers–native clients and native photographers–foreign clients as posited by Orientalism. These studies about the networks and zones of sociability, politics, and commerce of the Ottoman Empire coupled with the images of Ottoman elites and functionaries remind us of Oliver Wendell Holmes's assertion that "card portraits have become the social currency, the 'greenbacks' of civilization," which certainly takes on even additional

weight in a region so affected by the civilizational discourses of its people as well as the colonizer.[58] The carte de visite was circulated in the form of "social currency" in an exchange between subjects who, in the case of Ottoman Arab literati, reformers, and bureaucrats, were precisely institutionalizing "civilization" (*tamaddun*). But if "greenbacks" represented an exchange value greater than its actual cost (that is, a few milliliters of chemicals emulsified on a several square centimeters of paper, plus labor), then part of the value relied on the erasure of its production, the history of its indexical currency (that is, its representation), and the social nature of its exchange.

If the moment of the carte de visite production marks a specific time and place, an event of being photographed, which speaks to the desire of wanting to be represented, the circulation of that image is its social life that only is enlivened through its exchange. Bruno Latour's "actor-network theory" stresses the multivalent "social relations" that lie beneath the larger and more visible networks between institutions, nations, and industries. More important, the theory contends that objects like the photograph have "agency" within those systems of exchange, economy, and signification. However, he cautions that "talking about material objects would not help very much since objects, in this case, would be simply connected to one another so as to form an homogeneous layer, a configuration which is even less likely than one which imagines humans linked to one another by nothing else than social ties."[59] Latour may provocatively give independent autonomy to the photograph as an object exchanged in ideologically structured materialist and semiotic networks. The carte de visite circulated through multiple levels of social networks (family, class, sect, official, institutional, "professional"), but it also contributed to an accumulation and concretization of the new strata of society and of the signifying system and language that kept it together.

Photo Albums

Earlier in her narrative, Ellen Chennells recounts how her pupil, the princess, was very fond of "photograph-books." These albums, as popular in the Middle East as elsewhere in the world, began to appear with the rise of the carte de visite and contained empty vignette slots and frames into which the collector could simply slip a photograph into the display space. They were often ornate, bound in leather, cloth, or velvet, with clasps, brass corners, and illustrations on the pages. The princess's habit of collecting "photograph-books" was hardly rare. She had several, and some "only contained portraits of the ladies of the harem."[60] Chennells states that women photographers came to take their photographs because men were not allowed, producing "passable" but not "first rate" portraits. These were among the portraits that were collected and annotated within the albums. After all, "pho-

tography was quite the mania" during Chennells' residence in Egypt. The princess and her brother Ibrahim Pasha would both respectively collect portraits of foreign and domestic dignitaries and were "always buying photograph-books and filling them" not only with the women of the harem but with the visiting cards of "crowned heads and leading statesmen of Europe." Under the portraits, Ibrahim would write their names, thereby learning the names of statesmen and important figures. When they would buy a new "handsomer" album, they would transfer the portraits from older albums to it.[61]

These and other vignettes about the social currency of the photographic portrait leads us to conclude that the Ottoman Arab carte de visite and studio portraits were not "innocent of photographic or ideological meaning" as Wendy Shaw suggests.[62] Rather the social forces, class formations, ideological compulsions and origins, and political intentions and uses that have been contemplated in the context of official state photography underlie Ottoman "cartomania" among the functionary, the Egyptian and Istanbuli aristocracy, and the new middle strata. While I contend that the portrait did not produce signification, representation, or identities, it did ferry and feed class and ideological identifications throughout new social circuits that were being wired by capitalist and nationalist relations and networks. Simultaneously, the photographic subjects, the sitters, in cartes de visite, cabinet cards, and other larger-format studio portraits were precisely the owners, middle men, bureaucrats, officers, intellectuals, and nascent bourgeoisie who owned the factories, designed these bridges and towers, served in the military, manned the bureaucracy, and taught in the schools that appear in the sultan's albums. The cartes de visite such as those produced by Beirut's Nasr Aoun, Damascus's Habib Hawawini, and Chouha Frères in Aleppo are still found in the homes, markets, archives, libraries—and now, eBay-shop fronts—throughout Greece, Turkey, the Arab world, and the Armenian diaspora. If one sees the photographic acts of Sultan Abdülhamid as produced through his laborers and craftsmen, particularly Abdullah Frères and Sébah, then we must also realize that the power of those images in the Hamidian album—their discursive, representational, political, and class power—eclipsed the massive yield of privately patronized, individual and family portraits, of forgotten studios not only in Istanbul, Alexandria, Beirut and Cairo, but also in Port Said, Minieh, Tanta, Haifa, Tripoli, Homs, Aleppo, and Mosul. One will find only a waxing gibbous subjectivity in the Hamidian photographic archive, whose intent is to represent imperial rule, power, discipline, and surveillance rather than the individual subjects of the empire. Instead, those officials, workers, craftsmen, intellectuals, clerics, functionaries, industrialists, entrepreneurs, and even peasants who appear in the 1,800 photographs of Abdülhamid's fifty-one-volume gift to the World's Columbian Exposition in Chicago are likely to have, at some point, sat for a carte de visite portrait in the studios of the empire.

Writing Photography

TECHNOMATERIALITY AND THE
VERUM FACTUM

While the "fever for reality was running high" in Europe with the invention of photography, a Comptean compulsion for rationality and objectivity also undergirded the *nahdah* and *Osmanlilik* perspective.[1] Within the uncharted history of Middle Eastern indigenous photography, one characteristic is immediately identifiable: photography in the Arab world was not plagued by the questions of whether it was a "bastard child" of painting or science, as it was in Europe.[2] It was not caught between the "two chattering ghosts" of "bourgeois science" and "bourgeois art," as Allan Sekula comments.[3] The Arab world did not share Europe's concern about photography's artistic pedigree but perceived it as an embodiment of the sort of scientific knowledge and practice necessary to achieve "progress and reform."[4] In the words of one contemporaneous commentator, photography was not caught between science and art but between "naked, theoretical science," and "doing the work itself."[5]

This chapter takes a detour from examining select *indigenista* photographers to survey how photography coalesced into an Arab Ottoman discourse in the public writing of *al-nahdah al-ʿarabiyah*. If the photography of Abdullah Frères and the Saboungis show how *Osmanlilik* and *nahdah* social relations and civilizational discourses mediated "the intelligibility of the photography," this chapter maps how the writing of *al-nahdah* regularized and gave coherence to those discourses and social relations. In the process, we will discover how

Arab writers understand the "craft" of photography as a product of labor, materials, and exchange that demanded knowledge, virtues, and social networks for its social life. They understood it as a material object and a modern practice with profound ideological implications and effects. If producing or exchanging a photograph was a performative act that enacted the ideology of *al-nahdah* reform, then writing about it galvanized both ideological and social roles into a coherent discourse that was responding to a rapidly changing technology and social reality.

The First Arab Group Portrait: al-Madrasah al-wataniyah

An iconic image of the founding faculty of al-Madrasah al-wataniyah (the National School) speaks to the intersection between *al-nahdah* and *Osmanlilik* ideology (fig. 36). Jurji Saboungi took the portrait in 1866, which subsequently appeared in the Arabic scientific-literary journals *al-Muqtataf* and *al-Hilal*, Viscount Philippe (Filip) de Tarrazi's magisterial work *Tarikh al-sahafah al-ʿarabiyah,* and numerous twentieth-century publications.[6] Yʾaqub Sarruf, Faris Nimr, and Jurji Zaidan, the founders of *al-Muqtataf* and *al-Hilal*, trace their own intellectual origins to the community of men in this portrait, who are legends. Butrus al-Bustani was founder of al-Madrasah al-wataniyah, in 1863, which was the first independent and religiously unaffiliated school in the Arab world, established after the bloody sectarian massacres of 1860. Salim al-Bustani was Butrus's son and cofounder of the groundbreaking fortnightly periodical *al-Jinan*. The Sunni al-Shaykh Yusuf al-Asir, known for assisting the American missionaries with the translation of the Arabic Bible, was a luminary in the Beirut Sunni community. His Christian counterpart was neoclassical poet Nasif al-Yaziji, father of Ibrahim.

Saboungi's photograph is the first native faculty portrait in the Arab world, defined by an iconography that conforms to and ratifies the civilizational discourses and ideals of *al-nahdah*: native men, in native attire; Protestants, Muslims, Maronites, and Orthodox; doctors, poets, translators, religious men, and polyglots—all educators of a new generation. They are proud and erudite, holding books, pens, and papers, dignified and confident yet relaxed. The condensed space between them, their hands on each other's shoulders, son Salim standing behind father Butrus's back, assure us that this is a tightly knit intellectual class, a new elite subclass of the *effendiyah*. The portrait is an imprint of the progress of "the nation" (*al-watan*), about which all of these men wrote.

Taken only a few years after the wrenching sectarian violence in Mount Lebanon and Damascus, these men enacted *nahdah* ego-ideals and embodied its ideology: educated men of the first secular, "national," indigenously run and owned private school. While *nahdah* ideology

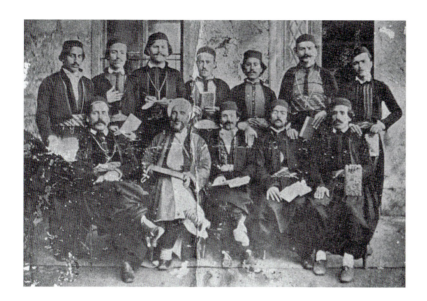

Figure 36.
[Saboungi],
Faculty of
al-Madrasah
al-wataniyah.
*Standing,
left to right*:
Sa'id Shuqayr,
Ibrahim al-
Bahut, S'adallah
al-Bustani,
'Abdullah al-
Bustani, Shahin
Sarkis, al-
Shaykh Khatar
al-Dahdah,
Salim al-
Bustani. *Sitting*:
Khalil Rebeiz,
'Abdullah
Shibli, Fadlallah
Gharzuzi,
al-Shaykh Yusuf
al-Asir, Butrus
al-Bustani.

arose from and overlapped with *Osmanlilik* ideology, the portrait is quite clear. These were Ottoman Syria's "new men" who were enacting the "formula" for reform even before the photograph was taken; the "sons of the nation" (*abna' al-watan*) who established the schools, journals, and publishing houses necessary to disseminate and implement modern knowledge (*al-ma'rifah wal-'ilm*) in order to create national concord and unity (*al-ulfah wal-ittihad*).[7] Saboungi's group portrait of the men of the National School performed the *nahdah*'s explicit formula for "progress and civilization."

Like his other portraits, Saboungi's group portrait of the al-Madrasah al-wataniyah is both a material and ideological object; it is a document of national "success" (*najah*) and an ideological calling card of new cross-sectarian "intermediary" effendi classes, which Jens Hanssen discusses in his study of turn-of-the-century Beirut.[8] As such, it also speaks to the political and social realities of nineteenth-century Lebanon, which was plagued by interconfessional rivalries, reorganizations of social and communal hierarchies, and radical shifts in the political economy of Beirut and Mount Lebanon. *Nahdah* intellectuals envisioned themselves and their class as an example and social bridge that traversed sectarian pettiness, narrow self-interest, and ignorance of the feudal caste, peasantry, and clerical classes. They emerged as interlocutors who connected the masses and the elites (*al-'umum wal-khass, al-ahali wal-'ayan*) with the new bureaucratic regime.

Gramsci's conceptualization of "organic intellectuals" is helpful. Traditional intellectuals, he states, think of themselves as "above the struggles of groups and not as an expression of a dialectical process through which every dominant social group elaborates" its own interests.[9] While often mistakenly considered a representative of the

exclusive interests of "subaltern classes," Gramsci was clear to note that the "organic intellectual" arises out of a particular "social group" in order to "give it homogeneity and a consciousness of its own function in the economic sphere."[10] The reference to Gramsci allows us contemplate the portrait as an imprint of that uniformity and unity, which served very clear ideological ends in an age and location that was defined by the rise of sectarianism and class conflict. Saboungi's faculty portrait provides us with a visual point of departure for a chapter that focuses on the writing of these very men as "organic intellectuals" of Ottoman Syria's *effendiyah* class and *nahdah* ideology. It provides an exemplary visual text that brings together the ideological work and social life of photography that is embodied in the writing of photography during *al-nahdah al-ʿarabiyah*.

The First Treatise: Yusuf al-Jalkh

In 1869, Dr. Yusuf al-Jalkh (1821–69) presented "A Treatise on Physical Science and Photography" (*Fi Nabdhah min ʿilm al-tabiʿiyat wa fi taswir al-shamas*) to al-Jamʾiyah al-ilmiyah al-suriyah (the Syrian Scientific Society). The Society was the who's who of intellectual and political elites not only of Beirut, Damascus, and Greater Syria but also Palestine and Egypt. Members ranged from the governor of Syria, Rashid Pasha, and the renowned Iranian political activist Mirza Hussein Khan, to the gadfly modernizer who was Qajari ambassador to Istanbul at this time, to activists and intellectuals, most of whom taught at al-Madrasah al-wataniyah.[11] The "Treatise" was the first public presentation in Arabic by an Arab intellectual about photography and was published in the Society's proceedings.[12] As a member of the Society, al-Jalkh was masterful in Arabic, a steadfast contributor to the community, an educator in one form or another, and a polymath, who believed in the Society's tenets of Syrian Ottoman patriotism (*wataniyah*). Like fellow members Shakir al-Khuri, Yuhanna Wortabet, Milham Faris, and Mikhaʾil Mishaqah, al-Jalkh was a physician and a poet of some repute, writing nationalist poems (*wataniyat*) and a variety of traditional *qasaʾid*.

Al-Jalkh was a product of Egypt's new higher education institutions. He was the first Syro-Lebanese to graduate from Qasr al-ʿAyni, Egypt's celebrated medical school established by Muhammad Ali Pasha's renowned surgeon general, Clot Bey, in 1828. After graduating from Qasr al-ʿAyni, he practiced medicine in Damietta before returning to Lebanon, where he worked for the Shihabi royal family. The Beirut physician was active in the city's legendary literary and intellectual community, writing poetry and publishing in the Ottoman press as well as practicing medicine. None other than the famous neoclassical poet of his time, al-Shaykh Nasif al-Yaziji, eulogized him:

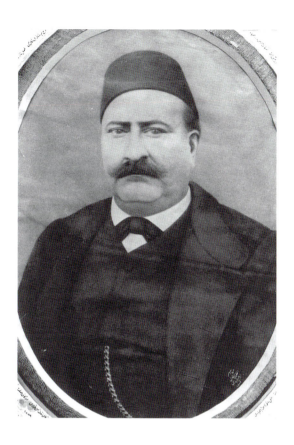

Halt upon the soil of Yusuf al-Jalkh,
upon which his faith and world still rule.
To that end, he has obtained His stamp of benevolence, victorious
Immortalized in Lord's mercy and reached his eternal
contentment.[13]

Figure 37.
Unknown
photographer,
Yusuf al-Jalkh,
undated.

Al-Yaziji's eulogy tells us more than that al-Jalkh was a valued member of Beirut's cultural community. It reminds us that his work should be read as a collective product of Beirut's new class of technocrats and "organic intellectuals." The *ritha'* (eulogy) draws us into the social practice where these poems were anthologized and published in print form by new presses. These poems and publications, not unlike the photograph, were circulated as new cultural commodities among an increasingly literate society, finding their way into Beirut's and other cities' reading rooms, homes, literary salons, libraries, and schools. Al-Yaziji's poem returns us to the circuit of men and women who were graduating from al-Madrasah al-wataniyah and Qasr al-ʿAyni, who were reading the productions of the Syrian Scientific Society, and who were exchanging the portraits of *indigenista* photographers.

If al-Jalkh was an amateur photographer, none of his photographs have been found. The only known picture of him is a large-format

painting, which remains wrapped in brown paper in the basement of the Lebanese National Archives (fig. 37). The portrait is clearly copied from a photograph. More remarkably, it is signed "by the brush of Ibrahim al-Yaziji." If this is true, this is the only painting by al-Yaziji known to us. The large, ornately framed, oval portrait is painted in colors so muted that the image itself can be easily confused for a photograph. Among the series of painted portraits of the *nahdah*'s intellectual pantheon ranging from Butrus al-Bustani to ʿAbd al-Qadir al-Qabbani to May Ziadah in the Lebanese National Archives, this is one of the few that is likely to have been produced by a contemporary of these *nahdah* superstars. Lebanon's most famous artists, including Daoud Corm, Habib Srour, and Moustafa Farroukh, executed the remaining oil paintings. The archive's founder, Phillipe de Tarrazi, author of *Tarikh al-sahafah al-ʿarabiyah*, commissioned these portraits for its opening. The half-length portrait of al-Jalkh is the only one of its kind in the series and the archive.

Photography as Science

In his introduction, al-Jalkh specifically identifies the "Treatise on Physical Science and Photography" as a scientific treatise and technical manual: "This brief lecture includes items concerning the priorities and principles of the science of nature. As far as time permits, I will tender a detailed account about photography and its technical operations [*kayfiyat al-ʿamal*] according to the opinion of experts in this art. …"[14] Al-Jalkh embeds his discussion of photography in the physical sciences, including the "mathematical sciences," which "find the unknown through proofs," and the "natural sciences," which "explore the properties of all visible bodies." The treatise is about science, not photography. Science, he exhorts, is "wholly sublime, noble, and delightful to the mind and utterly beautiful because we learn the facts of nature and their details, which the Creator has imparted to them."[15] Al-Jalkh's history of photography neglects the composition, quality, or aesthetics of the photograph itself and concentrates on photographic practice and technical language (*istilahat*) such as "positive," "negative," *paysage*, and *objectif*. Photography should be understood, not visually, but cognitively, processed by an individual's "intelligence, thought, understanding, and will," housed "within the great box known as the skull."[16]

Al-Jalkh's history of photography is the history of the science of light, optics, and chemistry. He leaps from Democritus and Pythagoras to Count Rumford's discovery of the light-sensitive properties of silver salts. His historical narrative ends with a detailed account of the technical accomplishments of Niécephore Niépce, Louis Daguerre, William Henry Fox Talbot, and Fredrick Scott Archer. With only a cursory mention of the Abbasids, his history is Eurocentric and

ignores Muslims' contribution to the study of light, optics, and chemistry that made photography possible.

An aggregate of discourses on the natural and biological sciences, photography had yet to emerge as a full-fledged, discrete discourse. The first mention of "the miraculous new invention called *photographe*" comes a quarter of the way into al-Jalkh's narrative, when he explains the discoveries about spectral properties of light that "initiated a new science called photochemistry."[17] Al-Jalkh makes clear that photography was produced by a combination of knowledge and mechanical know-how (*kayfiyat al-ʿamal*) that nested in interlocking but distinct fields of science. The camera reproduced vision and imprinted it on a surface just as the "brain-stem" (*jawhar lubbi nikhaʾi*; literally, "the essence of the brain-kernel") registers sight (*basirah*).

As a doctor, al-Jalkh's attention to sight as a normative physiological function is not unexpected, but as a "modern" trained doctor, polyglot, and "patriot" (*ibn al-watan*), he was bound to perceive photography as a modern practice essential to Arab "progress," yet rooted in a scientific history that was largely European. He makes this clear when he attributes photography to the very knowledge that caused European ascendancy: "As the sun of the sciences set on the horizons of the Abbasid Arabs' minds, it rose in the European sky until it reached its utmost limits. Its rays met the crowns of the Europeans' heads, enlightening their hearts. They innovated in these sciences, invented great machines, and mastered industry to suit their daily realities [*al-sinaʾi fil-haqaʾiq*]. … They investigated mysteries no matter how minute until they learned the elements can be divided into two parts; that which can be measured and that which cannot."[18] The archetypical *nahdah* language and imagery of this passage are also emblematic of the writing about photography. Al-Jalkh's meandering account of the natural sciences communicates that photography is the extension of scientific developments that uncovers what humans cannot regularly perceive, quantitatively registering and measuring what can and cannot be seen. Photography emerges as an example of scientific innovation, knowledge, and method, as an expression of a way of seeing and organizing the natural world and society. If photographic practice has any discursive integrity in and of itself, it is through the *nahdah* discourse of civilization and progress. Infused with *nahdah* nomenclature of reform and "progress," the lesson to his cohorts in the Syrian Scientific Society is clear: if one masters knowledge and technique, success (*najah*) will follow. Photography was yet one more social, technological practice that *enacted* progress and reform.

Production as Performance

Al-Jalkh's detailed instructions subjugated photography to a place in a disenchanted world that organizes all identifications—religious,

cultural, intellectual—into an overarching narrative of knowledge-production, the nation, and its progress. His treatise was a map of interlocking scientific discourses that crystallized into a material phenomenon, photography. Al-Jalkh treats photography as a prototype for al-*nahdah*'s scientific and rationalizing paradigms in action in "their daily realities" (*al-sina'i fil-haqa'iq*). Photography is exemplary of the generative quality of what happens when forms of modern scientific knowledge are put into practice. It is a product of "cadres of inventors and experimenters [who] have enhanced this art. They have tinkered with its original design, inquiring into the scarcity of some elements and plentitude of others that make it up. As for the sciences, a person becomes proficient in them through copious experimentation and testing. At times, this leads him to some other phenomenon from which he benefits."[19]

Photography has no discursive identity unto itself but offers an ideal example of the cumulative effect of scientific knowledge in the hands of motivated individuals. It was only the extension of science. Photography, then, is more than an allegory of scientific, social, and cultural progress. It is an enactment of the *nahdah* formula that enlisted *knowledge* in the service of national unity, progress, and elite-mass (*al-'umum wal-khass, al-ahali wal-'ayan*) unity. Al-Jam'iyah al-ilmiyah al-suriyah acted as such a "cadre." They were tinkerers with thought and masters of knowledge who "placed for us the Morning Star of scientific knowledge on the horizon of our Syrian country. It brought good fortune with the rise of the sun of tranquillity in our region."[20] Just as al-Madrasah al-wataniyah provides us an opportunity to think about the representation of a new social class, a group of organic intellectuals that acted as interlocutors for social changes, the members of the Syrian Scientific Society were not only responsible for spreading the "technical know-how" (*kayfiyat al-'amal*) to the "sons of the nation," but they were performing it through photography, medicine, engineering, education, and literature.

Al-Jalkh explains that he "chose what [he] collected on this topic in order to be extremely precise about the procedures one needs to try in performing its illustrious tasks. From this knowledge the reader can be delighted."[21] Photography, then, is not a discrete discourse that produces a photograph with a social role or a particular set of representations. For al-Jalkh, it was a set of procedures that had a social effect because of its scientificity. In his words, "the rays of light" captured by the camera "illuminate [*admihlal*] the darkness of the ignorance from our vision [*absarina*]" and provide our "daily realities" with scientific "proofs [*barahin*]."[22] Attention to process rather than product, the mechanics of representation rather than the representation itself, the components rather than aesthetic surface, all these reflect al-Jalkh's value of the practice of photography over its product.

While success in photography and mastery of knowledge is personally "delightful," al-Jalkh makes it unambiguously clear that the

practice of photography, execution of the instructions, learning the science, and physical production of the photograph was social performance of civilization. The wonderment of this "miraculous new invention called *photographe*" was its ability to provide "Easterners" a social opportunity to perform the scientific and national ethos of *al-nahdah* that existed and were at their disposal. Photography integrated new scientific knowledge into a larger set of social, cultural, and political practices meant to highlight the potentiality of the "native sons" and their "nation," recently fractured by sectarian violence. In fact, al-Jalkh's presentation and publication of the "Treatise" itself can be seen as a riposte to this violence, presented in the Syrian Scientific Society, which had an explicitly nationalist and antisectarian mission. Not only were the memories of the 1860 massacres still fresh in the minds of its members, but also, al-Jalkh himself explicitly rejects the sectarian reorganization of Lebanese communal life, specifically invoking *Osmanlilik* ideology.

Photography was an enactment of scientific knowledge that was already circulating throughout the empire, knowledge being reproduced and institutionalized by the Sublime Porte's Tanzimat project. Al-Jalkh specifically makes these connections when he dedicates his presentation to Sultan Abdülaziz, the grand vizier, the governor, and the mutasarrif and thanks them for lifting the veil of ignorance in Syria. The poetic verse, metaphors, and language he uses to discuss the Ottoman project resemble his discussion of scientific principles of light and the spectrum.[23] He praises the Sublime Porte, who "opened for us [in Syria] the gates of civilization and culture, makes radiant the sun through its exalted circumspection. [The Porte] has enflamed our hearts so that those who are able to rise up passionately to rebuild what the hands of time killed and those whom possess the initiative can exert their effort to achieve the success of the nation [*najah al-watan*]."[24]

Al-Jalkh's writing on photography was one that could not be separated from the *Osmanlilik* and *al-nahdah* ideology. The sultan, the state, and enlightened functionaries remain crucial in the betterment of Syria, and the discussion and practice of photography is yet one more fulcrum for collective and individual action for social betterment. Read against the faculty portrait of al-Madrasah al-wataniyah, al-Jalkh's "Treatise" instructs his reader on a means to perform civilization and progress (that is, modernity) while the photograph and his very treatise provide evidence that the social relations and native men already existed for this progress to come to fruition.

Shahin Makarius and the Birth of Photography

In 1882, Shahin Makarius published a series of articles in *al-Muqtataf* methodically defining various technical, scientific, and historical facets

of photography.[25] Born in Marjʾayun in southern Lebanon, Makarius's father died when he was four, and his house burned in the massacres of 1860, causing his mother to migrate to Beirut, where his uncle, Jirjis Shahin, ran the famous al-Matbaʾah al-wataniyah (the National Press). He apprenticed at the press, becoming its director before joining the American mission's press and al-Matbaʾah al-kathulikiyah, the Jesuits' famous publishing house. Henry Jessup notes that he was "the artist who photographed the portraits printed" in the American mission.[26] His success as a printer, a highly skilled and desirable profession in an age when publishing houses and journals were proliferating exponentially, drew him into the influential intellectual and craftsmen circles of Beirut. He befriended figures such as Ibrahim al-Yaziji, Ibrahim Ahdab, and *al-Muqtataf*'s founders Sarruf and Nimr, whose sister, Miriam Nimr, herself an accomplished intellectual, Shahin married. Shahin's life demonstratively exhibits the new sociability of the *effendiyah*, where textual and intellectual practices created a space that bridged social hierarchies.

He founded with this impressive cohort literary-scientific groups such as Shamas al-birr (the Coastal Sun) and al-Majmaʾ al-ʿilm al-Suri (the Syrian Scientific Association) as well as Jamiʾiyat al-sinʾah (Industrial Craft Association), which brought together an assortment of Syria's craftsmen and artisans in an association that retooled traditional guild occupations. Makarius was representative of this new craftsman, a self-educated and versatile intellectual who wrote on a number of issues, including a groundbreaking series on photography.[27] He opens his series thus: "Photography [*fotografia*]—'the writing of light,' or otherwise known as *al-taswir al-shamsi* [literally, sun-imaging]—is a modern craft that has reached in these recent years a level of unsurpassed credibility. Many of *al-Muqtataf*'s honorable readers like to approach its secrets through naked, theoretical science; others want to learn how to do the work itself. We wrote this article to fulfill both obligations."[28]

Perhaps Makarius did not invent the "photography discourse" of *al-nahdah*. More rigorous than al-Jalkh, he tracked the development of "photography from its earliest appearance in this world to nowadays with brevity and accuracy."[29] Makarius wrote as a practitioner, not of photography per se, but as a craftsman who understood the photograph's dimensions. Further distinguishing himself from al-Jalkh, whom he surely knew, the author's history was that of *photography*, not the natural sciences. He wrote about photography as a full-fledged *practice*. Makarius was concerned with the imprinting of the image, its fixing, and its reproducibility, locating "the first germ of photography" in Georges Fabricius and Carl Wilhem Scheele's respective discoveries that silver chloride blackens paper exposed to light.[30] Despite the breakthroughs by Thomas Wedgewood and chemist Humphry Davy, who "photographed" images on paper, he identifies the beginning of photography with subsequent discoveries of the nineteenth century

to *fix* the image, discoveries that made photography as a viable craft, with commercial and social utility, *possible*.

Makarius parses his examination of photography into installments. The first one, on photographic history, ranges from the usual litany of successes to score light on a tableau to the engineering and optics involved in Charles Louis Chevalier's lens for the first daguerreotype. This installment is punctuated by noting the French government's wisdom in awarding Niépce and Daguerre and their families lifetime pensions in exchange for the patent. Rather than presenting photography as an extension of the natural sciences, Makarius describes it as a holistic practice enabled by scientific knowledge, individual innovation, and state patronage.

The historical installments of the series conclude with an exploration of Frederick Scott Archer's discovery of the collodion process. Made from nitro-cellulose and ether, the collodion's light-sensitive silver halide emulsion is coated on a glass plate, hence becoming known as collodion wet plate process. Because of the importance of this process, the series returns to it, outlining the procedures to prepare the glass plates with collodion emulsion and then the process for printing the negative on paper, thereby producing a highly accurate image. Developments in the collodion process since Scott Archer's initial discovery, including discussions of its dry gelatin process sibling, remained the photographer's primary goal.[31] The following parts of the series are specifically identified as "the applied section." The reader learns how and what is needed to execute this primary goal. Camera, curtains, paper, and glass plates are described and illustrated. The names of chemicals are introduced. Makarius's narrative transforms into an instruction manual for an apprentice rather than guidelines for a dabbler. Illustrated diagrams detail the mechanics of the camera and lens but also the accoutrements of photography and the studio. Exact measurements and precise procedures are provided, and Scott Archer's procedure of how to properly pour collodion on a glass negative is illustrated (fig. 38).

After introducing photography's history, science, chemicals, and equipment, and providing directions for developing a print, Makarius, in contrast to al-Jalkh, supplies an explicit set of instructions on *how* to take a photograph. The voice of a master-craftsman addressing his pupils comes through, instructing novices to start with still lifes (statues, pictures, and so forth), explicitly warning them to avoid portraiture. When graduating to live models, the amateur photographer is told to beware of sunlight that is too harsh and to take special care to ensure that the subject does not look awkward or uncomfortable.[32] The head should be supported properly, but that support, which is illustrated, should not burden the sitter.[33] The end product of his instructions is not just a photograph, but rather a photograph with subjects. Makarius's directions for composition, the photograph's sharpness, exposure, saturation, and contrast of light and dark and so forth, do not aim at cre-

Figure 38.
"Pouring collodion." From Jirjis Tannus ʿAwn al-Sadalani, *al-Durr al-maknun fil-sinaʿah wal-funun.*

ating a successful scientific experiment but aim to accurately produce *representation* through technical practice, to represent the photographic subject who is a "native son" (*ibn al-watan*) through a *habitus* that he naturally occupies. Photographic discourse becomes not only the sum total of scientific and technical advancements. It is not even the sum total of these advances with state assistance. Makarius's series articulates a discourse that methodically organizes photography's scientific components with its technical, applied, and social components, forging them into a structured narrative of the craft that was regularized for native practice and representation.

The White Noise of Photography Writing

A number of lost journals create the white noise around photography, making photography discourse as natural and transparent as the surface of the portrait. The catalogue of Dar al-Kutub, Egypt's national archive, contains a handful of titles of lost Cairene, Beiruti, and Alexandrian journals, such as the short-lived *al-Fotograf* (The photograph, 1904), edited by Ahmad Mutawalla ʿAzmi; *al-Funun wal-tawsir al-shamsi* (Arts and photography, 1913); and the apparently more successful *al-Musawwar* (The weekly illustrated, 1902–7) owned and edited by Khalil Zenié. By the 1920s, with changes in technology that made printing images more affordable, the number of "illustrated" and photographic journals expanded exponentially to include titles such as *al-Lataʾif al-musawwirah* (Illustrated pleasantries), edited by Shahin's son Iskander Makarius. All of the leading journals of the day commented on photography, from Muhammad ʿAbduh and Rashid Rida's *al-Manar* (The lighthouse) to Farah Antun's *al-Jamiʿyah*. Under Nimr and Sarruf but also Makarius's editorship, *al-Muqtataf* was the most stalwartly positivist. Its reach and impact were second only to Jurji Zaidan's monumental *al-Hilal*.

Underwater photography, X-ray imaging, aerial photography, enlarging photographs, imaging microbes and bacteria, photographing lightning, and sending photographs through the telegraph are the subjects of only a small number of essays that coexisted in *al-Muqtataf* along with articles on how to take photographs, technological developments in the chemistry of photography, how to stage portraits, how to preserve them, and how to arrange them to beautify the home.[34] Specific instructions on enlarging processes or cleaning photographs were intertwined with the announcements, summaries, accounts, and explanations of the technicalities of new scientific photographic developments.

The instructional, scientific, and social articles about photography in all of these journals and the information about photographic lectures, exhibitions, and conferences in Cairo and Beirut as well as in London, New York, and Paris, came to form the white noise of photography discourse, where this writing expressly conceptualized and

categorically defined the discrete components, facets, and subtopics of a practice that was, frankly, banal but in a profound way. These articles organized photography's aggregate parts, so haphazardly presented in al-Jalkh's "Treatise," into a discourse called *al-taswir al-shamsi*. Summaries of books, lectures, conferences, and exhibitions all evinced that it was a practice already in play but also articulated photography's potential as social and scientific practice.

The proceedings of a photography conference in New York, for example, relayed new information about gelatin plates, which greatly improved the quality, precision, and ease with which photographs could be produced.[35] The review provided information regarding the latest "improvements in photography" made against the state of the art as already defined in the journal's accounts. As such, the author reminds the reader that this evolution is what maintains photography as an essential practice for the commerce, society, and science of a modern, "civilized" culture. The summary of a Paris conference in 1900 exemplifies how *al-Muqtataf*'s articles marshaled larger *nahdah* discourses into a set of conceptual templates, dividing it up into subtopics such as the materials and chemicals needed for photography, books and guides on the topic, and legal and professional questions related to "this art."[36] Presentation of the conference and its structure allowed for an opportunity to interpellate photography into an organized, public, and accessible discourse, rather than a discussion of a series of developments that could be presented only to a room full of enlightened thinkers, as was the case in al-Jalkh's "Treatise." Photography, in the writing of *al-nahdah*, had become natural.

Technomateriality and Writing

Between 1870 and 1910, articles on photography largely focused on technical and scientific components of the craft. The concern for photography's technological nature can be read through "technomateriality" of photography as defined by Christopher Pinney. Pinney adjures us "to understand photography as a technical practice" whose "data-ratio" of place, space, and time is intertwined with the "intentionalities and ideologies" of the photograph.[37] I build on this notion, however, by approaching the "data ratio" not necessarily as the imprint of historical and cultural particularities of the studio, although this might be very detectable at times. Rather, I use the term to mean a self-awareness of its own technological origins, style, and scientific pedigree: this book's tweaking of "technomateriality" implies that the photograph imprints its material history, the history of its production, its social relations, and the semiotic register of the social order in which it is produced.[38]

Print media encouraged amateur photographers like Louis Budur to provide step-by-step and highly technical instructions on,

for example, how to develop a negative onto paper, mount and gloss it, pick the proper paper, and fix errors in developing.[39] Directions on how to achieve the sharpest tones in developing, information on new inventions, and stories of the travails of amateur photographers and feats in photography such as the first photograph of lightning or photographing a moving bullet, and the ever-evolving trials of color photography may have naturalized the positivism, craft, and practice of photography as a discourse.[40] The instructions for chemically treating paper, using different solutions for fixing an image, and techniques for glossing the photograph may have been white noise of that discourse. This does not mean that we should overlook that writing. In fact, when taken as a whole, the *nahdah* writing on photography serves as testimony to photography's technomateriality. These articles understood photography as an ideologically laden material instantiation of modern knowledge and social practice.

The relationship between technology, science, and their ideological content was recognized early by Rifaʿah Rafiʿ al-Tahtawi, when he predicted, as paraphrased by Shaden Tageldin, that "Egyptians would never learn enough French to import the 'secrets of machines' into Egypt without importing also the seductions of French thought."[41] The Arabic literary-scientific journal, perfectly suited to prove him wrong, walked readers through the details of photography's most technical secrets. *Al-Mashriq, al-Hilal*, and Ibrahim al-Yaziji's *al-Bayan* and *al-Diya* were fascinated not only by the number of chemical processes by which one could develop photographs but by the myriad of materials upon which one could print a photograph, including eggshells, china, glass, lead, brass, silk, wood, or even fruit.[42] In this way, photography was saturated with the *Osmanlilik* and *nahdah* ideology, as the writing shows how technology was a material practice of knowledge production folded into the sundries of everyday life. As such, these articles made visible the "data ratio" of the process of photography, if not the photograph, and its "intentionalities."

While the articles' litany of sumptuary and quotidian objects suggests the increased circulation of commodities in the empire, the discussion was a public one among amateur photographers, dilettantes, and science dabblers. Those who wrote articles, questions, and comments were the civic-minded, entrepreneurial, educated, petit-bourgeois effendi class who populated the photograph and instantiated national progress. *Al-Muqtataf* was not alone in facilitating a new class of native technocratic class (those educated in native and European schools) to share technological know-how with a new readership of modern subjects, a readership who sat for, exchanged, and displayed the photographic portrait. *Al-Muqtataf* was, however, exemplary in creating a space where knowledge production, native performance of that knowledge, and a small degree of entrepreneurial self-fashioning took place.

"The expert [commercial] photographer" Hasan Rasim Hijazi, for example, not only advertised in but shared and demonstrated expertise and specialized knowledge with readership from the Arabic-speaking world. Born in Shabin al-Kawm in the Delta, he was a polymath in nearby Tanta, where he ran a number of journals, most notably *Rawdat al Bahrayn* and, according to advertisements in the contemporary press, a journal in the later 1920s, *al-Fotografia* (Photography). In addition to these endeavors, he also wrote poetry and at least two books, including *al-Kawkab al-munir fi sin'at al-taswir al-shamsi* (The radiant star in the craft of photography, 1892).

In his "Photographic Benefits: Glossing Pictures," Hijazi gives specific directions on how to gloss albumen photographs or clean the lens (*objectif*) of the camera. In explaining how to "repair photographs," he imagines how a photographer rips up his photograph when he develops it incorrectly and it comes out discolored, upset about the loss of his time, effort, and resources. In another section, "Returning the color to old photographs," he speaks directly to his reader: "If you have old photographs that no longer have their original color owing to the span of years and you want the color to return to it, then put the image on glass …" He continues to relate the chemical process to restore color and gloss to an image that was hand-treated.[43] Another article, about printing a photograph on silk, contrasts with this one, containing no narrative voice, introduction, or anecdotes, only instructions in the imperative voice (*anta*).[44] The language returns us to the materiality of the image, the necessities of its production by competent native individuals.

Nahdah writing highlights the technomateriality of photographic production and the photograph itself, its processes, materials, roles, intentions, and social effects. On the one hand, the direct, matter-of-factness of so many instructional articles couples the *viewer to the surface of the photograph*. Its effect reproduces the truth-value of the photograph itself. On the other hand, *nahdah* writing's obsession with photography's mechanical instruction serves to reproduce the dominant ideology of Ottoman reform by placing scientific knowledge in the hands of its native readers, who indigenously produce a material object that instantiates native civilization. Writing about photography, like photography itself, is an enactment of knowledge that constitutes modern society and therefore speaks demonstratively and objectively about that which the photograph as an object represents.

Photography's Publics

Ami Ayalon suggests that the press was not a unidirectional means of disseminating knowledge necessary for modernizing society but, rather, a critical venue for creating the modern sensibility of a public sphere.

He states that journals were intended not just for "readers" but also for "audiences." The social practice of reading a text to a large group of often (but not necessarily) illiterate listeners was reengineered by a shift in print technology. Schools produced literate readers in spaces and places where journals found their final destinations. There, readers shared journals and read aloud articles about news, science, politics, or commentaries not only in homes, schools, new reading rooms, and new libraries, but also to listeners in cafés, for example.[45] While it may be difficult to imagine someone reciting the most technical article on photography out loud to an audience, we can posit that this audience was *primed* to receive whatever information they were offered.

As technology advanced, making it more affordable to use half-tones in print photographs, journals reproduced portraits, landscapes, and ethnographic, journalistic, and documentary photographs to illustrate current affairs, news stories, biographies, and ethnographies. Journals paralleled photographs as commodities. These journals were, to borrow from Ayalon, critical in developing a modern public sphere, where the reading and listening publics, would-be citizens, authors, technocrats, and modes of thinking interfaced. They regularized a nomenclature of social reform, a "modern" and positivist vision of the world, a patriotic credo, and an individual's code of "character." Portraiture would capture and reproduce visual representation of the very discourses that journals organized for elites, middle class, and workers and peasants. This textual space of Arab print media cannot be overstated. It created a new form of public space and civil society where readers from all corners of the Arab and Muslim world, including the Americas, entered into dialogue via correspondence, questions, and commentaries with the editors, authors, and experts.[46]

In addition to contributions from photographers such as Saboungi, Hijazi, and Budur, the question-and-answer columns in journals such as *al-Muqtataf* offered a space for public intervention into photography. The question-and-answer section was a gestalt of the very nature of journals, new writing, and new cultural production, including photography. Sparse and direct questions about processes in photography were posed, some of which had been related through the journals, others not. Topics were as broad as explaining the basic process of taking a picture with a camera to as specialized as techniques for printing a photograph on wood, or simply polite comments that redirected readers to previous articles that addressed the question.[47]

The question-and-answer section in *al-Muqtataf* coalesced into a textual commons where a network of technical, scientific, and cultural knowledge met a social network of thinkers, activists, craftsmen, doctors, poets, literati, professionals, politicians, and, yes, photographers. For example, Jurji Mazannar wrote a letter from Beirut asking whether it is possible to print a photograph on cloth. In turn, the editors of *al-Muqtataf* replied, "It is possible to print photographs on fabrics. The famous photographer Mr. Jurji Saboungi, where you are [in Beirut] has

many pictures on them, so we have heard."[48] This topic linked to other articles that discussed Saboungi's inventions for developing photographs on textiles. This exchange was echoed years later in the journal when Tawfiq Kahil, the owner of the photographic studio Phébus, corrected Hasan Rasim Hijaz's account of how to print on silk. After witnessing the process in Paris, Kahil maintained that one uses ammonium chloride in place of gold collodion, as Hijazi had suggested.[49] Hijazi, one of the few regular contributors on photography, acknowledged his error and thanked Kahil and his fellow countrymen "*abna' al-watan*" for their diligence.[50] In this regard, the question-and-answer column buffered the intersection between print media and photography, bringing together, in Michael Gasper's words, "novel forms of sociability along with the technologies of capitalist print media" that were distilled into "an unprecedented type of public-ness and produced a new kind of performativity."[51] Writing photography was an example to add to Tarek El-Ariss's examination of how "Arab modernity" was "staged" within "writing spaces" of the nineteenth century.[52]

Indexicality and Manifest Content

We have seen how photography coalesced as a positivist discourse in *nahdah* writing in the nineteenth century. In this writing, that discourse understood, borrowing from Pinney's definition, the technomateriality of photography, the technomaterial underpinnings of photography, and how it is an applied science that requires native competency—and as such is a meeting ground between material production and processes and ideologies. We also have learned that journals offered a public space that allowed photography to be engaged with and enacted by the new readership and new subjects of the Arab world. The language of the journal is the language of photography in the nineteenth-century Arab world, ideologically "interpellating," in Althusser's definition of the term, "individuals in subjects."[53] In this way, the portrait was saturated with *Osmanlilik* and *nahdah* ideology, where the *indexicality* that defined the manifest content of the portrait was an interpellation of the *nahdah*'s "imaginary relationship" between people, groups, and institutions and their material social conditions.[54]

The concept of the index, the surface, and the materiality of photography has been central to this book. It is originally a philosophical concept that was introduced by the American philosopher Charles Sanders Peirce, a founder of semiotics.[55] The index is the *seme* in semiotics. It is that which denotes signs that link to the referent.[56] A symbol denotes a conventional relationship to the referent as opposed to the icon, which resembles the referent. A sign, and this could be visual and/or linguistic, is indexical because it refers not only to the physical object/thing but an amalgam of referents,

meanings, and effects. In the context of photography, Allan Sekula refers to Peirce's semiotic model "as having an indexical relationship to the world" it represents, which, inevitably, makes it "fundamentally grounded in contingency."[57] Rather than, however, indicting the political imperatives at the heart of Sekula's use of indexicality, we can understand the index at the surface level, or manifest level, of the photograph.

Christian Metz remarks precisely on Peirce's definition of indexicality, saying, "what is indexical is the mode of production itself." While he is referring to "the principle of taking" photographs, this is applicable to actual modes of production of the photograph, starting from its epistemological base to its physical development.[58] The point of this analysis, then, is not to exoticize the nineteenth-century "Arab" image, but to further expose the dense compression of production, representation, and ideology. Or, to crib Metz's reference to Lacan, the historicizing of Ottoman photography begins with tracking the ideological nature of its production, and such a method leads us to Lacan's realization that the materialism is the materialism of the signifier. The call to *experience* the producing of photography—to try, fail, and succeed—draws the subject to produce what is already naturalized, that which is the material object of photography, the image-screen, but also its indexical quality that gives representation to a political economy that is already there. Makarius could not escape the ideology that made photography possible. *Al-Muqtataf*'s articles and question-and-answer columns speak to that experience.

Photography's discussion in Arabic print media, along with the surrounding dialogue between reader and writer, audience and author, amateurs and practitioners, unfolded upon a plane of mutual intelligibility—within a common language of *Osmanlilik* and *nahdah* modernity. The portrait did not arrive in the Arab world as a static, opaque form. Its surface was recognizable, operating along a signification system flowing within the journals' pages that made the photograph legible. The lack of articles on "how to read" a photograph or what compositionally makes "good" photography suggest that the portrait was already legible. It already served the ideological function. This does not mean that the portrait's content or surface was unmediated, uncontested, or under threat of the instability of its own signification system. To the contrary, the language and grammar of the photograph, its index and the formalistic structure that made it "legible" (that is, that made it "make sense" and seem natural) in order for subjects to identify with its ideology, had to be continually buffered, repeated, defined, and mediated. Intelligibility was assured through the photograph's own reproduction, through a series of repetitions of its own form, content, and indexes, but also through the meta-writing of its science, history, production, staging, display, and utility.

Photography was a material object of a normative vision enacted through a variety of social practices, social relations, juridical processes,

and economic exchanges and structures. In explaining photography's "special connection to reality," Rosalind Krauss describes the primal materiality of the process of imaging (that is, photography) as "a photochemically processed trace causally connected to that thing in the world to which it refers." As such, the photograph is not an icon like a painting but an *index*.[59] This index has been examined in the previous chapters. It is the signs, props, backgrounds, poses, clothes, demeanor, sharpness, and format.

The material imprinting at work in the portrait is as much an imprinting of systems of economy and social relations between humans, groups, spaces, and objects as it is a photochemical process. What the Arab press shows is that, just as in Europe, photography in the Ottoman East offered a visible expression, a material transubstantiation, of an ideologically laden signification system of *al-nahdah*. The portrait provided a visual narrative of what *al-Muqtataf*'s subject looks like. The surface of the photograph, its *manifest content*, offered the visualization of an index of modernity that was already naturalized. At the level of the surface, the Ottoman portrait is structured by an index of recognizable signs that are both physical and ideological. Images as overdetermined as the faculty portrait of al-Madrasah al-wataniyah structured these indexes, which signify of their presence, position, and privilege with little ambiguity as to who they are as individualized and collective class and national subjects, let alone their actual identity.

At this *manifest* level, the index of the image, its representational fabric that makes it understandable and meaningful, is a representational surface of dynamic constitution, history, sociability, and language. The manifest content of the photograph is not one layer but, rather, one vector that runs along the image-screen of the photograph; the image-screen is manufactured through a material process of production, guided by a set of technologies and knowledge that emanates from the ideology of modern society. The physicality, accessibility, and tactile nature of the photograph itself is what marks it as a uniquely modern form; the image-screen is the materiality of that "touched" surface, the contact between the physical world in the form of light falling upon a chemically treated surface, transferring it onto a frame and into an index that speaks to the viewer's "frame" of reference.[60]

The indexed surface, the most immediate element of the manifest content, is meaningful because of conventional representation that is ideologically and historically contingent and culturally informed. Representation is the expression of processes that come to light as acts of power, of politics, and of economy, all in struggling concert with the processes of mediation, systematization, regularization, resistance, reconstitution, and reification. The indexical surface is not a dead or passive surface. Nor is it unchanging. The index of the photograph operates on a historically contingent surface. That surface is an interplay between light and chemistry, between the subject of

the photograph and its observer, between giver and receiver, between institutions and economies of production, deployment, consumption, and display.

Production as Illocutionary Act

Acknowledging the indexicality of the image is important because it foregrounds processes of signification vital to photography without suppressing the knowledge of its material history. The indexicality of the image is a discursive effect and consequence of ongoing semiotic and social processes. The portrait expressed social relationships between people, things, and signs that were constituted through dynamic networks of meaning, sociability, and interests already in play. While photography was, effectively, a different phenomenon for Makarius and al-Jalkh, a shared *nahdah* perspective bound both visions: the native subject's effort (*juhud*) and diligence were essential to the photograph's success (*najah*), and this success had a social impact. In the segue from the theoretical to the "applied section" of his tutorial, Makarius explains: "One learns through *experience* what one does not learn in studying. It is necessary that one's work fails frequently, no matter how much one devotes his attention to [photography]. One benefits from error just as much as one benefits from when he hits the mark. Failure happened in the work of the most famous photographers. Most of them were investigating unknown causes or causes that they were unable to foresee most of the time."[61]

The mention of failure, experimentation, and practice is a variation of the formula for subjective, cultural, and societal renewal found in the writing of the *nahdah* intellectuals. Yet, failure in early photography discourse, instead of being a current state of being, was the means by which one quantified *labor* and, more so, calculated the abstract *nahdah* priorities of desire (*raghbah*) and will (*iradah*) necessary not only to photography but to the acquisition and mastery of modern scientific knowledge. In the inaugural speech given to the Syrian Scientific Society, al-Amir Muhammad al-Amin Arslan sets for the agenda for the Society's first year, defining the relationship between the mastery of science and technology to labor, efforts, and ambition. The Arabs' forefathers, he states, had been "enslaved by work, lacking steam power and electricity to help them. They had no steam engine to cross the seas. ... They had no telegraph to travel above roadways to spread news." He concludes that "men are liberated now to use these forces and use these sciences" to enhance their efforts, ambition, and labor and, in turn, free themselves from ignorance, myths, and delusion.[62]

This axiomatic mantra of failure and experimentation emerges in virtually all of the instructional articles in *al-Muqtataf*, even in Iskander Makarius's announcement about Autochrome Lumière, an

early color process. Iskandar Makarius, Shahin Makarius's son and also a leading photography commentator, states that the invention "is not yet perfected," but "it is sure to be mastered and greatly improved if experimenting research continues."[63] This succession of failure, repetition, and success establishes photography as a process and physical practice, an act within time, space, and society. The repetition of photographic practice, in order to achieve "success," mirrors the repetition of backdrops and props, poses and formats; this repetition is inherent in the portrait's form and content, a repetition that stabilizes the index and referents of photography. Repetitious failing is a performance of the formula for subjective reform. As an article in *al-Muqtataf* titled "Criticism" demonstrates, the recognition of failure is an enactment upon which progress is built and perfection is achieved in the "beaux arts [*al-funun al-jamilah*]."[64] Failure, experimentation, knowledge, and the ability to recognize them, is a matter of competency and efficacy, ideals that the practice and representation of photography embody. In this regard, photography writing clearly brings material, representational, practical, and ideological facets of photography into one knotted discourse: the representational content of the image, its index, and ideology is born into the material world through a praxis of knowledge and will that replicates the formula for "progress," "civilization," and a successful "native son."

Al-Muqtataf's appeal to effort, desire, and experience is an utterance that makes photography an *illocutionary act*. The illocutionary act calls one to engage through practice; in other words, to perform, or what I have termed "enact," the tenets of reform through the "application" of knowledge, thereby inducting one into a universal history of science and progress. The constant instructions (reiterating the same processes of developing, glossing, enlarging, and so forth) and the authorial command to repeat procedures until success is achieved demonstrated the performative nature of Ottoman Arab photography. These multiple forms of repetition bound the ideology of capitalist transformations to acts and practices of everyday life. Repetition and performativity fused sets of knowledge to individuated actors and forged social groups with social platforms into an alloy of modern society.

Makarius's series on photography elucidates the centrality of performativity to photographic production, knowledge, and practice, but its archetypal organization also presents one more example of how the reiteration of processes, formulas, and procedures fosters the identification necessary to give photography, especially portraiture, its ideological cachet. *Nahdah* photography is performative only inasmuch as it enacts discourses of individualist and communal subjectivity, of class and national identification—all of which had already been laid out in the press, in the reform movement, in the Tanzimat, and in the marketplace. Photography does not transform the world or the environment of the photographer, the photographic subject, or the viewer. In the case of the nineteenth-century Middle East, the portrait

does not *produce* the subjectivities that it *manifests*. It makes sense of the world by reproducing it in its most coherent visual language.

While journals and commentators quickly reported the latest photographic breakthroughs, photographers in the Arab East did not always employ the latest or best technological developments. The inordinate attention that the Arab press gave to Scott Archer's and subsequent collodion processes is evidence that the process remained in effect in the Ottoman East well past its obsolescence in Europe. The same was the case for the popularity of the carte de visite and cabinet card in the Arab world.

Rather than speculating about the logistical, geographic, or economic practicalities that allowed the wet collodion process to persist until the turn of the century, focusing instead on its tenacity reveals that photographic practice was less bound to evolutionary shifts in technology than to the correlation between material realities and image production. But this lingering of old methods also produces an ideological effect. While it may evoke a perpetual structural under-development within the modernizing projects found in the Global South, the meticulous physical process and skill set at the heart of collodion wet plate procedures was exemplary of photographic practice as an illocutionary act. The rigors involved in producing a "clear image" called the reader (cum photographer) to enact reform through experimentation, trial-and-error, and application of a system of knowledge that was disseminated and regularized by a host of cultural infrastructure central to the *nahdah*'s formula for progress, including schools, libraries, and, yes, journals.

Verum Factum

Makarius's discussion of the collodion process is archetypal of scattered articles published in the Arabic press over four decades. Between these transitions from subtopic to subtopic and shifts within a constellation of statements, objects, and referents within photography discourse, seams appear where discrete topics or enunciations are conjoined. The discursive shifts, from history to science to application to enactment, reveal connections that are the photograph's only clue to its *latent content*, the social history of its ideology and economy.

The aggregate installments of *al-Muqtataf*'s series emulsify into a "clear," multifaceted discourse on photography. The series crosses between history, science, society, and craft in order to give photographic performativity its full ideological coherence. The repetitiveness of the issues, topics, instructions, and answers in the press created the white noise of photography normalization. But also, this repetition mirrors the portrait and confirms its positivist "truth-value" of the manifest content.

Nahdah writing about the materiality and production of photography fleshes out the textures of the truth-value of the photograph and illustrates that it was perceived as a *verum factum*. Giambattista Vico's principle of *verum factum* provides a useful analytical tool to understand how the portrait was perceived as a truth created by reality's conditions, where divine (allegory), aristocratic (metaphor), and democratic (poetic) elements meet in the images' *haecceity* (or thingness). In other words, the *nahdah* photography writing tells us that the photograph was a place where experience meets facts and knowledge, representation meets chemistry and physics, affection and community meet class and nation, and sociability meets social order. The "miraculous new invention called *photographe*" brought together the secular and divine, the scientific and natural, the social and the personal. This is not because it was not positivist and rational but because that positivism could capture and *contain* the realities and experience of its subjects.

The portrait as produced and reproduced by studios and photographers in Alexandria, Beirut, Cairo, and Jerusalem presents a micro-stage, a *verum factum*-in-the-age-of-mechanical-reproduction, of Ottoman Arab modernity, imprinting the material world and the conditions that produced it and gave it social currency. But the portrait represented all walks of life, all classes, and all ideological positions. It was not just the purview of the secular middle tier *effendiyah* that championed it; it spanned and connected all social groups. It could do this precisely because the "nature of photography," the nature of the *verum factum*, could be both secular and spiritual, objective and subjective, representing interiority and exteriority at the same time. In other words, the portrait as *verum factum* provides the ideological legibility of these material conditions (it is their afterimage). Opposed to the Heideggerian "world-as-picture" (*weltbild*), the portrait as *verum factum* contains its own limitations, the layers of the "divine," the haunting of experience and individual interiority that escape it and representation. The *verum factum* was an image-screen, forging the truth-value of "reality" and radical subjectivity into one representational space.[65]

The sudden mention of the "divine" within a work that has stressed the positivist nature of nineteenth-century Arab photography should not seem a contradiction. Indeed, if we are forced to credit the indigenous introduction of photography into the Arab world, we would point to Father Louis Saboungi's return to Beirut, fresh out of the seminary, and Armenian Archbishop Yessayi Garabedian (1825–85), who preceded him. Not only an expert photographer in his own right, Garabedian opened the first native atelier in the Armenian Seminary in Jerusalem, creating a generation of professional and amateur *indigenista* photographers, including Garabed Krikorian. Religious images were almost as prevalent in the nineteenth century as "secular" images. Krikorian's portrait of Orthodox Bishop Germanious was

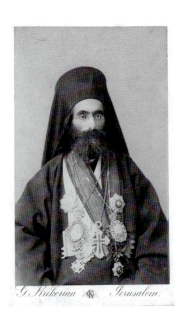

Figure 39.
G. Krikorian,
Bishop
Germanious,
ca. 1900–1920,
carte de visite.

not rare (fig. 39). It exhibits the same iconography and sartorial codes as numerous portraits of Orthodox, Syriac, Maronite, and Armenian clergy, including bishops and archbishops. Muslim shaykhs were photographed in similar poses, wearing their own clerical garb. Portraits of men and women after rituals such as weddings and, in the case of Christians, baptisms, First Communions, and funerals, were popular. These images explicitly displayed religious iconography, images, and props such as candles and baptismal or wedding gowns. The image of Bishop Germanious does not preclude its positivist nature. His many medals, including those bestowed on him by the sultan, punctuate the worldliness of the bishop's portrait, his own social relations that give the image value.

Understanding Bishop Germanious's portrait as *verum factum* allows us to understand not only the "nature of photography" and the limitation of its perspective in an age of positivism but also the power of that perspective to contain even the images of spirituality. The discussions and contributions about photography in the literary-scientific journal poses the *verum factum* of the portrait as a question of realism, the ability to document in an objective language life's *experiences* and the experience of life.

Omnia El Shakry shows that "ethnographic realism" provided an organizing "perspective" of rural life in the early nineteenth century. She focuses on another native priest of Syro-Lebanese origins, Father Henry Habib Ayrout. His description of the Egyptian peasantry, she quotes him as saying, was "based 'principally on personal observation … on personal intercourse with people of every rank, and on reflection upon things actually seen and heard.' "[66]

Ayrout's experiential narrative arises not only from the authority of the subject's act of looking but also from the understanding that this gaze originates with a self-aware, individualist subject—that same effendi who could look across the Bosporus, look from atop the Prophet's mosque, or look at Saboungi's portraits. Ayrout's realism does not look at bourgeois ideal-egos, but rather looks *through* bourgeois idealism, *through* effendi ego-ideals, in order to understand the plight of the Egyptian peasant classes. This realist vision represented the "mentality" of the Egyptian peasantry that implicitly contrasted with the objective "mentality" of Egypt's "new men and women" and their urbane educated classes, whose *effendiyah* ideals, in Ayrout's words, emanated "like a warming radiation from Cairo."[67]

Realism "sets its subjects in place at the point of intelligibility of its activity, in a position of observation and synthesis," John Tagg tells us, where, "the mechanism of realism has been effected over a multitude of 'texts'—in our case, of photographs and their supporting and surrounding discourses—which appear diverse and changing but are fixed and dependent on practices of production and reading."[68] The representational structure of a normative, realist vision—transliterated into the indexed surface of the portrait—tells us of Ottoman

modernity's scopic regime that sees the world as a *verum factum* that confirms a positivist subjectivity authorized by experience. Portraits may have imaged and imagined a variety of *indigenista* subjects but they all were organized by the same *nahdah* perspective and contained within the same *verum factum* of the portrait.

The Egyptian writer ʿIsa ʿUbayd highlights the importance of realism (*madhab al-haqaʾiq*) in the introduction to his *Ihsan Hanim*: "The vivid narrative and use of accurate realistic description have a strong impact on the reader, for they convince him of the truthfulness of the story and of its relevance to real life."[69] The truthfulness of representation and reaching into personal experience are characteristics that were described in the Arab press about photography; its raw objectivity evokes that which is beyond positivist representation, sentiment, experience, and emotion but also contends that its truth-value can conjure those experiences. It is hardly coincidental that Arab writers, artists, and critics throughout twentieth-century Arab literary criticism emphasized this comprehensive realism, insisting on the need for a literary form to understand individual problems as social problems, as a "consolidation of [class] phenomena and its material signifiers."[70] The identification with realism summons an unmediated language to represent the social reality of modern Arab society while also speaking to the *interiority* of the individual. Realism was the language of the *verum factum*. Such is a commentary on the transparency represented by photography and the evocative sentiment that so prevalently marks the portrait by its inscriptions and dedications. The *nahdah* writing itself was a form of this realism, representing at times the cold data-ratio of its production and its society and at times communicating the humanity and experience of those in the Arab world, often in their own voices.

Iskandar Makarius knew the complexities of writing a history of photography when he commented: "One thing or one man does not distinguish its invention or discovery. Rather many experimenters were involved in it and they followed each others' experiments one after the other."[71] Photography was a series of materialist acts that brought together social platforms with subjective ideals. It was a collective ideological act. The reportage on photography in the Arab print media at the turn of the century echoes the words of John Tagg: "Photography is a mode of production consuming raw materials, refining its instruments, reproducing skills and submissiveness of its labor force, and pouring on to the market a prodigious quantity of commodities. ... These take their place among and within those more or less coherent systems of ideas and representations in which the thought of individuals and social groups is contained and through which is procured the reproduction of submissive labor power acquiescence to the system of relations within which production takes place."[72] Tagg's words do not detract from the locality of *nahdah* photography writing. He helps us to think about how photography's technomateriality

traveled with the camera, picking up and shedding ideological effects and roles along the way.

The photography discourse congealed in the pages of the Arab press, making it a public discourse that provided a *habitus* where the subjective could meet the social and actualize modernity. Arabic writing defined photography in a way that al-Jalkh could not. It could not help but see the practice specifically as "a mode of production consuming raw materials" and produced through internalizing a knowledge-set that was connected to so much more than just a profession or a discrete technology. For this reason, Arabic writing couched a variety of social, technical, and logistical issues in the language of science and progress but, in turn, defined photography as a material practice that relied on the competency, knowledge, labor, and activity of "native sons" to come into being. The enmeshment of this photographic discourse in the national self was an interpellation of a vision, a perspective, that naturalized a new sort of self within a transforming social and economic world.

This chapter has begun to uncover the texture and contours of photography as a discourse, at least as they were drawn out in an equally new print media. I have focused on the writing of photography and its movement from a constellation of discourses into a public discourse. This public discourse gathered the various elements and layers involved in the practice of photography and riveted them to a materialist plane that would provide photography as a *habitus* in which subjective ideals and social truths were enacted. We have learned about the first intellectuals and craftsmen to write about photography, like al-Jalkh, Shahin Makarius, and Hasan Rasim Hijazi, emblematic new men of *al-nahdah*. But more than providing just an empirical history, examining *nahdah* photography writing reveals how the technomateriality of the portrait made the portrait a *verum factum* of the ideological perspective that organized *nahdah* and *Osmanlilik* normative vision. The writing in *al-Muqtataf* unpacked the *verum factum*; it was a scientific testimony to its "realism" but also an attempt at writing the experience and interiority of the effendi subject that the portrait promised to represent.

Case
Studies
and
Theory

Portrait Paths

**THE SOCIABILITY OF THE
PHOTOGRAPHIC PORTRAIT**

A Locality: Wasif Jawhariyyeh's Album

In his personal chronicle, *The Storyteller of Jerusalem*, Wasif Jawhari-
yyeh (1897–1972) opens his account by calling attention to a cherished
portrait that was presented as a gift to his father by his own namesake,
Wasif Bey 'Azim ('Azhim), a close friend of the senior Jawhariyyeh.
'Azim came from a prominent Damascene family and was a jurist
appointed by Istanbul to the Ottoman criminal court of Jerusalem
but also sent to establish the civil *nizamiye* court in which Jawhari-
yyeh and his father worked.[1] Musician, polyglot, libertine, litterateur,
and municipal bureaucrat, Jawhariyyeh came from a well-connected,
middle-class family in Jerusalem. His father was a well-respected
lawyer and civil servant who also became the *mukhtar*, or head, of the
city's Greek (Rum) Orthodox community and maintained close con-
nections with the Husseini family, Jerusalem's most powerful clan
of notables. Wasif, himself, was a municipal bureaucrat who worked
in the same legal system as his father and Wasif 'Azim. An accom-
plished musician and libertine, he stands apart from the "new men
and women" of Palestine and the Ottoman Empire.

　　Thanks to the masterful work of Salim Tamari and Issam Nassar,
we know much about Jawhariyyeh, because he left us an extensive
chronicle of his life, starting at the turn of the century until the
1960s, detailing the massive changes and challenges in Palestine that

culminated in mass dispossession of Palestinians in 1948.[2] Yet, adjacent to his autobiography, his unpublished photography albums, titled *Tarikh Filastin al- musawwar* (The illustrated history of Palestine), have received less attention.[3] These photography albums are a visual narrative of Jawhariyyeh's Palestine, opening not with an intimate account of his family members and the Jerusalem quarter but with a litany of portraits of Ottoman officials, Palestinian notables, civil servants, and municipal functionaries. The preamble of this visual narrative of the modern history of Palestine meanders from portraits of Ottoman mutasarrifs (district officers) of the *sanjak* of Jerusalem and city notables to the municipality's civil servants and mayors (*ru'us al-baladiyah*). Annotated with the names, posts, and *hijri* years, the litany includes 'Izzat Pasha (governor of Damascus before Jerusalem was made a sanjak in 1872), Fa'iq Bey, Nasim Bey Jawdat Bey, Subhi Bey, and Azmi Bey (the latter three governors of the city after the Committee of Union and Progress revolt of 1908), the accomplished Ottoman diplomat Ibrahim Haqqi Pasha, an older Rashad Pasha, and Ra'uf Bey, along with an image of Ra'uf with his son in an Ottoman maritime outfit for children.

The portraits of local officials, notables, and dignitaries commingle with the cartes de visite of Ottoman officials. 'Arif Pasha al-Dajani, Jerusalem notable, Arab nationalist politician, and the mayor during the final years of World War I, poses bespectacled in a suit at a table, hand on cheek, looking over papers. Dajani, like so many others in Jawhariyyeh's written and visual narrative, was a central figure in Palestinian polity and in the heady politics following the Arab Revolt and the Mandate period. The image is nested in an array of images of political figures such as Hussein Salim al-Husseini, the son of Jawhariyyeh's patron and friend Salim al-Husseini (fig. 40). Hailing from Jerusalem's most powerful political families, he was, along with the council of notables, given power over Jerusalem upon the Ottoman withdrawal from the city. He is the central figure in the iconic photograph and painting of the surrender of Jerusalem to the British during World War I. Hussein Salim al-Husseini wears a broad tie, suit, and the ubiquitous fez. The formalism of his image is repeated throughout the Palestinian archive and Jawhariyyeh's albums. Palestinian portraits, as seen in Jawhariyyeh's albums, are divided between two or three "genetic types." Virtually all portraits are of men, either Jerusalem notables, Ottoman officials, or Palestinian functionaries dressed in fez, ties, or the occasional white Sunni head turban ('*amamah*).

This chapter does not look at the compositional or formal qualities of the portraits in the albums of Wasif Jawhariyyeh. It offers a case study of how the portrait as a material object "worked" and looks at how the "portrait paths" of the carte de visite mark, what I will call, "networks of sociability" of the "new men and women" of Ottoman Palestine and the empire itself. That is, the constellation of cartes de visite in an album such as Jawhariyyeh's did not only instantiate a

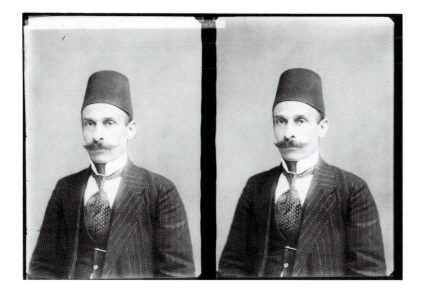

Figure 40.
American
Photo
Department,
Hussein Salim
al-Husseini,
Jerusalem,
glass, dry plate,
12.7 × 17.8 cm.

vision of modern Palestine or enact a Palestinian national narrative. Rather, this chapter explores how the photographic portrait served as a valuable material and ideological object that connected, verified, and defined social and political networks at a time of "interactive emergence" of new classes and subjects who form the bedrock of Ottoman and Mandate Palestinian society.[4]

The procession of portraits in Jawhariyyeh's photographic albums invites the viewer to enter an ambulatory of Palestinian history rooted in the late Ottoman Empire. Formalistically, these portraits offer nothing new. They reproduce the "genetic patterns" repeated in the formalism of portraits taken by native and European photographers throughout the empire.[5] They are frontal and side portraits of officials of the new Ottoman *askari* and bureaucratic classes, of officials in military and administrative uniforms, fezzes, and adorned with a variety of Ottoman medals. They are interspersed within cartes de visite of civilian notables, clerics, and officials such as the suave Tawfiq Bey, with his hand on a cane; Rashid Bey, whose front-on head shot looks straight into the camera; and a soft vignette of the twelfth mutasarrif of Jerusalem, ʿAli Akram Bey (fig. 41).[6]

Jawhariyyeh's photographic album confirms that the carte de visite was a common social practice in which every Ottoman official participated, from the grand vizier to governors, since the introduction of commercial photography studios into the empire in the 1850s. Photographers such as Garabed Krikorian and Khalil Raad produced these portraits as easily in Jerusalem and Jaffa as Abdullah Frères, Sébah, or Jurji Saboungi did in Istanbul and Beirut. The mobility of Ottoman officials, who might be governor or bureaucrat one year only to be reassigned to another province the next, echoed the mobility of the carte

de visite as a means to shore up relations between provincial capitals, the imperial center, and the locales that they were sent to manage.

It is not surprising, therefore, that the images of *ruʾus baladiyat al-Quds, ʿayan*, clerics and *ʿulemaʾ*, friends, and relatives in Jawhari-yyeh's photographic albums form a male visual gallery that reflect the ruling political and class spaces of Palestine, particularly Jerusalem. This gallery stretches from the new bureaucratic bourgeoisie, such as a portrait of Ishaq Abu al-Saʾud, the Orthodox Patriarchate's attorney, sitting on an ornately carved wooden chair at a desk with papers, to those Palestinians with a quite different pedigree, such as al-Shaykh Ahmad ʿArif al-Husseini, scion of the prominent Gaza branch of the Husseini family and once a candidate for the Ottoman Parliament (fig. 42).[7] The metanarrative of that particular portrait's inscription reminds us of al-Husseini's dubious celebrity: "Executed at the orders of Jamal the Butcher," the notorious Ottoman governor of Syria noted for hanging Arab nationalists during World War I.[8] Simultaneously, portraits of local bureaucrats such as that of Ahmad Sharif Effendi, the former comptroller of the Mutasarrif, dated AH 1288 (1879), and a portrait of al-Mutasarrif Rashad Pasha, sitting on wicker chair, legs crossed, arm on table, conjoin along a shared representational and ideological plane the sociability of Ottoman leadership with the locals who manned their administrative system.

In the words of Christopher Pinney, "what photography makes possible is not the creation of a dramatically new aesthetic *mise-en-scène*, but the mass-production and democratization of such an aesthetic."[9] This aesthetic of the Ottoman carte de visite was not a matter of colonial mimicry, of Ottoman Arab, Turkish, Armenian, and Greek subjects imitating Western forms of dress and portraiture. The aesthetic of the visiting card was the aesthetic of the ideology of *Osmanlilik* modernity and *nahdah* discourses and their concomitant subjectivity. Against the backdrop of the Ottoman Tanzimat and *al-nahdah al-ʿarabiyah* was the era in which Arab intellectuals and reformers articulated and instituted discourses of cultural, political, and social reform. These discourses were, simply put, formulated on civilizational discourses of "progress and civilization." Whether the topic was governance, commerce, education, or photography, these discourses articulated new national, class, gender, and individualist subjectivities that mediated the massive transformations in the political economy of the nineteenth century.[10] What is important for this chapter is to understand that the photographic portraits of turn-of-the-century Palestine were as bound to these *Osmanlilik* and *al-nahdah* discourses as they were to the formation of bureaucratic, ruling, and middle classes, who themselves were charged with managing and stabilizing the social transformations and economic reorganization instituted by the Tanzimat and increased European penetration.

Mary Roberts provides us with titillating examples of how Sultans Abdülaziz and Abdülhamid used "photographic portraiture as a

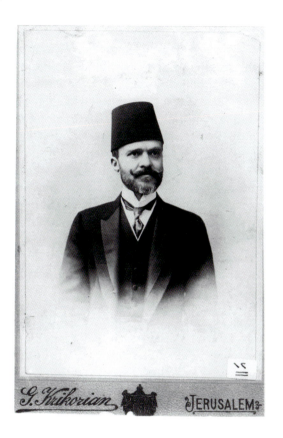

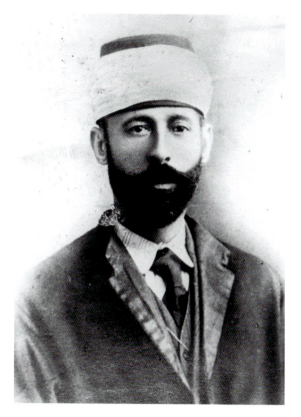

tool of Ottoman statecraft," which we can then extend to the sultans' own domestic political program.[11] With this understanding of photography as a political and social object, Jawhariyyeh's albums show us the extent to which cartes de visite and cabinet cards circulated among Ottoman officials, local bureaucrats, and new middle-class individuals—including intellectuals, educators, professionals and merchants—and thus, by extension, the degree to which new forms of *Osmanlilik* ideology and governance saturated localities in the empire. Moreover, the appearance of portraits in albums, homes, and institutions in provincial capitals such as Jerusalem or Beirut also show us the networks of social relations between new and old classes of subjects, between petit-bureaucrats, members of the new *askari* class, rural clients and *zu'amah* patrons, professionals, and educators of Palestine and Greater Syria.

For this study, Jawhariyyeh's portrait gallery in the first pages of his illustrated Palestinian history demonstrates that photographic portraiture was a local act of sociability that reached beyond its immediate geography. This act was inseparable from the discourses and practices of social, economic, and political reform in the empire and the radical transformations in political economy and society that produced them. As a local act, then, we approach the portrait's aesthetic form integral

Figure 41.
G. Krikorian, 'Ali Akram Bey, twelfth mutasarrif of Jerusalem (1906–8), Jerusalem.

Figure 42.
[G. Krikorian], Ahmad 'Arif al-Husseini, Jerusalem.

to photography as a social practice, organized around its circulation, distribution, and exhibition but also its techniques and places of its production. If we approach the photographic portrait as an ideological act of a particular kind of sociability (arranged around particular kinds of political and economic order, a class order), we, therefore, recognize photographic studios such as that of Garabed Krikorian not a source of production of nationalist, class, or subjective discourse or representation. Rather, we understand these studios as a site of material production itself, whose product worked to stabilize the class ideology of the Ottoman Empire through two coterminous and interlocking means. On the level of social practice, the circulation of portraits among individuals, institutions, and communities shored up class relations between them. Simultaneously, the portrait itself was a representational instantiation of class ideology as expressed in the discourses of *al-nahdah al-ʿarabiyah* and the *Osmanlilik* modernity.

Photographers: The Krikorians and Raad

Garabed Krikorian (1847–1920) is undoubtedly Palestine's most prolific and well-known photographer. He learned photography at the hands of Yessayi Garabedian, the Armenian patriarch of Jerusalem, who established Palestine's first native-run educational atelier in the Monastery of St. James in 1859, probably the first in the Arab world.[12] Garabedian studied in Manchester and Paris, writing four technical manuals in Armenian, which remain unpublished. He is credited with training several generations of leading Armenian photographers, most prominently Krikorian. Krikorian established a studio in the 1870s in Jerusalem. The evidence from early cartes de visite suggests that he associated with Beirut's most prominent photographer, Jurji Saboungi, later training and partnering with Daoud Saboungi in Jaffa. In 1913, Johannes (John) Krikorian, Garabed's son, returned from studying in Germany, took over his father's studio, and married Najlah, Kahlil Raad's (Rʾad's) niece.[13]

Krikorian trained Raad, who would become his rival, partner, and in-law. Khalil Raad was born in 1854 in Bhamdoun, Lebanon, where his father was killed in the massacres of 1860. Raad converted to Protestantism and relocated to Jerusalem because his paternal uncle taught in Jerusalem's famous missionary Bishop Gobat School. Much to the displeasure of Krikorian, Raad eventually broke off to open his own studio immediately across the street from his mentor in 1890.[14] After years of acrimony, the two photographers made peace after Garabed's son, Johannes, married Raad's niece Najlah in 1913. Issam Nassar's pioneering work on these studios surmises that Najlah worked in the Krikorian's studio, thereby making her among the Arab world's first native women studio photographers.[15] The two studios made an agreement to divide the market. Krikorian's studio dedicated

its energies to studio portraiture while Raad photographed Palestine's daily life, current events, and archeological sites. Indeed, on the cover of his 1933 *Catalogue for Lantern Slides and Views*, Raad advertises that he is a "photographer of sites, scenes, ceremonies, costumes, etc. etc."[16] Regardless, just as we find portraits produced by Raad, Krikorian, too, catered to the thirst for biblical and Orientalist imagery by Holy Land tourists and the American and European markets.[17] Likewise, their photographs illustrate a number of European publications with explicitly colonial underpinnings.[18]

The impact of Krikorian's and Raad's studio portraiture, like that of Abdullah Frères, Sébah, and Jurji Saboungi, has been overshadowed by the prominence of their lucrative "biblical" and Orientalist photographs. Even in Jawhariyyeh's albums, the introductory portraits give way to documentary photographs by Jaffa photographer Issa Sawabini and Jerusalem photographers such as Khalil Raad and the American Colony's photography studio, depicting current events and Palestinian communal life. The political relevance and ideological impact of the quotidian photograph in Jawhariyyeh's album is a clear riposte to the true claims of Orientalist and tourist photography. Local photographers' Holy Land photography serves to displace Western claims on the representation of Palestine. In addition to their formalistic tourist photographs, these photographers also recorded Palestinian Arabs, not Western pilgrims, celebrating trademark religious festivities, such as Holy Thursday, or the Washing of the Feet (*'id al-ghitas*) in the Jordan River in 1905. Furthermore, their photography of World War I Palestine offers us a keen counternarrative to Lowell Thomas's vision of Palestine during World War I. Lowell Thomas, famed for his portrayal of T. E. Lawrence, crafted a narrative in which Arabs were auxiliaries to British forces, who purportedly liberated Palestine from the Ottomans. Jawhariyyeh's albums provide a counterweight, where photographs of the mobilization of Palestine, Bedouin irregulars, sabotaged trains, and the surrender of Jerusalem are squarely situated in Arab and Palestinian polity and political participation.

Krikorian and Raad also produced an archive of portraiture, ranging from Palestinian peasants to high-ranking officials. The Krikorian name, in particular, is ubiquitous in the cartes de visite, cabinet cards, and portraits of Palestine from the 1880s until 1948, when the Krikorian and Raad studios were lost behind the Green Line. Their oeuvre and practice, the circulation, exchange, display, and loss of their portraits precisely demonstrate photography as expressing a series of social relations that gave it power and necessity.

History as a Photographic Album

Organizing a discussion and excavation of the Krikorians and Raad around Jawhariyyeh's photography albums reveals how photography

offered a visual *habitus* for the complex network of social, political, and economic relations, locally and regionally, in the Ottoman Arab world. Jawhariyyeh's photographic album is a visual narrative of Jerusalem's modern Ottoman history, rooted in the figures of Ottoman mutasarrifs, notables, and local functionaries. But also, his photographic album is a variation of the biographical dictionaries, new histories, and scientific journals produced during *al-nahdah al-ʿarabiyah*. Journals such as *al-Hilal* and *al-Muqtataf* had decades earlier broken new ground in popularizing and disseminating portraits of "famous people" (*al-mashahir*). Initially, they were reproduced as halftones, usually on the first pages of their editions. Over time, technology and financing permitted the number and frequency of portraits to increase in these journals' pages.

Simultaneously, the images of famous men and women were reproduced in a variety of different printed genres. The first volume of Philippe (Filip) de Tarrazi's monumental *Tarikh al-sahafah al-ʿarabiyah*, for example, served to codify the portraits of *nahdah* political and intellectual figures as representational doxa.[19] Tarrazi was a scion of a wealthy merchant family in Beirut whose connections with the papacy resulted in the honorific title of viscount. He was an encyclopedist and founder of the Lebanese National Library, whose biographies of *nahdah* intellectuals, reformers, and "journalists" institutionalized the Arab nationalist narrative of "the Renaissance," even though, ironically, Tarrazi later became a parochial Lebanese nationalist. The portraits in *Tarikh al-sahafah al-ʿarabiyah* became a visual compendium to new forms of Arabic fiction, poetry, and social and scientific commentary that were produced by the biographical subjects of Tarrazi's encyclopedia. Tarrazi's photographic compendium, while not necessarily the first, articulates the ideology of the "new men and women" into a visual narrative of progress. His portraits present a set of representational indexes that bind private achievement and individuality to the civilizational discourses and national subjectivities of *al-nahdah al-ʿarabiyah*. Jawhariyyeh's albums are a reiteration of Tarrazi's historical encyclopedia, moving from the biography of "great men" to the story of venerable institutions of Palestine to understanding all current events as national events.

On the other hand, Jawhariyyeh's photographic albums are a narrative version of the montage portraits that were popular by World War I. The montage portraits were an assemblage of multiple images throughout a distinguished notable's life, combining images of family, military, governmental, educational, or religious institutions. Explicitly patriarchal, these montages are usually organized around hierarchy, placing the patriarch or leader in the middle. One example of a popular montage found in many homes and institutions in Lebanon, Syria, and Palestine, and reproduced in many publications, is a portrait of Amir Faisal bin Hussein in military uniform, which is

Figure 43.
Amir Faisal
bin Hussein,
montage.

surrounded by a host of other portraits of political and military fig-
ures from the heady days of the Arab nationalist uprising and the Arab
Kingdom of Syria (fig. 43). The picture assembles all the leading figures
of the Arab Kingdom of Syria, crushed by the French in 1920. These
montage assemblages are, quite literally, the afterimage and imprint of
the social networks, birthed, in John Willis's words, by the "interactive
emergence" of a new social group that reached to photography as one
way to instantiate its ideological program.[20]

Arabic literary-scientific journals, encyclopedias, photographic
albums, and portrait montages testify to the predominance of a pho-
tographic practice by which turn-of-the-century Ottoman Arab, in
this case Palestinian, subjects not only were looking at themselves but
had organized that vision based on particular class formations and
civilizational *nahdawi* discourses. Walid Khalidi's *Before Their Dias-
pora* is a testimony to how Raad's and Krikorian's studios, for example,
contributed so intimately to interpellating Palestinians into national
and class subjects. Naseeb Shaheen's two-volume *Pictorial History
of Ramallah*, likewise, is a photographic mass of generations of men,
women, and children from Ramallah's native families. The over-
whelming presence of Krikorian and Raad portraits shows that their
pull was not limited to Jerusalem's *effendiyah* class, merchant fami-
lies, municipal civil servants, and Ottoman functionaries. Shaheen's
publications are awash with portraits of families and individuals

from rural areas and small towns and villages surrounding Jerusalem and Ramallah.[21] In fact, Shaheen tells us how going to Jerusalem to have one's portrait taken by Krikorian was a frequent and prized event practiced by a variety of villagers.[22] To punctuate this assertion, Edward Said records the swan song of the Krikorian and Raad studio in the 1940s. He personally witnessed Raad laboriously photograph a wedding rehearsal, alluding to the photographer's "finickiness" if not boorishness.[23]

The literary-scientific journal, the illustrated encyclopedia, and the photograph album naturalized a practice of nesting national and local histories in a vestibule of portraits. The photographic album and the montage followed journals and encyclopedias in that they interpolated subjects into national, class, and personal histories and narratives. But photography albums also interpellated the social relations that marked "portrait paths," the portraits' network of exchange between Palestine's national figures, new classes, and new individuals.

Portrait Paths

The predominance of the Krikorian and Raad portraits in such a variety of social spaces confirms that photographic practices were regular social practices. As such, all that was involved in studio portraiture (visiting the studio, posing for the image, exchange, dedication of, and display of the portrait) was a social and ideological enactment of a particular form of sociability that served to connect individuals, classes, institutions, and leaders, locally and throughout the empire. This is precisely what Jawhariyyeh's diaries give us when read against his photographic album. On the most localized level, people from every class, including working and peasant classes, are likely to have had their portrait produced at least once in their lifetime. While this conjecture is based on the irregularity of images of, say, peasants or by publications such as Shaheen's, for this chapter, what is important is that their existence, like that of the middle- and upper-class portrait, should be seen as a valued social act that produced a *social object*, an object of exchange and display endowed with considerable social currency, especially in a society that was so demonstratively defined by clan and personal ties. In reading Krikorian and Raad's photography against Jawhariyyeh's visual and written narratives, this chapter provides a *case study* in how the portrait's exchange tethered individuals to collectives, collectives to other collectives, and individuals and collectives to institutions and the state. The pairing provides us with an explicit demonstration of the "interactive emergence" of new subjects, subjectivities, and "social groups" that are clearly articulated in the *habitus* of photography.

The "portrait paths" of these subjects', collectives', and institutions' sociability are the common denominator of the work of Khalidi,

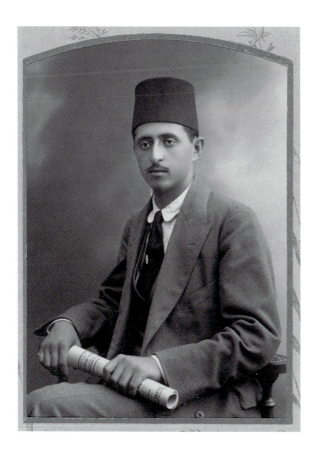

Figure 44.
G. Krikorian,
Jawad
al-Husseini,
carte de visite,
Jerusalem.

Shaheen, and Jawhariyyeh, each of whom cluster portraits of officials, notables, and remarkable figures as the narrative bedrock of national narration and local history. These shared portrait paths are better illuminated when we find the same carte de visite in collections across territories, as Jawad al-Husseini's portrait in the American Colony albums (now in the Library of Congress) and the American University of Beirut's archives demonstrates. Husseini came from Jerusalem's most powerful family, and his picture is found in both archives next to the nationalist leaders and prominent figures of World War I Palestine (fig. 44). It is important to detail how Ottoman Palestine functioned through complex sets of connections between notables, leading families, local functionaries, peasants, clans, and the Ottoman center. The visual archive is more than a historical documentation, a vestige of the social *enactments* of forms of *nahdah, Osmanlilik,* and national sociability—a sociability that operates on levels of representation and materiality in order to ideologically and socially facilitate networks of power, politics, economy, and indeed intimacy, between the empire's "new men and women." Rather than show, necessarily, a history of Palestine built on "great men," Ottoman secularizing order, and Palestinian sociability, Jawhariyyeh's portraits show how

subjects, who were both the viewers, recipients, givers, and sitters of the image, found identifications within the new configurations of social relations that were facilitated by national and class ideals, and their concomitant economic order.

In examining the self-presentation of the "new lady" in Republican China, particularly in women's journals, Joan Judge observes that the portrait functions on the seam of the tension between "representation and materiality," the "evocative and repeatable photographic image," and "photographic metonymy and photographic exigency"; it mediates between "an image that gestures beyond itself" and "an image that interpolates us as viewers."[24] Krikorian's and Raad's representations of a local Palestinian-Ottoman vernacular function along this same interface. They are objects with social currency, objects of exchange, texts with ideological weight, and opportunities for enactment of social relations and performativity of the class and national identities that were organized and envisioned in *nahdah* writing. Krikorian and Raad were consummate local photographers with a regional impact; they were close to the power elite, Ottoman functionaries, the new middle class, Palestinian nationalists, and colonial administrators. Their biographies fit *nahdah* ideals; they were patriotic Jerusalemites, successful entrepreneurs and, as modern craftsmen, masters of a particular form of modern knowledge. Their portraits participated in larger Ottoman discourses of photography, modernity, and social reorganization while at the same time articulating local politics that involved the self, the immediate family, notables and tribal leaders, education, local governance, and a whole slew of elements, factors, and figures to maintain and expand the social relations of Palestine's new political economy. In other words, portrait production concurrently operated within "portrait paths" that were ideological and social, national and local, semiological and material. Portraits activated identifications between individuals, collectives, and institutions that drew on the authority of sets of representation, signification, and ideology that were integral to networks of sociability and social relations at the heart of Palestine's and the empire's modernity.

Sartorial Palestinian Vernacular

Edward Said relates in the opening pages of his memoir that the reason for his father's emigration to the United States was the threat of being conscripted into the Ottoman army.[25] Such an anecdote finds meaning in the preponderance of officials, officers, and rank-and-file soldiers, not to mention children in maritime and military uniforms, boy scouts, and civil servants in prewar portraiture. While images of uniformed men are found in Egyptian and Syro-Lebanese collections, the prevalence of uniformed officers, soldiers, professionals, and civil servants are particularly evocative in the family albums and archives

of Palestinians, as Jawhariyyeh, Shaheen, and Khalidi's narratives show. This representational category of portraits, which so powerfully narrate the first pages of Jawhariyyeh's "Illustrated History," evokes the words of Vincent Rafael: that photographs "awaken in us, the unknown viewer from the future, a flood of associations that can barely find expression. Conceived from fantasies about identity, they propel their recipient to follow further identifications."[26] With this in mind, it is not surprising that the images conjure anachronistically a prescient story of a people in the dawn of settler colonialism.

Costume and dress tell us little, but their indeterminacy parrots the nature of photography itself. They are indexes that highlight the technical and semiotic mechanisms at work in the portrait, most notably ideological and subjective identification and repetition. Sartorial codes are not determinative of the social relations of the portrait or the sitter, but they offer "genetic patterns" within systems of ideology, within and across class identifications and affiliations, and within systems of sociability. After all, uniforms were not always military. More often, they were official, "honorary" Ottoman costumes, awarded by the Sublime Porte, and granted through accomplishment or intercession by high-ranking and well-positioned friends, connections, and superiors. Clothes, dress, and costume convey political and social choices but should not be overvalued as a definitive designator of photographic meaning or subject position of the photograph. These choices are not innocent, inherited, or coincidental, just as they are not deterministic. They are opportunities to cathect material and semiotic objects as ideological acts. Sartorial codes are opportunities for enactments.

For example, in Shaheen's *Pictorial History of Ramallah*, Palestinian families are photographed in "traditional" dress, worn by the peasant and middle classes alike on a daily basis, but especially during ceremonial occasions. Considering one's village and, potentially, religious sect and class, the portraits contrast the secularizing ubiquity of the standardized portrait of the Ottoman Palestinian uniformed subject. These images contrast with the subgenre of the self-Orientalizing portrait that was prevalent throughout the Arab provinces but particularly noteworthy in the Krikorian and Raad studios. Middle-class urban Palestinians frequently posed for studio portraits dressed in "Bedouin" costume or village attire. This phenomenon was popular with urban women, who would pose in skillfully embroidered *thiyab*, for which Palestinians are well known. Sartorial codes are statements of ideology, which are far too easily confused with empirical truths.

For example, the cabinet card of an Egyptian exhibits the model in contemporary costume. The description on the back reads, "My brother Hamid Bey Wahbi Raghib in Circassian dress." The portrait maintains a keen self-awareness of dress and what it was doing, even if we are not privy to the insider codes (fig. 45). While we may not

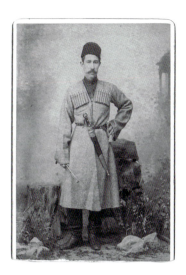

Figure 45.
Unknown photographer, "My brother Hamid Bey Wahbi Raghib in Circassian dress," Cairo, cabinet card, 15.6 × 10.8 cm.

know the intentions of photographic subjects, we must acknowledge that they are participants in ideological systems, which themselves are historically, culturally, and ideologically determined. The repetition of genetic sartorial patterns direct us precisely to the forces at play on the "seam" of the portrait, the meeting between materiality of history, the production of the image, the semiotic system at play that makes the image ideologically trenchant and intelligible, and the circuits of exchange that constitute its value and sociability. These patterns alert us to the degree to which the Ottoman and *nahdah* discourse of reform, its languages, priorities, nomenclature, and concerns were interwoven into all segments of Palestinian life and insisted on being enacted visually.

The portraits of uniformed Palestinians were indexically circumscribed by the portraits of the empire's highest officials, such as Abdullah Frères' portraits of Fuʾad Pasha, Dawud Pasha, or Sultan Abdülaziz himself. These high-ranking figures did not define such representation, but they imbued this formal uniformed representation of the new Ottoman subject with political and social currency. The uniforms that appear in early twentieth-century portraiture are *signs*— both material and semiotic— of the social and economic relations in which the sitter and Palestinian society were embroiled. The repetition of uniforms in portraits underscores *Osmanlilik* ideology but also its sociability. In the case of Palestine, this is represented in the "portrait path" of mutasarrifs, "mayors," jurists, and Palestinian functionaries in the first half of Jawhariyyeh's first volume, just as the portrait paths of those villagers in Ramallah circulated among newly educated villagers who moved to the urban centers or emigrated abroad.[27]

Those "traditionally" dressed and uniformed Palestinians were the mediating classes between prominent indigenous families, old modes of distribution of political offices, the Ottoman central bureaucracy, and the new classes and subjective consciousness emanating from Jerusalem, Ramallah, Bethlehem, Beit Jala, Nablus, Nazareth, Haifa, and Jaffa, not to mention their own relationships to Beirut, Alexandria, and Cairo. This administrative rationalization of society and economy came packaged in the same discourses as seen in the Arab print media regarding photography. Photography is not formative of these discourses. It did not create them; it did, however, manifest them. As such, photography stabilized *Osmanlilik* and *nahdah* discourses that were involved in the reorganization of land, wealth, social organization, and power. Just as the carte de visite circulated among the tarboosh-wearing *effendiyah* in Egypt and among the new urban bourgeoisie in Beirut, the photographic portrait functioned similarly in Jerusalem. It tied new functionaries to the Ottoman bureaucracy in Palestine and other provincial cities (such as Beirut), just as it brought together individuals from ascending local families and traditional elites.

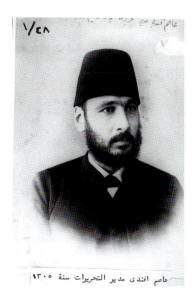

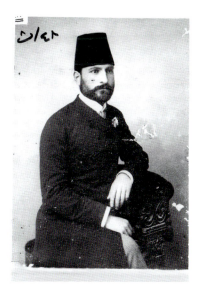

عاصم افندى مدير التحريرات سنة ١٣٠٥

Portraits' Currency

"The photographic portraiture," Vincent Rafael tells us in speaking of photography in the Philippines, "was meant not only to convey the person's likeness but to situate it in relation to the viewer. Such was the function of the dedications … addressed to specific recipients, evoking a sense of intimacy between sender and receiver."[28] The dedications and signatures on the cartes de visite of Jawhariyyeh's first album bear the stain of sentiment, intimacy, and social history. They trace vectors and connections essential to Palestinian social and political relations. Among the first pages of Jawhariyyeh's *Tarikh* are three images of an enigmatic ʿAsim Effendi, "director of the registry" (*mudir al-tahrirah*). The first image is a close head shot vignette taken by Garabed Krikorian (fig. 46). It is dated AH 1305 (1887), the end of the administration of Raʾuf Pasha, mutasarrif of Jerusalem. Adjacent to this portrait, there is a second carte de visite of ʿAsim Effendi, this time produced by G. Krikorian & G. Saboungi, who co-owned a studio in Jaffa (fig. 47).

While the Krikorian and Saboungi portrait is more groomed, compositionally and in content, the soft head vignette formalistically conveys a subjective depth that precisely illustrates the *verum factum*'s tension. In the end, little is known about ʿAsim Effendi. He could be the person with the same name who was lieutenant governor of Jerusalem in the early 1890s. If this is the case, his dedication and relation to Bishara Habib is telling. Bishara Effendi Habib was a high-ranking functionary in Raʾuf Pasha's office and mainstay in the office of the mutasarrif, outlasting in the Jerusalem administration an

Figure 46.
G. Kirkorian, ʿAsim Effendi Mudir al-Tahrirah, AH 1305 (1887), carte de visite given to Bishara Effendi Habib.

Figure 47.
G. Krikorian & G. Saboungi, ʿAsim Effendi Mudir al-Tahrirah, Jerusalem and Jaffa, AH 1308 (1890), carte de visite given to Bishara Effendi Habib.

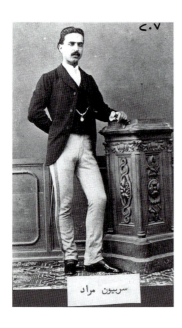

Figure 48.
Unknown photographer, Jacob Sarabian Murad, "With warm regards to Ibrahim Effendi Kayin," carte de visite.

assortment of subsequent governors. ʿAsim's sentiment of loyalty and appreciation to Habib is better understood when one remembers that Raʾuf Pasha attempted to dislodge both of Jerusalem's rival, leading families, al-Husaynis and al-Khalidis, from municipal and judicial positions that they had dominated for centuries, calling them "parasites" on the peasantry.[29] This is perhaps evidence that the image is certainly not ʿAsim Effendi al-Husseini. In the narrative of Arab nationalism, this attempt was spun anachronistically as an attempt to Turkify the administration of the sanjak. More accurately, however, Raʾuf Pasha was implementing governmental policies to curb notables' power in rationalizing principles of Ottoman governance. Simply put, he was attempting to implement the same forms of *Osmanlilik* governmentality that were being extended throughout the empire.[30] ʿAsim Effendi shared a social network with Bishara Effendi Habib, who as secretary and interpreter to successive governors, was an established functionary, with a degree of influence, if not power.[31]

If the story of ʿAsim Effendi suggests the political and social relations around men who were sent to rationalize Palestine, another portrait suggests how those relations reach into Palestinian society. On the back of Jacob Sarabian Murad's portrait, the American vice-consul writes, "With warm regards to Ibrahim Effendi Kayin." While Ibrahim Effendi may have disappeared in history, we do know that Murad maintained an expansive network of close relationships with notables, officials, missionaries, landowners, peasants, and foreign diplomats. These relations did more than allow him to secure his brother, Simeon, a position as the German vice-consul in Palestine.[32] A complaint from a disgruntled American resident of Jaffa claims that Jacob was "destitute of education and totally ignorant of English and any other European language."[33] The claim that the American consular agent lacked education and fluency in English might be corroborated by another comment about his brother, which stated, "beyond a slight acquaintance of our language, his culture was limited."[34] In fact, Jacob and his brothers were the sons of an Armenian rosary peddler in Jerusalem, all of whom were enfranchised by the eldest brother's considerable network of professional acquaintances (fig. 48).[35]

Jacob Murad had come into his position through his own close relationship with the previous native consular representative for the United States, named Arutin Murad, who effectively adopted him and eventually married him to his niece.[36] No doubt, his relationship with Arutin was the source of his securing such a well-connected post, which required not only the approval of American officials in Washington and Istanbul but also an endorsement from the Sublime Porte in 1846.[37] The reputation of Jacob and his brother's homes and "beautiful garden" in Jaffa are not the only evidence of their financial success and connections.[38] He and his brothers engaged in considerable financial activity, including moneylending and land deals, and each of them, at some point, was accused of misusing his considerable connections

for graft or favor. Whether this was true or merely the protestations of a slighted foreign diplomat, Jacob and his brothers did produce evidence that their position as consular agents hurt them financially because they often advocated for American citizens in the face of, what they identified as, vindictive and vengeful peasantry.[39]

The portraits of characters like Jacob Murad and ʿAsim Effendi operate on a series of *feuilles*, the crossing vectors of social relations, political culture, and economic systems in Palestine. Beneath the surface of the image, we learn how foreign interests were embroiled with discontented peasants, who were angered by the rearrangement of property rights and patron-client relations, while imperial policies relied on the mediation of a local functionary class that used those portraits adeptly. The portrait of the slightly crossed-eyed Murad and the two visiting cards of ʿAsim Effendi do not disclose their histories as children of peddlers and notables, respectively, nor do their portraits individually interpellate discourses and practices that they instrumentalized. Through photographic enactments, exchange, and circulation, the portrait bound Ottoman elites, along with Palestinian notables, to lower and mid-tier *petit-fonctionnaires*; new patrons to clients; and individuals to systems. Neither Jacob Murad nor ʿAsim Effendi had enormous historical consequence. That is precisely the point. One need not look at the biographies and portraits of political and intellectual colossi in order to find evidence for the portrait's social currency; it also exists among the scattered portraits among the array of social groups within Palestine who were collectively transforming political economy and local and communal governance. The social currency of a photographic portrait came from its ability not only to circulate within networks of relations, but also to traverse them. This sociability of the portrait was as public as it was private but also was intended to go between these two spheres. Its circulation then tracked new social relations between citizens and institutions as easily as between men and women.

One might look at the visual histories of those peoples such as the Palestinians, Kurds, Berbers, and western Armenians in order to pursue Prasenjit Duara's inquiry into the relationship between nationalist discourse and representations and the nation-state. when not accompanied by a nation-state apparatus.[40] The narrative bedrock of modern Palestinian history lay in a visual narrative for Jawhariyyeh. His visual narrative is staged as a constellation of portraits of Palestine's "new men and women" whose rise, in Peter Gran's words, "in politics and diplomacy … led to a new form of relations among elements from around the world," if not the region and empire.[41] The *bricolage* of Jawhariyyeh's portraits exhibit how the social currency of the carte de visite emerges from the "portrait paths" binding men and women within the "interactive emergence" of new individuals, institutions, and social groups. As a material object, the portrait as a currency is exchanged as a means of shoring up the new networks of

sociability. It is the object of a specific social practice with a concrete role in establishing new social relations between actors and classes. But as an ideological object, the portrait instantiates discourses, which naturalized the very existence and necessities for those class formations and social relations.

Ottoman portraits dovetail with Jawhariyyeh's national narrative because they took value from the same ideological systems that were at play within Palestine's social relations at the beginning of the century. The portrait stabilized that ideology by reproducing it repetitiously and drawing subjects into its networks of sociability. The portraits in Jawhariyyeh's albums could not be imagined without changes in land tenure, the standardization of currencies, the proliferation of print media, or the opening of new types of schools and education. The portrait was the surface where these transformations, institutions, and social relations appeared natural but also acted as a mediating object to gauge and make sense of the changes under way in Palestine.

The studio practice of Krikorian and Raad as seen in Jawhariyyeh's illustrated history cogently stands as representative of how the portrait was a visual condensation of a modern subjective ideal to which the composite new citizen, new class subject, new gendered subject, new national subject, and new individual could ideologically identify. Therefore, Jawhariyyeh's album evinces that portraits were the *afterimage* of social and economic shifts that had already inaugurated changes in what constituted selfhood itself, changes in what structured identification, and indeed subjective-social desire.

Stabilizing Portraits, Stabilizing Modernity

By the turn of the century, Iskandar Shahin Makarius had taken the place of his father, Shahin Makarius, as resident photography expert at *al-Muqtataf*. Iskander Makarius is best known for establishing the famously popular *al-Lataʾif al-musuwwarah* (Illustrated pleasantries), the Arab world's most prominent photographically illustrated magazine. In 1905, Makarius remarked that, since the wet collodion process had given way to gelatin plates, as "the number of photographers have increased, so too have the number of portraits increased."[1] Makarius's interest in photography and photographic innovation outstripped even that of his father's. He enthusiastically notes the centrality of photography in modern life: "The doctor, engineer, craftsman, scientist, scholar, and worker rely on photography in their work to various degrees of importance. You have seen what it has done in astronomy, medicine, engineering, etching, printing and other professions."[2] In relaying the latest technological developments, Makarius repeatedly identifies photography as a practice located in everyday life, at work and at home, during his father's tenure as editor. A commentator elsewhere in *al-Muqtataf* contrasted a scantly decorated native house to a European home in Beirut. The latter contained the very accoutrements and props that one finds in the studio portrait. The tables, chairs, and bookshelves were well crafted and displayed precious items (*tuhaf*), books, and a complete set of *al-Muqtataf*. "A variety of photographs representing some natural views and others portraits of

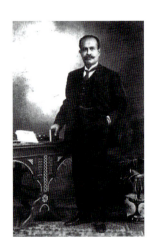

famous men," he states, were on the walls and tables, while photographic albums, at which "the eye would never tire of looking," were strewn across tables and shelves.[3]

By the first decade of the twentieth century, the props and signs replicated private spaces or at least idealized private spaces. The portrait of Jurji Zaidan, owner of *al-Muqtataf*'s rival *al-Hilal*, articulately details his identity (fig. 49). He chose a book to hold in his right hand, and on a desk behind him, papers abound; a plant, a carpet, and an inkwell complete the picture. Author, editor, social commentator, and self-educated historian, this might as well have been his office. A man interested in reform, of reaching into Arab history to recreate Arab modernity, his Damascene desk inlaid with mother-of-pearl provides him with the perfect, overdetermined index to represent his work in the modern arabesque, while also referencing his home province, Syria, famous for such furniture.

A man of great discretion, even Victorian sensibilities, Zaidan's portrait was a means for him to bring his private self into a public space. He was not a man of extravagance. Quite to the contrary, he, like *al-Muqtataf*'s Protestant Nimr and Sarruf, were men of thrift and prudence, whose temperance informed their vision of society and the home. The portrait reproduced this aesthetic from its earliest years, as was expressed in the omnipresent discourse of "taste" (*dhawq*).[4] *Dhawq* was the aesthetic of *al-nahdah*, integral to the process of *embourgeoisement*, at least, in the urban centers such as Beirut, Jaffa, Jerusalem, Alexandria, and Cairo. It united the expanding networks of mothers, fathers, sons, functionaries, professionals, clerks, intellectuals, merchants, and compradors within common rules of decorum and propriety that governed everything from behavior to decorating one's home.

Photography was an interpellation of this aesthetic, a concretization of *dhawq*'s multiple layers. Photographs, we are told, should be "proliferated in the living room" and photographs and albums were "spread throughout the room." The column "Tartib al-Bayt" (Arranging the home) explains how best to display them: "You can collect many of them in frames, which you can make inexpensively at home. This is done by cutting a piece from cardboard and making it into a frame, and you dress it in velvet or material or some sort of textile, … Gather these frames together and fill a narrow space with them one after the other. It can be simply arranged and standing up on a table in a zigzag pattern so all the photographs are apparent, thereby best utilizing the photographs from the purchased album."[5] Despite their differences, Wasif Jawhariyyeh's illustrated history of Palestine shared aesthetic and social qualities with the ready-made photograph albums of Princess Zeyneb and Prince Ibrahim, mentioned in Ellen Chennells account. Perhaps, they even found a shared aesthetic with Abdülhamid's albums, albums which themselves could be imagined as a reflection of his view that the empire was his own abode. The

formalistic and repetitious qualities of the studio portrait in these various albums were bound by a shared *dhawq* that "hailed" or interpellated new Ottoman, *nahdawi* subjects and interpolated them into new social (national) space that was represented so formalistically by the studio during the Ottoman era and *al-nahdah*.

This chapter is a case study of the "manifest content" of the portrait. It will show not only how the *nahdah* photograph ideologically "hails" or "interpellates," in the words of Althusser, the Arab subject to see him- or herself in the portrait but also that the portrait itself places, or "interpolates" that subject within a space that represents and organizes life and identity.[6] The portrait hails its sitter (and its viewer) as an individual, gendered, class, national and/or sectarian subject. This chapter culminates with a case study of Masis Bedrossian and Ahmad Amin, showing how this interpellation and interpolation occur and also how these processes stabilize the ideologies that enable photography and make it intelligible. The visual orthodoxy and repetition of this otherwise generic portrait stabilized the ideology of its own worldview and the social relations therein. As an image-screen of its materialist and ideological roles, the portrait as a material object and its manifest surface were a stabilizing object, as we will see, even if its latent content worked to disrupt the naturalness of this ideology.

Bullets, Droplets, *Taratir*, and X-Rays: Capturing the "Calm of Spirit"

At the turn of the century, Ibrahim al-Yaziji wrote in his short-lived journal *al-Bayan*: "Over the past twenty years, the craft of photography has reached degrees of accuracy the likes of which it would have been impossible for the imagination of humanity to reach. It has achieved an increase [*taqwiyah*] in the sensitivity of the [photographic] plate in ways that make it exceed human vision at a distance. [The camera] has become an eye for the human eye, seeing what is absent [*ghab*] because of [its] precision and speed."[7] Al-Yaziji, like al-Jalkh, observed photography's ability to allow humans to more accurately register visible and invisible objective experience.[8] If al-Jalkh saw the camera as a scientific instrument, an *extension* of natural science, al-Yaziji saw the photograph as *extending* limitations of human sight. In this regard, the rapid development in photographic technology affected its discursive developments. The "miracles of photography," to quote al-Yaziji, could exceed the limits of human vision. The fascination with the "speed and precision" of the camera in capturing images beyond the abilities of the naked eye persisted in the *nahdah* imagination. Articles frequently noted the improved technological and scientific developments within photography, which now allowed the camera to register "a drop of water falling on a flower, a lightning bolt, and a bullet exiting the mouth of a rifle."[9] Photography's miracle was

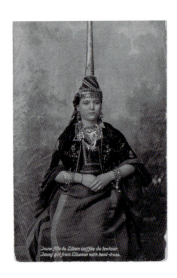

Figure 50.
"Jeune fille du Liban coiffée du tentour. Joung [*sic*] girl from Libanon [*sic*] with head-dress." Universelle Carte Postale André Terazi & fils, Beyrouth–Jerusalem.

not metaphysical; rather, the marvel was its ability to see scientific reality beyond the constraints of human physiology.

The vignettes of Zaidan and al-Yaziji complement and contrast with one another. Photography had become ubiquitous, insinuating its utility into commerce and technical professions while also interpellating "individuals to subjects," representing those like Jurji Zaidan in genetic patterns that reflect their identity. The portrait is where these two vignettes meet. Its surface is where realism meets representation of the subject's inner world. By the time Zaidan was posing for his portrait in Cairo, the camera was seen, in an unsigned article in *al-Muqtataf* titled "al-Taswir wal-jamal" (Photography/painting and beauty), as a "mirror drawing the person reflected in it. These images are perfect [representations] with nothing extraneous or lacking except in the absence of colors, all of which are made in black and white."[10]

The author goes on to instruct that, in order to capture the "calm of spirit," the sitter (the photographed, *al-musawwar*) should wear clothes that will capture the true self and that will not be distracting (fig. 50). He or she should not wear anything that is not worn naturally or that is a contrivance, "such as tarboosh, *'ammah*, hats, and seductive clothing like short sleeves, which women are wearing recently. They should not wear *taratir*, the conic hats they used to wear on their heads at the beginning of the last century. Other forms of women's fashion that change from year to year, and now even men's fashion do this as well, should be avoided. ... This is why portraits are taken of the head, neck and upper chest because only the face is a *valid* guide to the person, where dress cannot add anything to the picture."[11] Against the repetition of the idealized classical and bucolic backdrops, standardized postures, self-conscious props, and baroque furniture and salons, the interpellation of the indexicality of the photograph, the subject itself is the anchor of the portrait. Just as the camera captures a bullet, it captures the interiority and essence of the subject.

Dress, as we have seen, was an ideological choice, but it was not determinative of ideological or class position. However, costume *was* determinative of the character-type, where the sitter was an object of the photograph, not its subject. The image of a Lebanese "young girl" wearing a "traditional" head *tartir* (*taratir*, pl.) and dress was produced not long before George Tabet's cabinet card of a girl from Beirut (fig. 51). The image is flat despite its elaborate color. The sitter has no interiority. She is collapsed into costume. She is speechless and stagnant. The clothes, not the sitter, are the subject of the portrait. The image is not passed to her family or friends but detached from her life-world. The photograph is a picture, not a portrait. The young girl posing for Georges Tabet is anonymous, but she has subjectivity. Her white clothes and rose celebrate Easter, a ritual that was frequently commemorated with a portrait among Christians in Lebanon and Palestine. This image

would be displayed in her home and given to relatives. The "young girl" with the *tartir* sits in empty space; even her chair is enveloped by her robes. She is in the center of the photograph only as an object should be. Tabet's young girl stands in studio space, photographic space, and social space. The composition is based on the principle of thirds, where the bureau and basket of flowers, then her body, are offset by the empty space. The timelessness of the *jeune fille du Liban* contrasts with the Beiruti girl's Victorian collar, dress, and shoes.

Tabet's portrait fulfills the writer in *al-Muqtataf*'s requirement to "show the character of the sitter and his struggles, and how his face usually appears and what distinguishes him from others especially if he is handsome."[12] Photography in the Arab world reflected not only the individuality but also the sociability of the sitter. The portrait represents the self as a member of a social class, a community, nation and, simultaneously, an individual subject. The sociability of the Lebanese *jeune fille* is at best a fetishized romanticism or, at worst, a discredited mode of living that was archaic and backward. The sociability of Tabet's young girl, by contrast, enacts the *Arab imago*, not an arabesque. Her "calm of spirit" and the portrait conjoin to stabilize a *nahdah* representation that "hailed" both sitter and viewer, confirming that they were now subjects of *nahdah* modernity.

Photography's ability to capture raw character was a radical stroke of realism in which, as Egyptian literary critic 'Abd al-Muhsin Taha Badr put it, "representation of place and of the individual's self-experience of place merge."[13] But instead of creating a "proper narrative space of the modern novel," it imprinted a manifest surface and enacted an ideal *imago* that stabilized, brought together the seen and unseen, by making visible the concealed reality. Within a world of fluidity and change, of social and political transformations, "photography captures things that the eye cannot see; stars, planets and comets in astronomy; people and things in motion too fast for the eye to detect. ... The abilities of the camera extend beyond the limitations of human vision; it is a prosthetic to "expand the power of the individual."[14] Photography's charge to capture the "character" of the individual returns us to the "optical unconscious" of the camera and the photographic processes of repetition that obfuscates that unconscious.

Walter Benjamin coins the phrase specifically in reference to Eaweard Muybridge's experimentations with stop-motion photography, the phenomenon to which al-Yaziji was referring when he spoke of bullets, droplets, and lightning bolts. This "optical unconscious," Rosalind Krauss elucidates, is necessarily not the unconscious of the camera but of the "field of vision," the "scopic field," a regime of seeing, or, in the context of this work, the societal *manzhar*. It is the "projection" of how the world is seen that is, I would add, organized by the material forces and ideological formations that give the portrait meaning.[15] No doubt, the portrait is an instantiation of an ideal subject. The ideal subject, however, does not precede the individu-

Figure 51.
Georges Tabet, anonymous portrait, Beirut, cabinet card, 16.3 × 10.5 cm.

alized subject created by the Ottoman Empire's changing economy and social order. It proceeds from that subject. The Hamidian albums show that the realism of photography was a state project, as John Scott observes.[16] Likewise, the output of the studios of Beirut, Istanbul, Jerusalem, Alexandria, and Cairo shows that realist *manzhar* was also a class project and an *effect* of political economy. The *nahdah* was just as much an expansive project to negotiate, mediate, and interpellate social changes as to effectively reengineer civil and cultural order. The image imprinted the *manzhar al-nahdah* and the existence of its subject, proving, in fact, that the portrait was not just representation but material reality.

The technomaterialism of the photograph imprints, as Christopher Pinney suggests, material conditions on the image-screen—conditions that register the physicality of the photographed but also those that might otherwise escape yet that undoubtedly inform the manifest.[17] C. P. Goertz's familiar discussion of invention in *al-Muqtataf* tells us that his nine by six and a half–centimeter, compactable camera "takes a photograph faster than a blink of the eye" and "photographs figures that are motionless, such as natural or man-made views, or motion such as a flying bird and running horses, boats, and moving pieces of a machine."[18] In both cases, the cameras are easy to use; fast, inexpensive, and portable in one's pocket; and they can take pictures of objects more than six meters away. "This then makes it most possible to photograph whatever one might want to photograph. If the camera's owner comes across a famous man, a beautiful face, a common mare, a strange sight or a passing procession, he could photograph it without difficulty or effort."[19]

Nahdah commentators remind us of photography's abilities to capture stars or bullets exiting the mouth of a rifle. This is to say that photography writers of the time had a sense of the latency of vision and the perspective that lay within the abilities and limitations of the camera and the body. Perhaps this intuitive attention was most glaringly expressed in the attention paid to "new photography" between 1870 and 1910, particularly Enricio Salvioni's cryptoscope and, even more, Wilhelm Conrad Röntgen's "Röntgen rays" or X-rays. X-ray photography inventions probed the physical boundaries of what could be photographed to such an extent that articles were reproduced from Western scientific journals such as *Science* discussing the possibility of photographing dreams and ghosts.[20] Nickola Pazderic asserts that photography's fundamentally mysterious "nature" authorizes its visibility and visceral force.[21] The "mysteriousness" of photography is the effect of its ability, or sensibility, to "objectively" capture and index the invisible and visible. That the photograph's "miraculousness" was a part of the photography does not contradict its fundamentally proto-realism but confirms the image as a *verum factum*, a scientific and object statement still endowed with that which, scientifically, subjectively, and aesthetically, lies beyond human capacity.

The Shock of Modernity and Interpellation:
The Example of an Egyptian Shaykh

Scott McQuire observes that, "photography transforms the practice of self-identity and amplifies the duplicity of the term 'subject,' pointing on the one hand towards the sovereignty of the individual, and on the other to the possibility of being subjected to the rule of normalizing discourse."[22] Such an observation does not rob Arab photography of its own particular story. The story of photography starts not in the apparatus and the compositional form but in the normalizing discourses that it enabled and serviced. The normalizing discourse of the late Ottoman Empire was an overarching *nahdah* discourse, a civilizational discourse fully designed to stabilize societies and homogenize social order against the cataclysmic social, economic, and political turbulence that accompanied the capitalist reformation and reorganization of governance, social hierarchy, and cultural norms and practices.

The carte de visite represented the ideologically laden ego-ideals of new bourgeois and petit bourgeois classes, couched within the narratives of modern national identities. A history of Arab photography takes into account these ego-ideals and the way they overlap, formalistically, with European cultural and social practices, determined less by French or English culture than by the logic and contradictions of capitalism. Ottoman modernity dispossessed as much as it enfranchised. As we have seen, Abdülhamid's albums document the homogenization of the empire under his central power. The character-types of Osman Hamdi Bey and Sébah that were produced for Abdülaziz were visually displaced by the uniforms, clock towers, *serails*, municipal buildings, railway stations, and military academies of his successor. *Osmanlilik* ideology aimed for the uniformity of the empire, containing and disciplining "backward" and archaic confessional and ethnic identities.[23] *Nahdah* intellectuals subscribed to Abdülaziz's imperial vision that respected ethnic and religious diversity, but they distinguished themselves from Abdülhamid's co-optation of *Osmanlilik*, into which he injected pan-Islamism as a principal unifying feature in order to mobilize and unify Sunni majorities against ethnic communalism (namely, Arabs and Kurds) and religious minorities (namely, Armenians, Greeks, Slavs, and Christian Arabs). The tensions between communal and Ottoman identities are mediated in the photograph. Recent scholarship on the history of labor, state and institutional formation, and radical movements show how Ottoman cosmopolitanism's synthetic character speaks to the nature of capital, for example, in Beirut, Cairo, and Alexandria but also to the violent disruptions of modes of production and social hierarchies in Lebanon and Egypt against the otherwise celebrated homogenized representation of new liberal national identities.[24]

The photographic portrait presents a stable and fixed subject in an era defined by flux, by social disintegration and reconstitution. That

representation, as we have seen, is only bolstered by photography as a practice that socially actualizes native modernity through both its technical production and its social exchange. The constancy of the images mediates the transformations under way, transformations that often occurred before they clearly appeared. They do not provide a roadmap, diagram, or script by which new classes can construct themselves and perform their identities in order to become them. These images do not only perform new identities. *They stabilize them.*

To understand the carte de visite as a stabilizing force, we look to a variety of discourses and practices, experiences and narrations, to understand *al-nahdah* as a process of standardization and naming in an era where writing, social acts, and cultural practices, such as photography, offered a space for interpellation, a place where discourses could come together in order to produce a narrative and make sense of the changes that had transpired. The life and work of the Egyptian imam, translator, writer, and editor Rifaʿah Rafiʿ al-Tahtawi is illustrative. Myriam Salama-Carr notes that al-Tahtawi's translations of French Enlightenment literature were a "mediating agency" that negotiated the vertiginal social and physical landscape of Paris. The shaykh's writing was underscored by a strategy to de-exoticize the West to his Egyptian Arab readership and to fold its concepts into those found in Islamic heritage, in order to mitigate the epistemological rupture that this competing worldview otherwise engendered.[25] Scholars such as Shaden Tageldin, Kamran Rastegar, and Tarek el-Ariss, have commented on the conflicts within the process of naturalizing a *nahdah* perspective, most palpably seen in the works of Hassan ʿAttar, al-Tahtawi and al-Shidyaq in their encounters with the French and English.[26] Al-Tahtawi, el-Ariss observes, was unable to visually process the massive organization of space, resources, and infrastructure in his initial encounter with Marseille. El-Ariss understands al-Tahtawi's reaction to being disoriented by a series of mirrors on the walls of a café in terms of the Benjaminian "shock" of modernity, subsequently mediated by the shaykh's recourse to writing in the third-person in a neoclassical poetic style.[27] El-Ariss offers *nahdah* poetic, aesthetic, and narrative forms as the "stage" or site of negotiation for the "trials of Arab modernity."

The aesthetic foci of al-Tahtawi's "poetic associations" lead us to identify the passing of an alternative Alzhari epistemology that became arcane and recoded into his new modern perspective, or *manzhar*, a term that al-Tahtawi repeatedly relies on in his discussion of seeing himself vis-à-vis Egypt and the café in Marseille.[28] Al-Tahtawi's referencing himself in the third-person can provide a glimpse into a classical poetic perspective that is displaced by a subject-centric "view," one that places the author-subject-citizen-functionary as a subject of the rationalized state rather than only a subject of ruler-autocrat-patron social relationship. The aesthetic of the literariness also is an aesthetic of al-Tahtawi's vision. The anxiety of the

poetic association and literary form is an indication of a disintegration of a self that has passed into a new weltanschauung and social vision. The description of the time that Al-Tahtawi spent in France is not particularly useful as a chronicle of France itself or as an account of the "Arab encounter with the West." Rather, it offers a narration of how the use of public and private space, geography, architecture, urban design, and interiors, not to mention the space of certain novel modes of sociability, hailed the shaykh, to interpellate him as a subject of Western power. In turn, his own act of writing, his narrative, was an enactment of this interpellation as a means to process the overwhelming effects of the spectacle that assailed al-Tahtawi.[29] His poetic third-person gives way to the centrality of seeing from a first-person perspective. In other words, over his five-year sojourn in France, the shaykh is able to internalize a perspective that mitigates the initial disorienting effects of what will be Sadiq's cartographic vision, to eventually interpellate into the organizing framework and complete his own "transformation from Azharite ʿalim to bureaucrat."[30]

For all its haunting, *nahdah* writing served to process the effects of the social and economic shifts of the era. The manifest surface of the portrait was a projection of the vision and writing of *nahdah* intellectuals, like Khayr al-din al-Tunisi, whose texts conveyed absolute certainty, whose treatises and manifestos of reform, such as *Aqwam al-masalik* and *Ithaf ahl al-zaman*, explicitly laid out the formula, structure, and vision of what modern indigenous rule and order looks like. Photography, as we have seen, is the imprint of this narrative, intellectual, and social movement, of the vision of reformers, technocrats, bureaucrats, and organic intellectuals, who were instrumental in defining, naming, and systematizing the economic transformations, political tensions, and social contradictions and displacements of the late Ottoman period. Some have argued that railway travel stimulated the emergence of a new kind of visual perception. The spectacle of the landscape in movement allowed passengers on the train to experience a form of "panoramic travel" as never before experienced.[31] This is an example of technology, economy, and perspective's collusion in interpellation and interpolation.

Stabilizing Portraits and Interpolating Subjects

Just as Muhammad Sadiq Bey's *manzhar* of the Prophet's Mosque arose out of his knowledge as a geographer and cartographer, the "visual perception" that he could capture was already there, waiting to be represented. That perspective was predicated on and prepared by an inventory of knowledge, discourses, and technomateriality that preceded it, regularized and forged into a discourse not only through publications and the print media, but also by social and photographic practice. The photograph, rather than creating the new perspective,

was a material object of stability and certainty. True, the alterity of displaced systems of thought, experience, and sociability haunted photography. The violence of the disciplinary regimes and social history were pushed to the margins of visibility. However, its material and perspectival sureness mediated and deferred uncertainty. The portrait confirmed the coherence of what otherwise was the cultural dissonance of social transformation. It ratified the naturalness of visual and social practices that might otherwise seem *haram* (religiously prohibited). It made real what was "impossible for the imagination of humanity."

The social history of photography cannot escape the gravity of *al-nahdah*'s ideological hegemony. All cultural production was mediated by *nahdah* thought and activity; they were meant to provide, in the words of al-Yaziji, "the most stable effect on the society's ethics and its traditions, on knowledge, customs, and every cognitive level."[32] The portraits by Saboungi, Krikorian, Raad, Abdullah Frères, Sébah, and so on were informed by *nahdah* ideology and ideologically committed to interpellate the social transformations that the *nahdah* was organizing and making intelligible.

Just as the panoramic photograph helped mediate the dissonance of humans traveling at sixty miles an hour en masse, photography offered a place for the individual within the larger "picture" and vision of what society was supposed to look like, not in the future, but in the ever-reformed and modern present. The portrait then snuggly fits into the vision, writing, and project of those re-ordering the city and country such as ʿAli Mubarak, minister of education and public works, whose intellectual work and policies naturalized and gave elasticity to the *manzhar* that restructured Cairo.

Mubarak's work, while not commenting directly on photography, explicitly comments on the relationship between informed seeing and the limitations of the uninformed viewer—between the knowledge, science, truth, and subjectivity that underlie but are often disguised by the flux of change and the ignorance of the natural world and the "darkness" of an arcane subjectivity. His fictional travel epic *ʿAlam al-din*, for example, narrates the travels of an Egyptian shaykh and his son to Europe to assist an English Orientalist. The journey is a tour of engagement, mediation, negotiation, defense, and a processing of Egypt's emergence into a new era under the photophilic khedives. It was the khedival vision. Like the portraits in Jawhariyyeh's albums, vision collapses into subjectivity, melding exterior space with interior subjectivity to produce a national subject. Mubarak's *ʿAlam al-din* repeats the axiomatic nahdah mantra that the "light" of scientific and modern knowledge "illuminates the senses of Man. He looks to the sciences to discover the slumbering truths of physical realities [*akwan*]. Its possessor is cloaked in the magnitude of beauty, prestige, and sublimity, and that ignorance blinds his sight and covers him in the darkness of temptation and his dissolution."[33] Mubarak's tale

ventriloquized the Arab *nahdah* worldview regarding modern knowledge's position vis-à-vis social change that underlies the discourse on photography, a worldview expressed in works from al-Jalkh and al-Bustani to 'Abduh and Hussein Marsafi. His characters in *'Alam al-din* represent facets, layers, and strains of the disappearing, the arcane, the uncanny, and the modern. These characters are interpolated into the urban, rural, and national spaces of Egypt as defined so meticulously in Mubarak's twenty-volume *al-Khitat al-tawfiqiyah al-jadidah* (The new Tawfiqian plans); a magnum opus that mapped and organized the new streets and development of Cairo along with its history, monuments, and geography.[34]

Just as the "physical realities" of Cairo and the natural world existed and were waiting to be revealed, the portrait was a stabilizing sign of a subjectivity and subject that were already there. It was not a blueprint but a map of what already was. The portrait revealed the subjects of Mubarak's urban space. Photography served to interpellate the changes that had occurred and the transformations to come, inviting all to participate (or indeed get left behind) in the tour de force of national identity, class solidarity in the form of "unity and progress," market liberalization, and state order. The photographic event serves as a "hinge," the moment of the stability of recognition, the moment of intelligibility of ideological (class, gender, national, ethno-racial) positioning that facilitated the articulation of new social groups, capital flows, and power relations. The portrait reminds us that the rise of modern capitalism wrapped in the swaddling of Ottoman modernity, social reform (*islah*), and patriotism (*wataniyah*), in the words of Peter Gran, rested on "finding collaborators who would participate in one form of market restructuring or another or would go into the world and make new connections."[35] The carte de visite circulated to *confirm* these connections between the "new men and women" of the era, to perform them only as much as they awaited enactment. It was literally their calling card, left in the houses, stores, factories, schools, libraries, publishing houses, banks, *serail*s, municipalities, and palaces throughout the Ottoman Empire and beyond.

Chiasma Portrait: Ahmad Amin and Masis Bedrossian

Photography compresses time and space, bringing the ruler into the home as quickly as the suitor into the boudoir. It binds families across oceans and fugitives to the state. It freezes youth as readily as it freezes death, making both a measure of time, social space, and personal journeys. Within these transports, this compression of time and space, the portrait is a node of stability. In its own temporal field and its own circulating networks, it offers a stable screen from which ideology can be emitted. The carte de visite, the cabinet card, the portrait postcard, or larger-format portraits in the Arab world localized vernacular articula-

Figure 52.
Unknown photographer, Masis Bedrossian, 1920, portrait postcard, 13.9 × 8.9 cm.

tions of larger ideologies and sociabilities: uniformed men and boys in early Palestinian portraiture alongside traditional garb marking one's village, clan, and family; an inordinate number of frontal, half-shots of fez-donning *effendiyah* in the Egyptian archive; or portraits of local intellectuals, merchants, and statesmen wearing traditional Lebanese sirwal pants and *kubran* (vests). Localities within the Ottoman domain expressed vernacular politics and networks as much as visual forms, but the Krikorians and the albums of Wasif Jawhariyyeh or Jurji and Louis Saboungi, show us these vernacular accents were always mediated by, within, or against a nomenclature and epistemology structured by *al-nahdah al-ʿarabiyah*.

This study has focused on studios that highly associated with *al-nahdah* and the Tanzimat, such as the Abdullah Frères, Pascal Sébah, Jean Sébah et Joaillier, Saboungi, Kova Frères, the Krikorians, and Khalil Raad. These blue-chip studios are complemented by a throng of lesser known, virtually anonymous studios, ateliers, and photographers, who themselves were local entrepreneurs and craftsmen. Hasan Rasim Hijazi in Tanta or Soleiman Akle and Melik Photographie in Minieh or Georges Massaoud et Frères in Port Said, along with the number of high-profile Armenian and mixed-ownership studios in Egypt were not less informed by *al-nahdah* and the social transformations that produced it than their prominent counterparts.

It is the anonymity of these ateliers and photographers that matches the nature of the portrait. Regardless of their origins, innumerable portraits are found in the houses, stores, factories, schools, libraries, publishing houses, banks, *serail*s, municipalities, palaces, and archives of the former Ottoman Empire. Cairo and Alexandria pose fascinating examples of how history of photography is virtually impossible to comprehensively excavate but also an example of why such a history does not necessarily lie exclusively in the names of photographers, their origins, and their personal stories. The "genetic pattern" of the portrait reveals much about the portrait, its function, and its social value.

The portrait of Masis A. Bedrossian tells little alone (fig. 52). We know nothing about him, but his portrait was taken in 1920 in Alexandria by an unknown studio and produced as a postcard, as was common after 1910. Despite its anonymity, it offers a late example of this stabilizing image-screen. On the back of Masis's portrait, the Armenian inscription reads:

> *From my school memories,*
> *To my dedicated parents*
> *With the respects of your child,*
> *Masis A. Bedrossian*
> *Alexandria, 13 March 1920*[36]

The image stands as a surrogate for many others that mark the transition from boyhood to manhood, the transformation of a young man

to a "new man." Siegfried Kracauer reminds us that the photo-event maintains a special relationship between the materiality of the photograph and its history, and when the cords that bind the image to the social relations are ripped asunder, so, too, are the social currency and meaning of that portrait, and the viewer is left with a ghost of its original selfhood.[37] At this moment, however, the repetition of the image, its formality and content, its "painted scrims, dramatic props, whimsical frames," is the portrait's last defense against complete social oblivion, offering to us, as Joan Judge shows us, the "stubborn traces of quotidian materiality."[38] That is, if the portrait pivots on processes of identification—identification between self and ego-ideal, subject and society, or intersubjectively between individuals, between individuals and groups, and between individuals and institutions—the "quotidian materiality" is the last "tether" to the image's social reality, context, and history. Masis Bedrossian's image would offer up even less if he had not annotated it with his name, date, place, and some sign of its motivation.

Kaja Silverman's unpacking of Lacan's concept of "the picture" helps us rediscover the social force of Masis's portrait. She tells us that the representation and psychic meaning of the image "hinges less upon parody and deformation than upon the passive duplication of preexisting images."[39] The "duplication," indeed the repetition, of portraiture's formalism operates on a structural, semantic, and social "jointness," to borrow from Margaret Mahler. This jointness binds the subject to the portrait's materiality and provides that "object constancy" of the portrait itself, connecting its materiality to its societal network but also to the "interiority" of a new sort of individualized subject. Victor Burgin recognizes that the ideological effects of representation occur when "the stage of the represented (that of the photograph as object-text) meet[s] the stage of the representing (that of the viewing subject) in a 'seamless join.'"[40]

The *indigenista* portrait is an object of stabilization in the era of flux because, even if we lose the life history and experience of Masis Bedrossian, we find a meaning in its repetitious genetic pattern that was structured by a shared subjectivity and endowed with meaning and currency through a material social network that we see replicated throughout the cosmopolitan capitals of the Arab East. The repetition of the portrait provides, in Mahler's words, "object constancy" to the portrait despite the ravages of history and the cutting of its social tethers.[41] Repetition and duplication prevents the "splitting" of the object as it reinforces its permanence. This reinforcement only confirms the processes of identification—individually, socially, and ideologically.

This is not to say that photographs tell us something intrinsically. They often tell us nothing. Or worse, they lie. What is being offered here is a method. Studio portraits, such as that of Masis Bedrossian, provide us with an idealized subject who, "in effect, knows how to play with the mask as that beyond which there is the gaze." As such, we look to this portrait as a screen, a screen for the subject, the meet-

ing place between the internalized self and instantiated self, the individualized self with the social (class, confessional, national) self, and the object and the subject of gaze. This image-screen is "the locus of mediation."[42] Masis's image, in the end, offers us an opportunity to seize upon formalism's rootedness in "quotidian materiality" and pair it with narratives where the mediating image is otherwise lost.

Amin Ahmed (1886–1954) was a renowned literary historian, editor in chief, and social commentator. In his autobiography, he relates how he visited a "skilled photographer" in Cairo in order to take a "memorial picture" to commemorate his marriage a few days before. Along with the story, he provides an extended passage from what he wrote on the back of what must have been a large portrait, which is now lost:

> This is my picture taken on Friday April 7, 1916, four days after my marriage contract, and my age is twenty-nine and six months. I took books as my distinguishing mark in the picture, and so the photographer placed books of his in front of me. In my left hand I held Primer of Philosophy [by Angelo Solomon Rappoport], most of which I had translated into Arabic and almost finished. Thus I did not affect anything except that I chose to wear the suit I wore on the marriage day. Perhaps the motive behind this photograph was that I felt I was approaching a new life and a new phase. For I have finished the life of solitude and was approaching family life … Among the motives behind this photograph also is my knowledge that the thirtieth year ends the life of boyhood and youth, and opens a life in which reason and reflection will prevail. With a heart full of sorrow, I say that I did not take advantage of the period of boyhood and youth as I should have. Neither mirth, activity and entertainment however innocent, nor love found a way to my heart. I acted as an old man since youth, and this undoubtedly was a result of my home upbringing, which was based on fear and intimidation. For my home had no semblance of fun or joy at all. In this year, I feel some vitality as a result of the English lessons I took with an English teacher who reformed my mind as she reformed my tongue, and used to criticize my passivity and quiescence.[43]

Eventually a scholar and statesman, Amin was a product of the Khedival public educational project as much as he was a listless and alienated young man. He had studied in al-Azhar before transferring to the state's prestigious Dar al-ʿUlum. The school had made a considerable impact on him, not only directly but also producing his first intellectual mentor, a Shaykh in Alexandria who had "transformed [him] into a *new person*," freed him from "blindness" and "made [him] see" beyond being "a slave to tradition" and "liberated" him from "narrow-mindedness" and "broadened [his] horizon."[44] The rationalized knowledge of Dar al-ʿUlum prepared him for his studies in law

at the government's law school, Madrasat al-qudaah (Judges' School), which was established by Muhammad ʾAbduh and strongly supported by Egyptian nationalist leader and Amin's idol, Sʾad Zaghlul. Amin is known for his monumental studies of classical, particularly early Islamic, literature and also for arguing the social relevance of literature as an objective method of criticism.

The occasion of his marriage, and the event of having his portrait taken, appears as a very thinly veiled pretense for what is a narrative of self-awareness and self-discovery. The image is bare, heeding *al-Muqtataf*'s advice that nothing should be distracting, nothing contrived. The portrait was then the impetus for the young Amin's introspection and reflection that he wrote onto the back of the portrait. Literally the surface of the "mask" of the confident translator of Rappoport's *Primer*, Amin, the subject, tells us much about the anxieties of this Egyptian new man and the alienation of this "new person," who now could "see" from the perspective of the camera, his teachers, and cultural institutions. Much could be pursued in his narrative: the chasm between the ignorance of his father and the meritocratic order and rational knowledge of his mentors and schools, or the disjuncture between his deep, romantic melancholy over lost loves, including his neighbor's daughter, and the irrational behavior of her father, who prevented that love from maturing. He also had fallen in love with his English teacher, Ms. Powers, who "nurtured" his mind "with her education, knowledge, and experience," and who commented not only on his serious demeanor but insisted that a gentleman must have an "an aesthetic eye."[45]

At the time of the portrait, he had only recently mastered English, which he credits to Ms. Powers, who herself seems to have had a mental breakdown. In order to navigate these conflicts, he found solace and reassurance in two bookshops, one English and one Arabic. It is in these shops that he learned about the world and society, etiquette and swimming. He was charmed with the English bookstore where he bought three books written on how to behave as a husband, on what to expect from a wife, and what should be a proper family. Books, novels, and journals such as Sarruf's *al-Muqtataf*, ʾAbduh's *al-Manar*, and Jurji Zaidan's *al-Hilal*, "painted a picture" of what to expect from marriage and of what he "imagined" his wife to be, images and realities that were discordant.[46]

Amin grew up as a child of *nahdah*. He read not only the articles about new domesticity, public civility, and the value of modern education but was also reared on the novels of Jurji Zaidan (fig. 53). Zaidan's visual archive expresses his vision of domesticity, gender, and family found not only across his massive social commentary but also in his novels. This *nahdah* vision of domesticity advocated the "liberation of women," monogamy, and, of course, education. His family portrait from 1908 does not reproduce the photographic triangle that illustrates the father as the head of the family and the mother as the base. Rather, it presents his wife, Maryam, and Jurji sitting within the same

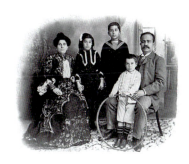

Figure 53.
Unknown photographer, Jurji Zaidan with wife, Maryam; daughter Asma; son Emile; and youngest son, Shukri, Cairo, ca. 1908.

plane, each bookends that contain their children. Zaidan's feminism was liberal but not radical. Females are clustered, Miriam's hand in daughter Asma's, who stands faithfully next to her mother, as if to promise loyalty to her gendered role in the future. The male cluster is anchored in Jurji's protective, affectionate hold on youngest son Shukri, while Emile, the older, stands verging on independence. Both his sons would grow up not only to pioneer photographic print media, but also follow their father as editors of *al-Hilal*, even though their own vision of Arab modernity would be quite different from their father's. Zaidan's family portrait instantiates the ideology of his novels, providing an intact, nuclear family that reproduces the ego-ideals of the *nahdah* in their children, their domesticity, their marriage, and their individuality.

For Amin, however, the lessons of these novels, books, the sciences and rationality of the new schools, and the knowledge relayed by the famed Arabic journals were discordant with reality. Amin's "imagination" had "painted my wife's picture, her character and quality in accordance with the description of the women" that he had read in the works of those new men and women of *al-nahdah*.[47] As such, he reached to the portrait to navigate this vertigo and make sense of the ideological imbalance between his personal life and his "seeing" and perspective.

While Amin's portrait is lost to us, the indexicality of Masis Bedrossian's portrait links the diachronic overlaying of the Egyptian intellectual's meditative narrative to the flat surfaces of portrait and its reverse side. The two are "duplicates," which together galvanize into a semiotic chiasma. Bedrossian's portrait postcard reproduces the ideology and priorities of *al-nahdah al-ʿarabiyah*: education, civility, patriotism, industry, respect, and love of family, all those very ideals that Amin repeatedly returns to and admires in Cairo, Alexandria, France, England, and the Netherlands. Although dated 1920, Masis's dedication, like Amin's narrative, contains a retrospective gesture to his "school memories," likely to have been before 1920. Amin's narrative, however, reveals the surface's *studium* as a material *point de capiton* between this ideology, new social practices, new dimensions of individualism (and self-interiority), and history. In this regard, Bedrossian's portrait is the image-screen to Amin's autobiography of "new manhood." As such it mediates the desires, dissonance, expectations, and alienating transformations of Amin's life. It represents a fixed, hegemonic representational set that reassures both subjects (Amin and Bedrossian) that their modern education and rationalist and cosmopolitan worldviews, their *manzhar*, would stabilize and mediate disruptions, alienations, discontinuities, and contradictions that occurred in their personal and public lives at the time. The image activates the undergirding identifications between the subject in the image and the ideology that gives that portrait meaning during a time when the old Ottoman order had collapsed, Egyptian confrontation

with the British was at hand, Egypt had been reoccupied during World War I, and the mandate and independence movements arose.

Lacan illuminates this process of identification and presentation, self-presentation, and representation into projecting our idealized self-image. The "scopic field" of modernity was reproduced methodically in the perspective of Madrasat al-qudaah, Dar al-'Ulum, and the national Egyptian University. This scopic field is not without its own mechanics, where self-views, individuality, sociability, and inter-subjectivity are organized by certain concomitant desires that are both the individual's and society's. The scopic field of *al-nahdah*, in Lacan's words, was "articulated between two terms that act in an anti-nomic way," where subjects are viewed by things (the object of the gaze) and the subject views the world (the subject of the gaze).[48] The portrait-image-screen is the composite of these two forces, which themselves are an assemblage of a vector of social forces and historical consequences.

Against the fact that anonymous studio photographers took both portraits, the social "tether" for both of these images has been frayed thin. Yet, Amin's narrative gives voice and sociability to forces impinging on Bedrossian's portrait—that of a young man living and educated in Alexandria's ancient Armenian community, which had swelled after the Armenian Genocide only a few years before Masis's portrait was taken. Indeed, Richard Milosh, grandson of Arakel Artinian, founder of Cairo's successful Studio Venus—which first opened in 1912 on 23 Rue Chubra before moving to the fashionable Kasr el-Nil Street—relates that the effects of the genocide were strongly felt and affected the Egyptian Armenian community.[49] Masis and Amin certainly are two completely different people: an Armenian, likely bourgeois, likely educated in European languages, and dedicated to and loved by his parents; the other a Muslim Arab Egyptian, product of state education, destined to be a bureaucrat, alienated, repressed, and impacted by an overbearing and harsh father. The image-screen is a chiasmic synthesis, presenting the indexical subject of the young, educated, dapper native graduate, certainly more confidently commanding the lens' gaze than the young Abdülhamid.

The ideological *studium* of the studio portrait gave meaning to this self in a time of flux. The portrait itself offered Amin, literally, a narrative space to stabilize his identity between those certainties in this life (such as the lessons of the *Primer*) and the uncertainties of how to be a "new person," Gran's new man, and new husband. The stability of the image spoke to the social and political changes on which Ahmad Amin himself is known to have commented throughout his life, not only in the print media of the day but also his scholarship. Amin's multivolume magnum opus on the history of Islam places modern Egyptian identity within a universalizing, rationalist, and secular history, endowed not by its special relationship to the divine but by their contribution as Muslim Arabs to knowledge, statecraft, and the beaux arts. Amin's portrait

is an interpellation of his scholarship, which is the direct consequence of the preceding half-century of political activism and ideological standardizing by nationalist and *nahdawi* intellectuals and reformers. His ideological and scopic *manzhar*, that sight that he began to see upon his apprenticeship under the Alexandrian shaykh, was shaped by those intellectuals, reformers, and functionaries preceding him and the transformations of political economy that accompanied, if not preceded, them. Shared class, national, and gender ideology, a shared investment in *nahdah* ideology, sutures Masis's portrait together with the overlapping narrative of Amin's absent portrait. On the cusp of Egyptian independence, in the wake of the collapse of the Ottoman Empire (and the Armenian Genocide), and the advent of the national victory of the *effendiyah* class, the portrait stabilizes the discourse of civilization and progress and the perspective of *al-nahdah*.

In brilliantly fleshing out the nuanced ethnic, racial, and social strati-fication of slaves and their lives in Egypt, Eve Troutt Powell notes Ali Mubarak's keen adeptness in narration through his writing of a "visual map" of Cairo.[50] She opines that Mubarak, a capable cartographer and draftsman himself, thought that the visual guides and maps would be beyond his readers' capabilities. Perhaps Mubarak feared that the naked and transparent photographs of Tawfiq's Cairo would have dis-rupted the authorizing a historical continuity between al-Maqrizi's Mamluk past and the "modern" khedival present. One thing is clear: Mubarak, for all his omissions, was "bringing history to his fellow Egyptians," history that his narrative needed to tightly mediate.[51] The city had changed in the fading memories of its inhabitants. Its reorga-nization is depicted in massive detail, a process that was repeated at various scales in Haifa, Beirut, Aleppo, Alexandria, Jerusalem, Istan-bul, and even Mecca and Medina.

Beirut, for example, exemplified the changes of the late Ottoman Empire. The city had grown exponentially by the end of the nineteenth century. The Beirut–Damascus Road was built in 1857, followed by the Beirut–Damascus Rail line in 1895. Development of the port and its modernization in 1892 by French and local capital secured it as the main entrepôt for shipping raw and finished materials and foodstuffs between the Mediterranean and the hinterland. The Ottoman bank opened in Beirut in 1856 and was built on the Beirut seafront in 1863; Credit Lyonais's branch opened in 1875, financing silk and tobacco sectors but also starting Beirut on its road to being a regional finan-cial hub. Beirut had become the city of famous *locanda*s and hotels, universities, banks, and salons—a city of new working classes, civil servants, *petits fonctionnaires*, craftsmen, students, educators, pub-lishers, dockworkers, and day-laborers. Architecturally, the explosion of new *maisons* built in the central-hall style marked the port along-

side an Ottoman construction project most prominently represented by the neo-Oriental style of Yusuf Aftimus.

Beirut was a city of new men and women of the carte de visite, a city that nested the networks of its circulation, that offered the interior and public spaces for the portrait's exchange and display. The Mountain and city, as Ilham Khuri-Makdisi shows, were rife with labor and economic tension that made the portrait's stabilizing effect more trenchant, serving as one small mechanism and trace of the social relations needed to maintain cohesion and cooperation not only within class networks, but also between classes, citizens, and the municipality, which often protected the rights of local workers and compradors against foreign exploitation.[52]

Against this urban backdrop, Jubran Khalil Jubran (Khalil Gibran) wrote *al-Ajnihah al-mutakassirah* (*The Broken Wings*), published in 1912, arguably the first Arabic novel. It is a bildungsroman of a young man living in a Beirut populated by wealthy, corrupt clergy and the poor, set against an increasingly distant mythical history and natural beauty and his love for an innocent girl.

In the story, the wealthy and yet affable Faris Effendi Karami lies on his deathbed and calls for his only child, Salma, a beautiful young woman whom the protagonist loved. Faris Effendi then

> *reached his hand under his pillow and pulled out a small, old portrait in a gilded frame. The frame's edges had been softened by the touches of hands and its inscriptions erased by longing lips. Then he said without turning his eyes from the picture [rasm], "Come closer dear Salma. Come closer to me, my child, to see the image [khiyal] of your mother. Come and look at her shadow cast on the page of this paper." Salma drew closer, wiping her tears from her eyes so they would not drop from her glances onto the tiny picture. After she had gazed at it for a long time as if it were a mirror reflecting her qualities, her form, and her visage, she drew the picture close to her two lips and kissed it repeatedly in profound grief. Then she screamed, "Oh, Mamma, oh Mamma, oh Mamma!" She added nothing to this word but only returning to it to place the portrait to her trembling lips as if she wanted to infuse life into it with her burning breath.[53]*

Jubran's story focuses on the vanishing bucolic spaces of Beirut, and we see the city's architectural and urban space only in the small, deriding glances at its opulent *maisons*, what he calls in his short story "Wardah al-hani," "whitewashed sepulchers in which the seduction of helpless women is concealed behind eyes darkened with kohl and reddened lips."[54]

This is Salma's trajectory; she is destined to marry against her will Mansour Bey Ghalib, the nephew of a powerful and corrupt Maronite bishop. Despite his vision of Beirut that is an explicit rejection of the *nahdah* positivist worldview, the story resonates with *nahdah* dis-

Figure 54.
Alexandre and
Joseph Kova,
anonymous
bridal portrait,
Beirut, ca.
1900, carte
de visite.

APⁱ & JOSⁱ KOVA. BEYROUTH.

courses on love, marriage, parenting, and domesticity, shared by Jurji Zaidan. The photograph hailed these discourses and offered a common representational space where Jubran's romanticism could meet Zaidan's positivism. For all of Jubran's rejection of modern Beirut and the vision that built it, the portrait posed a jointness that bound the vision of those as different as his romantic archetype and the urbanite Faris Effendi.

Images such as that of the Kovas' anonymous bride offer an example of a genetic pattern seen throughout Lebanon, Palestine, and Egypt, especially among its Christian minorities (fig. 54). The dresses are always white and "European," except in Palestine, where women often pose in Palestinian *thawb*. Women fill the frame, leaving little space between their bodies and the photograph's borders, and compositional delicacies often are left to the wayside to signify that the portrait is "all about the bride." They are, just as today, highly stylized and staged, displaying the great care devoted to elaborate dresses, flowers, hair braids, and bridal veils. These are the foundational images of families, families with different social and class conditions. They hold object constancy because their social networks and genetic patterns are so evocative, because these images travel across class and geography, and even particular worldviews.

This chapter has offered an exposition on how the photographic portrait was a *social product* and alludes to a methodology of reading it as a product with social currency. The portrait was the materialist instantiation of modern knowledge upon which "progress and civilization" are built; it offers the stage for modernity's *studium*, its index, and its language. On the other hand, this *studium*, this perspective of a disenchanted world, was imbricated with the personal, with interiority, with intimacy, as well as with faith, and that which the objective self is hard-pressed to represent. Living in one of Beirut's palatial homes built by the new flows of capital and commerce into the port city and its bucolic surroundings, Faris Effendi would have been acquainted with the photographers of the city and would also have been a reader of the journals that would tell him about the value of photography, decorum, and citizenry. His long-deceased wife had visited such a studio in the last decades of the nineteenth century, leaving her daughter and husband with a portrait "scored" by an inscription of sentimentality. While Jubran's romanticism questioned the disenchanted, *nahdah* perspective, the photograph remains a supplement for Salma and Faris Effendi as well as a conduit for emotions that are inextricably linked to change, loss, and death. The portrait both fills and empties. It is a stand-in and a sign of loss. The emotionalism invoked by the portrait points to the photograph's own limits, yet it also stabilizes those emotions, placing them within the *verum factum* of the image, offering a surface upon which to identify.

The Latent and the Afterimage

In Tawfiq Yusuf ʿAwwad's short story "Qamis al-suf" (The wool chemise), a nameless peasant woman spends the morning frenetically cleaning and organizing her rustic cottage in anxious anticipation of a rare visit from her son, Amin.[1] During her preparations, she stops and fixates on two photographs of her son and deceased husband hung on the mirror. One is the portrait of her son at ten years old with his hand on a book. The other photograph is of her handlebar-mustached husband with her son. After experiencing the repetitious genetic patterns of the carte de visite throughout this book, we can imagine what these photographs might look like. Perhaps Amin and his father looked similar to the Beiruti notable Ahmad Lababidi and his two young children, Salah and Yahya (fig. 55). Amin might have sat on his sitting father's knee, or perhaps he stood next to him, deferring to his position. The portrait of her husband, as well, was repeated throughout the years. Men's busts filled oval portraits. Just as described in the articles of *al-Muqtataf*, these vignettes offered only head and shoulders, as if their masculinity, and certainly character, revolved on the axis of their resplendent handlebar mustaches (fig. 56).

Amin, however, hardly demonstrated such vanities. He is an employee in the city, perhaps a petit-effendi who would have patronized the ateliers of Nasr Aoun or Assad Dakouny. He returns to his ancestral village for Christmas holiday, bringing his city-born, materialistic wife. The story that follows is one of alienation and loss,

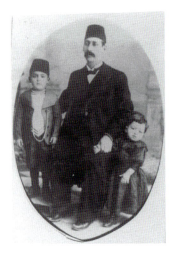

Figure 55.
Unknown photographer, Ahmad Lababidi and his two children, Yahya and Salah, black and white mounted on cardboard, 19.4 × 13.8 cm.

Figure 56.
Unknown photographer, George Sadiq, black-and-white print, ca. 1910.

illustrating the archetypal conflict between the ethos of urbanity and individualism and rural sociability. His mother, unable to share Amin's bed (as her husband's supplement) or his physical affections (as her son), is left with nothing but her photographs to fulfill her intense but cryptic, incestuous love for her son. The incestuous desire for Amin is a deterritiorialized communal desire. This was the misdirected desire that found no fecundity in place and time in a society that operated on either *Osmanlilik* uniformity or sectarian nationalism of Mandate Lebanon, both having reorganized the social relations between villagers and their land, if not gender roles and their families.

The identification with the portraits springs from a desire that originates and is structured by a psycho-social configuration that has been eroded by modernity's arrival in Lebanon. The portraits express a social relation and a *verum factum* that cannot be understood by the mother. No "jointness," in Margaret Mahler's words, between mother and son can be achieved because the process of individuation lies beyond her perception: she is not invested, in any way, in the *nahdah* and nationalist discourses of self and society, of gender roles and class ideals. These portraits do not offer a *habitus* for enactment and therefore cannot provide an "object constancy," a stabilizing force for her, because they function as a *literal stand-in* for an otherwise individualized son. Her interior world is linked to a communal subjectivity where such object constancy has no import.

This chapter develops the theoretical analysis that has been inlaid in previous chapters. Photographic vision expresses the consummate scopic regime of capitalist modernity, whose impact becomes more pronounced in the colonial setting but, equally, in the case of the Ottoman Empire, is intertwined with and created by a complex ideological assemblage that can be broadly termed Ottoman modernity. The portrait is the imprint of that perspective, the perspective of *al-nahdah al-ʿarabiyah*, which stabilizes the uncertainty not only of systems of representation and ego-ideals but social relations and social transformations that give a market and raison d'être to the portrait itself. This chapter, however, further teases out the portrait as an image-screen, a synapse connecting synchronic and simultaneous forces and tensions, a testimony to the obviousness of progress and civilization haunted by an alterity of that which cannot be assimilated or that which was displaced, and thereby, is uncanny or arcane. In demonstrating that the portrait is a *point de capiton* between simultaneous manifest and latent content, this chapter will unpack an example of the latent content under the overpowering manifest force of an iconic Ottoman portrait.

Tale of Two Photographs

"Qamis al-suf" opens up a level of the portrait's meaning that is not discernable through its surface and its institutional mode of repre-

sentation. The mother's two portraits are unable to provide a "locus for mediation" between her, her son, his wife, and the new social configurations that encompass them.[2] The portrait offers a *verum factum*, but one that is constituted by complexity of tensions, as we have seen. The portrait enacts and performs ideological identifications, organized and enunciated in *nahdah* and *Osmanlilik* social discourses, through the illocutionary act of photographic practice, representation, exchange, circulation, and display.

Repetition secures the unambiguousness and ideological hegemony of the portrait's meaning and social role. Simultaneously, the sheer surface area produced by the number of repetitively produced images provides an adjacency of images that produce seams of their own production and indeterminacy. We approach two portraits of a young man, one alone (fig. 57) and the other with, what one might assume, is his wife or sister. On the back of the couple's portrait, what we assume is his last name and a date are handwritten in ink: "Souvenir Affectueux, 16/5/04, Kassab" (fig. 58).[3] The photographer of the individual portrait is the unknown Khalil Hawie, "Artistic Photographer," whose studio was located at Number 1, Gordon Pacha Street, on the corniche in Alexandria. Kassab is quite dapper, the consummate, dashing dandy, confident in his bold windowpane, double-breasted Edwardian suit and a turned-up Panama hat. Kassab's individual portrait is a consequence-free gamble; an act of swagger that ideologically performs a desire and identification with masculine modernity; independent, solitary, and defined by consumption as much as character. The portrait places public performance before private display.[4]

Figure 57.
Khalil Hawie, Portrait of a young man named Kassab, Alexandria, 10.8 × 6.7 cm.

Figure 58.
G. Massaoud Frères, Kassab and unidentified woman, Port Said, May 16, 1904, 12.4 × 8.2 cm.

Wearing the same suit, tie, and stiff-collar, but with his hair revealed, oiled and parted in the middle, Kassab reemerges in Port Said. The daring of his dandyism is tempered by an air of emergent domesticity, accompanied by the companionship of an anonymous, smartly dressed young woman in a decorous Gibson girl blouse and hobble skirt. This domesticity supplants the dandyism of the individual portrait, which is recoded further by the relaxed and loving postures and tender sentiments scored on the portrait as "Affectionate Remembrance." The control, dignity, and domesticity of the portrait contrasts the individual portrait, which emanates a devilish air that matches Alexandria's cosmopolitan ambiance. Like Khalil Hawie in Alexandria, the photographer, G. Massaoud Frères, is also now forgotten. Also like Khalil Hawie, he was, guessing from the name, a Christian Shami (Syrian) émigré in Egypt, who, yet again, was overshadowed by the more prominent studios of the city, the Legekian Frères in the case of Port Said. The images present us with a gentleman and his attractive companion, both well-kept, confident, and if not successful, certainly aspiring. Singularly, we follow the indexical clues and read or misread Kassab's identity, drawn into the myth of his own individualism.

Together, the photos present us with a *punctum* in the form of doubleness. The adjacency of these images tells us little about whether Kassab is the persona that he is trying to communicate or whether his single suit betrays a *petit effete* sensibility. The adjacency of the images also provides us a clue to the performativity of the image and an ideological confirmation of the institutionalized indexes of Belle Époque Egypt's political economy. At the same time, the adjacency and doubleness, instead of stabilizing the portrait's *verum factum*, indicts the veracity of that representation, implicating its social history.

The histories of these "new men and women," whether anonymous or well known, need to be considered, Gramsci has taught us, as collective histories—the histories of groups, classes, movements, institutions, and practices. The composite portraits of Louis Saboungi, ʿAsim Effendi, Masis Bedrossian, and the faculty of al-Madrasah al-wataniyah parallel thousands of the anonymous "new men and women," who found themselves, like Kassab, often in new places, countries, and professions, bound to other "new men" through a similar network of sociability, a shared educational experience, and a common investment in the various pedigrees of social, cultural, political, and economic reform projects.

Just as intellectuals, functionaries, and cadres of new professionals (engineers, doctors, technocrats, "journalists") who appeared in Tarrazi's encyclopedia experienced common academic, textual, and ideological, if not physical, spaces, training, and practices, those Ottoman officials and bureaucrats who were found in the pages of Jawhariyyeh's album were class partners in the networks of the cartes de visite.[5] Despite the difference in their register and geography, Kassab's smart portrait differs little ideologically from that of Jurji

Saboungi's portrait of sirwal-wearing effendis in as much as they both express a shift in social relations and political economy that created, justified, and made quite logical, if not necessary, the desire to appear in front of the camera. The portrait's indexed surface stages the manifest content of the *verum factum*, a totalization of *nahdah* discourses and social relations. This manifest content represents social experience (a materialist past and present) and a psycho-social copula of discourses and identifications, that is, social desire. Kassab in Port Said could easily be Tawfiq ʿAwwad's Amin, and his partner just as easily could be the daughter or wife of Faris Effendi. While the sitters might have been enfranchised through the influx of new capital associated with the silk industry in Lebanon or perhaps might have been a part of the new administrative classes that ran the Suez Canal, the solitary presence of the new Arab man and woman contrasts the communalism of Amin's peasant mother; it clashes with those who, in the eyes of the Ottoman government, were easily excited by foreign provocations, and those who, as Henry Habib Ayrout observed, surrender "individualism" for "conformity to tradition."[6]

Jointness of the Image-Screen

The paradoxical "nature of [*nahdah*] photography" is this: The authority of personal experience rests at the interstice between the ontology of an individualized self and the epistemology of positivism; it rests at the base of a scopic regime that is a photographic vision and expressed in the *verum factum* of the carte de visite. Whether this is the nature of all photography or particular to the Arab Ottoman world is for others to answer. The camera appeared, not coincidentally, with modernity and capitalism's disenchanting paradigms of self and social order that were not always cleanly assimilated into this order. The complex and contradictory work of Louis Saboungi, the tensions of color photography, and the religiosity of strict positivists like Nimr and Sarruf have suggested that certain experiences, practices, and worldviews remained exterior to, or at least at the margins of, the "interactive emergence" of the empire's new men and women. Understanding, however, the portrait as a *verum factum* acknowledges that a rationalizing, photographic perspective worked to assimilate the incalculable nature of subjective experience, if not experiences that were made uncanny and backward by *al-nahdah*'s civilizational vision. The repetition, doubleness, mass production and circulation, and standardization of the portrait serves to push away this *punctum*, the disjuncture between the truth-claim of the *verum factum* and its experience, which bestows an ontological investment while that very ontology points to photography's own limitations.

Just as Masis Bedrossian's and Ahmad Amin's chiasmic portrait reveals its "jointness," the effect of juxtaposing Kassab's two unrelated

portraits reveals the adjacency and doubleness of the portraiture that draws them together in the authority of the sitter-subject. The random adjacency unstitches, or at least makes apparent, the jointness binding the chiasmic planes of the image-screen. This *mise-en-abyme* is not immediately detectable in the manifest content of studio portraits of the late Ottoman period, which presented the "world as a picture" bound by the *verum factum* of experience, modernity, and selfhood.[7] The jointness of the image-screen is not metaphorical but literal, materialist, and ideological. This image-screen is the meeting place between the subject's eye and the object of the gaze. It is the *synapse* between the rational subject and subjective experience, between material production and its ideological purposes, between fact and experience, between its displaced histories and its illocutionary force. The portrait as image-screen is the place for the projection of the ideal-ego and the enactment, or performance, of the ego-ideal, the ideological composite of the *nahdah imago*.[8]

The portrait as image-screen is just as much a document of the displacements, disruptions, and fissures in economy, social hierarchy, communal bonds and codes as it is a blueprint of subjective and social desires and putative discourse, social realities, and cultural transformations. Whether the carte de visite of Beirut merchants, Ottoman elites, or Egyptian intellectuals, the photographic portrait as image-screen was more than just a physical confirmation of *nahdah* discourses. Experience was mediated through the photographic gaze that privileged the perspective and positionality of the knowing-subject in contrast to its communal counterpart. The chiasmic image-screen was the end-effect of the individuated subject's place in a *verum factum* of the "world-as-a-picture." But also, this mediation stabilized the rationality of that experience while also pushing to its margins, in the form of alienation, the alterity of what lay outside the frame of perspective.

In the cases of "Qamis al-suf" and *al-Ajnihat al-mutakassirah*, for example, the photographic portrait is an unquestionable *mediating object*. Amin's peasant mother in "Qamis al-suf," apparently barred from the consumerist-rationalized urban perspective, is absent from the two photographs on her mirror. Yet her identification with these images, a *méconnaissance* that structures her worldview, is potent enough that her alienation is still expressed through a longing that is cathected onto her two portraits. In the case of Jubran's *Broken Wings*, Salma and Faris Effendi's pain and loss are mediated through the image-screen of the mother, which provides a stabilized and "constant" object upon which to hang Faris Effendi's death and Salma's marriage to the lascivious Mansur Bey Ghalib.

Many have theorized that the photograph is "all about the return of the departed" and that "the spectral is the essence of photography."[9] What haunts the portrait of Salma's mother and Faris's wife is the history of their social group, network, language, and geography, the loss

of a new urban nuclear family before it even came to fruition. The photograph mediates a social alienation resulting from the wrenching of the subject from his or her communal origins that occurs with the commodification of relationships as seen in the venal Bishop Ghalib's insistence on Salma's marriage to his wanton nephew Mansur. Against a new political economy that created new wealthy families, such as that of Faris Effendi, alongside *lumpenbourgeois* charlatans and corrupt sectarian elites, the ubiquity of the carte de visite attests to a particular self-view of a newly formed Arab class subject, as well as a new regime of materially and a discursively conditioned photographic vision that had been naturalized even though it ideologically precluded many subjects, experiences, and sensibilities.

Portrait as Dream: Afterimage and Ideology

Issam Nassar has shown how the documentary value of photography "presents us with a mélange of ideas and attitudes belonging to various contemporaneous cultural trends."[10] Bolstered by the use of autobiographies and other primary sources, Nassar's assertion should be taken seriously as an endorsement and validation of the value of the manifest content of *indigenista* photography. Such a reading strategy is faithful to the "realist" impulse so prominently communicated in the journals and literature of the time. The photographic portrait as an image-screen that documents historical developments, trends and transformations eventually leads back to a discussion of the image's truth-claim and the debates about the verisimilitude of the photograph's surface. From the cartes de visite of the sultans and middle-class families to portraits of the ʿulamaʾ and their photographers on Hajj, indigenous photography in the late Ottoman period must be read as an ideological-materialist chiasma, as an image-screen.

The photographic portraiture—the image-screen as the materialization of a projected ego-identification of these new Arab men and women—is the *afterimage* of writing, and the afterimage of epistemological, social, and economic ruptures that transpired during the mid-nineteenth century. This does not necessarily mean that the indexicality, staged on the manifest surface, is correct or incorrect. Rather, it tells us that "the intelligibility" and currency of the photograph, as exemplified in Krikorian's portraits, is "inextricably caught up with the specificity of the social acts, which intend that image and its meaning."[11]

From Saboungi and Spiridon Chaïb in Beirut to Abdullah Frères and T. Covas in Cairo, the photographic portrait provides the afterimage of the ego-ideal imprinted on the photographic image-screen, which performs the discourses of modernity that were so essential to the reorganization of turn-of-the-century life in Egypt and Greater Syria. That said, the idea that the surface of the photograph performs

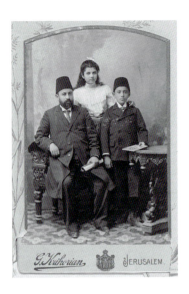

Figure 59.
G. Krikorian, Fadi Effendi al-ʿAlami, Mariam (daughter), and Musa (son), cabinet card.

established subjective and collective desires, economic realities, and discursive and social norms leads us to understand the ideological *dynamics* of the afterimage. In this regard, the indigenously produced photograph, as Freud would say in speaking of dream images, "is a conglomeration of psychic images."[12]

These "psychic images" are the symbolic fabric of the chiasmic *imago* of the Arab portrait. We have seen how this *nahdah* imago—the assemblage of discourses, desires, and identifications of the new Arab self functionalized by the shifts in political economy that created "new men and women"—is projected upon and instantiated in the image-screen, materialized as the portrait itself. Despite its representational density, the photographic afterimage does not *produce* meaning in-and-of–itself. In other words, the meaning and social currency of photographic portraiture is not forged the moment of sitting, during the photograph's circulation, or even exchange. These venues are just the social circuits by which the portrait flowed so as to maintain and enhance its and its sitter's value, perform its ideological function, and mediate and stabilize the new social relations that made the portrait necessary. Instead, the photographic portrait is the material manifestation of the image-screen, and the afterimage is its representational locution. In this way, photography is performative and reproductive, rather than productive.

Krikorian's portraits eloquently have demonstrated the density of the manifest image. The portrait of Fadi al-ʿAlami articulates his private and public lives (fig. 59). Al-ʿAlami hailed from an established Jerusalem family. He was an Ottoman official, a member of the Ottoman parliament, and mayor of Jerusalem between 1906 and 1909. Serene Husseini Shahid, whose mother poses with her own father (Husseini Shahid's grandfather) in Krikorian's portrait, relates a story of her grandfather before he was mayor, a story that presents the photograph as one "psychic image" from her life world. One of Fadi al-ʿAlami's duties as an Ottoman official, she tells us, was to survey the country:

> One summer day he was, with his aides, laboring on horseback up a hill between Beit Safafa and Sharafat near Jerusalem. It was noontime and despite a cool breeze wafting up from the valley, the sun was hot. They looked around for a place to rest. Then they saw the oak tree on a hill in the distance and headed towards it, longing to relax in the cool shades of its branches. This small event was a turning point in the life of my grandfather and his family. He fell in love with the oak tree, a love, which lasted all his life and through generations after him. ...
>
> The owner of the oak tree was one of the villagers who had greeted my grandfather and his companions. As the two groups sipped coffee together in the shade of the tree, grandfather made a proposal. Would the owner sell him the oak tree and its shade? The man was delighted to do so. Thus Fadi Effendi, as my grandfather

was known, became a lifelong friend of the village. The villagers suggested that he should buy enough land to build a house. He did so, and in time Sharafat became a happy summer home for the all the family.[13]

Does Fadi al-ʿAlami's portrait speak of his story? Does it speak to the interior experience of a man who "enjoyed the twist and turn of the road" in the countryside he was charged to survey? The manifest content speaks to his role as Ottoman official. He made sure to pose, as so many Palestinians in Krikorian's studio did, in his official Ottoman uniform, with rolled survey papers, maps, or, perhaps, an Ottoman *daftar* that registered ownership and taxation of the lands he inspected. His son, Musa, too, stands with a book in his hand, like the portrait of Amin in "Qamis al-suf," the difference being that Musa will grow up, like his father, to be mayor of Jerusalem and a prominent Palestinian-Arab nationalist. His sister Mariam's caring hand on Musa anticipates her role as wife of Jamal al-Husseini, also a high-profile Arab nationalist who opposed Ottoman rule, Zionist colonization, and British occupation. We could read this image as a statement of presence. "Jerusalem" is embossed on Krikorian's cabinet card. Fadi al-ʿAlami was its Palestinian mayor. Musa and Mariam were the children who ran through its streets and hung on the branches of the oak tree in a country from which Palestinians, some decades later, would be dispossessed. We could read it as a legal document, a contract as Ariella Azoulay suggests, that testifies to the ʿAlami claim to all of their land holdings that were lost after 1948.[14]

This is not the manifest content of the image, imbricated with *Osmanlilik* modernity and Arab *nahdah* ideology. Within the context of Ottoman Palestine, the indigenously produced portraiture was an afterimage that repeated the native self's original encounter with modernity's deterritorializing forces. These forces included the colonial encounter, the introduction of the cash nexus, the reorganization of land tenure, the restructuring of communal, tribal, and/or feudal social organizations into new confessional, class, urban, and/or national economic, political, and social associations. Fadi al-ʿAlami, who registered and assessed land ownership, was an executor of those changes, which were authorized by the Ottoman Land Law of 1858. Ironically, he was the agent of deterritorialization, the institutionalization of modern land rights and taxation, which displaced previous modes of land tenure. He himself was a beneficiary of these changes, which allowed him to buy, first a monumental tree, purported to be more than a thousand years old, and then land upon which to build a summer home. Therefore, the manifest speaks of the order, economy, education, liberation of women, and new family of Palestine. The latent, then, is not that—despite all the ink spent on women's rights and access to education and public space—the mother figure was displaced from the portrait. The latent is the history and displaced reality

of the "happy peasants," whose social practices with one another, the land, the state, and its officials were mediated by the policies of the Ottomans, the interests of local elites, the Zionist settlers, and the restructuring of the (mostly agricultural) economy.

The repetitive formality of the carte de visite, cabinet card, portrait postcard, and other portraits erases the seams within its composite nature because the photograph operates within a logic of *nahdah* ideology that reified modernity's ideals (individualism, social success, secular civil society, positivism, and so forth) as natural. The surface of the photographic portrait, whether of Fadi al-ʿAlam or numerous like him, presents gender, class, desire, capital, and social hierarchies and organizes them into an ideological unity, already formed by the rise of "new men and women," new classes, elites, and narratives as organized by *nahdawi* organic intellectuals, reformers, and politicians. As an ideological alloy of compressed "psychic images," materialist conditions, and social discourses, the photographic afterimage contains two conterminous levels of immediacy, which have been mentioned throughout this book, *the latent* and *the manifest*. The image speaks of the social relations of Fadi al-ʿAlami, its production in the studio of Krikorian, and its circulation among Palestinian and Ottoman elites not only in Jerusalem but Istanbul. As such, it speaks to those social relations that monetized village lands where, for example, absentee landlords and local elites, most notoriously the Sursock family in Beirut, sold their estates in Palestine to Zionists from underneath its occupants.

Against the loss of Palestine, its archives, and its stories in 1948, Serene Husseini Shahid's narrative helps provide evidence of the interplay of the image's performativity, its ready-made intelligibility (that is, its reified signification system), and ideology of Ottoman modernity. Simultaneously, it makes visible the displaced histories, the violent destruction, and the social dislocations caused by natively induced modernity, not to mention colonialism.

The latent and manifest should not be conflated in a crude parallelism with the contemporaneous and historical content of the image, or between existing as the subject of the gaze as opposed to its object. The terms are not even an analogue to photography's ability, as so noted in the Arab press, to "capture" and make visible the unseen in the manifest of the photograph's surface. The manifest and latent are two surfaces of the portrait that communicate and suppress *coterminous* meaning. The adjacency of portraits occurs through repetition, through their generic patterns, through their indexicality, and through the templates that make "individuals into subjects." The "jointness" of Krikorian's al-ʿAlami photograph—the meeting of its formalism and the staging within its own social milieu and history—reiterates a normative semiotic index where photographic meaning is reproduced through the difference/deferral between signs within signification systems—signification systems that ideologically main-

tain the logic of capitalist, Ottoman modernity. These ideologically laden signification systems are composed of interrelated but aggregate chains of signification, laid out and regularized, although not produced by, *al-nahdah* writing and reform activism. The displaced experience, logic, and social history of that semiological system and its ideology conterminously exist as "the repressed and unacknowledged condition of possibilities for both difference *and* identity," but, this book argues, are balanced, held in check, and stabilized, albeit contentiously, by the weight of the surface's *verum factum*.[15]

Point de Capiton: The Latent and Manifest Image

The portrait as a dream-image is a *point de capiton* between the manifest and the latent; an intersection where the vectors of social histories, discourse, social practice, and ideology meet displaced histories, the unassimilable, and anterior experience and cosmic views.[16] This is what makes "Arab photography" Arab, as it speaks to the collective, subjective, and class histories of the Arab world. If the manifest surface of the *nahdah* photograph seems indistinguishable from the formalism and social practice of photography in Europe, India, or Peru, then it is the photograph's latency that speaks of specific, but not necessarily dissimilar, histories that underwrite the standardization of a vision that is presented by the photograph.[17]

The portrait as a *point de capiton* between the expressed and the repressed, between representation and displaced material history, reaffirms the theory that portraiture was a stabilizing social practice. The photograph is a mediating ideological object, a mirroring *imago* that assured coherence with the social relations, discourses, and regimes of discipline and power at the base of *nahdah*, *Osmanlilik*, and khedival modernity. For example, sartorial codes expressed, on a manifest level, a "natural" desire for new forms of social order, capital, and capital accumulation. But they also hide, for example, the transformations of the market and people's livelihoods that emerge from the shift to a "mass fashion system."[18] The manifest hides the destruction of the livelihood of certain guilds, craftsmen, merchants, textile workers, and farmers who provided the materials for fabric.[19] The imago as represented by the portrait is made legible not through state programs alone but by a signification system that naturalized what "success" (*najah*) looked like. The latent contains the hidden histories of how the manifest became natural, how the signification system became intelligible, and how the *imago* of the portrait became recognizable and desirable.

I am not arguing that the manifest content of photography is "not real" and/or holds no value as a historical document. "Far from offering a simple objective description of its subject," the manifest content of photography, as Issam Nasser shows us, remains a valuable historical

resource that "very much offers a construction of that subject."[20] As a historical source, the manifest content of the photograph is best understood through its expressed social relations, its performative content, and its illocution. The manifest surface of the historical photograph is an *effect* of dominant discourses that *reproduce* meaning through the repetition, formalistic composition, and continued referencing to the *nahdah*'s bounded system of signification, its *verum factum*.

Rather than accepting the uncontested hegemony of the photograph's materialism and its surface, Freud provides a methodology to unpack the complex diachronic of how photography's meaning, social currency, and practice themselves became legible through processes of displacement. If we can understand the aggregate parts of the image-screen, structurally, like dream images, the manifest content is the dramatization of the dream and therefore the *condensation* and displacement of *latent* content. The manifest surface is the materiality of the disguised "primary process," the origins of the dream itself that are then reworked and projected on the image-screen. That "primary process" is the *latent* content of the image, the origins of its social history and relations. Latent content needs to be disguised, translated, and reformed into representation that will diverge from its original desire and wishes.

The Latent and Displaced Social History

In the case of the *nahdah* photographic image, the *latent* content of the portraiture, however, does not only speak to the interiority of the subjects—their inner soul that might somehow be photographed like the skeleton in an X-ray. Rather, it speaks to the violent processes by which modernity appeared and, indeed, to how its signifying system became naturalized. Studies over the past decade have returned to examining the radical transformation in modes and commodities of production, economic practices, the nature of land tenure, currency, governance, and consumption.[21] They have begun to show, even if inadvertently, that violent processes are not limited to the rawest forms of coercion by the Ottoman state and local feudal elites, who increased conscription, forced corvée labor and taxation, or dispossessed people from their homes and livelihoods by, for example, reorganizing land and cityscapes. Nor are they limited to the machinations and agents of foreign powers who conspired with communal leaders to undermine reform or force the Ottoman state into capitulations and indebtedness. Neither is the violence limited to the property theft by new landowners that was legalized by changes in land tenure by the new Ottoman law in 1858. Studies by Peter Gran, Allen Richards, Sevket Pamuk, Halil Inalcik, and others on the formation of the petit bourgeois merchant class, capitalist accumulation, domestic commodity production, and the effects of imported finished textiles

are particularly relevant to this study.[22] Rather, the violence of the *nahdah* is tantamount to the ripping apart of communal identities and social organizations as much as economies.

Marx's, perhaps dated, characterization of precapitalist society is pertinent: "Personal dependence here characterizes the social relations of production just as much as it does the other spheres of life organized on the basis of that production."[23] Amin's alienation from his mother and village in "Qamis al-suf," for example, signals the denigration of social relations based on the primacy of familial, tribal, village, or feudal social relations. Identifying the portraits in the story as an afterimage permits a mapping of the ideology of its surface content without preventing an excavation of the dissonance between its legibility and illegibility in the differing perspectives of Amin and his mother.

Saboungi's Portrait of Midhat Pasha

The theoretical mapping of the latent and manifest is no doubt complex and needs further investigation. This book has concentrated largely on the manifest, on examining the technomateriality of the portrait, its social relations and circuits of exchange, and its ideological surface. The manifest is hegemonic and has invited us to engage its own functions. The latent is equally complex, as it seeks to give voice to the displaced. In 1905, *al-Muqtataf* published two portraits to accompany otherwise standard biographies of famous men. The first was a portrait of Muhammad ʿAli, a photographic reproduction of Auguste Couder's painting *Méhémet Ali, vice-roit d'Égypte* (1841), commissioned by King Louis-Phillippe and hung in Versailles. The second was a portrait of Muhammad ʿAli's famous son and general, Ibrahim Pasha (1789–1848), reproduced from either an etching or oil painting.[24] Both portraits were signed by Saboungi. If Jurji Saboungi had photographed these painted portraits (and those like them that appeared in *al-Diyaʾ, al-Muqtataf, al-Jadid, al-Hilal,* and others), or whether the journal's photograveur etched his name in the negatives, or whether this was another B., G., or M. Saboungi/Sabungi is yet to be determined. What is for certain is that Saboungi's name carried currency. Anyone who has even a casual interest in the nineteenth century is, perhaps unknowingly, familiar with Saboungi's portraits of *nahdah* reformers, educators, merchants, elites, and intellectuals, including Cornelius Van Dyck's iconic Arabized studio portrait. His most illustrious job was as official "photographer of his highness Midhat Pasha, Governor of Syria."[25] During this commission, Saboungi invented a method and received commendation for printing photographs on linen, reproducing the Pasha's image on thirty-six linen foulards.[26]

Midhat (1822–83) was the legendary reformer and onetime governor of Syria (1878–81) and Baghdad (1869–71), as well as grand vizier (1872) to the sultan, and rival to the same Ali Pasha so loathed by Ziya

Pasha and the cofounders of the Young Ottoman movement. Midhat was very familiar with and sympathetic to Ziya Pasha at a time when they both were central to the inauguration of a new constitution and parliament and found themselves in the sights of the sultan. The son of a high-ranking Ottoman functionary of Turkish-Bulgarian descent, Midhat rose through the upper echelons of court-assigned posts, proving himself a capable leader and administrator. He is best known for his vocal reformist and constitutionalist positions, which he diligently worked to implement not only in Istanbul but also with every appointment he held in the provinces.

Considering his pedigree as a reformer and Tanzimat activist as much as functionary, it is not surprising to learn that Midhat was fond of getting his portrait taken. Many portraits exist, including Alexander James Grossman's carte de visite in London's National Portrait Gallery archive (fig. 60). Midhat in that portrait seems too young for the photograph to have been taken during his visit to London in 1877. It is one that resembles so many other *Osmanlilik* portraits. He likely had his image taken by London's famous portraitist during his self-imposed exile in France in the late 1850s.[27] That said, I suspect that Saboungi was responsible for a number of portraits of the Pasha that repeat Midhat's famous visage. Most of Midhat's portraits, including Grossman's minimalist vignette, are headshots that rivet the looker to the subject alone within the darkened backdrop or sparse minimalist background. The discipline and direction of the image actualizes the efficiency and disciplinary power that the Pasha so diligently worked to institute throughout the empire. His posture and focus do more than communicate his single-minded vision and commitment to reforming Ottoman societies. His portraits signify that this "new man" is an individual who is both a national subject, imperial representative, and ideal citizen that should be replicated in all Ottoman subjects regardless of whether they are in Syria, Iraq, or the Balkans. Midhat Pasha was representative of the project he worked to implement. He was a new individual, but also this individual was, as Gran suggests, an actor within a governing class of "new men." As a material object of ideology, the portrait was hung in state offices; printed in journals, newspapers, encyclopedias, and histories; and passed between underlings and local and Ottoman leaders. Its manifest surface projects an ethos of *Osmanlilik* modernity, a social order based on unity, civic responsibility, moral rectitude, modern knowledge, and the separation of church and state. As this ethos calls every individual to act as a citizen, Midhat's portrait instantiates a decentralizing Ottomanism that brings individuals into collectives, to act in solidarity within social groups in service of the nation (*watan*) and the empire.

The life of Midhat is an excellent example of the density of the portrait as a *point de capiton* of social relations, tensions, processes, effects, and displacements. While his portrait projects an *imago* of the Ottoman ego-ideal, we know from the biography of the pasha, who

was imprisoned and executed by the sultan, that such principles and programs were not without great consequences and resistance. His son, Ali Haydar Midhat, published a memoir of his father, filled with personal correspondences, communications, and legal writs (fig. 61). Most important, the biography marks the complexities and complications within the social networks through which the carte de visite passes. It maps fault lines within the Tanzimat era that run through the relationships between reformers, bureaucrats, and the sultan, and define the political landscape of the Ottoman reform project, of which Midhat was a chief prosecutor.

Within Ali Haydar's biography, the echoes of a displaced history emerge adjacent to the effects of the rationalization of governance and economy in places such as Iraq and Syria. Saboungi's commission as official photographer dovetails with the very reason that Midhat was assigned to Syria; that is, to organize and discipline the unwieldy sectarian forces that had fractured Lebanon in particular, since the 1840s. Haydar speaks for his father, saying: "The population of Syria, composed as it is of people of diverse races and religions, who are always at enmity with each other, had preserved their ancient customs and manners. The overwhelmingly difficult task of creating a complete union between all these jarring elements, and of strengthening the Ottoman Supremacy in the country—where the minds of the populace were excited by foreign influences—consisted at first in the re-organisation of the administration, in Judicial and Financial Reforms."[28] The passage summarizes the sum total of the Ottoman *nahdah* portrait so succinctly manifested in the surface content of Midhat's image-screen. Saboungi's portrait of the pasha, along with others taken throughout Midhat's life as reformer, governor, and grand vizier, was an enactment of *Osmanlilik* ideology. As such, it was an afterimage of the reorganization of Syro-Lebanon's political economy and social relations that needed to be rationalized through the illocutionary act of the portrait.

At that same time, the currency of his portrait, the value of which Midhat clearly placed on the *practice* of portraiture, rests on an ideological intelligibility of signs that are found within a chain of differences and discourses that give the indexicality of the manifest surface meaning. To be specific, the Ottoman ego-ideal was communicated through a differentiating series of binaries as elicited in Midhat's biography and *al-nahdah* itself, the binaries of liberalism that contrast communal identity (confessionalism and tribalism) with Ottoman patriotism, ancient customs with Ottoman rational order, and passion with reform rationality. The narrative speaks directly to the tension between the manifest and latent contents not only of the portrait of the governor, but also to a similar portrait, perhaps also taken by Saboungi, which adorns the 1903 edition of his son's biography.

The latent content of Midhat's portrait demands careful archaeology that juxtaposes the historical record of Midhat with the ideology

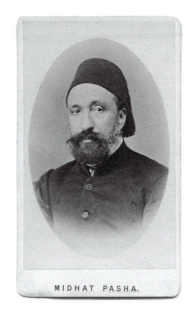

MIDHAT PASHA.

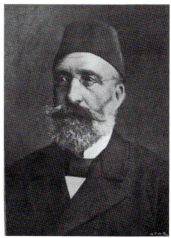

Figure 60.
Alexander James Grossmann, Midhat Pasha, 1860s, albumen carte de visite, 8 cm × 5.4 cm.

Figure 61.
Midhat Pasha, frontispiece of Ali Haydar Midhat's *The Life of Midhat Pasha*.

of Ottoman modernity and the violent resistance and contestations that they might have witnessed. As a reformist governor of Iraq as well as Syria, Midhat's career was underscored by consistent measures to further centralize the power of the Ottoman state, not in the figure of the sultan but in a diffuse archipelago of state and local institutions and disciplinary practices. Midhat's very career challenged the concept of state power, shifting it further from power invested in the unquestionable supremacy of the sultan to power that is administered through a secularized, orderly bureaucratic model that drew its legitimacy from the pretense of being representational of its citizens and their collective interests (*maslahat*), or at least the bourgeoisie, elites, and "enlightened" classes.

Arriving in Baghdad in 1869, Midhat was a visible prosecutor of policies of centralization that secularized land tenure, wrenching it away from semifeudal classes and tribal alliances. Ottoman land reform pulled property away from *multazim*, tax-farmers, and local elites to new and refurbished ruling classes who purchased and registered unclaimed, collective, and/or peasant landholdings, which usurped and prevented their usufruct rights to the land. Midhat was charged with making Baghdad a *vilayet*, extending and regularizing Ottoman administrative and economic power throughout Iraq and the western Persian Gulf. Potentially a rich agricultural region, Iraq was governed by powerful tribal leaders and entrenched local elites, whose antagonism to the Ottoman state and each other suppressed productivity. Midhat Pasha implemented the *vilayet* system of provincial government in Baghdad and its surroundings, introducing new models in the administration of land and revenue. Specifically, he initiated the *nizam tapu*, a system of private ownership of *miri* land. In order to increase the "dominion of the state" over the province and implement administrative, economic, and land reform, he had, in the words of a Mandate British official, to "break the power of the great tribes."[29] His intention was to give individuals more control over the land they farmed and raise productivity levels. The goal was familiar to the Ottoman *vileyet* governance; that is, to establish law and order and settle nomadic peoples by investing them with land and empowering merchant classes as representatives to circumvent entrenched ruling elites.[30]

Undermining 'ayan ruling families, Midhat enforced the Vilayet Law of 1864. He redrew administrative boundaries in the *wilayah* and institutionalized new forms of municipal and rural governance, such as electing municipal representatives (*mukhatir*). He made premodern communal formations, most notably pastoralist *asha'ir* (peasant communities), as Charles Tripp notes, more *visible* subjects of the state.[31] Midhat was responsible, then, for directly enacting the disciplinary technologies of Tanzimat onto the new Ottoman citizens of Iraq by making them accountable to new tax collection schemes as well as mediating their behavior by new criminal and legal codes.

Unpacking the Portrait

Abdullah Frères' successful photograph of Sultan Abdülaziz provides several benchmarks for Suraiya Faroqhi's assertion that "among the earliest examples of the use of photography in Ottoman public life are the portraits of the various sultans which were to be found in more and more magistrate's offices."[32] In the new visual and social order of the nineteenth century, the Eureka realization, perhaps, should not be that the Ottoman Sultan and Commander of the Faithful "circumscribed what constituted an Ottoman royal photographic portrait" and offered a "codification of Ottoman imperial ideology" and the subjective representation of the Ottoman idiom "patriotism, zeal, loyalty."[33] Rather, the portraits of the sultans are socially affective because they enacted their own ideology. They were *necessary* and *timely*. The nature of the sultanate had changed with, among other things, Sultan Abdülmecid's edicts, the Tanzimat firman Hatt-i-Şerif in 1839, and then Hatt-i-Hümayun in 1856, which radically confirmed the juridical definition of legal subjects/citizens. New Ottoman elites, bourgeoisie, and working craftsmen and merchant strata, according to Faroqhi, constituted a group that "no longer saw itself as virtually enslaved to the sultan" and "did not feel constrained to leave the sultan a monopoly on such tokens of power."[34] Subjects (*reaya*, or flock) had become citizens and compatriots (*abna al-watan*).

Sultan Mahmud II, with a fancy for Western oil painting, ordered his portrait "hung in the official buildings being built during his reign."[35] But in the age of mechanical reproduction, the image of the sultan could be reproduced en masse and distributed, like Sultan Abdülhamid's albums, throughout his domain and abroad. The difference is, however, that this same age of mechanical reproduction crushed previous social hierarchies and replaced them with a system of representation that permitted them to cross regional, ethnic, and religious communal identities and interact as "Ottoman brothers" and even equals.[36] The sultan's portrait then was only a macro-model of the role and the currency of the carte de visite in maintaining the social relations essential to the success of the new order built upon a network of collectivized, individuated subjects. The sultan and his administration, as we have seen, deployed photography as a technique of disciplinary power, an actualization of modernity, and a retort against Orientalism. But more, the sultan's portrait *had* to hang in the magistrate's office in order to remind these "new men and women" of their rights and responsibilities as citizens of the state and not, in principle, abject subjects of the sultan. Attesting to this leveling effect of liberalism in the constitutional and post-CUP revolution periods, Jawhariyyeh's deployment of portraiture shows how the Krikorian's and Raad's portraits of functionaries are almost interchangeable with those of Palestinian elites, intellectuals, and merchants.

This is not to contend that the sultan, Midhat Pasha, Maryanna

Marrash, Muhammad ʿAbduh, and/or Louis Saboungi, for example, all acted on the same social plane. I am arguing, rather, that the ideological nature and social role of the portrait was a consequence of a dramatic shift in political economy. Let it not be misunderstood, Midhat was no subaltern. Nor was he Arab, ethnically, culturally, or sympathetically, despite his years governing Arab lands and developing many relationships and connections with notables, the bourgeoisie, technocrats, reformers and intellectuals, and tribal leaders. I am using Midhat's portraits as a case study of image-screen because his portraits remain *visible*. His portrait is a visible archetype with historical "tethers" that rivet it to materialist history supported by a supplemental archive unlike, say, that of Kassab and his sister/wife/partner. While he was no commoner, Midhat's portrait and life speaks to the tensions within the reign of Abdülhamid and the preceding Tanzimat project. He was the shining model of Ottoman modernity but also a rival to the power of the Sublime Porte and allied with Ziya and the élan vital of the reform movement. He implemented imperial policies and the dictates of Istanbul but was undermined by the sultan's appointees and distrusted by the sultan himself. He was a successful reformer who established modern imperial power in Iraq, the Balkans, and Syria, but the reform vision was essentially a constitutionalist one.

Not unlike Ahmad Amin's narration, Ali Haydar's narrative fleshes out the surface effect of the indexical formalism, the ideology of Ottoman modernity as expressed in his father's portrait. His account illustrates the force of why the portrait is an afterimage and how the various portraits of the pasha, including Saboungi's, form a generic composite that makes authorship almost irrelevant. The illocution of the collective portrait's *studium* articulates the subjective ideal of the learned, orderly, future-looking, modern, and circumspect male Ottoman citizen. He is patriotic, judicious, and secular, determined to establish social order and to increase productivity and national prosperity. But, if nothing else, Midhat's violent death at the hands of the sultan's agents in the Arabian Peninsula offers a *punctum* to the orderliness and coherence of the image. The policies and principles that Midhat purported and administered were violent. They challenged the power of the sultan, his household, and his office (the Sublime Porte).

On the other hand, the policies upended many traditional patron-client relations; tribal, clan, and communal hierarchies; feudal notables; and urban elites, not to mention rising sectarian social formations (particularly in Lebanon). To be more specific, the latent content of Saboungi's Midhat portrait reveals that the orderly image displaces the violence of the success of a governor who "did not hesitate" to suppress revolts, including uprisings by "Arab tribes" in Iraq, whom he considered "turbulent and independent by nature [and] had shown themselves refractory to enlistment" while openly rising against the Ottoman state.[37] After suppressing the rebellion in Iraq, Ali Haydar Midhat tells us: "Midhat Pasha clearly discerned that if an end was to

be put to these chronic troubles [in Iraq], and these nomad tribes were to be reduced to anything like permanent order, it was not sufficient to defeat them in battle and that a radical change had to be brought about in their general status, and especially conditions of land tenure in the country."[38] Such a statement unpacks the composite image of Midhat Pasha. The repetitive formalism, circulation, and deployment of Midhat's portraits mask the violence of modernity and the reform project. The violence latent in his portrait stems certainly from the crushing of recalcitrant tribes. But more so, the image embodies discourses and programs that stigmatized rival social hierarchies and sociabilities. The ideology of his portrait reached into every facet of society and culture in order to identify cultural and social practices, beliefs, and affiliations as either arcane or productive.

When he was the governor of Syria, Midhat decried the widespread affection for shadow plays, *karakuz*, which he felt were a salacious and lurid influence on the people. At the same time, Jurji Zaidan, quite the Edwardian moralist, mentioned the *karakuz* of Beirut of the 1870s, which during his youth had both repelled and fascinated him. Well-attended by people of all classes, the *karakuz* "was a vile play [*tamthil*], all of it indecent and indecorous."[39] To counter the ill-effects of the shadow plays, Midhat asked Farah Iskandar, his customs official, to help Ahmed Abu Khalil al-Qabbani form a troupe, which the governor funded. They founded the Damascus Theatre (*masrah al-dimashq*), which opened in 1879. Its first operetta was written by al-Qabbani, titled *al-Amir al-Mahmud najl shah al-ʿajam* (Prince Mahmud, son of the Shah of the Persians). The story is about a prince who fell in love with a woman after seeing her portrait. Traveling to India, he discovers that she is Zahr al-Riyad, the daughter of the Chinese emperor. He flies on a magic carpet to China and saves Zahr from a *jinn*, who tried to force the emperor to marry her to the *jinn*. Despite the fantasy, the story plays on tropes found in *nahdah* fiction, most notably the notion of "modern love" and the right to marry one's partner of choice.

The play and the theater met with resistance from local *ʿulamaʾ* and the city's notables, stating that such plays and notions of love enticed husbands away from their wives who waited at home.[40] While exchanging visiting cards was a common practice among the "new men and women" of the empire, if not among elites of Greater Syria, Egypt, and Istanbul as Emine Foat Tugay tells us, the vestigial castes under assault by Midhat Pasha's regime of reform still resisted the transparency of the image. This play offered a double surface-area in which to confront Midhat, politically and morally. It represented a challenge to imperial authority, to the supernatural, and to the spaces that women and their images could traverse. Likewise, the portrait itself in the play demonstrates a bewitching, anthropomorphic quality that is diametrical to the tenets of Islam itself. That is, the image acts just as Salma desires the portrait of her mother to function, imbibed with life so much that it provides a cathected object, which the princess comes to inhabit

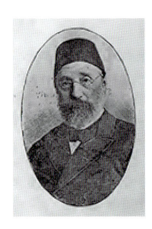

Figure 62.
Midhat Pasha,
frontispiece
of Sulayman
al-Bustani's
*'Ibrah wa dhikra
aw al-dawlah
al-'Uthmaniyah
qabla al-dustur
wa b'ad.*

through the prince's *identification* with the surface of the image.

This anecdote provides insight into understanding the Tanzimat not only as an ordering regime but also as a deterritorializing force. The performativity of the portrait and the hegemony of its signification system, of its ideological representation, could only be established, naturalized, and imbued with value at the expense of delegitimizing other social practices and decoding other flows of social codes. *Karakuz*, sword-play, and oral storytelling faded away or were marginalized with the appearance of theater, novel, and print fiction. Moreover, new performative, cultural, and artistic forms pushed against and made these antecedent cultural forms arcane, heightening the contrast between the ideological effects of their *perspective* against those political, social, and paradigmatic identifications that were now obsolete.

On the social-communal level, the primary process, the original desire of the portrait, is to "reduce" and isolate the individual subjects to a "permanent order," to strip them of their tribal and communal identity. In the case of Midhat in Iraq, this stripping, while an attack on the premodern, arcane, and feudal, still was a stripping of tribes' and nomads' liberty and sovereignty. In the process, those rights as endowed by the constitutional, juridical order—rights cast in terms of inalienable rights of imperial citizens—disenfranchised them from their ancestral community. If the manifest content of Midhat Pasha's portrait signified his administrative efficiency and "fairness" as an arbitrator of a new civil, criminal, and land law code, then this illocutionary statement is precisely the image's violence. The order of the portrait—a portrait to be passed between Ottoman citizens—displaces the social history that stripped local peoples of their communal history, practices, and political economies.

Dedication to a Portrait

Sulayman al-Bustani (1856–1924) dedicated his book *'Ibrah wa dhikra aw al-dawlah al-'Uthamaniyah qabla al-dustur wa b'ad* (A lesson and memory, or the Ottoman state before and after the constitution) to Midhat Pasha's "pure spirit," or perhaps, in the words of *al-Muqtataf*'s article, the "calm of spirit" (fig. 62). The dedication itself displays Midhat's portrait and praises him as a "man of freedom" and "martyr" for the nation (*al-ummah*).[41] Written after the deposition of Sultan Abdülhamid, al-Bustani addressed Arabic-speaking "sons of the Ottoman nation" (*abna' al-watan al-'uthmaniyin*).[42] Recounting the days of oppression under the sultan, al-Bustani stresses ethnic Arab pride along with secular patriotism and loyalty to the Ottoman state, which itself trumps all religious, ethnic, and local allegiances.

Originating from an esteemed Maronite clerical and intellectual family, al-Bustani himself was an established intellectual in Syria, maintaining a complex network of friends among intellectual, merchant, clerical, aristocratic, and bureaucratic classes. He graduated

from al-Madrasah al-wataniyah, which was run by his illustrious relatives Butrus, Salim, and ʿAbd Allah al-Bustani and the other faculty in the famed group portrait. He cut his teeth working alongside al-Muʿallim Butrus and Salim at the journal *al-Jinan* as well as contributing to his uncle's encyclopedia *Daʾirat al-maʿarif* (The circumference of knowledge). Albert Hourani states that Sulayman is likely to have become familiar with Midhat Pasha during his residency in Baghdad and Basra, where he worked as an export merchant and perhaps held the post of a lower Ottoman functionary.[43] After the constitution had been reinstated as a result of the 1908 Young Turk revolt, Sulayman served as Beirut's parliamentary representative. He eventually held ministerial posts in the Young Turk government until he resigned on the eve of World War I. In this regard, Sulayman stands apart from many of the other marquee pioneers of the *nahdah* in that his role was not only as an organic intellectual but also an actual functionary, indeed, politician. He further distinguished himself from many of his compatriots by remaining against decentralization of power and a firm supporter of the Committee for Union and Progress after the military coup and subsequent "Turkification" project of the committee.

Sulayman's panegyric paratext speaks to the manifest and latent content of the portrait and the *nahdah* project at the time when it began to be confronted by an inevitable clash of ethnic and Ottoman nationalism. The dedication posthumously remarks on Midhat's life as a reformer, a "patriot," an implementer of a new social order, an advocate of political representation, and the swan song of secular, multiethnic Ottomanist patriotism. The verse belies the violence that operates within the portrait's latent content contemporaneously and historically. It agitates contradictions within the reformist and disciplining Ottomanism of Midhat Pasha that demanded local and communal affiliations be displaced by loyalty to the Ottoman state, even when that state itself had been taken over by Turkish nationalists. Polemically arguing against a nascent Arab nationalist project that called for increased autonomy and self-rule, Sulayman's Ottomanism entailed calling for patriotism and intersectarian unity and even went so far as to advocate the forced conscription of Christian Ottoman subjects in order to make them more loyal Ottoman citizens.

Despite Sulayman's distinguished political career, he is most celebrated for his translation of the *Iliad* into Arabic verse. The task was monumental, considering that Arabic poetic tradition does not have a genre of epic poetry and the diversity of its poetic meter and verse differs from Homer's dactylic hexameter. Sulayman's secularized strophic verses, found in popular ballads and Christian hymns, translated the ancient form into quatrain meters to accommodate the epic's narrative content. In so doing, Shmuel Moreh states, "the strophic form was transferred from the narrow sphere of Christian hymns, school songs and versified translations, to the task of translating" one of humanity's greatest epics into a secularized language.[44] He further credits the translation's introduction into Egypt through the

expatriate Syrian community and press as the occasion that encouraged Arab romantic poets, such as Khalil Mutran and ʿAbbas al ʿAqqad, to adopt it to challenge the neoclassical prose and the *qasidah*.[45] Sulayman's dedication to Midhat Pasha, coupled with his portrait, produces the same effect as the secularization of vernacular and religious verse. He was not the first to do so. Butrus al Bustani, Nasif al-Yaziji, Ibrahim al-Yaziji, Ahmed Faris al-Shidyaq, and Yusuf al Asir, many whom were members of al-Madrasah al-wataniyah, were all involved with efforts in translating Protestant and Catholic Bibles into Arabic, despite the preexistence of Arabic versions. Likewise, Nasif al-Yaziji, in returning to the *maqamah*, instills the genre with a new social value located in modernity and the revival of classical forms and language.[46] But, unlike the poetic verse of al-Jalkh or Louis Saboungi, Sulayman al-Bustani wrote in a highly transparent, unencumbered Arabic, in which even his short panegyric poem to Midhat Pasha reflected the reform and regularization within the language itself.[47]

Unpacking ideological effects of Midhat's portrait in his son's and Sulayman's narratives seems prescient considering the betrayal of the empire's minorities after the Young Turk revolt. The patriotic narrative and the transparency of Sulayman's language melds with the representation of *Osmanlilik* ideology. This natural "jointness" would have previously made this portrait a stabilizing force because its hegemonic signification had succeeded in making certain configurations arcane, at least from the perspective of the *nahdah* master narrative. This stabilization quivers under the eventuality of its own internal latency, where the violence of Midhat's project had come to revisit post–CUP revolution Ottomanism in the form of the militarization of the state and the Turkification of education and provincial administration. For example, these state policies and the use of state force eventually led to the ethnic cleansing and/or suppression of Greeks and Kurds and the genocide of the empire's Armenian and Assyrian populations by the Ottoman state. Sulayman's atemporal deployment of Midhat's image invokes an ideal constitutionalist Ottomanism couched in the transparency of unencumbered *nahdawi* Arabic at a time when such an ethos was clearly in danger, if not yet antediluvian. At the same time, it indicts not only the violence of those who threaten "unity and progress" but also the violence that Midhat himself exerted to attain those goals. Midhat's portrait is the consummate afterimage, a composite of manifest intelligibility and displaced latent content, of ideological illocution and haunting alterity. The orderliness of the portrait's manifest content reworks the latent content in a constant attempt to reinforce the reform values of patriotism, civic virtue, individualism, and progress. The repetition of Midhat's portraits discloses how its manifest content and the Tanzimat social order were entrenched within a regime of power established long before Midhat sat in front of Saboungi's camera.

The Mirror of Two Sanctuaries and Three Photographers

However precise my descriptions I could never have been able to depict the whole truth nor fascinate you in any way [as effectively] as looking and beholding can.[1]

IBRAHIM RIF'AT PASHA

Muhammad Sadiq Bey

After his inaugural cartographic mission to Medina in 1861, Muhammad Sadiq Bey made two more journeys to the Hijaz in 1880 and 1884 as a high-ranking official accompanying the palanquin known as *al-mahmal*. Since the Ayyubid dynasty, this annual official caravan had been sent by the leader of Egypt to Mecca during the Hajj. It carried tribute, or *al-surrah*, and the *kiswah*, which was the sacred tapestry that drapes the Ka'bah and is replaced every year. Reflecting the prestige of the official mission, Sadiq Bey published his photographs and diaries in four separate books in Arabic, as well as other writings in French and Arabic journals.[2]

Also known as Sadic Bey and Sadek Bey, he was the consummate new Egyptian functionary, the ideal nineteenth-century military technocrat par excellence. His portrait shows him as a decorated officer with the embroidery of his rank and experience (fig. 63). His full frontal portrait is unapologetic and reflects his training during a time when photography had not consolidated itself into a discourse that could distinguish itself as anything other than a tool of his cartographic perspective. He was trained as an Egyptian officer at one of Egypt's new, state-of-the-art military academies. As a colonel, he was a military attaché to France, where he also studied engineering

محمد صادق باشا صفحة ١

Figure 63.
Unknown
photographer,
Muhammad
Sadiq Bey,
Cairo, halftone
on paper.

and cartography at the renowned École Polytechnique. He climbed the ranks in Egypt's new military bureaucracy, reaching the rank of *liwaʾ* (lieutenant general), eventually receiving the honorific title of Bey. In the United States and Europe, his photographs of Medina were exhibited in the Egyptian Pavilion at the Philadelphia World's Fair in 1876, alongside those of Kova Frères and Sébah. He mentioned these accomplishments in the introduction to his 1896 *Dalil al-Hajj* (Guide to the Hajj). In particular, he "was awarded the Gold Medal of the First Order at the Venice Exhibition in 1881," which was the Third International Congress of Geographers, where he had presented his photographs of the khedival *mahmal*.[3] As in the case of Saboungi, the Kovas, Sébah, and Abdullah Frères, these official accolades were embossed on his circular stamp, signing each photograph:

> *Sadic Bey Colonel d'Etat-Major égyptien, Photographe Diplôme à "'Exp de Philie 1876 Médaille d'Or a L'Exp de Venise 1881."*[4]

Sadiq was elected as a member of the Société Khédiviale de Géographie and eventually became its president.[5] His photographs of the holy sites and saintly shrines of the Hijaz adorned the entrance of Egypt's first Musée de Géographie et d'Ethnographie, opened by the Khedive Abbas Hilmi II in 1898.[6] By this date, he had achieved a considerable amount of success in the Ottoman Empire itself, including being awarded the Third Class Ottoman Mejidiyah Medal by the sultan.[7]

The geographer's published accounts contained three types of photographs, "panoramas, landscape-format images, and portrait-format images."[8] The combination is not inconsequential. Sadiq Bey's perspective (*manzhar*) was already, in Victor Burgin's words, "implicated in the reproduction of ideology" of Ottoman and Ottoman Egyptian modernity and new Arab selfhood.[9] His portraits of the officials of Islam's most holy sanctuaries interpolated subjects into the organized yet sacred spaces of the Hajj, Ottoman power, and Egypt's social and economic network. After all, Sadiq Bey's cartographic detail to Medina was commissioned by the Egyptian wali, Saʾid Pasha, who granted concessions to Ferdinand-Marie de Lesseps to create the Compagnie Universelle du Canal Maritime de Suez, which built and managed the Suez Canal until 1956. Lesseps created and named Port Said after the governor, whose interest in the mapping of the pilgrim route in the Hijaz seems logical, even though Egypt returned the Hijaz to Ottoman suzerainty in the 1840s. As Egypt grew as a regional power—jockeying with the sultan for economic dominance in the region, including the Arabian Peninsula—the political and social relations between Cairo and Istanbul were often more self-servingly symbiotic than antagonistic. Alan Mikhail, for example, provides an analysis of the Hijaz's centrality to the agricultural sector of Egyptian political economy. Egypt was provided grains and foodstuffs necessary to feed the enormous population influx every year as a result of

the annual Hajj, a fact that is relevant to the social and economic networks that lay at the base of photography.[10]

This study is concerned with the portrait as a multivalent point of contact: the photograph as an image-screen. This image-screen is an instantiation and the materiality of these social forces that created the generic and collective social actor (in this case, the functionary but also the intellectual, the entrepreneur, the enlightened aristocrat, the laborer, the peasant, the *sitt al-bayt* (the modern woman), and others. This chapter seeks to explore how *indigenista* Arab photography was an interpellation of these new social relations and an imprint of *nahdah* ideology in the nonmetropolitan spaces and a nonsecular practice of the empire, notably the Hajj. This chapter engages the largely neglected travels and images of three Egyptian functionaries: Sadiq Bey, Ibrahim Rif'at Pasha, and Muhammad 'Ali Sa'udi. They shared common social relations that arose from their rank and their political position but also were embodiments of social and cultural discourses that defined *nahdah*, specifically in their case, khedival, modernity.

The span between Sadiq Bey's first journey in 1861 and Rif'at Pasha's last in 1908 offers a historical time frame within which, what I have called, *nahdah* photography discourse congealed. Hajj photography and travel accounts present an opportunity for us to explore the tension between the manifest and latent within the image-screen. It allows us to explore the portrait as a meeting place of ideology and practice, between the rationalizing force of Sadiq Bey's perspective—which, as in Istanbul and khedival Cairo, was reorganizing Hijazi space—and competing life-worlds and social practices. Hajj photography allows us to understand the power of the manifest surface (its ideological effects and its social roles), while also naming the anxieties produced by, and the alterity that was created by, the hegemony of the surface.

Breaching the Portrait's Surface

During his first pilgrimage to Mecca in 1880, Sadiq Bey photographed Shaykh 'Umar al-Shaybi, keeper of the key of al-Ka'bah (*muwakkil bi-miftah Bayt Allah al-Mukarram*) in the Great Mosque in Mecca. After he returned to Cairo, he sent a copy to the shaykh, accompanied by a poem:

> My heart photographed your person in the Ka'bah
> built in benevolence and radiance.
> Yet, the heart is enflamed with fire upon your departure,
> for the photographer is not consigned to the fire of hell.
> By my hand, I have drawn your likeness on a sheet
> Hoping for closeness in fondness and remembrances.[11]

Sadiq Bey's short poem gestures to the social practices and relations that circulate around and in the portrait. In an age where the Arabic novel sought to express the *nahdah*'s perspective, Sadiq Bey, al-Jalkh, and Louis Saboungi remind us that poetry remained valued, commonly interspersed in the lines of personal correspondence, prose-fiction, social commentary, and other forms of print and non-print writing and photographs. Like Saboungi's poetic sentiment, Sadiq displays an anxiety that contrasts with the certainty of an image that is now lost. Sadiq and al-Shaybi, perhaps, passionately discussed the permissibility of photography in Islam. The address suggests that the shaykh recognized that the Egyptian's rational and rationalizing "point of view" (*manzhar*) gave "coherence" to a field of vision that was not "natural" or without serious ideological implications.[12] Sadiq's poetic verse juxtaposes the sociability of the photograph's "modern" perspective with a preceding perspective that it cannot fully assimilate. The poem relates an uncanny dissonance between Sadiq Bey's secularized, cartographic "perspective," shared by his own class of Egyptian and Ottoman functionaries, and the sacred worldview of the shaykh.

Like Ahmad Amin's lost portrait, the absence of the portrait itself highlights the fact that the poem provides "object constancy" *in lieu* of the absent portrait but also apart from the portrait. It discursively and *materially* forms "jointness" where the ideology of Sadiq Bey's perspective meets the cosmic view of the shaykh, where the modern, present, arcane, and sacred conjoin within the certainty of the stabilizing portrait, which itself is made uncanny by its absence. This jointness of the poem brings together two worlds and ontologies but also differentiates them, perhaps because the portrait did not hold object constancy for the shaykh.

The *liwa'* was an ideal representative of hundreds, if not thousands, of functionaries like him, "new men" such as ʿAli Mubarak Pasha, whose *Khitat* textually narrated an organized visual space that such subjects would ideally inhabit. At the same time, the shaykh was the keeper of Islam's most holy site, dominated by dense tribal politics. Yet, at the same time, the Great Mosque was not a monastic shell, cut off from the regional developments that so drastically impacted the region. Al-Shaybi lived in the aftermath of the Wahhabi movement's defeat at the hands of Muhammad ʿAli Pasha and the eventual return of the Hijaz to the Ottoman Empire. Mecca was filled with intrigue that involved Cairo, Istanbul, and London as much as rivalries of tribes, families, and cities. Al-Shaybi's image appeared in a latter account written by Saleh Soubhy (Salah Subhi), a doctor in charge of quarantine and public health in Cairo, who traveled with the khedival *mahmal* in 1888 and 1891 and wrote his well-known *Pèlerinage à la Mecque et à Médine* on behalf of the khedive.[13] As Sadiq Bey mapped the Hijaz, the French-educated doctor, Soubhy, wrote for a foreign audience in order to show both the sanctity and orderliness of the Hajj, regulated by quarantines and public health measures through which

a great number of pilgrims flowed. The Hajj, Valeska Huber confirms, was subjected to rationalized management while new tax codes and administrative districting were implemented. Urban development plans were discussed for Medina, Mecca, and Jeddah in Istanbul, which still appointed many high-ranking officials in the city.[14]

All of this went against al-Shaybi's own tribal pedigree. The al-Shaybi family had been the custodian of the key to the Ka'bah since the time of the Prophet, placing him and his tribe at the center of the web of complex inter-clan relations within Mecca and in the peninsula. The walls of the Great Mosque, its institutional culture, and an orthodox tendency of Islam dominated Shaykh 'Umar's worldview. But this worldview itself contrasted with even more conservative Wahhabi beliefs that challenged the political and tribal network of al-Shaybi. The anxiety of Sadiq Bey in his *qasidah* points to the uncanny, arcane existence of an imageless world, dominated by writing that presupposes the *afterimage* of the portrait. If the poem bridges the absences and the portrait, this jointness makes visible a breach in the seamless surface of the photographic image-screen that was otherwise couched in its "truth-claim."

The seam of this jointness exposed by Sadiq Bey's poem to al-Shaykh Umar is that last call across two collapsing perspectives, from his khedival and Ottoman world to the "focal point" of the cleric, who, despite whatever resistance we might poetically detect, was still willing to be represented photographically. Sadiq Bey's world had become dominant even in the Hijaz, at least on a political level. The world of Ottoman reform and modernity was a perspective organized by the photographer's *manzhar*, a geomatic perspective and frame, which might have run aground in a world defined by Meccan textual practices. This seam, this fault line between two perspectives, between the image and the poem, is the joint where modernity and tradition meet, but also the trace of the uncanny presence of the past in the present. The anxiety expressed by Sadiq Bey's poem speaks to a historical disjuncture within the photographic unconscious, or in the words of Walter Benjamin made famous by Rosalind Krauss, photography's "optical unconscious" that structures Sadiq Bey's vision. When Lacan speaks of the gaze, he also speaks of the falling away of the subject and how this "sliding away" remains "unperceived."[15] In the social exchange between Shaykh 'Umar and Sadiq Bey, the subjectivity of the photographer and the naturalness—and invisibility—of photography's artifice could not "slide away" into a secular, modern, rationalized consciousness. In turn, the exchange produced an uncanny "strangeness" that forces Sadiq Bey to recognize the historical and social disjuncture between the two perspectives, between the textual, sacred cosmic view of the Great Mosque and the worldliness of cameras, portraits, and cartographic equipment.[16]

Sadiq Bey produced two portraits in Medina two months later that contrast with the absence of al-Shaybi's portrait and the presence of

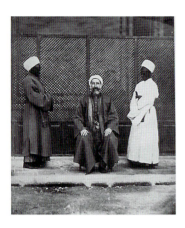

Figure 64.
Muhammad
Sadiq Bey,
"The shaykh
and the aghas
of the Proph-
et's Mosque,"
1880.

the poetic dedication. The images are of another cleric-administrator, al-Sharif Shawkat Pasha, the shaykh of the Mosque of the Prophet in Medina, and his attendants, who assisted him in care of the mosque.[17] Taken during Sadiq Bey's second trip in 1880, al-Sharif Shawkat Pasha is flanked by three servants, black eunuch slaves, who bore their own titles of *agha* (in this context meaning head servant). Two of them sit to the left and right of a seated Shawkat Pasha; although seated on the ground, their posture and body language communicates poise and stature in what was a prestigious position. The third attendant stands powerfully with his hand on his hip, behind the right shoulder of the sharif.[18] Against a blank white backdrop, all three seated characters (two aghas and the central figure of the sharif) look forward, forming a synergetic pyramid that poses Shawkat Pasha as central to an administrative unit. The dignity, restraint, and confidence of these men, taken singularly and as an administrative and photographic cluster, almost undermines the social hierarchy (of master-slave) that structures the social relations between these figures.

In contrast to this portrait, Sadiq Bey offers another image that follows the contours of Orientalist photography, where socio-racial hierarchy is far less ambiguous than it is in the image's partner. In this second portrait, Shawkat Pasha is majestically seated on a stool outside the mosque in the exact pose as the aforementioned portrait (fig. 64). Despite his identical posture, the dynamics of the image are radically different. Against a backdrop of latticework, he poses on a stark exterior pavement, flanked by two of the same servants. These two figures, however, are now deflated. Empty of the poise and dignity in the previous portrait, they deferentially stand and face him, not the camera. There is no synergy in this image. Each portrait demonstrates balance and a formal composition that places the sharif at the center of the mid-ground, flanked by the attendants as counterweights. Yet Sadiq Bey's second photograph depicts a clear master-slave relationship between the sharif and his servants.

While ignoring the figures of the "eunuchs," Claude Sui ameliorates the formalistic tension between the two images by introjecting Sadiq Bey the photographer into the photograph of Shawkat Pasha. He remarks that the portrait "would not have been possible if the photographer had not enjoyed the full confidence of this high-ranking Muslim dignitary; thus, at this time, such pictures could not have been taken by European studio photographers."[19] Sui is correct that Sadiq Bey must have established a rapport with the sharif Shawkat Pasha as only a skilled, native photographer could have done. But more so, his observations crucially conjure a significant and far-reaching interplay at work within the production, circulation, and reading of the nineteenth-century photographic Arab portrait. That is, the legibility of the photograph with no sentiment, no poem, no narrative. The absence of these "tethers" allow the photographer and camera, in the words of Lacan, to "slide away" into the transparent gaze that

relies unquestionably on the photograph's *studium*, its indexical and ideologically infused representation, to relate the multiplicity of its *verum factum* and give it value. The "nature of photography" rests on this *truth-effect* that recuperates its anxiety in the face of alterity's appearance. This is the stabilizing nature of the portrait, where photographic practice, enactments, and semiotics assume their a priori legibility and pose as if the image-screen can communicate its content without mediation.

The Egyptian technocrat's portraits of a Muslim official along with his black slaves in 1880 Ottoman Medina clash but redouble to confirm each image's *verum factum*. This recuperative formalism of the portrait summons us to deliberate not only the *verum factum* of the portrait, but also the host of social relations at play within the portrait's production, exchange, and circulation. The Sadiq-Shawkat-attendants nexus presents a three-dimensional matrix of social relations. These relations cross between photography's introduction into Mecca and the social history of the city after its return to the Ottoman Empire by Muhammad Ali Pasha. The nexus involves the changing social relations between race, slavery, and social roles at a time of the implementation of rationalized modes of governance, rights, and civil society. The Ottoman Hijaz was shaped by the shifting political economy of the Hajj itself during the nineteenth century, especially as a space of contact and contestation between Arab tribes, Egypt, Britain, and the Ottoman Empire. Like other parts of the empire, the integration of new technologies (whether photography, telegraph, cartography, or engineering), functionaries such as Sadiq Bey, and Ottoman policies impacted the daily and professional lives of residents (both free and enslaved) as well as pilgrims.[20] Neither Shawkat Pasha, his attendants, nor the photographer can be freed from these social relations, just as the perspective of al-Shaybi is historically interlocked with the photographer's rationalizing *manzhar*. We receive the portrait of Shawkat Pasha from a world that Sadiq Bey himself cohabited with his photographic subjects.

While the two images compositionally clash, they are bound by the repetitious formalism of portraiture, which *mediates* the photographer and sitters' relations *within* their shared world. This does not mean that they inhabit the same social, political, or material *conditions*. This world includes, as we discern from Sadiq Bey's poem to al-Shaybi, rival worldviews of technocrat, cleric, and slave. But these worldviews are a part of larger social groupings, larger collective and political formations. The particular staging, framing, and balance of Sadiq Bey's photographic portraiture does not "capture" and contain the sharif and his attendants. Rather, it reflects a logic of symmetry and organization that politically and aesthetically constituted Ottoman and Egypt's social, economic, and political power, which embroiled Hijazi local politics, administration, and economy. At the same time, the two contrasting images suggest an alterity to that normative

scopic regime. In this way, the "perspective" of Sadiq Bey's improvised "studio" portraits differs little from the studio portraits of Sadiq Bey in military uniform or slightly slovenly effendi apparel.[21]

Prohibition and Anxiety

At the same time, while Sadiq Bey was accompanying the Egyptian *mahmal* on Hajj, ʿAbd al-Ghaffar bin ʿAbd al-Rahman al-Baghdadi had become Mecca's first native photographer. Sadiq Bey states that he met ʿAbd al-Ghaffar in Mecca and then again in Cairo, when the Meccan ophthalmologist came to learn about dentistry.[22] Otherwise known as the "the Doctor of Mecca," ʿAbd al-Ghaffar maintained a prominent social and economic relationship with the Dutch Orientalist and convert to Islam, Christiaan "Ghaffar" Snouck Hurgronje (1857–1936).[23] Snouck Hurgronje was a prolific photographer, whose character-types and flat portraits contrast with the more intimate and textured images of contemporaneous native photographers, namely, ʿAbd al-Ghaffar, Muhammad Ali Saʿudi, and General Ibrahim Rifʿat Pasha. This is not to say that Snouck Hurgronje did not have a genuine fondness and reverence for the people, culture, and religion of the Arabian Peninsula.

Whether Snouck Hurgronje taught the Meccan polyglot photography is unknown. However, he and ʿAbd al-Ghaffar maintained a relationship after the Orientalist's impromptu departure from Mecca. The few letters that still exist confirm that ʿAbd al-Ghaffar served as Snouck Hurgronje's photographer in the Hijaz after the Dutchman was evicted.[24] ʿAbd al-Ghaffar sent him landscapes, architectural shots, and portraits after 1887. These images were republished in Snouck Hurgronje's ethnographic *Bilder Aus Mekka*.[25] ʿAbd al-Ghaffar preferred to photograph notables, much to the chagrin of Snouck Hurgronje, who wanted character-types of servants, the poor, and women. He wanted the image of Bedouin tribesmen, with elaborate mounts on their camels, inlaid swords, and flowing gowns—images that he did, in fact, get and use as central to his own album, which he circulated throughout Asia during his stay in the Dutch colonies (fig. 65). While "scores" of ʿAbd al-Ghaffar images remain unpublished, together the Meccan Doctor and Dutch Orientalist succeeded in producing portraits of Turkish military elites, the notables and merchants of the city, and the most important members of the Sharifan family, most conspicuously the sharif of Mecca, ʿAwn al-Rafiq, and a very young Abdullah ibn Hussein, the future king of Transjordan.[26] Sadiq Bey himself photographed a younger ʿAwn al-Rafiq and attained permission to publicly release and display his likeness in 1880.[27]

Hurgronje's spontaneous exit from the Hijaz is shrouded in intrigue, but he traveled to Indonesia as a Dutch official where he continued his scholarly and personal interest in Islam and photog-

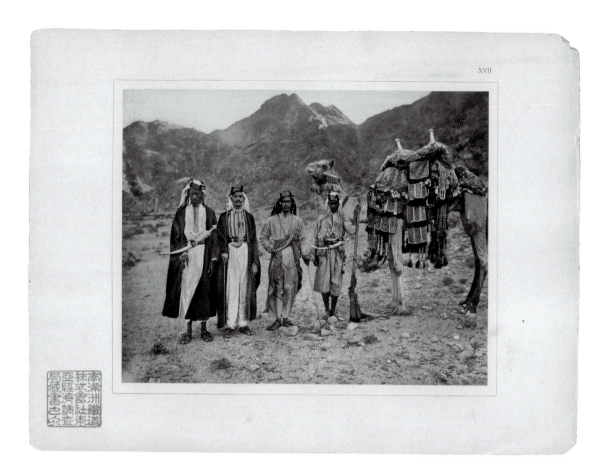

raphy. There he read a treatise written in 1882 by a Meccan shaykh, protesting about the proliferation of "unlawful usages and infidel culture." In particularly convoluted language, the shaykh warns of "the things that lead into Hell is that the devils in these times have put into the heads of the Christians and other God-abandoned people to place on all wares that are used by man pictures of living creatures so that there is hardly a house, shop, market, bath, fortress, or ship without pictures … even into our mosques pictures come, for most people, when they come to prayer, have with them little packets of cigarettes and tobacco on which there are pictures."[28] The passage demonstrates the proliferation of image making by the 1880s, even in Mecca. In their study of H. A. Mirza, an early South Asian Muslim photographer of the Hajj, Ali Asani and Carney Gavin quote the renowned South Asian salafi Abu ʿAla al-Maududi, who issued a *fatwa* against photography for its corrupting effects some decades later.[29] A more timely example, however, is a *fatwa* by Shaykh Muhammad al-Inbabi, shaykh of Azhar in 1893. Al-Inbabi's legal opinion was that photography is *haram*, suggesting, in language evocative of Sadiq Bey's *qasidah*, that photographers will be cursed and suffer in hell on

Figure 65. ʿAbd al-Ghaffar, "The riding camel of Sharif Yahya, one of the sons of Sharif Ahmad, whose father was the famous Great Sharif … ʿAbd al-Mutallib, who died in 1886. . . . The bridle is held by the slave." *From Bilder Aus Mekka* (1889), stamped with the seal of its former owner: Southern Manchuria Railroad Co., East Asia Economic Research Division.

the day of redemption because they lead one down the path of idolatry (*wathaniyah*).[30]

A decade later, Rashid Rida rejects al-Inbabi's ruling. He notes that photography has a positive role in society and science and that the government can use it to track down escaped prisoners. And indeed, by 1887, police began to use photography to find and register criminals. Rida's defense of photography comes from his particular ideological position as "Islamic reformer," as a disciple of "Islamic modernists" Jamal al-din al-Afghani and Muhammad 'Abduh, both with whom Muhammad Sadiq Bey was well acquainted—if not personally than intellectually. Rida's defense of photography reveals that the discussion of Islam's alleged interdiction against it was a political and ideological, not religious, debate between conservatives and reformers, between the old guard whose ground was "sliding" away underneath them against the rising tide of a new organic *ulama'* and secular nationalist thinkers, such as Ahmad Amin and his first mentor. In their journal *al-Manar*, Rida and Muhammad 'Abduh replied to several queries about the permissibility of photography. In a letter from Borneo, al-Shaykh Muhammad Bisyuni inquired into whether photography was *haram* because it captures the human image. He also asked whether the hanging of an image in the house is equivalent to idolatry. Rida quotes from the hadith of the Prophet, relating a story where Muhammad's wife Aisha, who hung a curtain made from the Ka'bah's *kiswah*. The Prophet did "not see in that any evil." Rida then specifically states that there is no direct mention of the prohibition of images themselves, but that the matter is contextual.[31]

In a reply to Ahmad Issam in Mecca asking about photography's status in Islam, Rida unequivocally endorses photography as an essential means to increase and connect the "chain of science," stating: "Its benefits in this age are many in the sciences such as medicine, inquiry, and natural history and in the crafts [*sina'at*)], in politics, administration and military and in language. The many names of plants and animals are not known by name in Arabic because we lack their image. The language books do not add much to the animal or plant vocabulary or knowledge. Photography is needed to connect sets of existing knowledge essential to this day and age."[32] Rida's defense of photography animates Yumna al-'Id's observation that "knowledge is only produced by a fundamental relationship between its subjects."[33] In the era of *al-nahdah* and Tanzimat, where progress relied on connecting sets of knowledge, Rida keenly pinpoints photography as an ideological and social tool essential in reforming Arab-Muslim society and, indeed, achieving Syrian and Egyptian independence. Rida's *nahdah* perspective bursts through when he concludes that "photography is a pillar among the pillars of civilization [*al-hidarah*]; the sciences, arts, crafts, politics and administration are raised by it. It is not possible for a nation [*ummah*] to leave it aside if it is to keep pace with the nation that uses [photography]."[34]

Photography, then, for Sadiq Bey and Rida, was an instrument of national progress, national order, and organization. Since photographic perspective was "modern" perspective, Rida had to address the claim of Islam's prohibition on image making, saying that this interdiction only applies to the worshipping of images and statues. The Prophet, he elaborated, did not take issue with the image itself because *al-mushtarikin* worship it and that "the pleasures of [the image] are not prohibited."[35] Reminiscent of Sadiq Bey's plea to al-Shaykh 'Umar, Rida defends the photographer because he is not attempting to reproduce the image of God, which would be sinful. The photographer, as a man of knowledge and craft, *reproduces* images of what Allah has created just as the phonograph reproduces the sounds of His creations.[36] This argument deploys the classical use of *qiyas*, analogue, which was central to Muslim reformist methodology during *al-nahdah al-'arabiyah*.

Shaykh Muhammad Bakhit al-Muti'i (1856–1935), the grand mufti of Egypt sometime between 1914 and 1920, issued an extensive *fatwa* regarding photography. Al-Muti'i was himself a leading political figure in Egyptian national politics, an Islamic reformer and prolific scholar, whose prominence rose during the Egyptian nationalist, independence movement and coincided with Egypt's nominal independence in 1919.[37] In his *fatwa, al-Jawab al-shafi'i fi ibahat al-taswir al-futughrafi* (The Shafi reply regarding the legality of photography), Shaykh Bakhit repeats the anecdotes from the hadith of Bukhari about the prohibition of graven images. Most prominently, "angels do not enter in a house with a dog or a statue," nor do they "enter into a house with a picture." Likewise, the Prophet is related to have said that *musawwirun* (image makers, which is the same word for painters and photographers) will "suffer on the day of redemption."[38] That said, his stance aligns with that of Rida, where the grand mufti asserts that the photograph is permissible because it represents, and therefore glorifies, the creations of God. More interesting than Rida's defense, Shaykh Bakhit states that photography is permissible because it uses light and shadows, which God created. The image is not brought into being through the human hand as other forms of image making. Rather the camera simply captures what God has already created though elements that He created (that is light and shadow).[39]

The overabundance of cartes de visite and formal portraits between 1870 and 1914 is echoed by a regular trail of portraits of Egypt's grand muftis, starting consistently before 1909. The thoughts of the Islamic reformer and provocateur 'Abd al-Rahman al-Kawakibi (1855–1902) reflects a consensus among turn-of-the-century conservative Arabo-Islamic thinkers. He contemplates, on the one hand, how Muslim traditions have become Christianized and traditional practices have become "Westernized." Arabs fly the sultan's flag in lieu of the flag of Islam, and they "hang various name-signs on the wall suspended from pictures and statues."[40] On the other hand, his

exculpation of photography reaches into the discourses of *al-nah-dah* that run through reform thinkers of the day regardless of their religion or political persuasion. Specifically, al-Kawakibi anticipates Shaykh Bakhit al-Muti'i's *fatwa* and states that modern technologies, including photography, are forms of knowledge already revealed to God and capture the light and shade of His making:

> In recent centuries, many discoveries and inventions have come to light by American and European scientists. But if one examines the Qur'an closely, they will find that most of these discoveries and inventions were stated clearly or hinted at indirectly in the Qur'an thirteen centuries ago. Indeed, these mysteries have been hidden for long as to give them a stronger and more miraculous impact once they appear, only to prove that the Qur'an is truly the words of the Lord, who alone knows the Unseen. ... [For example,] they found out how to hold the shade, namely, photography. The Qur'an says, "Have you not considered the work of your Lord, how He extends the shade? And if He had pleased He would certainly have made it stationary; then We have made the sun an indication of it" ([from Surat Furqan], 25:45).[41]

Al-Kawakibi's life was marked by forging a new political idea: the return of the caliphate to the Arabs in order to lead the new Arab nation built on principles of justice, equality, and Islam. Islam itself accommodates all new forms of knowledge that contribute to the good of the community (*al-ummah*) and the nation (*al-watan*). While the Qur'an does not mention explicitly a prohibition on portrait making, according to al-Kawakibi, it anticipated the technology and knowledge that made it possible. Like Rida, Abduh, Shakib Arslan, the Lebanese Shaykh Yusuf al-Asir, 'Abd al-Qadir al-Qabbani, and so many other Arab Muslim reformers, a handful of elusive portraits of al-Kawakibi exist. Along with stories that the Prophet Muhammad prevented the images of Abraham, Jesus, and Mary on the Ka'bah walls from destruction, the Qur'an also relates that the *jinn* army of King Solomon, a prophet in Islam, made for him many statues and other decorative works.[42]

That said, Shaykh Bakhit in his *fatwa* relates a long countertradition in the hadith against figurative depictions, which tells us that the religious debate on photography and an actual prohibition of the portrait are a distraction from photography's more ponderous historical implications at this time. The ambivalence and debate around the issue of an Islamic prohibition of photography and the eternal damnation of photographers reveals itself as less a moral question than a *social anxiety*. That is, the earliest photography produced around the Hajj contrasts with the abundance of portraits being produced simultaneously in the Ottoman Arab cities. Muslim reformers and traditional conservative 'ulama', the latter of whom were being pushed

out of their traditional leadership and political roles by the former, wrestled with Ottoman and Egyptian modernity in ways that made photography one more space of political confrontation. Any actualization of modernity, such as photography, within a setting so sensitized and sacred as the Hajj, became an opportunity for the stripping of the veneer of the rationalizing perspective, for tripping the "sliding away" of a self, photographer, and camera that endows the naturalness and seemingly logical transparency of photographic representation. The discussion of the permissibility of photography was not a religious issue but a *social anxiety* that revealed the seam between Sadiq Bey's rationalizing perspective, the *nahdah verum factum*, and a politicized, cosmic vision of an old guard.

Ibrahim Rif'at Pasha

Sadiq Bey's many books and accomplishments were eventually overshadowed by a later photographic Hajj account, written by another *liwa'*. General Ibrahim Rif'at Pasha published a lusciously illustrated book, *Mir'at al-Haramayn aw al-rihlat al-hijaziyah* (The mirror of the two sanctuaries; or, Hijazi journeys), documenting his four journeys to Mecca and Medina, first as head of the guard and then as amir al-Hajj, leader of the Egyptian *mahmal* in 1901, 1903, 1904, and 1908. The accounts were heavily illustrated by photographs and published collectively in Cairo in 1925.[43]

Ibrahim Rif'at Pasha was an amateur photographer, but his account anchors itself in his position as a leading military and political functionary (fig. 66). In it, he provides little commentary on photography itself. Images visually supplement his geo-political account, showing local tribal and Ottoman figures, conditions of the pilgrimage routes and pilgrims, the newly established lazaretto in al-Tur in Egypt, dealing with corrupt Ottoman-Meccan officials, and the paying of tariffs. The title "Mirror of the Two Sanctuaries" unambiguously refers the reader to the narrative's photographic content, which illustrates the pasha's journeys to Mecca, Medina, and a handful of ancillary locations in the Hijaz and the Hajj route.

Despite the fact that Rif'at Pasha's narrative is negotiated by his position as a high-ranking Egyptian officer, *Mir'at al-Haramayn* is an account that intertwines an august, political mission with Islam's most intimate religious experience. In this regard, the general's humanity comes through in his photography, which includes a number of informal and personal photographic vignettes. He candidly poses with local officials in front of the tomb of the Prophet's uncle al-Sayyid Hamza ibn 'Abd al-Muttalib, sitting on the ground and drinking tea along with underling and fellow photographer Muhammad 'Ali Effendi Sa'udi and others. Or, surrounded by his entourage, wearing the white garments of a pilgrim (*ihram*), the general sits on sacks of

Figure 66.
Unknown photographer, al-Liwa' Ibrahim Rif'at Pasha Amir al-mahmal al-misri, amir of the Egyptian *mahmal*, 1908. Frontispiece, *Mir'at al-Haramayn*.

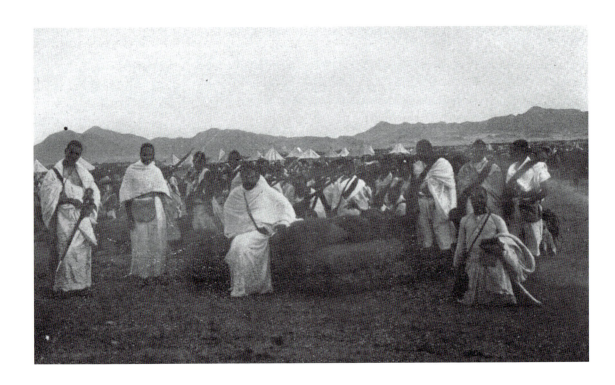

Figure 67.
Ibrahim Rif'at Pasha, Self-portrait, "al-Mahmal at Bahrah Station: Amir al-Hajj wearing *ihram* and sitting on zwieback. To his left, assistant, kneeling, carrying camera equipment and the guards standing." From *Mir'at al-Haramayn.*

zwieback (*baqsumat*) at Behrah, the first station on the way to Mecca from Medina (fig. 67). The underexposed image is one of the few that shows his photography equipment, albeit toted by attendants.[44]

Published after Egypt officially became a nominally independent, constitutional monarchy in 1919, the account functioned as an exercise of power for the new kingdom, *historically* documenting Egypt's political and military presence in the Hijaz. Apart from World War I and the collapse of Ottoman rule, these tribal rivalries resulted in the displacement of the Ottoman, Egyptian, and British-friendly Hashemite Sharifate in the Hijaz by the Wahhabi-backed Ikhwan-Sa'udi ruling alliance at the very moment of the book's publication. While photography seems only an embellishment to the narrative, it makes Rif'at Pasha's otherwise dated narrative noteworthy. The images act as a supplement that *mediates* the dual roles of pious pilgrim and functionary, believer and representative of a rationalized order, and, quite literally, an enforcer and "guardian" of its new disciplinary regime of power.

Nahdah Imago as Stability

If the *mise en temps* of *Mir'at al-Haramayn* is unreliable as commentary on the "nature" of Ottoman Arab photography because the narrative was published almost two decades after Rif'at Pasha took his

last Hajj photograph, Rif'at Pasha's text boldly establishes a vital point of this study; that is, indigenously produced photography of the late Ottoman period was an afterimage of social transformations and the arrival of Arab modernity. The belated publication of Rif'at Pasha's photographic journeys is a literalization of how photography's structure, its legibility, its vision, its "perspective," and its alterity during the late Ottoman era had been established well before its own publication and dissemination. By his first Hajj in 1901, Ibrahim Rif'at Pasha was already acting well within practices and technologies of "visualization through which geographical knowledge" that had already been "conceived, constructed, and communicated" by ventures and projects such as Muhammad Sadiq Bey's cartographic and photographic journeys. Rif'at Pasha's mission was embedded in a state program and in the massive discourse and knowledge production in the nineteenth century that made both photographers' careers, positions, and authority possible.[45] The geographic and subjective "imagination" of the functionaries, intellectuals, and reformers in the late Ottoman period was organized by a *nahdah imago* and an ideological and discursive "imaginary" which structured it. The photographic frame of reference, the modern Arab "perspective," had already been organized by previous decades of shifts in political economy, social organization and hierarchy, and notions of selfhood that initiated *al-nahdah* and produced Ibrahim Rif'at Pasha as a "new man" of modern military and administrative knowledge.

If we read *Mir'at al-Haramayn* synchronically between colonial and postcolonial Egypt, or the Ottoman and post-Ottoman Arab world, we witness that the decade in which Rif'at Pasha made his pilgrimages was informed by a century of developments in economy, politics, and culture. Its narrative and visual structure were organized by the binaries of the *nahdah* standard, where reform and progress of the new political and social order inevitably run up against the decay, corruption, and backwardness of the old. The many studio cartes de visite in the open and closing pages of *Mir'at al-Haramayn* recall Jawhariyyeh's own history. They depict a visual narrative of Egyptian officials, his colleagues, and Ottoman officials, all of whom collectively convey not only the official nature of the *mahmal* and the authority of the amir al-Hajj and his liege, but also the civilizational and developmentalist discourses that they represented and championed.

Among this procession of Egyptian-Ottoman sociability, the signed studio portrait of the Moroccan notable, al-Wazir al-Sayyid al-Mahdi ibn al-ʿArabi al-Munabihi, stands out. Taken in 1904 (dated AH 1322), the portrait serenely displays the Moroccan *wazir*, or minister, in grand yet not ostentatious Moroccan dress against a classical studio backdrop (fig. 68). The pasha and *wazir* spent a considerable time in the lazaretto in al-Tur together, where the former clearly expressed admiration and friendship for the latter.[46] As in the studio portraits of the many officials in their Ottoman military and admin-

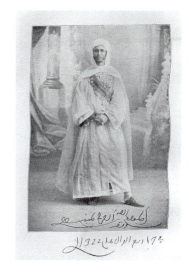

Figure 68.
Ibrahim Rif'at Pasha, "al-Sayyid al-Mahdi bin al-ʿArabi al-Munabihi, posing Rabiʿ al-awal 17, 1322," 1904. From *Mir'at al-Haramayn*.

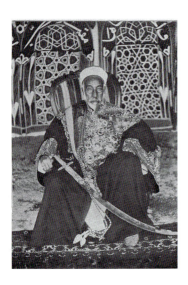

Figure 69.
Unknown photographer, Sharif ʿAwn al-Rafiq Pasha, former amir of Mecca. From *Mirʾat al-Haramayn*, plate 318.

istrative uniforms, the two are bound by a respect for political order, the piety of al-Hajj, and protocol (which contrasts with many of Rifʿat Pasha's other portraits of tribal leaders) but also by an exchange of gifts, including golden and silver clocks and the portrait that Rifʿat Pasha reproduces.[47] Namely, his book also includes the portrait of the notoriously corrupt sharif of Mecca, ʿAwn al-Rafiq (1882–1905) whose graft and oppression Rifʿat Pasha spends considerable energy detailing, including representing official complaints to the Sultan Abdülhamid (fig. 69).[48] Rifʿat Pasha and his entourage were held up at the lazaretto with al-Munabihi and his young son ʿAbd al-Rahman, because of the Meccan sharif's machinations. Contained within the openness of an idealized studio space, al-Munabihi's serene and dignified *contrapposto* confronts Rifʿat Pasha's portrait of Sharif ʿAwn al-Rafiq, whose figure munificently sprawls to the floor. His oversized, ceremonial sword and lushly embroidered *ʿabayah* overwhelm the barely detectable Ottoman medals that he wears. His cold look and body lost in opulent garb contrasts the literal uprightness and dignity of al-Munabihi, who lived at a time when France and Spain were carving out their own "spheres of influence" in Morocco.

In the figure of ʿAwn al-Rafiq, highlighted by the contrast with that of al-Munabihi, Rifʿat provides an enactment of the *nahdah* narrative of "progress and civilization," cloaked in a discourse of moralism and civility. Moreover, the commentary on ʿAwn al-Rafiq needs to be read against Rifʿat Pasha's own context of serving as a military functionary for Khedive Abbas Hilmi, who was educated in Austria and was a nationalist in his own right. The effects of the modernizing project, schools, institutions, laws, development projects, agricultural modernization, and so forth, were matched by al-Sharif ʿAwn al-Rafiq's tyranny, which itself is represented in portraiture. Rifʿat Pasha provides two portraits of the brothers ʿAbdullah Pasha and Muhsin Pasha, sons of al-Sharif Muhammad [Pasha] ibn al-Sharif ʿAbdullah Pasha, the former amir of Mecca (fig. 70). These two are nephews of the notorious al-Sharif. We learn that al-Rafiq's corruption was not limited to shaking down pilgrims with excessive tariffs, bribing Ottoman officials, or isolating his rival kin. Rather, his corruption was as programmatic as *nahdawi* progress and patriotism were. Muhsin Pasha and ʿAbdullah Pasha, hardly eighteen years old, for example, "were not even rudimentarily educated due to the neglect of education and the paucity of schools in Mecca." The general's analysis rings of al-Kawakibi's writing, saying that "al-Sharif ʿAwn al-Rafiq Pasha desires this because he sees in learning the illumination of thought, leading to the demand of *rights*, which infringes upon the hands of oppressors and compels one toward liberation from tyrants."[49]

Photography provides a supplement to the discourses of knowledge and progress where Rifʿat Pasha provides another portrait as a counterbalance to those of the uneducated nephews. In this group portrait taken by Muhammad ʿAli Saʿudi, the pasha stands behind the

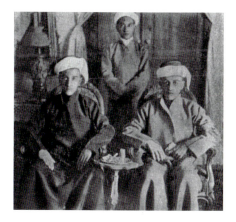

two nephews with other prominent men of knowledge. Ibrahim Bey Mustafa al-Ma'mam was the former supervisor of Dar al-'Ulum (the House of Knowledge) in Mecca, and Ahmad Bek Zaki Amin al-Surrah was the keeper of the *mahmal*'s tribute to Mecca. They flank Rif'at Pasha, who stands behind the two brothers but remains the central focal point of the portrait (fig. 71). Rif'at Pasha's physical presence, not to mention that of the former head of the Dar al-'Ulum, is a commentary on the social value with which any discourse on "knowledge" immediately endows a figure. These discourses on the value of modern and classical knowledge underwrote the enactment of photography, as we have seen, reinforced through the formalistic staging of social hierarchies in the portrait. The formalism of the group portrait is repeated throughout the two volumes, where the ranks and centrality of seated and standing figures visually reaffirms in geometric order the social hierarchies of the portrait.

But more than the visual formalization of social hierarchy, Egypt's century of modernization, progress, and education, in the body of the pious general, contrasts with the ineffectualness, quarrelsomeness, and capriciousness of the Meccan tribal leaders as represented by the two young slouching pashas. The semiotics of Ibrahim Rif'at's upright and central presence emanate from his position as an official of a rationalized bureaucracy as represented in his group portraits with Hijazi and Najdi officials. Rif'at Pasha was a counterpoint to the figures of the neglected nephews, who materialize the effects of the despotism of al-Sharif 'Awn al-Rafiq. The figures of the nephews elicit the knowledge of a number of high-profile sons of those tribal leaders, by contrast, who were invested in the Ottoman perspective, not the least of which was Hussein bin 'Ali and his son Amir Faisal bin Hussein al-Hashmi, both who lived and were educated in Istanbul. When Rif'at Pasha's account narrates these portraits, he asks the viewer to read them intertextually, against the acts of the sharif, who deprives his rivals and subjects of their inherent *rights*, from access to knowl-

Figure 70.
Ibrahim Rif'at Pasha, 'Abdullah Pasha and Muhsin Pasha, the sons of Sharif 'Ali, [AH 1326 (1908)?]. From *Mir'at al-Haramayn*, plates 34 and 35.

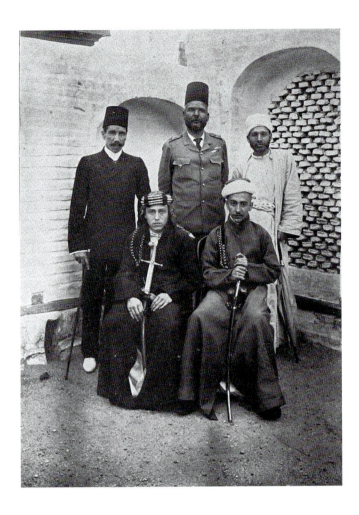

Figure 71.
Muhammad 'Ali
Sa'udi, *Standing*: Ibrahim
Bey Mustafa
al-M'amam,
Ibrahim Rif'at
Pasha, Ahmad
Bek Zaki Amin
al-Surrah; *sitting*: 'Abdullah
Pasha and
Muhsin Pasha,
sons of Sharif
'Ali. From *Mir'at
al-Haramayn*,
plate 36.

edge and order, and no doubt foremost among them, from the right to claim property and authority.

Belated *Unheimlich*

The semiotic structuring of Rif'at Pasha's portraits operates on the ideology, discourses, and priorities of the Arab and Egyptian *al-nahdah* as laid out in writings, thoughts, and political platforms since the time of Rifa'a Rifi' al-Tahtawi and Muhammad 'Ali in Egypt. However, the temporal disjuncture between the time of *Mir'at al-Haramayn*'s publication (1925), and the time when the journey was undertaken and the images were photographed (1901–8), analytically produces a breach in the jointness of this semiotic surface. *Mir'at al-Haramayn*'s untimeliness allows a return of the otherwise displaced *unheimlich* of Sadiq Bey's absent photograph and its anxious poem. The temporal distance between his pilgrimages and the publication date were

separated by the passing of the Ottoman Empire, the passing of his narrative's characters, rise of Bayt Saʾud, and the destruction by the iconoclastic Wahhabis of the saintly shrines he photographed. This discontinuity makes the image self-aware when it otherwise demands to be transparent and insists on its own truth-claim.

The belated publication of a photographic account of the Hajj makes the album irrelevant as a guide. Its untimely release, well after the demise of the Ottoman Empire, the fall of the Sharifate of Mecca, and the fruition of Egyptian national aspirations that transformed a viceroy into a king, disturbs the transparency, naturalness, and the truth-claim of the photograph's *verum factum*. To put it more simply, the critical distance between the late Ottoman journeys to the Hijaz and the book's publication in 1925 Cairo summons aspects of social and political history that otherwise would have been erased in the photographs' exchange and circulation.

This repetitious twinning is found throughout Rifʿat Pasha's visual narrative. The portraits of ʿAbdullah Pasha and Muhsin Pasha are examples that, for every portrait of a tribal leader or notable, the Egyptian general produces a group portrait where he is inserted within their presence. Rifʿat Pasha is both subject and object, photographer of himself and narrator of his own journey. His image acts as the "constant object" within the repetition of the images, offering jointness between subjective experience and political economy. But, *Mirʾat al-Haramayn* is less a guide than an anamnesis. It is more a remembrance than a history such as Jawhariyyeh's, or even a guide to *al-nahdah*, like Tarrazi's encyclopedia. The certainty of Muhammad Sadiq Bey's cartographic vision, some half century before the publication of *Mirʾat al-Haramayn*, is haunted by the uneasiness of a poem that accompanies the portrait. The poem obstructs the photographer's "sliding away" into the objective and universal perspective of his instruments and calls into question the naturalness of its worldview. Likewise, the repetitive insertion of Ibrahim Rifʿat Pasha into his group photography reveals, as Geoffrey Batchen remarks, "the subject of the photograph's intervening within or across the photographic act."[50]

The belated publication date confirms that the photographs are an *afterimage* of practices and projects that structured *al-nahdah*. The internal pairing of portraits, where Rifʿat Pasha is both photographer and subject in group portraits, divulges the political nature of a supposedly personal journey and religious obligation. In turn, the contingency of the photograph, which formalistic and practical repetition displaces to the margins only to emerge in anxious traces, is recentered in *Mirʾat al-Haramayn*'s delayed publication. The repetition of Rifʿat Pasha in the portraits of the subjects he meant to document was not coincidental. It transformed a guide into a personal journal, a documentary of the two holy sites into a "mirror" of them with the general at the center of those reflections. It mitigated the disciplinary intent of the mission and stabilized the narrative as

a personal journey. In the process, Freud reminds us that, "whatever reminds us of this inner 'compulsion to repeat' is perceived as uncanny."[51] The uncanny is marked by a "doubling, dividing and interchanging of the self."[52] This doubling resurfaces persistently in *Mir'at al-Haramayn*, acting as a "preservation" against the anxiety of the social history of photography and the photograph. The repetitious appearance of Rif'at Pasha's figure in the group portraits points to and displaces the same apprehension that peeks out of Muhammad Sadiq Bey's accounts fifty years before, where photography's truth-claim is challenged by the photograph's alterity, the existence of alternative "perspectives" that history has vilified, erased, or marginalized.

Let it be clear that the jointness of photography and the narrative of *Mir'at al-Haramayn* stabilizes the historicity of the guide. The uncanniness is an effect that only appears with the reading against the text's untimeliness. The highlighting of the temporal disjunction between the time of the journey and the release of the guide makes the photographer-subject's presence in his group portraits into a haunting "twin." Just as the text's narrative synchronically transpires in colonial and post-independence time, the photographer and photographed are a double that are coterminously both present and absent. The simultaneity of Rif'at Pasha's visual-textual narrative tells us of the *condition* of early Arab portraiture, which is otherwise made transparent by the force of hegemonic discourses that make it intelligible. This condition is that photography during the late Ottoman Empire was the handmaiden to social and subjective discourses that naturalized the radical transformation of the political economy and social fabric of the Middle East during the nineteenth century. But also, as a stage of enactment and an afterimage, the stabilizing portrait pushed the forces of instability beyond the portrait's frame. Such instability would return in the case of the Wahhabi-Ikhwan-Ibn Saud blowback by the time the book was published.

Doubleness and Recuperating the Surface

The internal and temporal "doubleness" of *Mir'at al-Haramayn* is not limited to the vagaries of Hajj photographies. Rather, the geographic, social, and religious complexities involved in early Hajj photography was just as susceptible to its disclosure. At the same time the book was published in Cairo, surrealists were seizing upon this paradoxical doubleness within the "nature of photography," which, in the world of Rosalind Krauss, is "the paradox of reality constituted as sign—or presence transformed into absence, into representation, into spacing, into writing."[53]

This paradoxical, synchronic doubleness is the very nature of Ottoman photography and modernity itself. The doubleness is an

adjacency of the material and the ideological, and the manifest and latent content of the nineteenth-century Ottoman photograph. One might say that Ibrahim Rifʿat Pasha's *Mirʾat al-Haramayn* (The mirror of the two holy shrines), is aptly titled not because its "illustrations" are images that reflect the previously unseen, or represent individuals who were never previously imaged. Rather, each of these images, particularly each of these portraits, is a screen of the pasha's reflection and the iridescence of all that makes him, his journey, and mechanical-chemical image making possible. Each portrait, Foucault reminds us in reference to the mirror in Velázquez's *Las Meninas*, "isn't a picture." It is a mirror that offers us an "enchantment of the double," a modern subject that is both subject-viewer and object-observed.[54]

The unified Cartesian "cogito" and self-enclosed Albertean perspective is far too frequently predicated as the basis for *Osmanlilik* modernity, let alone in defining discourses particular to modern Middle Eastern art, architecture, and the organization of modern space. Instead, the national subject is caught between the principles of the Enlightenment and the realities of an increasingly alienated and decentered subject, who is both subject and object of knowledge, between cartographic knowledge and the transcendental faith of the Hajj. The national subject during *al-nahdah*, whether in Egypt, Lebanon, or Palestine, is always both subject and object of his or her own progress and civilization as well as a source of his or her own "backwardness." The concept of backwardness camouflaged or housed the alienation inevitable in capitalism's radical nature of economy, money, and selfhood, the alienation resulting from individuating and ripping subjects away from "traditional" communal polities into *nahdawi* ethos of nation and citizen.

The pasha's doubled image, his reflection and presence in the portraits of his journey, however, remain unproblematic because the anxiety that we have teased out is displaced and hidden in history. Recalling Sadiq Bey's repetitive referencing to his perspective and positioning in the photographic "sights" of the Hijaz, Jonathan Crary notes that the notion of a rupture was essential to modernity's vision, which "depends on the *presence of a subject* with a detached viewpoint."[55] The vision that erases the doubling within Ibrahim Rifʿat's portraits, the photographer being both his own subject and object, should be understood "against the background of a normative vision" of *Mirʾat al-Haramayn*'s narrative and subject position. Buffered by the discourses of modernity and reform against the political economy of Egyptian regional politics, Rifʿat Pasha's power, position, and leadership in *mahmal* is inseparable from every photograph taken. This is what recuperates and stabilizes the image, displacing the temporal dissonance that I have highlighted. Every photograph hails the pasha, seeking security in his authority and competency, to his success in enacting *nahdah* ideals.

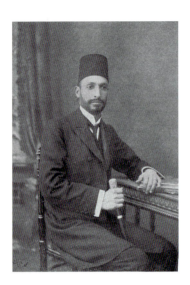

Figure 72.
Muhammad
ʿAli Saʿudi,
Self-portrait,
print on paper.
From *Mirʾat
al-Haramayn*,
p. 321.

Superstition as Alterity

Rifʿat Pasha was the organizing center, and copyright holder, of the images in *Mirʾat al-Haramayn*; however, he was not necessarily always the photographer. Muhammad ʿAli Effendi Saʿudi (or Souadi, 1865–1955) assisted Ibrahim Rifʿat Pasha in taking photographs as well as photographing the Hajj himself.[56] But Saʿudi was more than an assistant, friend, and underling to the pasha on the *mahmal*. He was an official in the Ministry of Justice and accompanied the *liwaʾ* on the official Hajj. Saʿudi held positions of great prestige and responsibility, acting as the treasurer of the *mahmal*, which included the *surrah* (tribute) to pay the *mahmal*'s detachment, provisions, and expenses. Muhammad ʿAli Effendi was an avid and prolific photographer, who wrote three unpublished diaries about his expeditions.[57] Farid Kioumgi and Robert Graham suggest that the reason for not publishing his accounts was in order to deferentially allow Rifʿat Pasha to first publish his account.[58]

Saʿudi's portrait is an imprint of his biography (fig. 72). This is not to say that the portrait is determinative but, rather, the visual genetic patterns of effendi subjectivity that we have experienced throughout this book match the template of the lives of these functionaries. Raised in an *effendiyah* family of Cairo, Saʿudi was an admirer and acquaintance of Muhammad ʿAbduh, the great Egyptian "Muslim reformer" and mufti of Egypt. ʿAbduh himself asked Saʿudi to photograph and write a report on the religious buildings in the two holy cities as well as provide an assessment of the conditions for pilgrims along the Hajj route. ʿAbduh, however, passed away in 1905, which might have prevented Saʿudi's work from having an opportunity to be published and receive greater attention. Muhammad ʿAli Effendi, however, used his notes and photographs as a basis for lectures he gave throughout his life, including at the Société Sultanieh de Géographie in 1919, which was well-attended by political and intellectual notables including Ahmad Fuʾad, the future King Fuʾad.[59]

Using a Stereo Palmos Ica made in Dresden with a lens made by its sister company Zeiss Tessar in Jena, Saʿudi experimented with photographic techniques, including trying to take nighttime photographs of fireworks.[60] On his second pilgrimage, he was employed as a photographer and "fixer" for the noteworthy ʿAli Bahget Bek (Bahjat Bey), Egypt's first native archeologist who was interested in Islamic as much as pharaohnic sites and was involved in the founding of Cairo University. In addition to his past experience on the Hajj, Saʿudi had kinship ties to Mecca and Medina, which positioned him to help Bahget Bek. As part of his work for ʿAli Bahget Bek, he photographed the sacred sites, mosques, and ancient shrines on the pilgrimage route to Medina and Mecca. Likewise, he took ceremonial photographs (for example, Ottoman soldiers greeting the Egyptian *mahmal*, or the departure of the *mahmal* from Cairo), cityscapes and landscapes, and also what might

be seen as ethnographic photographs of religious rituals, masses of pilgrims in quarantines, and the daily life of the Hijaz. Within this oeuvre, he also took photographs in Egypt (for example, of the pyramids), formal studio individual portraits and group pictures, along with many portraits taken in improvised studios in homes, offices, and mosques. The quality of Saʿudi's photographs was outstanding, but what makes his rare photographic archive valuable is that it demonstrates the social nature of photography in a way that previous photographic Hajj accounts do not, because they were shielded by their positions and privileges of power, position, and rank.

Kioumgi and Graham insinuate that Saʿudi was sensitive to a treacherous landscape of superstition and religious taboo in the Arabian Peninsula, evoking Islam's alleged prohibition on figurative representation and the Hijaz's supposed barbarity in relation to the refined and educated Egyptians. The anecdotes they provide include hostile Bedouin tribesmen, who superstitiously believe, like *Lawrence of Arabia*'s Auda Abu Tayi, that the camera steals someone's soul, leading to the person's death. While we are led to believe that this hostility to photography comes from religious taboos about image making, each anecdote provided by Saʿudi's translators contains counterfactual and counternarrative information. This information shows that the unease surrounding the camera originated less from religious taboo than from the popular fear of widespread espionage and political intrigue owing to the rivalries between the khedive, the British in the Gulf, and the Ottoman authorities, let alone the struggles between and within tribes and tribal leaders. The threat and fear of spies was rife throughout the Ottoman Empire at the turn of the century and appears in the work of contemporary commentators, such as Ibrahim al-Muwaylihi's *Ma Hunalik* and Jurji Zaidan's *al-Inqilab al-ʿuthmani*.[61]

Saʿudi was aware of the dangers of being considered a spy. Accompanying the mercurial ʿAli Bahget Bey, Saʿudi preempted rumors that he and the archeologist were British spies by attaining letters of passage from the highest level of the khedival court before his departure. Saʿudi was deliberate and certainly more composed than his companion and charge, Ali Bahget Bey Saʿudi notes how Bahget expertly, if not hurriedly, sketched interiors, copying ornamental calligraphy on the walls of monuments and within mosques because he was nervous when Saʿudi took photographs.[62] When taking photographs, Saʿudi kept his camera concealed so as not to provoke suspicion. He even dressed as a sweeper in Medina so as to avoid any misunderstanding surrounding the nature of photography in the Prophet's mosque. The fear of being accused of espionage was not unfounded or unwarranted. Eventually, the rather shifty ʿAli Bahget Bey made a backroom alliance with Ottoman authorities against the Egyptian *mahmal*, unbeknownst to Saʿudi, resulting in a sudden and unexpected break in ʿAli Bahget's relationship with Saʿudi midway through their mission. Apart from rejecting Saʿudi's advice and hospitality, Bahget Bey threatened to

"denounce Sa'udi to the Hijaz authorities should he use his camera" and also not leave Bahget alone.[63] Ironically, Sa'udi learned later that Istanbul had ordered the governor of Mecca to place 'Ali Bahget under surveillance.[64]

Rather than a pervasive religious inhibition against photography, these precautions indicate that Sa'udi was aware of the political landscape of the Hijaz, Egypt, and the Ottoman Empire. Indeed, a group of pilgrims tried to stone Sa'udi at Suez, calling him an "infidel" (*kafir*), a term more likely to be used because the crowd thought the photographer was a foreigner than an Egyptian with a camera.[65] On a similar occasion, tribesmen followed Sa'udi and Bahget Bey back to his relative's home in Mecca after a day of taking photographs. The tribesmen's aggression, we discover, was not due to any putative religious prohibition but to superstition incited by a foreign presence. Previously, a foreigner with a camera had visited the tribe and taken photographs of some members. When he left, the tribesmen died.[66]

Superstition in the Arabo-Muslim world against photography arises, I would argue, as a form of alterity, of reworked uncanniness. The camera portably symbolized the mechanistic and rationalized world order that pushed against older regimes of social hierarchy (the social order of tribal hierarchy, semifeudal patron-client relations, and urban guilds). On a discursive level, the *nahdah*'s disenchanting camera juxtaposed an enchanted world of nature and the divine, which was as customary in the Arab world as in Europe, North America, East Asia, sub-Saharan Africa, or India. In the context of the subcontinent, for example, a "traditional" sentiment was that the camera was a "witch-machine" that "sucked away life." Even if this were true, this reaction "was scarcely a deterrent."[67] In the context of Europe, Walter Benjamin notes photography was haunted by a "mystical experience." The intent of this "black art" to "capture" the figure of "Man made in the image of God" is frustrated by the divine because "God's image cannot be captured by any machine of human devising."[68] Photography's alternative histories in the West show an archive of its obsession with the occult and paranormal but also genres and movements such as the symbolist photographers who conceived of photography as a metaphysical act in itself.

The observation that the camera and photograph were an act of *shirk, haram,* profanity, or sacrilege arises in a world that refused to become fully demystified. It is not characteristic of one particular religion or culture but a political act that inevitably arises from the current political economy of social hierarchies, which include who, what, *whether*, and *how* figures are represented. Chased in Mecca, stoned in Suez, or robbed of bags of photographic equipment, Muhammad 'Ali Sa'udi was concerned with his safety and that of his equipment for sure. But these worries come from the Hijaz's political and social fabric at the time, where the "rising fanaticism" was a reaction to the modern project as presented by the Ottomans, Egyptians, and Europeans, espe-

cially the British, who had a strong foothold in Aden since 1839. The house of Saʿud had captured Riyadh from the rival house of al-Rashid, a ruling tribe that had been closely aligned with the Ottomans, who soon after dislodged Ibn Saʿud from Riyadh. In addition, Suraiya Faroqhi has adeptly shown, the political economy of the Hajj and the Arabian Peninsula and the complex political network between Istanbul and Mecca permeated every corner of the empire.[69] If there was a photographic angst, it was less a barometer measuring primordial Islamic prescripts than it was a gauge detecting the resurgence of Wahhabi and Ikhwan in the Hijaz and Najd, a resurgence linked to the rejection of modernity and Western powers at the end of the empire. Any aggression and "superstition" toward the camera, photographer, and photograph were symptoms of interlocking political tensions surrounding these peninsular villages, towns, and tribes at the beginning of the century that enmeshed intra-clan power struggles with intertribal rivalries and Ottoman governance, British machinations, and Egyptian politics.

If this were the backdrop for Saʿudi's expedition into the political minefield of the Hijaz, the concern for one's safety was reasonable. All this said, Saʿudi was more explicit about political intrigue and accusations of espionage than he was afraid of religiously motivated violence. The social character of photographic practice, the creation, display, and dissemination of its production burst forth in Saʿudi's vignettes. Just as Rifʿat Pasha's figure protected the nephews from the corrupt ʿAwn al-Rafiq, local dignitaries, Ottoman officials, and Egyptian functionaries defended the photographer and the use of photography from unruly mobs or disgruntled tribesmen at every turn.

If the uncanniness of Sadiq Bey's poem and the absences of Shaykh ʿUmar's portrait divulge an anxiety produced by the arrival of modernity to the hinterland, superstition and suspicion surrounding the camera in Saʿudi's narratives alerts us to the alterity surrounding the practice of photography and how it symbolized violent transformations that had been carved deep into the Hijazi polity. This is not an abstract concept limited to British, Egyptian, and Ottoman powers vying for allegiances of Arabian tribes. The arrival of the Hijaz Railway in Medina in 1908 during Ibrahim Rifʿat Pasha's last Hajj is an obvious example of how space had been redefined and the Hijaz firmly linked to Istanbul and Arab capitals, notably Damascus, and indirectly Haifa and Beirut.

Quarantining Alterity

The prominence of the lazaretto in Saʿudi's and Rifʿat Pasha's narratives makes apparent the jointness between perspective and new social practices that guided new subjects, contained arcane subjects, and regulated both. The new scopic regime of photography walked in lockstep with the reorganization of public health and medical practice

central to social and class formation, as Jens Hanssen notes about Beirut.[70] The cordon sanitaire and quarantine linked and delinked cities and regions in order to physically reengineer the flows of capital and goods through centers of new political and economic power, reflecting the new social relations and networks through which the portrait was exchanged. Rif'at Pasha, Sa'udi, and Sadiq Bey, not to mention Dr. Saleh Soubhy, were all functionaries of this disciplinary order. They spent an inordinate amount of narrative time on their experiences in the lazaretto of al-Tur, occupying a literal space between the Ottoman disciplinary regime and the arcane capriciousness of rulers like 'Awn al-Rafiq.[71]

Lazarettos built by the Ottoman imperial bureaucracy in the eastern Mediterranean flowered in the nineteenth century owing to modern discourses on public health and commerce that were not without their own political motivations. The quarantine system was based on "rationalization" and "efficiency" of commerce and trade and therefore was inextricable from the Tanzimat's governance of economic structures and systems that would better facilitate capital growth, circulation, and accumulation of surplus. Indeed, like the lazaretto in Beirut, the lazaretto in al-Tur and al-Wajh "depended on efficiently organizing," or perhaps better reorganizing, "commercial activity around port cities that provided fixed points of contact in a global commercial network."[72] Toufoul Abou-Hodeib shows that the route was used by Muhammad 'Ali Pasha in Egypt, Istanbul, and the European powers to manipulate trade where capital would flow between East and West under their control and to benefit their mutual economic interests.[73]

Expanding and challenging the theories of David Harvey and Marx, Abou-Hodeib shows how the quarantine regime inserted or "fixed" Beirut into the world economy, improving the circulation and accumulation of expanding capital in the hands of new and old elites. The growth of Beirut as an entrepôt rewired the mercantile class in Beirut no doubt. Its increased regulation and management by the Ottoman Empire impacted the political economy of the Hajj and its spatial economy.[74]

New regimentation was met with resistance in the form of running contraband goods through old land and sea trade routes and smaller ports and trading posts, just as the coercive regulatory regimes led to labor protests in Beirut's port.[75] Superstition against photography was a reaction against this order, against Ottoman centralized control and its leveling of Hijazi space and tribal and religious identity. Reaction against photography was not a reaction against image making but a lashing out against the fait accompli of *Osmanlilik* modernity. Against the hegemony of *nahdah* and its secularizing and rationalizing ideology, "religious violence" against the camera was an expression of alterity itself, an enactment of the displaced experiences, social hierarchies, and world visions that had to be contained within the logic

of the quarantine. New imperial subjects recognized that "there is an aggression implicit in every use of the camera," as Susan Sontag observed. Therefore, "to understand the camera as a weapon implies there will be causalities."[76] The outbursts against photographers in the Red Sea or in the holy places of Islam—by mobs who were undoubtedly perceived by the likes of Sadiq Bey, Rifʿat Pasha, and Saʿudi as rabble—were not a reaction against photography as an act of image making but against the social practices, works, and political economy that surrounded and imbricated photography and that photography enacted, that is, *nahdah* ideology and *Osmanlilik* (khedival, in the case of Egyptian relations with the Hijaz), modernity.

Within Muslim photographic practice, if one might even use such a term, photography's tension of subjective experience and objective representation served to narrate the Hajj in a specifically modern way. In the collective accounts of Sadiq Bey, Ibrahim Rifʿat Pasha, and Muhammad ʿAli Saʿudi, "modern," cultured, and educated friends, relatives, functionaries and even clerics pose in the most sacred of places in Islam, at times wearing the garb of pilgrims. Kioumgi and Graham reproduce an ethereal portrait of Saʿudi in a studio portrait, wearing the pilgrim's linens (*ihram*) superimposed on Arabic verse.[77] Sadiq Bey, Rifʿat Pasha, Muhammad ʿAli Saʿudi, and the Meccan doctor ʿAbd al-Ghaffar took images of some officials and clerics of Islam's most revered holy sites. Indeed, the occasions where Meccans and Hijazis facilitated photography far outnumber the anecdotes of suspicion. This includes instances when Saʿudi used his relatives' roof to photograph the stoning of al-Jamra al-sugra.[78] Furthermore, Saʿudi took a portrait image of the chief of the Urwa tribe and promised to send him a copy upon his return to Cairo.[79]

The accounts of Rifʿat Pasha, Saʿudi, and Sadiq Bey dovetail with the Hajj photographs by Delhi photographers H. A. Mirza and Sons, whose rare monumental photographs were accompanied by Qurʾanic verse or Urdu poetry. One Urdu guidebook to the Hajj stated, "the photographs [are] arranged so that the pilgrim, once having seen them, can memorize them and when he reaches the palace, it does not appear foreign to him." But also, for "he who is not granted the good fortune of visiting the House of God, by seeing a vague reflection of it in the photograph of the House of God, can arouse freshness in his soul. … The viewer feels that he is actually sitting and standing at that place."[80] As Asani and Gavin suggest, these images and texts were intended to "assist Muslims in prayerful contemplation … their use in a devotional context punctuates a whole new phase in transnational communication."[81] The photographic image conjoined with and recoded "traditional" poetic verse, creating a visual experience that spoke to the spirituality of Muslim identities that were undergoing redefinition in South Asia as much as the Arab world. In this context, it is essential to understand the photography of the Hajj and the hinterland by native photographers not as ethnographic works, not even

as documentary objects, but as social texts and effects produced to articulate identities and media—print and photographic—that were already legible and *recognizable*, and that circulated through flows and paths of communication, commerce, and transportation that were already established.

Saʿudi's signed self-portrait in Ibrahim Rifʿat Pasha's account presents an archetypal educated, "civilized" effendi. Involved in the reformist circles in Cairo, Saʿudi was a regular contributor to the nationalist newspaper *al-Muʾayyad*, commenting on the dreadful conditions for the poor in the Hajj.[82] In these articles, he argued for equity in dealing with the poor as well as a reorganization that would make the Hajj more orderly, clean, healthy, and less unpredictable.

Saʿudi undertook his account at the behest of his ideological mentor, the legendary Muhammad ʿAbduh, who himself was well acquainted with photography. Several portraits of him exist, including one where ʿAbduh is seated next to a standing, slender Muhammad ʿAli Saʿudi.[83] His support and patronage of photography was not without controversy. During a visit to London, he posed with an English male and two female acquaintances. As we have seen, the practice of photographing oneself at a local studio during one's visit to a distant locale seems quite common. Yet within the carte de visite's circuits of sociability and exchange, ʿAbduh's portrait was reproduced in the press by ʿAbduh's friends and foes alike. The portrait appeared in Muhammad Tawfiq's newspaper *Humarit Munyati* in 1902 along with a vitriolic attack on ʿAbduh's religiosity, morals, and patriotism. The newspaper was disseminated throughout Cairo and the shaykh's conservative enemies used the image, accompanying commentary, and satirical poem, among all classes to slander ʿAbduh. Even though Muhammad Tawfiq was prosecuted for the slander, Ziad Fahmy tells us that two other satirical newspapers, ʿAbd al-Majid Khalim's *Babaglu* and Husayn Tawfiq's *al-Arnab*, published caricatures based on the photograph.[84]

The anecdote confirms that photography cannot be extricated from taboo, controversy, and scandal. It is a social product and operates through its social currency and exchange. ʿAbduh, like his protégé Rashid Rida, advocated the use of photography in the larger context of social and national reform, but perhaps he overvalued the *verum factum* of the portrait. The incident brings to light that the *ideology of the portrait was literally embodied in the image*. The portrait was the materialist embodiment of the ideology of Islamic modernity, for lack of better terminology, that ʿAbduh championed, based on principles of a new, visible subject-citizen-believer, the universality of progress and Islam's place in it, and the inevitable mixing of genders and nationalities. But as such, it offered a surface of contestation. ʿAbduh did not perceive his portrait in London as a picture of collaboration with the colonizer. He saw it as a representation of the meeting of equals on the flatness, the objectivity, and the evenness of the portrait's surface. Yet, in his vision of progress and Islamic modernity, he was unable to anticipate the contingency and

perception of the image in the hands of his adversaries and those whose position, privilege, and paradigms had been uprooted by the putative notions of "progress" and "civilization," even if they had been informed by modernity's arc of national identity.

'Abduh was himself an icon. In addition to the portrait of Sa'udi and 'Abduh together, Muhammad 'Ali Sa'udi took an elegant portrait of the shaykh, reworked so as to give him a radiant aura.[85] This image became the iconic image of 'Abduh himself and embodied what modernity in Egypt and the Arab world can *look* like. The portrait was reproduced in many venues in the press at the time and has adorned many of a biography in Arabic. The portrait was codified not only because it appeared in the press but also because Sa'udi's portrait of 'Abduh is apparently published in Philippe de Tarrazi's *Tarikh al-sahafah al-'arabiyah*.[86] Interestingly, the image in Tarrazi's encyclopedic work was not signed "Sa'udi" but rather "Saboungi," further evincing the currency of Jurji Saboungi's name, or the Saboungi who acted as *al-Muqtataf*'s photograveur.

Sa'udi recounts that he found this portrait of 'Abduh hanging in his relative's house in Mecca. This did not shock the photographer because the portrait was hung in the home of an established Meccan family, or out of fear of any prohibition of displaying a figurative image. Rather, he was astonished because 'Abduh's written publications, not his photographic representation, were banned in Mecca.[87] This ban speaks to the presence, force, and threat of 'Abduh's social project and to the efficiency by which it was circulated throughout all Arab provinces of the Ottoman Empire through the Arabic press and intellectual networks. The pushback against 'Abduh in Egypt and Mecca confirms the extent to which the photographic image had been disseminated throughout the empire, so much so that the portrait itself had preceded its photographer's own arrival.

The anxieties and the uncanniness that we teased out refer to the social conditions of the production, dissemination, currency, and ideology of photography that gives meaning to the portrait's surface. If resistance was expressed in popular superstition, this was only a symptom of social and political conditions of the age. Officials were mapping the Hijaz. Plans from Istanbul were being drawn to demolish city blocks and build new roads. Lazarettos, ports, and railways were being built or planned, connected not only by social, administrative, and political links but other inventions such as the telegraph.[88] Sa'udi mentions that religious scholars in the town of Mina outside Mecca argued with Ottoman authorities about "modernizing" the city by opening the streets, as had been done in other Ottoman towns and cities. The plans were consistent with the visions of 'Ali Mubarak, Yusuf Aftimus, and Habib Ayrout et fils. Ironically, Sa'udi agreed with the city's religious scholars, stating that the opening of the streets would only lead to more congestion by providing more space for more vendors to crowd. Not only would the increase in street vendors lead to

increased trash and degrade sanitation, but, also, traditional shopkeepers who were the residents of the town would be undermined.[89]

The region was awash in spies from Istanbul, Cairo, and the West. Images of Muslim reformers were hung in places where their works were banned. Muslims were not only making maps and architectural plans of sacred sites, but these sites themselves were being transformed into representations by Muslim archeologists, such as Bahget Bey. In other words, the uncanniness of the photograph was social. It arose from interaction between social groups (tribesmen, native officials, and foreigners) and social forces (Ottoman reform, family rivalries, modernization, and the intrusion of Westerners/"infidels"). If, then, any disquiet emanates from portraits related to the Hajj, it does not arise from the ease by which clerics, *ulema*, and functionaries of Islam's most venerated and sacred sites themselves sat for their portraits. Rather, the disquiet seeps from the dissonance between the ideologies that they are *supposed* to presage. These anxieties do not, then, destabilize the *indigenista* photographic image but are, to the contrary, a principal indicator of the materialist and ideological "nature of photography" and, indeed, of the social relations central to it.

On the Cusp of Arab Ottoman Photography

Suleiman Girby, "a magnificent oarsman," lived in a small but bustling seaport of Palestine around the turn of the century (fig. 73). Girby was head boatman for Thomas Cook and Son, the tourist company that virtually created commercial Holy Land tourism in the 1880s. While he and his brother were noted for their skill, Suleiman, in particular, "saved many lives, landing in rough seas in Jaffa, where the reef of rocks made winter landings very dangerous. Among those whom he saved were Bishop [George] Blyth, and members of his family and Sir George Newnes, publisher and founder of *The Strand Magazine*." As a result of his bravery, Sir George sent Girby a gold watch from England, with an engraved inscription. The governor of Jaffa had learned of this gold watch and "coveted it and asked Suleiman for it several times and as he refused, the Governor sent him to prison," first in Jaffa and then in Jerusalem, where the boatman "literally pined for the sea."[1] After the governor left, Girby returned to Jaffa, and died soon after, along with his brothers, in the cholera epidemic in Palestine in 1905. While on "daily parole" during his imprisonment in Jerusalem, he visited the bishop's house frequently, and he gave Mrs. Blyth his portrait, taken by Jaffa's most established photographer, Daoud Saboungi.

Girby's portrait is an image-screen of multiple vectors of history, power, subjectivity, sociability, and photographic practice. It is rife with the tensions that this book has tried to ferret out of the lost history of indigenous photographic production of the Ottoman Arab world. Like so many other images, his story is recorded on the back of the

Figure 73.
Daoud
Saboungi,
Suleiman
Girby, Arab
boatman,
Jaffa, ca. 1900.

portrait, which was given to a foreigner as a gift. The portrait is stiff; Girby's posture and demeanor are stilted, awkward, and tense. The image is evocative of a character-type. Even the inscribed story on the reverse starts by categorizing him as a type in a particular place: "Arab Boatman (Moslem) Jaffa." From a Western perspective, the boatman's story is mediated by an English voice, which structures it through a binary of a kind Anglican bishop of Jerusalem and an Asiatic despot. Yet, looking at it from an Eastern point of view, the individualized portrait of Girby breaks through the emptiness of the typical Orientalist character-type by conveying his humanity and tribulations.

The portrait, however, provides a crack in a charming narrative that would otherwise come to us only through the largess of a missionary's tale. Photography's trace breaks open, or, perhaps, provides

a "jointness" of another space for the humanity and history of Girby as a Palestinian and Ottoman subject. The "tether" that the inscription provides frays the Orientalist truss between civilizing missionary and noble savage, leading to the civilizational discourses, economic transactions, and regimes of power within which Girby lived. Daoud Saboungi provides this fissure, as his practice enframes the portrait, which is the product not only of his labor but also of the intersection of sociability of his life, his community, and Girby's. Saboungi-Girby's image does not only rebut the Orientalist character-type. Within the context of native photography, it offers a counter to the standardized portraiture of Ottoman functionaries as so thoroughly produced by Garabed and Johannes Krikorian and Khalil Raad in Palestine. The image even formalistically recalls such portraits of Ottoman functionaries, intellectuals, and the "new men and women"; Girby stands strong and proud, brandishing his many medals of honor.

Understanding the "nature" of early *indigenista* photography as an image-screen allows us to focus on the adjacency of forces that compose collectively and materialize into photography. Girby's image-screen, one of countless, exposes the textured surface of even the flattest photographic portrait. Its manifest content, buffered by writing, tells us about the political economy of Palestine, the tourist industry, the circulation of the image between different strata (labor–Girby, technocrat–Saboungi, expatriate–Blyth), and semiotically balances the virtues of the laborer's character and heroism with his awkwardness in "modernity" and its photographic perspective. Simultaneously, as an ideological alloy of compressed "psychic images," the photographic afterimage contains another coterminous level of immediacy, that of *the latent*. The latent content of Girby's portrait is betrayed by the death of the subject in a cholera epidemic that was not contained by the Ottoman public health project or its chain of lazarettos. Juxtaposed against the portraits of government officials, Suleiman's imprisonment contrasts with the rationalized, non-capricious Ottoman order that these men were charged to implement. These readings of the manifest and the latent are cursory remarks that are elicited from the surface of the image. The past chapters have begun to offer a methodology and theory, if not also some material and empirical foundation, for the way we approach indigenously produced photography.

The questions raised by Girby's image direct us to what this study could not pursue, not the least of which are photographic practices that do not fit neatly into the repetitive formalistic, practical, and social structure of the portrait. The repetitive format of the studio portrait erases the seams within its composite nature because it operates on a system of signification that had been reified by modernity's ideals as natural. The seamless surface of the photographic portrait presents gender, class, desire, capital, corporality, sexuality, and social hierarchies, organizing them into an ideological unity. The portrait interpellates "individuals into subjects. It reproduces a photographic

perspective, a rationalizing scopic regime that was deeply rooted in the transformations that defined the late Ottoman Empire. This *nahdah* perspective is not produced but re-produced through the photographic image, a perspective and *verum factum* that is narrated in an abundance of textual, poetic, epistolary, and literary forms—from the romanticism of Jubran and the "realist" language of ʿIsa al-ʿUbayd to the historical novels of Jurji Zaidan and the "telegraph style" of *al-Muqtataf*'s "language of the newspaper" (*lughat al-jaraʾid*).[2]

How to Become a Photographer?

This book has read the first decades of photography and *nahdah* photography through the prism of Ottoman modernity and *al-nahdah al-ʿarabiyah*. In doing so, it has resisted looking through a derivative lens of European photographic history by instead examining images produced by indigenous photographers, through their photographic practice and the social practice of the image's circulation, and through their voices in primary Arabic sources. The project of "provincializing" European photography and centering marginalized histories such as that of the Ottoman Arab world entails parsing out the European master narrative from the "nature of photography," from its templates and genetic patterns, from the practices and representations that accompanied it.

As a consequence, this study has also hoped to not overcompensate and portray the "*nahdah* portrait" as a stagnant template or ideological slave of the ruling class that cut across five decades. Photography was a dynamic practice undergirded by fluid discursive shifts, many of which we were not able to broach. In order to ferret out the story of "Arab photography" from its entanglements with European narratives and the hegemony of its own *nahdah* ideology, this study has rooted itself in the *nahdah* portrait as well as listened to those like Ahmad Fahmi. Fahmi was an Egyptian engineering student at the École des Beaux Arts in Paris who, in 1887, wrote to his compatriots that the beaux arts (*al-funun al-jamilah*) are the highest achievement of a "civilized society," but "the Creator is the origin of natural beauty, beauty of wisdom and cultural beauty."[3] Fahmi was interested in the creation of culture, including literature, art, and photography, as a means to express the moral rectitude, even piety, of "character" (*akhlaq*) of the compatriot sitter. While he delves into aesthetics as an expression of the divine and morality, art was an expression of beauty that conjoined civility, citizenry, and character.

Fahmi's position on beautiful and artistic production allows us to understand the representation of the "character" and the "calm of spirit" of the *nahdah* ego-ideals as well as the nuanced movements and variations within photography discourse. We have seen the shifts between al-Jalkh and Makarius, between Sadiq Bey and Ibrahim Rifʿat Pasha. Ahmad Fahmi's national character can be contrasted against

the views and work of the illustrious Egyptian photographer Riad Shehata. Shehata's career began at the start of the twentieth century and was enmeshed within the vestiges of the practices, ideologies, and social relations of Ottoman and khedival Egypt, which transformed into national networks during Egyptian "independence."

Shehata opened a studio on al-Fijalah Street in 1907 and eventually moved it to Maghrebi Street. While we know little of his education and upbringing, he must have read the journals of the day and was likely a product of the national schools, discourses, and "circuits of sociability" central to the discussions in chapters 3, 4, 6, and 7. Only through these circuits could he have exhibited photographs in 1912 and eventually become the court photographer to King Farouk, thereby running a very successful studio that outlived him, lasting until 1942 (fig. 74). Dawlat Riad Shehata, his daughter, trained at the hand of her father in Germany and is said to have become a successful photographer, allegedly responsible for taking photographs of Hoda Sh'arawi and Safiyah Zaghlul, S'ad Zaghlul's wife.[4] In 1912, before his immense celebrity, Shehata wrote *Kitab al-taswir al-shamsi*, a lucid and methodically written manual for photography. Its technical instructions are informed by the articles and discourses discussed in chapters 1 and 5. He opens his penultimate chapter, "How to Become a Photographer," by stating: "Many desire, due to the love of this wondrous art, to become one day photographers. I do not discourage their determination. To the contrary, I encourage them with the utmost enthusiasm. I hope to see among them tomorrow masterful photographers no less in their skill than the skill of the greatest photographers in all the extent of the civilized world."[5]

I close this book with an examination of Shehata not only because he is forgotten within the history of Middle Eastern photography but because the civilizational and national discourses of *al-nahdah* are so deeply infused in his worldview. It is less abstract than Ahmad Fahmi's thoughts on visual culture and the national self but not so concrete so as to vacate photography of its personal, experiential, and even moral referentiality. Desire, art, knowledge, determination, skill, the nation, and civilization emerge in his narration as if directly from the writings of *nahdah* intellectuals and photographers. But rather than detail how one might pursue a technical apprenticeship in photography, Shehata offers an anecdote. One day, a "decent, young man" came into his establishment and asked the photographer if he could become an apprentice. Shehata enthusiastically commenced training the young man. After three days, however, the would-be apprentice did not return because of the tediousness and meticulousness of the work. Against the backdrop of pages of fastidiously detailed technical instruction, Shehata directly addresses the reader: "Now, dear reader, I tell you that the secret of success in this craft [*al-sin'ah*] and in every craft in the world is patience and deliberateness. This is the secret of success, to pay utmost attention to care and cleanness. If you are

Figure 74.
Riad Shehata, King Farouk, negative.

patient, fastidious, and clear, you may be certain that you can become, one day, a photographer. Otherwise, cut the rope of home and leave the art for those who can actually do justice to it."[6]

Within its shadow of the rise of amateur photography and the Kodak camera, the skill and knowledge of photography had become an "art" and thing of beauty to which Ahmad Fahmi had alluded two decades before from Paris.[7] Unlike Fahmi, photography was explicitly an enactment and not a reflection of self, character, and effort (juhud). The formula articulates the *nahdah* subjective and social ideals that photography promises to actualize. The photographer's knowledge is matched by temperament and discipline, which translates into the ability to connect photographer with the sitter in order to bring out the "delicacy" of the "fairer sex" and the "nobleness" of men.[8]

Shehata's narrative however, sees the photographer as more than a technician or even scientist but also as a "doctor and priest [al-tabib wal-kahin]." Shehata relates another anecdote in which he was sitting in a café and overheard two men conversing. Relating the conversation in dialect and dialogue form, Shehata learns that one of the men had acquired a picture of a young woman and intended to show it to his friends. The portrait was of his sister, which he procured directly from the photographer who photographed her. Scandalized and enraged, Shehata sprang upon the man, beat him and took the portrait, then reported him to the police and the magistrate. He concludes: "Just as it is incumbent upon the priest and the doctor to securely protect secrets, it, too, is the responsibility of the photographer to protect them. If a young lady, for example, comes to a photographer for him to photograph her and take her portrait, then, someone comes to him and requests of him to see and examine the image etc., he must not show it to anyone. Nor should he hand it over to anyone other than the photograph's owner even if the person requesting it is the closest relative to her."[9]

While Shehata's oeuvre falls generally outside of the span of this study, his work, writing, and certainly his anecdotes summarize many of the issues, themes, processes, ideological formations, and practices that this book examines. Nestled within the detailed technical instructions, descriptions, illustrations, and index of equipment and chemicals as discussed in chapter 4's examination of *nahdah* photography writing, the author reveals the intimacy and social nature of the photograph. His anecdotes are not about landscapes, but about portraits. His narrative interweaves technical knowledge with national and civilizational discourses but also brings us into the private and public spaces of the studio and city streets. Even more, his narrative reveals that photography speaks of the very materiality and politics of the photograph, the labor, materials, and care needed for its production and the ways in which it passes between people. As such, we learn in Shehata's written and visual work that the photograph fundamentally expresses social relations, both manifest and displaced. Yet, these social relations are both expressed in the indexed surface of the

photograph as well as in the compressed physical object itself. The challenge of this study, then, is to unpack this compression and find, if nothing else, a methodology by which we can decompress the manifest and latent content of indigenously produced photography in order to begin to understand the "nature of photography" of the Ottoman Arab world and restore the histories of its ideology and social relations.

All photography expresses social relations and, hence, the studio portrait is an imprint of the Arab *imago* that undergirds a variety of class, gender, sectarian, and national subject positions. The carte de visite and other formats of studio portraiture offer a secure, stabilizing object. The surface of the image-screen expresses the illustrative, representational context of the photograph's ideology, the discourses of self, modernity, class, gender, and nation. It is the ideological unity of the image that makes it intelligible and a stable stage upon which subjects reproduced and enacted this ideology and the social relations that gave them value. Against the continual repetition of form, content, exchange, circulation, and display, the architecture and aesthetics of the *nahdah* perspective and the network of its sociability interpellate the *verum factum* of "civilization and progress" while also interpolating native subjects into the vision of a modernity that is specifically theirs. Yet, tension bound this legibility, the manifest, to the portrait's alterity, its latent, abject, arcane, and sublime experiences beyond, if not prohibited by, the hegemony of the surface's *nahdah* ideology.

This study focuses on the studio portrait, one sliver of the history of native photography of the Ottoman Empire. Much work is to be done. I am fully cognizant that this study is in no way comprehensive or complete in regard to the history of various photographic genres and formats in the Ottoman long century. As I have only briefly mentioned in the discussion of al-Jalkh and the faculty of al-Madrasah al-wataniyah, institutional photography, for example, was a widespread means of popularizing portraiture. Group portraits from schools, hospitals, firehouses, government bureaus, commercial companies, banks, philanthropic organizations, intellectual "clubs," and salons portrayed students of all ages, faculty, administration, laborers, employees, intellectuals, and "journalists."

In addition to institutional group photographs, children's portraits are easily found in the collective photographic archive of the Arab world. Since the establishment of the first studios, both girls and boys, from infancy to adolescence, were regularly photographed alone or with their siblings. These images are not limited to family portraits, school pictures, or photographs commemorating First Holy Communion. Rather, infants and toddlers abound. Portraits of boys were frequently photographed sitting in loose smocks, Christening gowns, and white dresses with their penis exposed (fig. 75). They resembled girls, wearing dresses or in their white cotton T-shirts with one shoulder exposed. Equally prevalent, old wedding portraits of ancient matriarchs are found, not unlike that which was kept under the pillow

Figure 75.
G. Massaoud, anonymous portrait, Port Said, cabinet card, 19.4 × 13.8 cm.

of Salma's father in *Broken Wings*, along with images of educated daughters, peasant mothers, and clusters of sisters.

Portraits did exist of "subaltern" subjects. Some of these portraits replicated the composition, formats, and genetic patterns of *effendiyah* studio portraiture. Some eerily courted but challenged Orientalist or Hamdi Bey-Sébah's character-types as well as *nahdah* formalism. The portraits of traveling photographer Camille El-Kareh (al-Qarih) in rural northern Lebanon evince this challenge. The montagnard Gergess Bou Zeid from Zgharta stands on a carpet in front of a bucolic but crude backdrop in El-Kareh's makeshift *en pleine air* studio (fig. 76). His full frontal view offers the camera his masculinity. His weight is solid, his form open, and his eyes piercing. He is no character-type, and that is no handlebar moustache of an effendi bureaucrat. He is an individual that has not been interpellated in *nahdah* subjectivity. His weapon, his bandolier, and the copious number of bullets around his waist tell us that Bou Zeid is not a national subject, but a sectarian and tribal individual, hailing from a mountain village known for a closed and clannish society. These portraits were not of the new men and women but of the unapologetically local individuals who refused to be assimilated into the leveling patterns, templates, and genes of bourgeois effendi civilizational and nationalist discourses.

This study of *indigenista* photography reaches into theory not in order to displace the multiple subgenres and compositional "genetic patterns" that escape the orbit of this study. Nor has it been my intent, by using Marxist, psychoanalytic, and photography theory or focusing on generic patterns of the Beiruti-Jerusalemite-Cairene *effendiyah*, to recuperate the lost history of *indigenista* photography by linking it to the uniformity of the Western portrait in some perverse form of native empowerment that highlighted the kinship between the liberal bourgeoisies of Europe and the Arab world. Quite to the contrary, photography, poststructuralist, and psychoanalytic theory have helped locate how the particularities of Arab photography operated within the seemingly generic, "flattening" forms and patterns of the portrait.

Many genres of photography practiced by *indigenista* photographers remain to be critically explored and theoretically engaged, including landscape, tourism, ritualistic, amateur photography (including candid photography and the Kodak camera), and institutional photography, not to mention ateliers like the Arab world's most ancient—in the Armenian seminary in Jerusalem or the Jesuits in Lebanon.[10] This book, however, does hope to traverse these gaps precisely through its empirical research and its theoretical engagement. I hope to offer an initial path through the uncharted and largely unknown constellation of indigenous photographers, studios, and studio practices of the Ottoman Arab world.

By merit of the expansive "nature of photography" of the Middle East and the dearth of critical studies on *indigenista* production and practice, this book has been very circumspect in approaching

Figure 76.
Camille
El-Kareh,
Gergess Bou
Zeid, Zgharta,
ca. 1910–20.

the massive history of Ottoman "Arab" photography by limiting the study to studio portraiture of the Ottoman Arab world's "new men and women," while admittedly engaging mostly Peter Gran's "new men." If we are to understand the studio portrait, notably the carte de visite, as a *pars pro toto* of the many types of portraiture mentioned and unmentioned, I nevertheless do not intend this to wipe out the specificities and dynamics particular to each genre. The repetitious formalism and social practices of the carte de visite do not mean that portraiture is monochrome, static, or one-dimensional.

These various formats and genres, however, along with alternative photographic practices such as amateur photography, did share a common photographic practice and sociability, if only in mechanisms of production, distribution, exchange, and display. They also shared a

common perspective and participated in similar parallel if not shared social practices. As we have seen, by the 1880s "the shelves and tables" of Beirut's wealthy homes, "were filled with precious items including photography books which the eye would never tire of looking at."[11] While everyone in Beirut might not have had such a home, indeed, men, women, and children from all denominations and classes were patronizing studios and having their portraits taken, even if only once or twice in a lifetime.

We have seen how the cartes de visite of family, relatives, friends, and potential suitors were collected alongside images of diplomats, royals, and leaders, displayed in homes, public buildings, and albums. Bound in various forms of photographic albums, the images inhabited a cross-section of social and economic practices and discourses. Whether self-generated or purchased, the "picture album" in the Ottoman world was a unique object of sociability that deserves a study unto itself. It was part visual product, part autobiographic literature, part social history, and even part fiction; a literary micro-act particular to modernity. We have seen albums such as that of Princess Zeyneb and Jawhariyyeh, structurally, visually, and narratively blend into those encyclopedic, historical, and cultural narratives institutionalized by Tarrazi and the journals of the day. The albums remark on the ways that photographs were exchanged, deployed, and arranged.

The new men and women of the provincial capitals of the Ottoman Arab East were provided specific instructions on how to organize and display the photographs in new interior spaces and, perhaps at times, even to create new interior space. Likewise, organic intellectuals and photographers provided the technical know-how to the readership in showing a direct correlation between practice, failure, and success to provide a means of enacting the knowledge-civilization matrix and the *nahdah* formula for progress. These instructions and accounts show us how photography involved processes of interpellation and interpolation. The subjects of the photographs were physically interpolated, specifically visualized, and placed in the social space of the new home and city while, simultaneously, they were interpellating those spaces and subjects ideologically.

The portrait enunciated the Arab *imago* literally, instantiating an Ottoman Arab imago that embodied new forms of sociability, new self-conceptions, reworked identities, and ideological identifications that defined the late Ottoman era in Lebanon, Palestine, and Egypt. Lest we think that the cartes de visite of Saboungi, the Kova Frères, Krikorian, Raad, and their colleagues in Lebanon, Palestine, and Egypt, as well as Abdullah Frères and Pascal and Jean Sébah, were a statement of progress and civilization, we must remember, too, that these portraits presented a *verum factum* of the *nahdah* self, a stabilizing "object of consistency," whose a priori intelligibility operated on an array of identifications and ideological conditions by the political and economic transformations of late Ottoman modernity.

This study has offered a methodology to begin the archeology of these processes of interpellation and interpolation. The process has uncovered that the portrait is an image-screen, the *point de capiton* of latent and manifest discourses, political forces, historical materialism, political changes, and social developments and displacements. The portrait, read methodologically as a dream image, reveals, then, how the manifest enforces and performs the *nahdah*'s class, gender, individualist, and national discourses and disciplinary practices while also recognizing the underlying and marginalized "latent" social history and experiences of that same image-screen. I have focused on the writing, production, exchange, dissemination, display, and social practice of photography as an ideological enactment of the formula for Ottoman reform. These photographic enactments mediated the very material object of the photograph itself and stabilized the changes in social relations and political economy that had already been initiated in the region. In this regard, portrait photography, whether it was individual or group, studio or amateur, institutional or personal, was an afterimage of these transformations. What is at play in this analysis is a materialist history of the photographic surface, form, practices, and their ideological roots and effects that take into account the overwhelming force and intelligibility of the image's surface (the manifest) while also recognizing how that legibility itself harbors displaced histories and competing realms of knowledge and experience.

"The most beautiful craft," *al-Muqtataf* reminds us, "is in representing something as it really is. But one must do this by representing the most beautiful things in the most beautiful way. Knowing the most beautiful does not come to someone except with time and refinement of taste."[12] Knowledge, practice, and representation produced the portrait as an image-screen, a *verum factum* of ideology, fact, and experience. But if "taste" is a process of "time and refinement," we also have seen that the portrait as image-screen, as the afterimage of social transformations, "refined," wore down, destroyed, or displaced life-worlds that could only express themselves in riots against the photograph and the photographer. We see the reverberations of these flattening effects today, where the "return of the repressed" reaches deep into Arab civil society, released by the collusion of Arab regimes and foreign (especially American) powers. The images of beheadings and destruction of ancient artifacts match the images of humiliated Iraqi prisoners and "trophy-pictures" of dead innocent Afghani civilians hunted and murdered by American "kill-teams." They, too, are the afterimage of empire, capitalism, despotism, and fanaticism. They are imprints of ideology that has been co-created by the West and the Middle East. Yet, in the images with which we are now more inundated than any photographer of the nineteenth century could ever imagine, we can hope perhaps that a new manifest and latent will conjoin to eventually offer the hope, love, and beauty that every act of a portrait's production, exchange, and display potentially may contain.

NOTES

Introduction

1. For extended discussions on Muhammad Sadiq Bey and republications of his photographs of Mecca and Medina, see Alfred Wieczorek, Michael Tellenbeck, and Claude W. Sui, eds., *To the Holy Lands: Pilgrimage Centres from Mecca and Medina to Jerusalem* (Mannheim: Reiss-Engelhorn Museum, 2008); Badr el-Hage, *Saudi Arabia: Caught in Time 1861–1939* (London: Garnet, 1997); and William Facey and Julian Granite, *Saudi Arabia by the First Photographers* (London: Stacey International Publishers, 1998).

2. Muhammad Hammam Fikri, *Muhammad Sadiq Basha, al-Rihlat al-hijaziyah* [Muhammad Sadiq Pasha: Hijazi journeys] (Beirut: Badr lil-nashr wal-tawziʾ, 1999), 127.

3. Muhammad Sadiq Bey, *Nabdhah fi iktshaf tariq al-ard al-hijaziyah*, in ibid., 38 (all translations are my own unless otherwise noted).

4. See Jamal Elias, *Aisha's Cushion: Religious Art, Perception, and Practice in Islam* (Cambridge, MA: Harvard University Press, 2012).

5. Claude W. Sui, "Pilgrimage to the Holy Sites of Islam and Early Photography," in Wieczorek et al., *To the Holy Lands*, 52.

6. Jonathan Crary, *Techniques of the Observer: On Vision and Modernity in the Nineteenth Century* (Cambridge, MA: MIT Press, 1990), 5.

7. See Noël Marie Paymal Lerebours, *Excursions daguerriennes: Vues et monuments les plus remarquables du globe*, 2 vols. (Paris: N.p., 1840–44). Or specifically, Noel Paymal Lerebours, *Prix-courant des daguerreotypes* (N.p.: N.p., 1843); and *Excursions daguerriennes: Vues et monuments les plus remarquables de globe* (Paris: N.p., 1842), pl. no. 57. For some examples of this narrative, see Nissan Perez, *Focus East: Early Photography in the Near East (1839–1885)* (New York: Abrams, 1988); Paul Chevedden, *The Photographic Heritage of the Near East* (Malibu, CA: Undena, 1981); Fouad Debbas, *Romantic Lebanon: The European View 1700–1900* (London: British Lebanese Assoc., 1986); Debbas, *Beirut: Our Memory; A Guided Tour Illustrated with Picture Postcards*, 2nd ed. (Beirut: Naufal, 1986); Michel Fani, *Liban 1848–1914: L'atelier photographique de Ghazir* (Paris: Éditions de l'Escalier, 1995); and Carney Gavin, *Legacy of Light: Photographs from the Last Century* (Araya, Lebanon: Imprimerie Catholique, 1983).

8. See M. Christine Boyer, "La Mission Héliographique: Architectural Photography, Collective Memory and the Patrimony of France," in *Picturing Place: Photography and the Geographical Imagination*, ed. Joan Schwartz and James Ryan (London: I. B. Taurus, 2003), 21–54.

9. Kathleen Stewart Howe, *Revealing the Holy Land: The Photographic Exploration of Palestine* (Santa Barbara, CA: Santa Barbara Museum, 1997), 26, 28; and Derek Gregory, "Emperors of Gaze: Photographic Practices and Productions of Space in Egypt, 1839–1914," in

Schwartz and Ryan, *Picturing Place*, 200.

10. Maxime Du Camp as quoted in Howe, *Revealing the Holy Land*, 28.

11. See, for an example, the discussion of photography's centrality to Egyptology and Egyptmania, in Elliot Colla, *Conflicted Antiquities: Egyptology, Egyptomania, Egyptian Modernity* (Durham, NC: Duke University Press, 2008), 184–86.

12. Gregory, "Emperors of Gaze," 207.

13. Abigail Solomon-Godeau, *Photography at the Dock* (Minneapolis: University of Minnesota Press, 1991), 159.

14. Anne McCauley, "Photographic Adventure of Maxime Du Camp" as quoted in Ken Jacobson, *Odalisques & Arabesques: Orientalist Photography 1939–1925* (London: Quaritch, 2007), 24.

15. For example, in their study of postcards, Malek Alloula and David Proschaska show how photography evinced Orientalist discourse and acted as an apparatus of colonial power. See Malek Alloula, *The Colonial Harem* (Minneapolis: University of Minnesota, 1986); David Prochaska, "Archive of *l'Algerie imaginaire*," *History and Anthropology* 4 (1990): 373–420.

16. Deborah Poole, *Vision, Race, and Modernity: A Visual Economy of the Andean Image World* (Princeton, NJ: Princeton University Press, 1997), 184–88; see also her "Figueroa Aznar and the Cusco Indigenistas: Photography and Modernism in Early-Twentieth Century Peru," in *Photography's Other Histories*, ed. Christopher Pinney and Nicolas Peterson (Durham, NC: Duke University Press, 2003), 173–201.

17. For example, see Christopher Pinney, *Camera Indica: The Social Life of Indian Photographs* (Chicago: University of Chicago Press, 1997).

18. Martin Jay, *Downcast Eyes: The Degeneration of Vision in Twentieth-Century Thought* (Berkeley: University of California Press, 1993), 519.

19. Geoffrey Batchen, *Each Wild Idea: Writing, Photography, History* (Cambridge, MA: MIT Press, 2000), 60; my italics.

20. Dipesh Chakrabarty, *Provincializing Europe: Postcolonial Thought and Historical Difference* (Princeton, NJ: Princeton University Press, 2000).

21. Solomon-Godeau, *Photography at the Dock*, 167.

22. Batchen, *Each Wild Idea*, 57.

23. Gayatri Spivak's criticism and generative theories about locating historical and cultural subjects and phenomena are too massive to fully quote or paraphrase. However, for a brief and enlightening introduction to this gesture of undermining Eurocentrism without inscribing radical relativism of cultural multiculturalism that perpetuates and does not disrupt these geographic, ethnic, and regional structures, see her *Death of a Discipline* (New York: Columbia University Press, 2013).

24. Chakrabarty, *Provincializing Europe*, 4.

25. Samir Amin, *Eurocentrism* (New York: Monthly Review Press, 2009), 14.

26. Ilham Khuri-Makdisi, *The Eastern Mediterranean and the Making of Global Radicalism 1860–1914* (Berkeley: University of California Press, 2010), 37.

27. See, for example, Khalil Khuri's book of poetry, *al-ʿAsr al-Jadid* [The new era] (Beirut: al-Matbʿah al-suriyah, 1863).

28. Many important studies on land tenure and economic transformations in the Middle East during the nineteenth century have been written. For example, see Kenneth Cuno's study that ends the year of the khedival land reform, *The Pasha's Peasants: Land, Society and Economy in Lower Egypt, 1740–1858* (Cambridge: Cambridge University Press, 1993); or Dina Rizk Khoury, *State and Provincial Society in the Ottoman Empire: Mosul, 1540–1834* (Cambridge: Cambridge University Press, 1997). For an interesting micro-examination in the context of Jordan, see Eugune Rogan, *Frontiers of the State in the Late Ottoman Empire: Transjordan 1850–1921* (Cambridge: Cambridge University Press, 1999), 75–94. Likewise, for a critical reevaluation of property relations during the nineteenth century, see Roger Owen, ed., *New Perspectives on Property and Land in the Middle East* (Cambridge MA: Harvard University Press, 2000). The classic works, mostly compilations, still remain valuable, including Tarif Khalidi, ed., *Land Tenure and Social Transformation in the Middle East* (Beirut: American University of Beirut, 1984); and Charles Issawi, ed., *The Economic History of the Middle East, 1800–1914* (Chicago: University of Chicago Press, 1966).

29. John Chalcraft, *The Striking Cabbies of Cairo and Other Stories: Crafts and Guilds of Egypt 1863–1914* (Albany: SUNY Press, 2004); Beshara Doumani, *Rediscovering Palestine: Merchants and Peasants in Jabal Nablus 1700–1900* (Berkeley: University of California Press, 1995); Akram Khater and Antoine Khater, "Assaf: A Peasant of Mount Lebanon" and Sherry Vatter, "Journeymen Textile Weavers in Nineteenth-Century Damascus: A Collective Biography," in *Struggle and Survival in the Modern Middle East*, ed. Edmund Burke and Nejde Yaghoubian (Berkeley: University of California Press, 2006), respectively, 35–47 and 64–79; Joel Beinin and Zachary Lockman, *Workers on the Nile: Nationalism, Communism, Islam and the Egyptian Working Class, 1882–1954* (Cairo: American University of Cairo, 1998).

30. For example, James Grehan shows that price manipulation and currency speculating in eighteenth-century Damascus were prevalent enough that a *fatwa* would declare its immorality. Likewise, Grehan notes legal judgments of other *ʿulamaʾ* that denounced any profit margin of more than 5 percent. James Grehan, "Market Culture and the Problem of Money in Ottoman Damascus, ca. 1700–1830," *MIT EJMES* 3 (Fall

2003): 64, 67. See also James Grehan's excellent study, *Every Day Life and Consumer Culture in Eighteenth Century Damascus* (Seattle: University of Washington Press, 2007).

31. 'Ali Mubarak Pahsha, *al-Khitat al-tawfiqiyah al-jadidah li-Misr al-Qahirah wa muduniha wa baldiha al-qadimah* (Cairo: Bulaq, 1887–89). For an instructive discussion of Mubarak's writing, his achievements as public works minister, and the reorganization of the urban fabric of Cairo, see Timothy Mitchell, *Colonizing Egypt* (Berkeley: University of California Press, 1991), 63–69.

32. Mercedes Volait *Le Caire-Alexandrie: Architectures européennes 1850–1950* (Cairo: Institut Français d'Archéologie Orientale, 2001).

33. See Jens Hanssen's excellent study of Beirut's development in *Fin de Siècle Beirut: The Making of an Ottoman Provincial Capital* (Oxford: Oxford University Press, 2005), 237.

34. See Pierre Pinon, "The Parceled City: Istanbul in the Nineteenth Century," in *Rethinking XIXth Century City*, ed. Attilio Petruccioli (Cambridge, MA: Aga Khan Program for Islamic Architecture at Harvard University and MIT, 1998), 45–64. See also Zeynep Çelik, *Remaking of Istanbul* (Berkeley: University of California Press, 1993).

35. For the most comprehensive early history of the Suez, see Valeska Huber, *Channeling Mobilities: Migration and Globalization in the Suez Canal Region and Beyond: 1869–1914* (Cambridge: Cambridge University Press, 2013). For the history of governance and political economy, see, for example, Ehud Toledano, *State and Society in Mid-Nineteenth Century Egypt* (Cambridge: Cambridge University Press, 1990); Roger Owen, *The Middle East in the World Economy 1800–1914* (London: I. B. Tauris, 2002); and Joel Beinin and Zackary Lockman, *Workers on the Nile: Nationalism, Communism, Islam, and the Egyptian Working Class, 1882–1954* (Cairo: American University of Cairo Press, 1998).

36. For a history of the sectarian violence in Lebanon, see Leila Fawaz, *Merchants and Migration in 19th Century Beirut* (Cambridge, MA: Harvard University Press, 1983); see also her *An Occasion for War: Civil Conflict in Lebanon and Damascus in 1860* (Berkeley: University of California Press, 1994). For the best economic histories of nineteenth-century Lebanon, see Carolyn Gates, *The Merchant Republic: The Rise of an Open Economy* (London: Tauris and Centre for Lebanese Studies, 1998); Dominique Chevallier, *La Societé du Mont Liban a l'époque de la revolution industrielle en Europe* (Paris: Paul Geunther, 1971); Butrus Labaki, *Introduction à l'histoire economique du Liban: Soie et commerce exterieur en fin de periode ottomane (1840–1914)* (Beirut: Université Libanaise, 1984); and Elizabeth Thompson, *Colonial Citizens* (New York: Columbia University Press, 1999).

37. Hanssen, *Fin de Siècle Beirut*. For studies on the urban history and development of Beirut, see, for example, May Davie, *Beyrouth et ses faubourgs* (Beirut: CERMOC, 1997); Davie, *Beyrouth 1825–1975* (Beirut: Ordre de Ingeniuere Architects, 2001); Robert Saliba, *Beirut 1920–1940: Domestic Architecture between Tradition and Modernity* (Beirut: Ordre de Ingeniuere Architects, 1998); Anne Mollenhauer, "The Central Hall House: Regional Commonalities and Local Specificities," in *The Empire in the City: Arab Provincial Capitals in the Late Ottoman Empire*, ed. Jens Hanssen (Beirut: Ergon Verlag Wurzburg, 2002).

38. Doumani, *Rediscovering Palestine*; Gershon Shafir, *Land, Labor and the Origins of the IsraeliPalestinian Conflict 1882–1914* (Cambridge: Cambridge University Press, 1989); Mark LeVine, *Overthrowing Geography: Jaffa, Tel Aviv, and the Struggle for Palestine* (Berkeley: University of California Press, 2005); Michelle Campos, *Ottoman Brothers: Muslims, Christians, and Jews in Early Twentieth Century Palestine* (Berkeley: University of California Press, 2011); and Salim Tamari, *Mountain against the Sea: Essays on Palestinian Culture and Society* (Berkeley: University of California Press, 2009) as well as his and Issam Nassar's editing of several Palestinian memories, including, and central to this study, *The Storyteller of Jerusalem: The Life and Times of Wasif Jawhariyyeh, 1904–1948* (Northampton, MA: Olive Branch Press, 2014).

39. Karl Marx, *Wage-Labor and Capital*, trans. Harriet E. Lothrop (New York: New York Labor News Co., 1902), 36.

40. Ibid.

41. For a discussion of amateur photography, including the introduction of the Kodak camera in the Ottoman Arab East, see Stephen Sheehi, "Glass Plates and Kodak Cameras: Arab Amateur Photography in the 'Era of Film,'" in *The Indigenous Lens: Early Photography in the Middle East*, ed. Markus Ritter and Staci Scheiwiller (Zurich: University of Zurich Press, forthcoming).

42. For some discussion of gender, photography, and print media in the Middle East, see Beth Baron, *Egypt as a Woman: Nationalism, Gender and Politics* (Berkeley: University of California Press, 2005); Elizabeth B. Frierson, "Cheap and Easy: The Creation of Consumer Culture in Late Ottoman Society" in *Consumption Studies and the History of the Ottoman Empire, 1550–1922*, ed. Donald Quataert (Albany: SUNY Press, 2000), 243–87; and Nancy Micklewright, "Personal, Public, and Political (Re)Constructions: Photographs and Consumption," in Quataert, *Consumption Studies and the History of the Ottoman Empire*, 261–88.

43. Margot Badran, *Feminists, Islam, and Nation: Gender and the Making of Modern Egypt* (Princeton, NJ: Princeton University Press, 1995), 276n15.

44. Lisa Pollard, "The Family Politics of Colonizing and Liberating Egypt, 1882–1919," *Social Politics* **7**, no. 1 (Spring 2000): 47. Also, Marilyn Booth's work illuminates further avenues by which we might think about how gender and photography operated within nationalist and *nahdawi* discourses of social reform, especially because these discourses articulated national and cultural identities and projects through enacting new domestic practices and space (femininity, marriage, childrearing, domestic economy, education, hygiene, etc.) built around women's subjectivity. See Marilyn Booth, *May Her Likes Be Multiplied: Biography and Gender Politics in Egypt* (Berkeley: University of California Press, 2001).

45. Dorothy Holmes, "The Wrecking Effects of Race and Social Class on Self and Success," *Psychoanalytic Quarterly* 75, no. 1 (2006): 215–36.

46. See W. Shoucair in Michel Fani, *Une histoire de la photographie au Liban 1840–1944* (Beirut: Éditions de l'Escalier, 2005), plate 241.

47. Philip Mattar, Charles Butterworth, Neil Caplan, Michael Fischer, and Eric Hooglund, *Encyclopedia of the Modern Middle East and North Africa* (New York: Macmillan, 2004), 1:13.

48. Despite the pressures of the digital age and the predatory behavior of real estate developers who are pushing the remaining family businesses out of their ancestral ateliers, a handful of Armenian studios, albeit retooled for the digital age, still exist in Lebanon, Syria, Israel-Palestine, Jordan, Iraq, and Egypt.

49. Dickinson Jenkins Miller, "The Craftsman's Art: Armenians and the Growth of Photography in the Near East 1856–1981" (MA thesis, American University of Beirut, 1981); Badr el-Hage, "The Armenian Pioneers of Middle Eastern Photography," *Jerusalem Quarterly* 31 (2007): 22–26; Mona Khazindar, Djamila Chakour, and Hoda Makram-Ebeid, *L'Orient des photographes arméniens* (Paris: Institute du Monde Arabe, 2007).

50. Despite their enormous output, little has been written on them. For a rare study, see Sami Toubia, *Sarrafian Liban 1900–1930* (Beirut: Aleph, 2008).

51. Debbas, *Beirut: Our Memory*, 15.

52. Much has been written about "enactments," most of which specifically deals with it as a Kleinian defense or an object relations product of a co-created process of transference and countertransference. For the earliest use of the term and the specific concept of "enactment," see T. J. Jacobs, "On Countertransference Enactments" in *Journal of the American Psychoanalytic Association* 34 (1986): 289–307. While rooted in Freudian theory (especially processes that are illustrated in *The Interpretation of Dreams*), Jacobs himself draws on Joseph Sandler's work on countertransference and "actualization." See Sandler's seminal "Countertransference and Role-Responsiveness," in *International Review of Psychoanalysis* 3 (1976): 43–47.

53. For a more rigorous definition of how actualizations function as a consequence of transference and countertransference, see Sandler, "Countertransference and Role-Responsiveness."

54. For a definition and discussion of *punctum* and *stadium*, see Roland Barthes, *Camera Lucida: Reflections on Photography* (New York: Hill and Wang, 1981), 25–26.

55. Zahid Chaudhary, *Afterimage of Empire: Photography in Nineteenth Century India* (Minneapolis: University of Minnesota Press, 2012), 90.

Chapter 1

1. Quoted in Engin Özendes Çizgen, *Photography in the Ottoman Empire 1839–1919* (Istanbul: Haset Kitabevi, 1987), 20.

2. See, for example, Mary Roberts, "The Limits of Circumscription," in *Photography's Orientalism: New Essays on Colonial Representation*, ed. Ali Behdad and Luke Gartlan (Los Angeles: Getty Research Institute, 2013), 60.

3. Özendes Çizgen, *Photography in the Ottoman Empire*, 225.

4. Ruth Victor-Hummel, "Christians and the Beginning of Local Photography in 19th Century Ottoman Palestine," in *The Christian Heritage in the Holy Land*, ed. Anthony O'Mahony, Goren Gunner, and Kevork Hitlian (Jerusalem: N.p., 1995), 187; and Dickinson Jenkins Miller, "The Craftsman's Art: Armenians and the Growth of Photography in the Near East 1856–1981" (MA thesis, American University of Beirut, 1981), 14.

5. Fatma Müge Göçek, *Rise of the Bourgeoisie, Demise of Empire: Ottoman Westernization and Social Change* (Oxford: Oxford University Press, 1996), 81.

6. Roberts, "The Limits of Circumscription," 53, 54.

7. These portraits are found at the National Portrait Gallery. One colorized image of Abdülhamid is reproduced by the famous publisher Cassel Petter Galpin in *International Portrait Gallery* (London: Cassel Petter Galpin, 1878), stating it was taken in Scotland (104). Mary Roberts states that the royal portrait was taken at Buckingham Palace. Mary Roberts, "Ottoman Statecraft and the 'Pencil of Nature': Photography, Painting, and Drawing at the Court of Abdul-Aziz," *Ars Orientalis* 43 (2013): 18.

8. Nancy Micklewright, "Personal, Public, and Political (Re)Constructions: Photographs and Consumption," in *Consumption Studies and the History of the Ottoman Empire*, ed. Donald Quataert (Albany: SUNY Press, 2000), 279.

9. See John Scott, *Seeing like a State: How Certain Schemes to Improve the Human Condition Failed* (New Haven, CT: Yale University Press, 1998).

10. John Tagg, *The Burden of Representation: Essays on Photographies and Histories* (Amherst: University of Massachusetts Press, 1988), 61.

11. For a thorough and dynamic rereading of the Mecelle's far reach as seen in the *nizamiye* (secular civil) courts, see Avi Rubin, *Ottoman Nizamiye Courts: Law and Modernity* (New York: Palgrave-Macmillan, 2011).

12. Many important studies on land tenure and economic transformations in the Middle East during the nineteenth century have been written. For example, see Kenneth Cuno's study that ends at the year of the khedival land reform, *The Pasha's Peasants: Land, Society and Economy in Lower Egypt, 1740–1858* (Cambridge: Cambridge University Press, 1993); or Dina Rizk Khoury, *State and Provincial Society in the Ottoman Empire: Mosul, 1540–1834* (Cambridge: Cambridge University Press, 1997). For an interesting micro-examination in the context of Jordan, see Eugene Rogan, *Frontiers of the State in the Late Ottoman Empire: Transjordan 1850–1921* (Cambridge: Cambridge University Press, 1999), 75–94. Likewise, for a critical reevaluation of property relations during the nineteenth century, see Roger Owen, ed., *New Perspectives on Property and Land in the Middle East* (Cambridge, MA: Harvard University Press, 2000).

13. Suraiya Faroqhi, *Subjects of the Sultan: Culture and Daily Life in the Ottoman Empire* (London: I. B. Tauris, 2000), 95, 97. For economic histories, see Ehud Toledano, *State and Society in Mid-Nineteenth Century Egypt* (Cambridge: Cambridge University Press, 1990); Roger Owen, *The Middle East in the World Economy 1800–1914* (London: I. B. Tauris, 2002); Resat Kesaba, *The Ottoman Empire and the World Economy: The Nineteenth Century* (Albany: SUNY Press, 1988); John Chalcraft, *The Striking Cabbies of Cairo and Other Stories: Crafts and Guilds of Egypt 1863–1914* (Albany: SUNY Press, 2004); Joel Beinin and Zachary Lockman, *Workers on the Nile: Nationalism, Communism, Islam and the Egyptian Working Class, 1882–1954* (Cairo: American University of Cairo, 1998). The classic works, mostly compilations, still remain valuable, including Tarif Khalidi, ed., *Land Tenure and Social Transformation in the Middle East* (Beirut: American University of Beirut, 1984); and Charles Issawi, ed., *The Economic History of the Middle East, 1800–1914* (Chicago: University of Chicago Press, 1966).

14. See Husayn Marsafi, *Risalat al-Kalim al-thamin* (Cairo: al-Maktabah al-sharqiyah, 1881).

15. Wendy Shaw, "Ottoman Photography in the Late Nineteenth Century: An 'Innocent' Modernism?" *History of Photography* 33, no. 1 (February 2009): 80.

16. See Wendy Shaw, *Ottoman Painting: Reflections of Western Art from the Ottoman Empire to the Turkish Republic* (London: I. B. Tauris, 2011), 31–39.

17. Sarah Graham-Brown, *Images of Women: The Portrayal of Women in Photography of the Middle East, 1860–1950* (London: Quartet, 1988), 59.

18. Roberts, "Ottoman Statecraft and the 'Pencil of Nature,'" 17.

19. Hummel, "Christians and the Beginning of Local Photography," 188; and Badr el-Hage, "The Armenian Pioneers of Middle Eastern Photography," *Jerusalem Quarterly* 31 (Summer 2007): 25.

20. Wendy Shaw, *Possessors and Possessed: Museums, Archaeology, and Visualization of History in the Late Ottoman Empire* (Berkeley: University of California Press, 2003), 141.

21. See Özendes Çizgen, *Photography in the Ottoman Empire*; and Özendes Çizgen, "Ottoman Empire: Asia and Persia (Turkey, The Levant, Iraq, Iran)," in *Encyclopedia of Nineteenth Century Photography*, ed. John Handy (New York: Routledge, 2008), 1036. See also Bahatin Oztuncay, *Dynasty and Camera: Portraits from the Ottoman Court* (Istanbul: Aygaz, 2011); and Engin Özendes, *Abdullah Frères: Ottoman Court Photographers* (Istanbul: Yapı Kredi, 1998).

22. Shaw, *Possessors and Possessed*, 140.

23. Badr el-Hage, *Saudi Arabia: Caught in Time 1861–1939* (London: Garnet, 1997), 36; Nissan Perez, *Focus East: Early Photography in the Near East (1839–1885)* (New York: Abrams, 1988), 222.

24. Engin Özendes, *From Sébah & Joaillier to Foto Sabah: Orientalism in Photography* (Istanbul: Yapi Kredi Yayinlari, 1999), 232.

25. Osman Hamdy Bey, *Les costumes populaires de la Turquie en 1873* (Constantinople: Levant Times & Shipping Gazette, 1873). For a critical mention of Osman Hamdy's *Costumes populaire de la Turquie*, see Zeynep Çelik, "Speaking Back to Orientalist Discourse," in *Orientalism's Interlocutors: Painting, Architecture, Photography*, ed. Jill Beaulieu and Mary Roberts (Durham, NC: Duke University Press, 2002), 21–25; Mary Roberts, *Intimate Outsiders: The Harem in Ottoman and Orientalist Art and Travel Literature* (Durham, NC: Duke University Press, 2007), 144; and Ussama Makdisi, "Rethinking Ottoman Imperialism: Modernity, Violence, and the Cultural Logic of Ottoman Reform," in *The Empire in the City: Arab Provincial Capitals in the Late Ottoman Empire*, ed. Jens Hanssen (Beirut: Ergon Verlag Wurzburg, 2002), 42–45.

26. Özendes Çizgen, *Photography in the Ottoman Empire*, 94.

27. Faroqhi, *Subjects of the Sultan*, 258.

28. Gilbert Beauge and Engin Çizgen, *Images d'empire: Aux origins de la photographie en Turquie: Collection de Pierre de Grigord* (Istanbul: Institut d'Études Francaises d'Istanbul, [1993?]), 176–77.

29. Roberts, "Ottoman Statecraft and the 'Pencil of Nature,'" 12.

30. Sophie Gordon, *Cairo to Constantinople: Francis Bedford's Photographs of the Middle East* (London: Royal Collection Trust, 2013).

31. El-Hage, "The Armenian Pioneers," 25.

32. Özendes Çizgen, *Photography in the Ottoman Empire*, 92.

33. Beauge and Çizgen, *Images d'empire*, 177.

34. El-Hage, "The Armenian Pioneers," 25, and Engin Özendes Çizgen, "Abdullah Frères," in *Encyclopedia of Nineteenth Century Photography*, ed. John Handy (New York: Routledge, 2008), 1.

35. Özendes Çizgen, "Abdullah Frères," 1.

36. Esra Akcan, "Off the Frame: The Panoramic City Albums of Istanbul," in *Photography's Orientalism: New Essays on Colonial Representation*, ed. Ali Behdad and Luke Gartlan (Los Angeles: Getty Research Institute, 2013), 100.

37. Özendes Çizgen, *Photography in the Ottoman Empire*, 97.

38. See Miller, "The Craftsman's Art," which remains one of the few studies in English that details Armenian sources.

39. For a discussion of these "patterns," see Julia Hirsh, *Family Photographs: Content, Meaning and Effect* (New York: Oxford University Press, 1981), 99.

40. Christopher Pinney, *Camera Indica: The Social Life of Indian Photographs* (Chicago: University of Chicago Press, 1997), 72, 95–96.

41. Zahid Chaudhary, *Afterimage of Empire: Photography in Nineteenth Century India* (Minneapolis: University of Minnesota Press, 2012), 127.

42. Vincent Rafael, "The Undead: Notes on Photography in the Philippines, 1898–1920s," in Rafael, *White Love and Other Events in Filipino*

History (Durham, NC: Duke University Press, 2000), 99.

43. Ibid., 100; see also Pinney, *Camera Indica*; Chaudhary, *Afterimage of Empire*; and Karen Strassler, *Refracted Vision: Popular Photography and National Modernity in Java* (Durham, NC: Duke University Press, 2010).

44. For two different readings of how the image is produced by and articulates the desire, see W.J.T. Mitchell, *What Do Pictures Want? The Lives and Love of Images* (Chicago: University of Chicago Press, 2005); and Geoffrey Batchen, *Burning with Desire: The Conception of Photography* (Cambridge, MA: MIT Press, 1999).

45. See Ayshe Erdogdu, "Picturing Alterity: Representational Strategies in Victorian Type Photographs of Ottoman Men," in *Colonialist Photography: Imag(in)ing Race and Place*, ed. Eleanor Hight and Gary Sampson (London: Routledge, 2013), 107–25; and Nancy Micklewright, "Alternative Histories of Photography in the Ottoman Middle East," in *Photography's Orientalism: New Essays on Colonial Representation*, ed. Ali Behdad and Luke Gartlan (Los Angeles: Getty Research Institute, 2013), 89, 95.

46. Micklewright, "Personal, Public, and Political (Re)Constructions, 261–88. For an equally interesting discussion of consumerism in the empire, see Elizabeth B. Frierson, "Cheap and Easy: The Creation of Consumer Culture in Late Ottoman Society," in *Consumption Studies and the History of the Ottoman Empire, 1550–1922*, ed. Donald Quataert (Albany: SUNY Press, 2000), 243–87.

47. Paul De Man, *Allegories of Reading* (New Haven, CT: Yale University Press, 1979), 79.

48. Akcan, "Off the Frame," 102.

49. Jonathan Crary, *Techniques of the Observer: On Vision and Modernity in the Nineteenth Century* (Cambridge, MA: MIT Press, 1990), 3.

50. Martin Jay adopts "scopic regime" from Christine Metz. See Martin Jay, "Scopic Regimes of Modernity," in *Vision and Visuality*, ed. Hal Foster (New York: New Press, 1988), 3–23.

51. Roberts, "The Limits of Circumscription," 53–54.

52. Walter Benjamin, "Little History of Photography," in *Walter Benjamin, Selected Writing*, vol. 2, *1927–1934*, ed. Michael Jennings, Howard Eiland, and Gary Smith; trans. Edmund Jephcott and Kingsley Shorter (Cambridge, MA: Belknap, 1999), 515.

53. Ibid., 517.

54. Suren Lalvani, *Photography, Vision, and the Production of Modern Bodies* (Albany: SUNY Press, 1996), 68.

55. Elizabeth Edwards, *Raw Histories: Photographs, Anthropology, and Museums* (Oxford: Berg, 2001), 143.

56. Tagg, *Burden of Representation*, 50.

57. Ibid., 111.

58. Benjamin, "Little History of Photography," 511–12.

59. Tagg, *Burden of Representation*, 49.

60. Benjamin, "Little History of Photography," 512.

61. Kemal Karpat, *The Politicization of*

Islam: Reconstructing Identity, State, Faith, and Community in the Late Ottoman State (Oxford: Oxford University Press, 2001), 226.

62. In theorizing the difference between Freud's repeating (*wiederholen*) and remembering (*erinnerung*) within the context of psychoanalytic therapy, Lacan postulates that "repetition is something which, of its true nature, is always something veiled in analysis, because of the identification of repetition with the transference in the conceptualization of analysts." Jacques Lacan, "Of the Network of Signifiers," in *Four Fundamentals of Psychoanalysis: The Seminar of Jacques Lacan XI*, ed. Jacques-Alain Miller; trans. Alan Sheridan (New York: Norton, 1998), 49.

63. Lacan, "Of the Network of Signifiers," 51.

64. Aijaz Ahmad, *In Theory* (London: Verso, 1994), 74.

65. Roberts, "The Limits of Circumscription," 54.

66. Suraiya Faroqhi, *Subjects of the Sultan*, 258–59.

67. Sultan Abdülhamid photographic collection at the Library of Congress, given as a gift. See William Allen, "Analysis of Abdülhamid's Gift Albums," *Journal of Turkish Studies* 12 (1988): 33–37; and Nurhan Atasoy, "Sultan Abdülhamid II's Photo-Collections in Istanbul," *Journal of Turkish Studies* 12 (1988): iii–xi. For a slightly more sophisticated reading of Abdülhamid's photographic collection, see Zeynep Çelik, "Speaking Back to Orientalist Discourse at the World's Columbian Exposition," in *Noble Dreams, Wicked Pleasures: Orientalism in America 1870–1930*, ed. Holly Edwards (Princeton, NJ: Princeton University Press, 2000); and Michelle Woodward, "Between Orientalist Clichés and Images of Modernization: Photographic Practice in the Late Ottoman Era," *History of Photography* 27, no. 4 (2003): 363–74. Many have discussed Sultan Abdühamid's use of albums for Foucaultian, disciplinarian control, categorization, and organization as well as in response to the West. See Faroqhi, *Subjects of the Sultan*; Zeynep Çelik's pioneering *Displaying the Orient: Architecture of Islam at the Nineteenth Century World's Fairs* (Berkeley: University of California Press, 1992), 42–43; Shaw, *Possessors and Possessed*; Wolf-Dieter Lemke, "Ottoman Photography: Recording and Contributing to Modernity," in *The Empire in the City: Arab Provincial Capitals in the Late Ottoman Empire*, ed. Jens Hanssen (Beirut: Ergon Verlag Wurzburg, 2002).

68. See Çelik , "Speaking Back to Orientalist Discourse at the World's Columbian Exposition," 89, and also Çelik, *Displaying the Orient*; and Çelik, *Empire, Architecture, and the City: French-Ottoman Encounters 1830–1914* (Seattle: University of Washington Press, 2008); Shaw, *Possessors and Possessed*, 141; Özendes Çizgen, *Photography in the Ottoman Empire*, 94; and Eric Davis, "Representation of the Middle East at the American World's Fairs 1876–1904," paper in *The United States and the Middle East: Cultural Encounters*, Yale Center for International and Area Studies, vol. 5, 2002, 342–84, http://opus.macmillan.yale.edu/workpaper/pdfs/MESV5-12.pdf.

69. Roberts, "The Limits of Circumscription," 69–70.

70. Lemke, "Ottoman Photography," 237–38.

71. Hamdi Bey, as quoted in Makdisi, "Rethinking Ottoman Imperialism," 44.

72. Peter Gran, *Rise of the Rich: A New View of Modern History* (Syracuse, NY: Syracuse University Press, 2009), 60.

Chapter 2

1. Despite the study's problematic theoretical and political prism, for information about the Patriotic Alliance, see Serif Mardin, *The Genesis of Young Ottoman Thought: A Study in the Modernization of Turkish Political Ideas* (Syracuse, NY: Syracuse University Press 2000), 10–80.

2. See Fruma Zachs, *The Making of a Syrian Identity: Intellectuals and Merchants in Nineteenth Century Beirut* (Leiden: Brill, 2005). Zachs's discussion of intellectuals arising from the "middle strata" does not take into consideration Marxist or Gramscian notions of class formation or organic intellectuals' role as representatives of those particular class interests. Perhaps this is because organic intellectuals are frequently misunderstood exclusively as intellectuals that rise from and speak for subaltern social groups, not the bourgeoisie or middling classes. Zachs's study succeeds in introducing the concept of the middle strata as distinct from an all-encompassing and generic use of the concept "bourgeoisie."

3. Viscount Philippe de Tarrazi, *Tarikh al-sahafah al-ʿarabiyah* (Beirut: al-Matbaʾah al-adabiyah, 1913), 2:88, 214. Debbas asserts the date was later; see Fouad Debbas, *Des photographes à Beyrouth 1840–1918* (Paris: Marval, 2001), 49. Michel Fani, *Une histoire de la photographie au Liban 1840–1944* (Beirut: Éditions de l'Escalier, 2005), 66. For information about Dumas, see Carney Gavin, *Legacy of Light* (Araya, Lebanon: Imprimerie Catholique; Cambridge, MA: Harvard Semitic Museum, 1983), 4.

4. Carney Gavin, *Romantic Lebanon: The European View, 1700–1900* (London: British Lebanese Association, 1986), 68.

5. Fani, *Une histoire de la photographie*, 66.

6. Debbas, *Des photographes*, 50.

7. Ibid.; and Abd el-Basset al-Ounsi, *Dalil Beirut* (Beirut: Matbat Iqbal, 1909), 148.

8. Muhsin Yammin, "David kharaj min al-adraj wa Louis khala thawb al-kahnut," in *Mulhaq al-nahar* 10 (May 1997). Eyal Onne, *Photographic Heritage of the Holy Land 1839–1914* (Manchester, UK: Institute of Advanced Studies, 1980), 67.

9. Debbas, *Des photographes*, 48.

10. I thank Christine Lindner for sharing her archival work in the Near Eastern Theological Seminary in Beirut.

11. See Yammin, "David kharaj min al-adraj wa Louis khala thawb al-kahnut."

12. See B. N. Sabungi's name signed on the portrait of the Khedive Abbas Hilmi. Signatures on photographs in journals, however, often are the signature of the typesetter or someone who reproduced the photograph, as the names are

often etched into or painted on the negatives. See "Hay'ah majlis al-nizhar bi-ri'asah samu al-Khadawi ʿAbbas Basha al-Mʿazhzhim," in *al-Ajiyah* 1 (1897): 3.

13. In Yildiz Archives in Istanbul; see Tarih: 05/Ca/1310 (Hicrî) Dosya No:9 Gömlek No:1310/Ca-006 Fon Kodu: Đ..TAL. (25.11.1892): "Beyrut muteberanından Sabuncuzade Joj Efendi'ye rütbe-i salise tevcihi"; and Tarih: 25/S /1316 (Hicrî) Dosya No:143 Gömlek No:1316/S-133 Fon Kodu: Đ..TAL. (14.07.1898): "Beyrut muteberanından Sabuncuzade Jorj Efendi'ye terfian saniye rütbesi tevcihi ve sairenin taltifleri." Also, for his appointment as a customs inspector, Tarih: 19/Za/1319 (Hicrî) Dosya No:15 Gömlek No:1319/ZA-11 Fon Kodu: Đ..RSM. (28.02.1902). I thank Özcan Geçer for sharing these references.

14. In Yildiz Archives, see Tarih: 26/S /1313 (Hicrî) Dosya No:414 Gömlek No:13 Fon Kodu: DH.MKT. (17.08.1895). Debbas also cites *Le Moniteur Oriental*, published in Istanbul (August 20, 1895), which I am assuming is the same issue. See Debbas, *Des photographes*, 50.

15. For an example of images from Lebanon, see "Jerusalem and East Mission Collection," Middle East Centre Archive, St. Antony's College, Oxford University, box 163. Fani also provides two landscapes (one of Nahr al-Kalb) in Fani, *Une histoire de la photographie*, plates 40 and 41.

16. Jurji Saboungi, "Talmiʿ al-suwar" [Glossing photographs], *al-Muqtataf* 8 (1883–84): 684–85.

17. Ibid., 685.

18. For an exemplary discussion of the innovations of pioneering photographers in India, see Malevika Karlekar, *Re-visioning the Past: Early Photography in Bengal 1875–1915* (New Delhi: Oxford University Press, 2005), 133–63.

19. See Jirjis Tannus ʿAwn al-Sadalani, *al-Durr al-maknun fil-sinaʿah wal-funun*, 3rd ed. (N.p.: Matbaʿat Amin Haniyah, 1924; originally published, Istanbul: Matbaʿah Jawaʾib, AH 1301 [1883]).

20. Jurji Saboungi, "ʿAmal al-miraya" [Mirror work], *al-Muqtataf* 8 (1883–84): 208.

21. Khalil Khuri, "al-Tamaddun," *Hadiqat al-akhbar* 28, nos. 5–17 (July 1858); reproduced in Sharbil Daghir (Charbel Dagher), *al-ʿArabiyah wal-tamaddun fi ishtibah al-ʿalaqat bayn al-nahdah wa al-muthakafah wa al-hadathah* [Arabism and civilization in the suspicious relationship between the nahdah, intellectuals, and modernity] (Beirut: Dar al-nahar, 2008), 13.

22. The imago, according to Lacan, arises from the psychic field of the Imaginary, which is itself structured by its relation to language (and, therefore, society); that is to say, Lacan's Symbolic. The imago holds desires and identifications that were formed before its immersion into the Symbolic and, as such, offers that which lies beyond representation, otherwise thought of as the Real. Within this trifecta of crisscrossing psychic planes, we see parallels in the relationships between societal forces (including political economy and hierarchies and practices of power), individual subjects, and collective social formations, and the forces, histories, and expe-

riences that are often seen as uncanny, arcane, degraded, reactive, or outdated.

23. Jacques Lacan makes clear the centrality of identification in "Beyond the 'Reality Principle,'" in *Écrits: A Selection*, trans. Alan Sheridan (New York: Norton, 1977), 71. He also specifically states that the mirror stage is a process of identification (Lacan, "The Mirror Stage as Formative of the Function of the I as Revealed in Psychoanalytic Experience," in *Écrits*, 75).

24. Roland Barthes, "The Photographic Message," in *Image, Music, Text*, trans. Stephen Heath (New York: Hill and Wang, 1978), 17.

25. Victor Burgin, "Looking at Photographs," in *Thinking Photography*, ed. Burgin (New York: Macmillan, 1982), 144.

26. Siegfried Kracauer, "Photography," trans. Thomas Levine, in *Critical Inquiry* 19, no. 3 (1993): 429–30.

27. See Donald Quataert, "Clothing Laws, State, and Society in the Ottoman Empire, 1720–1829," in *International Journal of Middle East Studies* 29 (1997): 403–25. James Grehan provides us with a wonderful inventory of the variety of clothing worn in the previous century in Damascus alone, see James Grehan, *Everyday Life and Consumer Culture in Eighteenth-Century Damascus* (Seattle: University of Washington Press, 2007), 243–44.

28. Charlotte Jirousek, "The Transition to Mass Fashion System Dress in the Late Ottoman Empire," in *Consumption Studies and the History of the Ottoman Empire, 1550–1922: An Introduction*, ed. Donald Quataert (Albany: SUNY Press, 2000), 224; and Palmira Brummett, *Image and Imperialism in the Ottoman Revolutionary Press 1908–1911* (Albany: SUNY Press, 2000), 221–58.

29. Elizabeth Brown Frierson, "Mirrors Out, Mirrors In: Domestication and Rejection of the Foreign in Late-Ottoman Women's Magazines," in *Women, Patronage, and Self-Representation in Islamic Societies*, ed. D. Fairchild Ruggles (Albany: SUNY Press, 2000), 170.

30. For one example, see an illustrated article providing information on the current fashion for women's dresses, hats, and accessories, with accompanying directions about what is appropriate attire for which event (e.g., greeting guests, etc.): "Aziyaʿ hadha al-shahar" [Fashion this month], *Fatat al-Sharq* 7 (1912): 156. For other examples from preceding decades, see "Aziyaʿ al-nisaʾ" [Women's fashion] for the column "Bab Tadbir al-Bayt" [Organizing the home], *al-Muqtataf* 8 (1883–84): 53–54; and ʿAfifah Azhan, "al-Malabas wal-zinah," (Dress and ornamentation/accessories) *al-Muqtataf* 19 (1894–95): 216–18.

31. Ahmad Faris al-Shidyaq, *al-Saq ʿala al-saq fi ma huwa al-Fariyaq* (Beirut: Kutub, 2009); facsimile of original, Paris, 1855), 523–24.

32. Toufoul Abou-Hodeib, "Taste and Class in Late Ottoman Beirut," *International Journal of Middle East Studies* 1, no. 43 (2011): 481.

33. Jurji Zaidan, *Mudhakkirat Jurji Zaydan* (Beirut: Dar al-kitab al-jadid, 1968), 19, 40.

34. Tarrazi, *Tarikh al-sahafah al-ʿarabiyah*, 2:88.

35. The article reviews the art exhibition

that opened at the Academy of Arts in Cairo on February 22, 1896, attended by the khedive. See "Mʿarid al-suwar" [Exhibitions of images], *al-Muqtataf*, 20 (1895–96): 228.

36. Suraiya Faroqhi, *Subjects of the Sultan: Culture and Daily Life in the Ottoman Empire* (London: I. B. Tauris, 2000), 95, 97.

37. Ibid., 258. Faroqhi asserts that visual culture in the Balkans and Asia Minor was linked to the development of secularism in Turkey.

38. For some of their works, see Gilbert Beauge and Engin Çizgen, *Images d'empire: Aux origins de la photographie en Turquie: Collection de Pierre de Gigord* (Istanbul: Institut d'Études Francaises d'Istanbul, [1993?]). The Gigord Collection is housed at the Getty Research Institute. Numbering more than six thousand images, it contains albums of photographs by Abdallah Frères, Pascal Sébah, Legekian, and European photographers, many patronized by the sultan.

39. Muhsin al-Yamin, "Thalatha imtahanou al-shughal bil-shamas wa zhalaliha," *Mulhaq al-Nahar* 30 (August 1999): 14–15.

40. "Al-Fotographiyah al-suriyah" [Syrian photography], *al-Muqtataf* 1 (1876–77): 685.

41. See Stephen Sheehi, "A Social History of Arab Photography; or a Prolegomenon to an Archaeology of the Lebanese Bourgeoisie," *International Journal of Middle East Studies* 39, no. 2 (Spring 2007): 177–208.

42. Heghnar Zeitlan Watenpaugh, "The Harem as Biography: Domestic Architecture, Gender, and Nostalgia in Modern Syria," in *Harem Histories: Envisioning Places and Living Spaces*, ed. Marilyn Booth (Durham, NC: Duke University Press, 2010), 230.

43. Portrait of Mariyana Marrash by Saboungi (or probably reproduced by photogravure "B. Sabungi"), *Fatat al-sharq* 5 (1910–11): 361, followed by biography. Saboungi also supplied a portrait of the famed Wardah al-Yaziji, sister of Ibrahim and daughter of Nasif, in another profile piece in the column by Labibah Hashim, "Shahirat al-nisa" [Famous women], *Fatat al-sharq* 2 (October 15, 1907–8): 1. Portrait of Mariyana Marrash, found in Tarrazi, *Tarikh al-sahafah al-ʿarabiyah*, 2:241.

44. See Marilyn Booth, *May Her Likes Be Multiplied: Biography and Gender Politics in Egypt* (Berkeley: University of California Press, 2001); Beth Baron, *Egypt as a Woman: Nationalism, Gender and Politics* (Berkeley: University of California Press, 2005); Lisa Pollard, *Nurturing the Nation: The Family Politics of Modernizing, Colonizing and Liberating Egypt, 1805–1923* (Berkeley: University of California Press, 2003).

45. Jacques Lacan, "What Is a Picture?" in *The Four Fundamental Concepts of Psychoanalysis*, ed. Jacques Alain Miller, trans. Alan Sheridan (New York: Norton, 1978), 107.

46. Ibid., 106–7.

47. John Tagg, *The Burden of Representation: Essays on the Photographies and Histories* (Amherst: University of Massachusetts Press, 1988), 65.

48. For a number of interesting anecdotes about Ziya Pasha's political dealings as governor of a few Ottoman cities, see Sam Kaplan, *The*

Pedagogical State: Education and the Politics of National Culture in Post-1980 Turkey (Stanford, CA: Stanford University Press, 2006), 6–10.

49. Stephen Penrose, *That They Might Have Life: The Story of the American University of Beirut 1866–1941* (Princeton, NJ: Princeton University Press, 1941), 20.

50. Tarrazi, *Tarikh al-sahafah al-ʿarabiyah*, 6.

51. Michel Fani suggests that Louis left Beirut in 1874 because of riots that destroyed his brother's studio, although little evidence supports this. Fani, *Une histoire de la photographie*, 62.

52. See Rogier Visser's wonderfully informative dissertation that focuses on Louis Saboungi's debates and political embroilments with leading Beirut intellectuals and the Maronite church. Visser, "Identities in Early Arabic Journalism: The Case of Louis Sabunji," (PhD diss., University of Amsterdam, 2014). I also greatly thank amateur historian Özcan Geçer in Istanbul for his generosity in sharing his own boundless knowledge on Louis.

53. This is confirmed by Jean Fontaine's biography of Louis Sabungi, which is written in French, and from which Fani lifts verbatim in his biographical information about Louis. I hesitate to cite Fontaine at length because I am in the possession of an incomplete electronic copy of his work, with no source for where it appeared. The pages are 99–102.

54. See Leon Zolondek, "Saboungi in England," *Middle East Studies* 14 (1978): 102–15. For his activity supporting Egyptian independence and relationship with Blunt and his wife, see Wilfred Blunt, *Secret History of the English Occupation of Egypt* (London: Unwin, 1907).

55. Engin Özendes Çizgen, *Photography in the Ottoman Empire* (Istanbul: Haset Kitabevi, 1987), 116. Despite the scattered nature of his work, Saboungi was a prolific author, apparently writing in Arabic, Turkish, and English, if not also in Italian and French. His diary, *Yıldız Sarayiʾinda Bari Papaz* [A priest in Yildiz Palace] (Istanbul: N.p., 1952) was recently republished in Turkish as *Yıldız Sarayında bir Papaz* (Istanbul: Selis Kitaplar, 2007). He wrote the earliest explanation of the Syriac Catholic rite in English, *A Short Exposition of the Liturgy and Holy Mass according to the Syrian Catholic Church* (New York: D. J. Sadlier & Co., 1872), which, along with another lecture, was presented in the United States in 1872. The other is *Old Mother Phoenicia and Young Daughter America* (New York: Wynkoop and Hallenback, 1872). Jean Fontaine suggests that he visited the United States upon leaving Beirut after attacking Butrus al-Bustani's *al-Jinan*. Given that Louis died in his nineties—and not from natural causes—it should be noted that he also wrote a book about discovering the secret to lengthening life, *Kitab al-iktishaf al-thamin li-itaalat al-ʿumr miʾat min al-sinin bi sahhah tammah wa-shaykhukhah salihah* (The book of discovering the lengthening of life to a hundred years in good health and sound old age) (N.p: N.p., 1919). While living in the United States, he also wrote a historical romance about Abdülhamid's wife, under his Italianized name, Giovanni Luigi Bari Sabungi: *Jehan Aftab: The*

Sun of the World (New York: Real American Syndicate, 1923). He also wrote plays, which are lost, such as *A Trip round the World, Presented at Court at Crystal Palace* (1888–89). I am deeply indebted to Özcan Geçer for our discussions on both the Saboungis. He is, undoubtedly, the most versed scholar on the life, times, and work of Louis Saboungi.

56. Tarrazi, *Tarikh al-sahafah al-ʿarabiyah*, 72–73.

57. Ibid.

58. Visser, "Identities in Early Arabic Journalism," 84.

59. I thank Özcan Geçer for this information.

60. Fani, *Une histoire de la photographie*, 62.

61. Visser, "Identities in Early Arabic Journalism," 110.

62. Ibid., 120.

63. Alan Sekula, "The Invention of Photographic Meaning," in *Thinking Photography*, ed. Victor Burgin (New York: Macmillan, 1982), 95.

64. Edward Soja, *Third Space: Journeys to Los Angeles and Other Real and Imagined Places* (New York: Blackwell, 1996), 64.

65. Christopher Pinney, "Introduction: 'How the Other Half …,'" in *Photography's Other Histories*, ed. Christopher Pinney and Nicolas Peterson (Durham, NC: Duke University Press, 2003), 14.

66. Roland Barthes, "The Rhetoric of Meaning," in *Image, Music, Text*, trans. Stephen Heath (New York: Hill and Wang, 1978), 44.

67. Jurji Saboungi, in Debbas, *Des photographes*, 46.

68. Fani, *Une histoire de la photographie*, plate 35 (my translation).

69. Roland Barthes, *Camera Lucida: Reflections on Photography* (New York: Hill and Wang, 1981), 27. For an example of the punctum's "alternative histories," see Elizabeth Edwards, *Raw Histories: Photographs, Anthropology, and Museums* (Oxford: Berg, 2001), 101.

70. See Fani, *Une histoire de la photographie*, plate 63. I thank Özcan Geçer for this image and the information about it.

71. For a discussion of some of these traditions, see Magdi Guirguis, *An Armenian Artist in Ottoman Cairo: Yuhanna al-Armani and His Coptic Icons* (Cairo: American University in Cairo Press, 2008); and Kamal Boullata, *Palestinian Art: 1850 to the Present* (London: Saqi, 2009). Also, for iconography and modern Arab oil painting's relationship to photography, see Stephen Sheehi, "Before Painting: Niqula Saig and Photographic Vision," in *Arab Art Histories: Khaled Shouman Collection (Qiraʾat fil-fann al-ʿarabi)* (Amman: Darat al-Funu; Amsterdam: Idea Books, 2014), 361–74.

Chapter 3

1. Emine Foat Tugay, *Three Centuries: Family Chronicles of Turkey and Egypt* (Westport, CT: Greenwood Press, 1974), 8. There are a number of fascinating first-person "Haram narratives" being studied, translated, and published. See, for example, Eve Troutt Powell, *Tell This in My Memory: Stories of Enslavement from Egypt,*

Sudan and the Ottoman Empire (Stanford, CA: Stanford University Press, 2012).

2. For a few critical studies rethinking the Ottoman haram, see Nawar al-Hassan Golley, *Reading Arab Women's Autobiographies: Shahrazad Tells Her Story* (Austin: University of Texas Press, 2003); Leslie Pierce, *The Imperial Harem: Women and Sovereignty in the Ottoman Empire* (Oxford: Oxford University Press, 1993); Douglass Scott Brookes, *The Concubine, the Princess, and the Teacher: Voices from the Ottoman Harem* (Austin: University of Texas Press, 2010); Mary Roberts, *Intimate Outsiders: The Harem in Ottoman and Orientalist Art and Travel Literature* (Durham, NC: Duke University Press, 2007).

3. Suraiya Faroqhi, *Subjects of the Sultan: Culture and Daily Life in the Ottoman Empire* (London: I. B. Tauris, 2000), 258.

4. Esra Akcan, "Off the Frame: The Panoramic City Albums of Istanbul," in *Photography's Orientalism: New Essays on Colonial Representation*, ed. Ali Behdad and Luke Gartlan (Los Angeles: Getty Research Institute, 2013), 95.

5. Ellen Chennells, *Recollections of an Egyptian Princess* (London: William Blackwell and Sons, 1893), 153.

6. Ibid., 271–72. Mary Roberts mentions part of this vignette in her "Contested Terrains: Women Orientalists and the Colonial Harem," in *Orientalism's Interlocutors: Painting, Architecture, Photography*, ed. Jill Beaulieu and Mary Roberts (Durham NC: Duke University Press, 2002), 43, 202.

7. Chennells, *Recollections of an Egyptian Princess*, 272.

8. Eve Troutt Powell, *Tell This in My Memory*, 119.

9. Hasan Rasim Hijazi, "Photographic Pictures on Tin-Plating," *al-Muqtataf* 20 (1895–96): 138.

10. As quoted by Rosalind Morris in her introduction to *Photographies East: The Camera and Its Histories in East and Southeast Asia*, ed. Rosalind Morris (Durham, NC: Duke University Press, 2009), 11.

11. Suren Lalvani, *Photography, Vision, and the Production of Modern Bodies* (Albany: SUNY Press, 1996), 59. For additional discussions on photography's role in the representation of the body and capitalist forms of social discipline, see Gisele Freund, *Photography and Society* (Boston: David Godine, 1980); and Alan Sekula, "The Body and Archive," in *The Contest of Meaning*, ed. Richard Bolton (Cambridge, MA: MIT Press, 1999), 343–89.

12. For a comprehensive history of Disdéri, see Anne McCauley, *A.A.E. Disdéri and the Carte de Visite Portrait Photograph* (New Haven, CT: Yale University Press, 1985).

13. John Tagg, *The Burden of Representation: Essays on Photographies and Histories* (Amherst: University of Massachusetts Press, 1988), 47.

14. Max Kazloff, "Nadar and the Republic of Mind," in *Photography in Print: Writing from 1816 to the Present*, ed. Vicki Goldberg (New York: Simon and Schuster, 1981), 130.

15. Tagg, *Burden of Representation*, 50.

16. Ibid.

17. Beaumont Newhall, *The History of Photography* (New York: Museum of Modern Art, 1982), 64; Robin Wichard, *Victorian Cartes-de-Visite* (London: Osprey, 1999), 34; and Helmut Gernsheim, *A Concise History of Photography*, 3rd ed. (New York: Dover, 1986), 55.

18. Helmut Gernsheim, *A Concise History of Photography*, 55. See also Deborah Poole, *Vision, Race, and Modernity: A Visual Economy of the Andean Image World* (Princeton, NJ: Princeton University Press, 1997), 107–52, for a complex, if not exemplary, discussion of the carte de visite in Peru.

19. See Malivika Karlekar, *Re-visioning the Past: Early Photography in Bengal 1875–1915* (New Delhi: Oxford University Press, 2005), 4; Michael Gibbs Hill, *Lin Shu Inc.: Translation and the Making of Modern Chinese Culture* (Oxford: Oxford University Press, 2013), 137; Robert Hellyer, *Defining Engagement: Japan and Global Contexts* (Cambridge, MA: Harvard University Press, 2009), 248; and Stephen Sheehi, *Foundations of Modern Arab Identity* (Gainesville: University Press of Florida, 2004).

20. See Deborah Poole, "Figueroa Aznar and the Cusco *Indigenistas*: Photography and Modernism in Early-Twentieth Century Peru," in *Photography's Other Histories*, ed. Christopher Pinney and Nicolas Peterson (Durham, NC: Duke University Press, 2003), 176.

21. See Karlekar, *Re-visioning the Past*; Christopher Pinney, *Camera Indica: The Social Life of Indian Photographs* (London: Reaktion, 1997); and Zahid Chaudhary, *Afterimage of Empire: Photography in Nineteenth-Century India* (Minneapolis: University of Minnesota Press, 2012).

22. Viscount Philippe de Tarrazi, *Tarikh al-sahafah al-ʾarabiyah* (Beirut: al-Matbaʾah al-adabiyah, 1913), 2:88.

23. Badr el-Hage asserts that Lind was German and Dakouny bought his studio in the early twentieth century (*Des Photographes a Damas 1840–1918* [Paris: Marval, 2000], 37). Fani provides more detailed information about Antoine, Assad, and Frédéric and also provides many images of their prestige photographs of founding Lebanese political figures. Michel Fani, *Une histoire de la photographie au Liban 1840–1944* (Beirut: Éditions de l'Escalier, 2005), 356.

24. Octavia Covas, also a painter and friend of Lebanese painter Habib Srour, came from a famous family of iconographers. Her father, Pandaléon Covas, was an iconographer and fresco painter in the 1830s. Michel Covas, his son, became a photographer in 1875. But business in her last years was failing so much that, according to Fani, she put an ad in the local press reducing her prices (*Une histoire de la photographie au Liban*, 290).

25. Fani, *Une histoire de la photographie au Liban*, 362.

26. Karl Baedeker, Albert Socin, Emmanuel Benzinger, John Prunnet Peters, *Palestine and Syria with the Chief Routes through Mesopotamia and Babylonia* (Leipzig: Karl Baedeker Publisher, 1906), 276. The exact entry is repeated in Karl Baedeker, *Palestine and Syria: Handbook for Travellers*, 4th ed., rev. and augmented (Leipzig: Karl Baedeker Publisher, 1906; New York: Charles Scribner), 115.

27. Fani, *Une histoire de la photographie au Liban*, 300.

28. See, for example, another edition of the Baedeker guide: Karl Baedeker, *Palestine and Syria: Handbook for Travellers* (Leipzig: Karl Baedeker Publisher, 1894), 307.

29. Maria Antonella Pelizzari, "Retracing the Outlines of Rome: Intertextuality and Imaginative Geographies in Nineteenth Century Photography," in *Picturing Place: Photography and the Geographical Imagination*, ed. Joan Schwartz and James Ryan (London: I. B. Tauris, 2003), 63; and Kathleen Stewart Howe, "Mapping a Sacred Geography: Photographic Surveys of the Royal Engineers in the Holy Land, 1864–1869," in *Picturing Place*, 226–41. Also see, Kathleen Stewart Howe, *Revealing the Holy Land: The Photographic Exploration of Palestine* (Berkeley: University of California Press, 1997).

30. Nissan Perez, *Focus East: Early Photography in the Near East (1839–1885)* (New York: Abrams, 1988); and Kenneth Jacobson, *Odalisques and Arabesques: Orientalist Photography, 1839–1925* (London: Bernard Quaritch, 2007).

31. Iskander Makarius, "al-Taswir al-Hadith: al-Taswir al-Autochromatiki," *Muqtataf* 30 (1905): 402.

32. Issam Nassar, "Familial Snapshots: Representing Palestine in the Work of the First Local Photographers," *History & Memory* 18, no. 2 (Fall/Winter 2006): 139–55; and Nassar, "Early Local Photography in Palestine: The Legacy of Karimeh Abbud," *Jerusalem Quarterly* 46 (Summer 2011): 23–31.

33. Issam Nassar, "Photography as Source Material for Social History of Jerusalem," in *Transformed Landscapes: Essays on Palestine and the Middle East in Honor of Walid Khalidi*, ed. Kamil Mansur and Leila Tarrazi Fawaz (New York: American University of Cairo, 2009), 142. See also Nassar, "Familial Snapshots: Representing Palestine in the Work of the First Local Photographers," *History & Memory* 18, no. 2 (Fall/Winter 2006): 146.

34. Badr el-Hage, *Shweir and Its Hills: A Photographic Record*, trans. Sabah Ghandour (Beirut: Kutub, 2013). Muhsin al-Yamin researches many unknown Lebanese photographers in "Yawmiyyat Wadiʾ Nawfal 1854–74," *al-Mustaqbal* 27 (April 2000); and Akram Zaatari has compiled a list of biographies of various pioneering Arab studios and photographers, which remains unpublished but can be found at the Foundation for the Arab Image in Beirut.

35. Will Stapp, "Egypt and Palestine," *Encyclopedia of 19th Century Photography*, ed. John Hannavy (New York: Routledge, 2008), 477–78.

36. Carole Escoffey, "The AlexCinema Project; Retracing the Birth of the Seventh Art in Alexandria," *Alex-Med: Bibliotheca Alexandria* (May–July 2007): 12.

37. For example, one finds a contract and correspondence between Felix Bonfils and expatriate photographer Henri Rombau in the Fouad Debbas Collection in Beirut. See also Nancy Micklewright, *A Victorian Traveler in the Middle East* (London: Ashgate, 2003), 84–85. Also, Fani notes the circulation of plates and personnel between Beirut studios (*Une histoire de la photographie au Liban*, 80).

38. One may think of many examples, along with the rather rapid rise of Lebanonism at the beginning of the twentieth century, that otherwise arose out of Ottomanism. See Asher Kaufman, *Reviving Phoenicia: The Search for Identity in Lebanon* (London: I. B. Taurus, 2004). For a micro-study of this transformation of cosmopolitanism to, say, Nasserist regionalism in Alexandria, see Deborah Starr, *Remembering Cosmopolitan Egypt* (New York: Routledge, 2009).

39. John E. Wills, "Maritime Asia 1500–1800: The Interactive Emergence of European Domination," *American Historical Review* 98, no. 1 (1993): 83–105. Gran refers to "interactive emergence" all too briefly in *Rise of the Rich: A New View of Modern History* (Syracuse, NY: Syracuse University Press, 2009), 67.

40. Tagg, *Burden of Representation*, 48–49.

41. Roger Brubaker, "Rethinking Classical Theory: The Sociological Vision of Pierre Bourdieu," in *After Bourdieu: Influence, Critique, Elaboration*, ed. David Swartz and Vera Zolberg (Dordrecht: Kluwer, 2005), 45. For a more direct definition of *habitus*, see Pierre Bourdieu, *The Logic of Practice* (Stanford, CA: Stanford University Press, 1990), 200.

42. Christopher Pinney, *The Coming of Photography to India* (London: British Library, 2008), 30.

43. Karl Marx, *Capital*, trans. Samuel Moore and Edward Aveling (New York: Appleton, 1889), 44.

44. Pinney, *Coming of Photography to India*, 30.

45. Gran, *Rise of the Rich*, 60.

46. Poole, *Vision, Race, and Modernity*, 112.

47. Karl Marx, *A Contribution to the Critique of Political Economy* (Chicago: Charles Kerr, 1904), 11.

48. Rather than "New Men," I have been referring throughout this study to the "new men and women" of the empire. Gender was central not only to the ideology and circulation of the portrait but also particularly to the formation of new conceptions of sociability, the civilizational discourse of *al-nahdah*, and the ideologies of national progress, unity, and development in every corner of the Ottoman Empire. To play on Gran's idiom, the term "the new woman" was a central fixture in *nahdah* discourses, popularized most famously by Qasim Amin's celebrated book, *al-Marʾah al-jadidah* [The new woman] in 1900. The concept of "new men and women" is not deployed as a patronizing attempt at being "inclusive" in order to accommodate the limitations of this study but as a *collective* analytical idiom. It gestures to acknowledge how the work of those such as Wilson Chacko Jacob and Marcia Inhorn show that the conceptualization of gender social roles and ideals, including practices of cultural, social, and biological reproduction, are interlinked with colonialism and imperialism but also with state power, social

hierarchy, and political economy, which are negotiated by shifting cultural norms. Moreover, while circumscribed by patriarchal power, these roles, practices, and ideals require mutual complicity among men and women. See Wilson Chacko Jacobs, *Working Out Egypt: Effendi Masculinity and Subject Formation in Colonial Modernity 1870–1940* (Durham NC: Duke University Press, 2011), and Marcia Inhorn, *The New Arab Man: Emergent Masculinities, Technologies, and Islam* (Princeton, NJ: Princeton University Press, 2012).

49. Max Kozloff, *Photography and Fascination* (Danbury, NH: Addison, 1979), 79.

50. Antonio Gramsci, *Prison Notebooks*, trans. Joseph Buttigieg, vol. 3 (New York: Columbia University Press, 2007), 199.

51. Sibel Zandi-Sayek, *Izmir: The Rise of a Cosmopolitan Port 1840–1880* (Minneapolis: University of Minnesota Press, 2012), 50.

52. Dyala Hamzah, ed., *The Making of the Arab Intellectual: Empire, Public Sphere and the Colonial Coordinates of Selfhood* (London: Routledge, 2013), 8.

53. Laila Tarrazi Fawaz, *A Land of Aching Hearts: The Middle East in the Great War* (Cambridge, MA: Harvard University Press, 2014), 123–25.

54. For an interesting history of how these military schools were staffed by and graduated an array of officers who came from various parts of the empire to study at the School of Military Sciences (Mekteb-i Ulum-i Harbiyye) in Damascus, see Michael Province, "Ottoman Modernity, Colonialism, and Insurgency in the Interwar Arab East," *International Journal of Middle East Studies* 43 (2011): 205–25. Many of the graduates went on to fight in anticolonialist struggles in Syria and Palestine, for example.

55. Christine Philliou, *Biography of an Empire: Governing Ottomans in the Age of Revolution* (Berkeley: University of California Press, 2010). Alan Mikhail demonstrates how commerce and agriculture in Egypt were not based on center-to-periphery social and economic relations but, instead, on changing hubs, networks, and nodal points within regional routes between Egypt and various parts of the empire. He also shows how these networks of commerce and agriculture were not the sole purview of landowners, tax-farmers, and officials. Rather, the peasantry too were actors in negotiating the management and means of production in agricultural lands and their infrastructure.

56. Cem Emrence, *Remapping the Ottoman Middle East: Modernity, Imperial Bureaucracy, and the Islamic State* (London: I. B. Taurus, 2011), 121.

57. Janet Abu Lughod, *Before European Hegemony: The World System A.D. 1250–1350* (New York: Oxford University Press, 1991).

58. See Geoffrey Batchen, "Dreams of Ordinary Life," in *Photography: Theoretical Snapshots*, ed. J. J. Long, Andrea Noble, and Edward Welch (London: Routledge, 2009), 87. See also Poole, *Vision, Race, Modernity*, 112; and John Tagg, *Grounds for Dispute: Art History, Cultural Politics, and the Discursive Field* (Minneapolis: University of Minnesota Press, 1992), 125. Oliver Wendell Holmes, "Doing of the Sunbeam," *Atlantic Monthly* 12 (July 1863): 8.

59. Bruno Latour, *Reassembling the Social: An Introduction to Actor-Network Theory* (New York: Oxford University Press, 2005), 84–85.

60. Chennells, *Recollections of an Egyptian Princess*, 155.

61. Ibid., 155–56.

62. Wendy Shaw, "Photography of the Late Ottoman Empire: An 'Innocent' Modernism," *History of Photography* 33, no. 1 (February 2009): 84.

Chapter 4

1. Beaumont Newhall, *The History of Photography*, 4th ed. (New York: Museum of Modern Art, 1964), 12. For an examination of positivist paradigms within Arab subjectivity, see Stephen Sheehi, *Foundations of Modern Arab Identity* (Gainesville: University Press of Florida, 2004).

2. Peter Galassi, *Before Photography: Painting and the Invention of Photography* (New York: Museum of Modern Art, 1981), 12.

3. Allan Sekula, "Traffic in Photographs," in *Photography against the Grain: Essays and Photo Works, 1973–1983* (Halifax: Press of the Nova Scotia College of Art and Design, 1984), 93.

4. Sarah Graham-Brown, *Images of Women: The Portrayal of Women in Photography of the Middle East, 1860–1950* (London: Quartet, 1988), 56.

5. Shahin Makarius, "al-Fotografia," *al-Muqtataf* 7 (1882–83): 95.

6. The image appears in many twentieth-century publications, including the front cover of *Maqallat wa khutub fil-tarbiyah: ʿAsr al-nahdah al-hadith*, ed. Yusuf Qizma Khuri (Beirut: Dar al-Hamra, 1990). The portrait that appears here is taken from Philippe de Tarrazi, *Tarikh al-sahafah al-ʿarabiyah* [History of the Arabic press], bk. 1, vol. 1 (Beirut; al-Matbaʿah al-ʿadabiyah, 1913), 136.

7. For a discussion of this formula, see an examination of positivist paradigms within Arab subjectivity in Sheehi, *Foundations of Modern Arab Identity*.

8. For an unparalleled discussion of the rise of these social groups within the larger political economy of late Ottoman Beirut, see Jens Hanssen, *Fin de Siècle Beirut: The Making of an Ottoman Provincial Capital* (Oxford: Oxford University Press, 2005), 145–61.

9. Antonio Gramsci, *Prison Notebooks*, trans. Joseph Buttigieg, vol. 3 (New York: Columbia University Press, 2007), 332.

10. Gramsci, *Prison Notebooks*, trans. Joseph Buttigieg, vol. 2 (New York: Columbia University Press, 1996), 199.

11. For information about the renowned Mirza Malkhum Khan, see Hamid Algar, *Mirza Malku Khan: A Biographical Study in Iranian Modernism* (Berkeley: University of California Press, 1973). For a more contemporary reading that examines the positionality of the conversion of Malkhum Khan, an Armenian, to Islam, see Kamran Rastegar, *Literary Modernity between the Middle East and Europe: Textual Transactions in Nineteenth Century Arabic, English, and Persian Literatures* (New York: Routledge, 2007), 120–25.

12. Yusuf Effendi al-Jalkh, "Fi Nabdhah min ʿilm al-tabiʿiyat wa fi taswir al-shamas," in *Aʿmal al-jamʿiyah al-ʿilmiyah al-suriyah 1868–69*, ed. Yusuf Qizma Khuri (Beirut: Dar al-Harma, 1990), 43–49.

13. Nasif al-Yaziji, *Musahhah diwan Nasif al-Yaziji al-lubnani: al-nabdhah al-thalithah wa hiya al-mʿarufah bi'thalith al-qamarayn*, ed. by Ibrahim al-Yaziji (Matbaʿah al-adabiyah, 1903).

14. Al-Jalkh, "Fi Nabdhah," 43.

15. Ibid., 43–44.

16. Ibid., 43.

17. Ibid., 45.

18. Ibid., 44.

19. Ibid., 49.

20. Ibid.

21. Ibid.

22. Ibid.

23. Al-Jalkh intersperses poetic verse in his narrative. For example, in discussing the nature of light, which will then lead to how it is captured by chemical means, he composes a two-stanza poem on the spectrum's colors: "The colors of the Sun's spectrum are seven / Red, Orange, Yellow, then Green / Blue, Indigo and after that, Violet. / And in inverting the spectrum, an opposite appears" (al-Jalkh, "Fi Nabdhah," 45).

24. Sharbil Daghir (Charbel Dagher), *al-ʿArabiyah wal-tamaddun fi ishtibah al-ʿalaqat bayn al-nahdah wa al-muthaqafah wa al-hadathah* [Arabism and civilization in the suspicious relationship between the nahdah, intellectuals, and modernity] (Beirut: Dar al-nahar, 2008), 49.

25. Makarius, "al-Fotografia," 95–97, 225–32, and 270–72.

26. Henry Harris Jessup, *The Women of the Arabs* (New York: Dodd and Mead, 1873), 123.

27. See Nadia Farag, "al-Muqtataf 1876–1900: A Study of the Influence of Victorian Thought on Modern Arabic Thought" (PhD diss., Oxford University, 1969), 48–51. See also Marwa Elshakry, *Reading Darwin in Arabic 1860–1950* (Chicago: University of Chicago Press, 2013), 61–62.

28. Makarius, "al-Fotografia," 95.

29. Ibid., 95.

30. Ibid., 95.

31. The simplicity of using a gelatin layer of bromide potassium is discussed, even though this seems to be the same process as that invented by Richard Leach Maddox in the 1870s. See "Manaʿ tajʿad al-suwar al-gelatin," *al-Muqtataf* 10 (1885–86): 420; or "Tabʿ al-suwar bi-suhulah" [Printing pictures with ease], *al-Muqtataf* 23 (1899): 233.

32. Makarius, "al-Fotografia" (part 3), 225–30.

33. Ibid., 225.

34. See, for example, Jesuit Père Butrus De Virgil, "al-Taswir al-nuriyah al-mukabbirah" [Enlarging photographs], in *al-Mashriq* 6 (1903): 1131–1133; or, about how to clean oil-painted photographs and paintings, "Tanzhif al-suwar" [Cleaning photographs], *al-Muqtataf* 8 (1883–84): 157. For another article on enlargement,

see "Takbir al-suwar al-fotografiyah" [Enlarging photographs], *al-Muqtataf* 10 (1885–86): 180–81; as well as other articles about large-format photographs, such as those by the famous Legekian Brothers and others, of American Presidents Grant, Arthur, and Cleveland. See, respectively, "Takbir al-suwar," *al-Muqtataf* 20 (1895–96): 638–39; and "Suwar fotografiyah kabirah," *al-Muqtataf* 9 (1884–85): 570.

35. "Tahsin jadid fil-fotografia" [A new improvement in photography], *al-Muqtataf* 9 (1884–85): 297–98.

36. "Mu'tammar musawwari al-shamas" [Conference of photographers], *al-Muqtataf* 24 (1900): 173–74.

37. Christopher Pinney, *The Coming of Photography to India* (London: British Library, 2008), 3.

38. Ibid., 29.

39. Louis Budur, "al-Fotografiyah: Tab' al-suwar 'ala waraqah" [Photography: Printing the photograph on paper], for the column "Bab al-sina'ah" [Crafts and industry] *al-Muqtataf* 19 (1895): 291–93.

40. The following are a sampling of examples: For how to fix an image on paper, see "al-Taswir al-fotografi" [Photography], in "Masa'il wa ajwiba" [Questions and answers], *al-Muqtataf* 19 (1895): 303; "Ikhtira' jadid fil-taswir" [New invention in photography], *al-Muqtataf* 4 (1879–80): 52; and "Talmi' al-suwar al-fotografiyah" [Glossing photographs], *al-Muqtataf* 10 (1885–86): 300. The process of glossing also appeared in an article in the English-language journal *Photographic Nature*. See also "al-Taswir al-shamsi al-mulawwan" [Color photography], *al-Bayan* 1 (1897–98): 393–97; and "Taswir al-suwar al-fotografiyya," [Blackening of photographs], *al-Muqtataf* 24 (1899): 366.

41. Shaden Tageldin, *Disarming Words: Empire and the Seduction of Translation in Egypt* (Berkeley: University of California Press, 2011), 117.

42. See "al-Taswir al-shamsi 'ala qishr al-bayd" [Photography on an eggshell], *al-Diya* 1 (1898–99): 755; "Naql al-suwar al-fotografiyah 'ala al-zujaj aw al-sini" [Transferring the photographic picture to glass or china], *al-Diya* 4 (1901–2): 531–32; "al-Suwar 'ala al-rasas wal-nahas" [Photographs on lead and brass] (question from Ms. Anis al-Khuri, Beirut), *al-Muqtataf* 24 (1900): 552; "al-Suwar al-fotografiyah ma' al-mansujat al-haririyah" [Photographic images on silk cloth], by Hasan Rasim Hijazi from "Shabin al-Kum" (in al-Minufiyah, south of Tanta in the Delta), *al-Muqtataf* 21 (1896–97): 455; "Naql al-suwar al-matbu'ah 'an al-waraq ila al-khashab" [Transferring printed pictures from paper to wood], *al-Muqtataf* 9 (1884–85): 492; and "al-Taswir al-shamsi 'ala al-fakihah" [Photography on fruit], *al-Diya* 5 (1902–3): 175–78.

43. Hasan Rasim Hijazi, "Fu'ad fotografiyah: talmi' al-suwar" [Photographic benefits: Glossing pictures], for the column "Bab al-Sina'ah" [Crafts and industry] *al-Muqtataf* 23 (1899): 364–65.

44. Hasan Rasim Hijazi, "al-Suwar al-fotografiyah ma' al-mansujat al-haririyah" [Pho-

tography on silk cloth], *al-Muqtataf* 21 (1896–97): 455.

45. Ami Amaylon, *The Press in the Arab Middle East: A History* (Oxford: Oxford University Press, 1995), 154–56.

46. Ziad Fahmy himself picks up on Ayalon's discussions of audience but in the context of the frequent use of 'ammiyah (vernacular) Arabic in some journals. See Ziad Fahmy, *Ordinary Egypt: Creating the Modern Nation through Popular Culture* (Stanford, CA: Stanford University Press, 2011), 34; and also his discussion of the creation of mass culture, 39–60.

47. "Kayf tasawwar al-suwar al-fotografiyah" [How to take photographs], *al-Muqtataf* 26 (1891–92): 681; and "Masa'il wa aljwabatuha" [Questions and answers], *al-Muqtataf* 7 (1882–83): 246–47.

48. "Masa'il wa aljwabatuha" [Questions and answers], (question from Jurji Muzannar from Beirut), *al-Muqtataf* 10 (1885–86): 378.

49. *Al-Muqtataf* 21 (1896–97): 543–44. This studio should not be confused with Bogos Tarkulyan's studio Phoebus in Pera, Istanbul; rather, it is likely to be Atelier Phébus in Beirut, which produced cartes de visite and cabinet cards during the mid-1890s.

50. "Shakr" [Thanks], *al-Muqtataf* 21 (1896–97): 604.

51. Michael Gasper, *The Power of Representation: Publics, Peasants, and Islam in Egypt* (Stanford, CA: Stanford University Press, 2009), 36.

52. Tarek El-Ariss, *Trials of Modernity: Literary Affects and the New Political* (New York: Fordham University Press, 2013), 5.

53. Louis Althusser, "Ideology and Ideological State Apparatuses," in *Lenin and Philosophy, and Other Essays* (New York: Monthly Review, 1972), 164.

54. Ibid., 165.

55. See Charles Sanders Peirce, "Logic as Semiotic: The Theory of Signs," in *The Philosophy of Peirce: Selected Writings* (New York: Dover, 1950), 98–119; 108.

56. A complex and nuanced group discussion of the index can be found in James Elkins, ed., *Photography Theory* (London: Routledge, 2007).

57. In critiquing his issues with Sekula's theory of the radical contingency of photography, Allan Geoffrey Batchen quotes Sekula. See Batchen, *Burning with Desire: The Conception of Photography* (Cambridge, MA: MIT Press, 1999), 194.

58. Christian Metz, "Photography and Fetishism," in *October* 34 (Autumn 1985): 81–90.

59. Rosalind Krauss, *The Originality of the Avant-Garde* (Cambridge, MA: MIT Press, 1986), 110.

60. Geoffrey Batchen, *Each Wild Idea: Writing, Photography, History* (Cambridge, MA: MIT Press, 1999), 61.

61. Makarius, "al-Fotografia" (part 2), 155.

62. Al-Amir Muhammad al-Amin Arslan, "Fi fu'ad al-'ilm," in *A'mal al-jam'iyah al-'ilmiyah al-suriyah 1868–69*, ed. Yusuf Qizma Khuri (Beirut: Dar al-Harma', 1990), 17.

63. See Iskander Makarius writing from Khartoum, "al-Taswir al-Shamsi al-mulaw-

wan" (Color photography), *Muqtataf* 32 (1907): 854–58.

64. These beaux arts are explicitly listed in a footnote as poetry, literature, music, painting (*taswir*), engraving (*al-naqsh*), and architecture (*al-bina'*). See "al-Intiqad" [Criticism], *al-Muqtataf* 12 (1887–88): 162–70.

65. The portrait was a chaismic image of the self that binds and mediates the relationship between *Innenwelt* and *Umwelt*, the "organism and its reality," in the words of Lacan. Jacques Lacan, "The Mirror Stage as Formative of the Function of the I as Revealed in Psychoanalytic Experience," in *Écrits: A Selection*, trans. Alan Sheridan (New York: Norton, 1977), 2.

66. Omnia El Shakry, *The Great Social Laboratory: Subjects of Knowledge in Colonial and Postcolonial Egypt* (Stanford, CA: Stanford University Press, 2007), 99.

67. Henry Ayrout, *The Egyptian Peasant*, trans. John Alden Williams (Cairo: American University Press, 2005), 154. See also El Shakry, *The Great Social Laboratory*, 96–103.

68. John Tagg, *The Burden of Representation: Essays on Photographies and Histories* (Amherst: University of Massachusetts Press, 1988), 101.

69. 'Isa 'Ubayd as quoted in Samia Kholoussi, "Fallahin: The 'Mud Bearers' of Egypt's 'Liberal Age,'" in *Re-envisioning Egypt 1919–1952*, ed. Arthur Goldschmidt, Amy Johnson, and Barak Salmoni (New York: American University of Cairo Press, 2005), 295.

70. Ahmad Ibrahim al-Hawwari, *Naqd al-riwayah fil-adab al-'arabi al-hadith fi Misr* (Cairo: Dar Ma'arif, 1978), 230.

71. Iskandar Makarius, "al-Taswir al-hadith: al-Film wal-Raqq" [Modern photography: Film and negative], *al-Muqtataf* 30 (1905): 224.

72. Tagg, *Burden of Representation*, 165–66.

Chapter 5

1. See Wasif Jawhariyyeh, *The Storyteller of Jerusalem: The Life and Times of Wasif Jawhariyyeh 1904–1948*, ed. and introduction Salim Tamari and Issam Nassar, trans. Nada Elzeer (Northampton, MA: Olive Branch Press, 2014).

2. For more information, see Wasif Jawhariyyeh, *Tarikh Filastin al-musawwar fi ahd al-'uthmani* [The illustrated history of Palestine in the Ottoman era], 2 vols., archived in the Institute of Palestine Studies, Beirut. Vol. 1 of the albums ends at 1918. The diary has been published in full in Arabic in two volumes: Wasif Jawhariyyeh, *al-Quds al-'uthmaniyah fil-mudhakkirat al-Jawhariyyeh: al-Kitab al-awal min al-musiqi Wasif Jawhariyyeh 1904–1917*, ed. Salim Tamari and Issam Nassar (Beirut: Mu'assasah al-dirasat al-Filastiniyah, 2003); and Wasif Kindh, *al-Quds al-intidabiyah fil-mudhakkirat al-Jawhariyyeh: al-Kitab al-thani min al-musiqi Wasif Jawhariyyeh 1918–1948*, ed. Salim Tamari and Issam Nassar (Beirut: Mu'assasah al-dirasat al-Filastiniyah, 2005). For an introduction to Jawhariyyeh, see also Salim Tamari, "Jerusalem's Ottoman Modernity: The Time and Lives of Wasif Jawhariyyeh," *Jerusalem Quarterly* 1 (Summer 2000): 1–34.

3. See Jawhariyyeh, *Tarikh Filastin*.

4. John E. Willis Jr., "Maritime Asia 1500–1899: The Interactive Emergence of European Domination," *American Historical Review* 98 (February 1993): 83–105.

5. Paul De Man, *Allegories of Reading* (New Haven, CT: Yale University Press, 1979), 79.

6. The images are found in the first pages of Wasif Jawhariyyeh's albums of photographs, corresponding with annotated notes in his diary.

7. Ilan Pappe, *The Rise and Fall of a Palestinian Dynasty: The Husaynis 1700–1948* (Berkeley: University of California Press, 2010), 156.

8. Jawhariyyeh, *Tarikh Filastin*.

9. Christopher Pinney, *The Coming of Photography to India* (London: British Library, 2008), 134–35.

10. For a critical examination of these discourses of *al-nahdah al-ʿarabiyah*, in particular their relationship to subjective formation, see Stephen Sheehi, *Foundations of Modern Arab Identity* (Gainesville: University Press of Florida, 2004).

11. Mary Roberts, "The Limits of Circumscription," in *Photography's Orientalism: New Essays on Colonial Representation*, ed. Ali Behdad and Luke Gartlan (Los Angeles: Getty Research Institute, 2013), 54.

12. Badr el-Hage, *L'Orient des photographes Arméniens* (Paris: Institut du Monde Arabe, 2007), 42–43.

13. Badr al-Hajj (Badr el-Hage), "Khalil Raad—Jerusalem Photographer," *Jerusalem Quarterly* (Winter 2001): 11–12, 39.

14. Ibid., 39.

15. Issam Nassar, *Laqatat Mughayirah: al-taswir al-fotoghraphi al-mubakir fi falastin* (Ramallah: Kutub and Qattan Foundation, 2005), 23.

16. Nassar provides an image and brief comment on this catalogue in ibid., 26.

17. Annelies Moors, "Presenting Palestine's Population Premonitions of the Nakba," in *MIT Electronic Journal of Middle East Studies* 1 (May 2001): 1–12. See also Moors, "Presenting People: The Politics of Picture Postcards of Palestine/Israel," in *Postcards: Ephemeral Histories of Modernity*, ed. David Prochaska and Jordana Mendelson (University Park: Pennsylvania State University Press, 2010), 93–105.

18. Raad's and Krikorian's images of monuments, construction projects, and holy sites in Palestine and Transjordan appeared alongside photographs by the Zangaki Brothers; Bonfils; American Colony photographer, the famous James Robertson; and Beato in publications such as C. Geoffrey Gaunt's *Touring the Ancient World with a Camera* and Edwin Sherman Wallace's *Jerusalem the Holy*, as well as images found in publications and archives of the Palestine Exploration Committee. See Colin Osman, *Jerusalem: Caught in Time* (Reading, UK: Garnet, 1999), and Eyal Onne, *Photographic Heritage of the Holy Land 1839–1914* (Manchester: Institute of Advanced Studies, Manchester Polytechnic, 1980).

19. Philippe de Tarrazi, *Tarikh al-sahafah al-ʿarabiyah* [History of the Arabic press] (Beirut: al-matbaʿah al-adabiyya, 1913), vols. 1–3.

20. Willis, "Maritime Asia," 83–105.

21. A large number of these photographic family (immediate family, extended, and clan), individual, school, and group portraits, especially those *en plein air*, were the product of the very mobile atelier of the American Colony, which deserves closer attention beyond the scope of this study.

22. Naseeb Shaheen, *Pictorial History of Ramallah* (Beirut: Arab Institute for Research and Publishing, 1992).

23. Edward Said, *Out of Place: A Memoir* (New York: Vintage, 1999), 76–77.

24. Joan Judge, "Portraits of Republican Ladies: Materiality and Representation in Early Twentieth Century Chinese Photographs," in *Visualising China, 1845–1965: Moving and Still Images in Historical Narratives*, ed. Christian Henriot and Wen-hsin Yeh (Leiden: Brill, 2013), 131.

25. Said, *Out of Place*, 8. For corroborating studies about the threat of conscription that came when the Ottomans changed conscription laws to include all men over twenty years of age after 1908, see Sarah Graham Brown, *Palestinians and Their Society 1880–1946* (London: Quartet, 1980), 158–59. See also E. J. Zucher, "The Ottoman Conscription System in Theory and Practice," in *International Review of Social History* 43, no. 3 (1998): 437–49.

26. Vincent Rafael, "The Undead: Notes on Photography in the Philippines, 1898–1920s," in *White Love and Other Events in Filipino History* (Durham NC: Duke University Press, 2000), 101.

27. I am elaborating and playing with the phrase "portrait path" as offered by Sarvos and Frohich to mean the paths in which the portrait is exchanged, is produced, etc., rather than the path society took in choosing a medium for photographic portraiture alone. For the idea of "portrait paths," see Risto Sarvos and David Frohich, *From Snapshot to Social Media: The Changing Picture of Domestic Photography* (London: Springer, 2011), 23–44.

28. Rafael, "The Undead," 92.

29. Simon Sebag Montefiore, *Jerusalem: A Biography* (New York: Random House, 2011), 381.

30. For one exemplary micro-study of the negotiation of these local versus imperial forces and projects, see Alexander Scholch, "An Ottoman Bismarck from Jerusalem: Yusuf al-Diyaʾ al-Khalidi 1842–1906," *Jerusalem Quarterly* 24 (2005): 65–76.

31. Little is known about Bishara Habib and less about ʿAsim Effendi, save for scattered mention of him in studies about the period. For an example, see Neville Mandel, *Arabs and Zionism before World War One* (Berkeley: University of California Press, 1976), 42, 49.

32. See some of his correspondence to Berlin as vice-consul in Johann Bussow, *Hamidian Palestine: Politics and Society in the District of Jerusalem 1872–1908* (Leiden: Brill, 2011), 373.

33. Mr. Wigley, who had been rejected as the American vice-consul in favor of Murad, as quoted in Ruth Kark, *American Consuls in the Holy Land, 1832–1914* (Detroit: Magnes/Wayne State University Press, 1994), 105.

34. Edwin Leon, "An American in Palestine," *Frank Lesley's Sunday Magazine* 13 (June 1882–January 1883): 179. For how Jacob Sarabian (a.k.a. Sarapion) Murad quickly accumulated his wealth (through marriage and/or "subterfuge"), see Kark, *American Consuls*, 103.

35. As cited in Kark, *American Consuls*, 102.

36. Kark, *American Consuls*, 102–3.

37. Ibid., 103.

38. Karl Baedeker, *Palestine and Syria: Handbook for Travellers* (Leipzig: Karl Baedeker Publisher, 1876), 128; and Kark, *American Consuls*, 105.

39. Kark, *American Consuls*, 105–6.

40. Prasenjit Duara, *Rescuing History from the Nation: Questioning Narratives of Modern China* (Chicago: University of Chicago Press, 1996). For a powerfully elegant and inspiring example of the modern identity and history of Kurdistan, see Susan Meiselas, *Kurdistan: In the Shadow of History* (New York: Random House, 1997).

41. Peter Gran, *Rise of the Rich: A New View of Modern History* (Syracuse, NY: Syracuse University Press, 2009), 61.

Chapter 6

1. Iskandar Makarius, "al-Taswir al-hadith: al-taswir al-autochromatiki" [Modern photography: Autochromatic photography], *Muqtataf* 30 (1905): 402; and Makarius, "al-Taswir al-hadith: al-Film wal-Raqq" [Modern photography: Film and the negative], *al-Muqtataf* 30 (1905): 225.

2. Iskandar Makarius, "al-Taswir al-Hadith: al-zujaj wal-taswir al-autochromatic" [Modern photography: Glass and autochromatic photography], *al-Muqtataf* 30 (1905): 317.

3. "Zinat al-bayt" [Ornament of the home], for the column "Tadbir al-manzil" [Organizing the home], *al-Muqtataf* 6 (1881–82): 368.

4. During *al-nahdah*, aesthetic sensibility was expressed in the discourse of "taste" (*dhawq*), which, among other things, as Toufeil Abou-Hodeib shows, discursively invested women in their roles as wives in the household, which was increasingly defined by practices of commodity consumption and display. Toufeil Abou-Hodeib, "Taste and Class in Late Ottoman Beirut," *International Journal of Middle East Studies* 43 (2011): 475–92.

5. "Tartib al-suwar," *al-Muqtataf* 14 (1889–90): 484, 485.

6. Louis Althusser, "Ideology and Ideological State Apparatuses," in *Lenin and Philosophy, and Other Essays* (New York: Monthly Review, 1972), 164.

7. "ʿAjaʾib al-taswir al-shamsi" [The miracles of photography], *al-Bayan* 1 (1897–98): 175.

8. Yusuf Effendi al-Jalkh, "Fi Nabdhah min ʿilm al-tabiʿiyat wa fi taswir al-shamas," in *Aʿmal al-jamʿiyah al-ʿilmiyah al-suriyah 1868–69*, ed. Yusuf Qizma Khuri (Beirut: Dar al-Harmaʾ, 1990), 43.

9. "Taswir al-shamas bi-tarafat ʿayn" [Photography in the blink of an eye], for the column "Fuʾad sinaʿyah mujarrabah" [Benefits of experimental industry], *al-Muqtataf* 3 (1878–79): 64.

10. "Al-Taswir wal-jamal" [Photography/painting and beauty], *al-Muqtaf* 29 (1904): 474.

11. Ibid., 473.

12. Ibid., 472.

13. ʾAbd al-Muhsin Taha Badr as quoted in Samah Selim, *The Novel and the Rural Imaginary in Egypt 1880–1885* (New York: Routledge, 2004), 69–70.

14. Rosalind Krauss, *The Optical Unconscious* (Cambridge, MA: MIT Press, 1993), 176.

15. Ibid., 178–80.

16. See John Scott, *Seeing like a State: How Certain Schemes to Improve the Human Condition Failed* (New Haven, CT: Yale University Press, 1998).

17. For a discussion of these "limitations" within the colonial context, see Christopher Pinney, *The Coming of Photography in India* (London: British Library, 2008), 29.

18. C. P. Goertz, "Alatan rakhisatan lil-taswir al-shamsi" [Two inexpensive cameras], *al-Muqtaf* 11 (1886–87): 636.

19. Ibid.

20. See, for example, "al-Cryptoscope," *al-Muqtaf* 20 (1895–96): 307–8; "al-Taswir al-Jadid," *al-Muqtaf* 20 (1895–96): 308–9 (about X-rays); "Fuʾad al-taswir al-jadid," *al-Muqtaf* 20 (1895–96): 391 (about uses of X-rays); "Taswir al-afkar," *al-Muqtaf* 20 (1895–96): 765–66 (about experiments similar to X-rays, or Röntgen rays); "al-Taswir bi-ashʾah Roentagan," *al-Muqtaf* 24 (1900): 558 (about "Röntgen's rays"); and "al-Photographiya fil-zhalam," *al-Muqtaf* 23 (1899): 8 (offering a discussion of the Henri Becquerel's discovery of the photographic properties of uranium salts).

21. Nickola Pazderic, "Mysterious Photographs," in *Photographies East: The Camera and Its Histories in East and Southeast Asia*, ed. Rosalind Morris (Durham, NC: Duke University Press, 2009), 186–87.

22. Scott McQuire, *Visions of Modernity: Representation, Memory, Time, and Space in the Era of the Camera* (London: Sage, 1998), 40.

23. For a discussion of how the Ottoman government viewed Lebanese as "premodern," barbarous, and antithetical to the "Ottoman civilizing mission," see Ussama Makdisi, "Rethinking Ottoman Imperialism: Modernity, Violence, and the Cultural Logic of Ottoman Reform," in *The Empire in the City: Arab Provincial Capitals in the Late Ottoman Empire* (Beirut: Ergon Verlag Wurzburg, 2002).

24. A series of insightful books recount the rise of new subjectivities and classes, if not the demise of the old, especially in Egypt: Raouf Abbas and Assem El-Dessouky, *The Large Landowning Class and Peasantry in Egypt 1837–1952*, trans. Amer Mohsen and Mona Zikri, ed. Peter Gran (Syracuse, NY: Syracuse University Press, 2011); and Nelly Hanna, *Artisan Entrepreneurs in Cairo and Early Modern Capitalism 1600–1800* (Syracuse, NY: Syracuse University Press, 2011); Michael Gaspar, *The Power of Representation: Publics, Peasants, and Islam in Egypt* (Stanford, CA: Stanford University Press, 2009); Michelle Campos, *Ottoman Brothers: Muslims, Christians, and Jews in Early Twentieth Century*

Palestine (Stanford, CA: Stanford University Press, 2011); Deborah Star, *Remembering Cosmopolitan Egypt: Literature, Culture, and Empire* (New York: Routledge, 2009).

25. Myriam Salama-Carr, "Negotiating Conflict: Rifaʾa Rafiʾ al-Tahtawi and the Translation of the Other," *Social Semiotics* 17, no. 2 (2007): 213–27.

26. For the best examples regarding the "shock" of modernity and the Arab intellectual's "encounter with the West," see Kamran Rastegar, *Literary Modernity between the Middle East and Europe* (London: Routledge, 2007); Elliot Colla, *Conflicted Antiquities: Egyptology, Egyptomania, Egyptian Modernity* (Durham, NC: Duke University Press, 2008); Shaden Tageldin, *Disarming Words: Empire and the Seduction of Translation in Egypt* (Berkeley: University of California Press, 2011); and Tarek El-Ariss, *Trials of Arab Modernity: Literary Effects and the New Political* (New York: Fordham University Press, 2013).

27. El-Ariss, *Trials of Arab Modernity*, 34.

28. See El-Ariss's passage, provided in the original, in ibid., 35.

29. Colla, *Conflicted Antiquities*, 122.

30. El-Ariss, *Trials Arab of Modernity*, 45.

31. See Simone Natale's discussion of German cultural historian Wolfgang Schivelbusch in the context of new media of the long century, "Photography and Communication Media in the Nineteenth Century," in *History of Photography* 36 (November 1999): 453.

32. Ibrahim al-Yaziji, *Lughat al-Jaradah* [The language of the newspaper] (Beirut: Dar Maroon Aboud, 1984), 26.

33. ʾAli Pasha Mubarak, *ʾAlam al-din* (Alexandria: Matbaʾat jaridat al-Mahrusah, 1882), 35–36.

34. ʾAli Mubarak Pahsha, *al-Khitat al-tawfiqiyah al-jadidah li-Misr al-Qahirah wa muduniha wa baldiha al-qadimah* (Cairo: Bulaq, 1887–89). For an instructive discussion of Mubarak's writing, his work as public works minister, and the reorganization of the urban fabric of Cairo, see Timothy Mitchell, *Colonizing Egypt* (Berkeley: University of California Press, 1991), 63–69.

35. Peter Gran, *Rise of the Rich: A New View of Modern History* (Syracuse, NY: Syracuse University Press, 2009), 71.

36. My thanks to Ara Sarafian of Gomidas Institute in London for the translation.

37. Siegfried Kracauer, "Photography," trans. Thomas Y. Levine, *Critical Inquiry* 19, no. 3 (1993): 429–49.

38. Joan Judge, "Portraits of Republican Ladies: Materiality and Representation in Early Twentieth Century Chinese Photographs," in *Visualising China, 1845–1965: Moving and Still Images in Historical Narratives*, ed. Christian Henriot and Wen-hsin Yeh (Leiden: Brill, 2013), 131.

39. Kaja Silverman, "Fassbinder and Lacan: A Reconsideration of Gaze, Look and Image," in *Visual Culture: Images and Interpretations*, ed. Norman Bryson, Michael Ann Holly, and Keith Moxey (Middletown, CT: Wesleyan University Press, 1994), 291.

40. Burgin, *Thinking Photography* (New York: Macmillan, 1982), 150.

41. Mahler states that "object constancy can be said to have been reached when one particular defense—the splitting of the object image—is no longer readily available to the ego." Margaret S. Mahler, *On Human Symbiosis and the Vicissitudes of Individuation* (New York: International University Press, 1968), 224.

42. Jacques Lacan, "What Is a Picture?" in *The Four Fundamental Concepts of Psycho-Analysis* (New York: Norton, 1978), 107.

43. Ahmad Amin, *My Life: The Autobiography of an Egyptian Scholar, Writer, and Cultural Leader*, trans. Issa Boullata (Leiden: Brill, 1978), 122–23. I have tweaked Boullata's translation, using Ahmad Amin's *Hayati* (Cairo: Lajnah al-taʾlif wal-tarjamah wal-nashr, 1950) as a reference.

44. Ibid., 57.

45. Ibid., 105, 103–4.

46. Ibid., 114, 117, and 121.

47. Ibid., 125

48. Lacan, "What Is a Picture?," 109.

49. Personal papers of and personal interview with Richard Milosh. I am very thankful to Mr. Milosh's generosity in providing me with written accounts and images of his family archive and the story of Artinian and Studio Venus.

50. Eve Troutt Powell, *Tell This in My Memory: Stories of Enslavement from Egypt, Sudan, and the Ottoman Empire* (Stanford, CA: Stanford University Press, 2012), 7–9, but see also the entire chapter, "Public Workers, Private Properties: Slaves in ʾAli Mubarak's Historical Records," 7–38.

51. Powell, *Tell This in My Memory*, 11.

52. Ilham Khuri-Makdisi, *The Eastern Mediterranean and the Making of Global Radicalism 1860–1914* (Berkeley: University of California Press, 2010), 145.

53. Jubran Khalil Jubran, *al-Ajnihah al-mutakassirah* (Beirut: Dar al-thaqafah, [1912]), 70.

54. Jubran Khalil Jubran, "Wardah al-hani," in *al-Majmuʾah al-kamilah li-Jubran Khalil Jubran* (Beirut: N.p., 1961), 81.

Chapter 7

1. Tawfiq Yusuf ʾAwwad, "Qamis al-suf" [The wool chemise] in *Qamis al-suf* (Beirut: N.p., 1937), 9–27.

2. Jacques Lacan, "What Is a Picture?," in *The Four Fundamental Concepts of Psychoanalysis*, ed. Jacques Alain Miller, trans. Alan Sheridan (New York: Norton, 1981), 107.

3. There is an illegible letter before "Kassab," probably an initial.

4. Christopher Pinney, *Camera Indica: The Social Life of Indian Photographs* (London: Reaktion, 1997), 176.

5. These figures, intellectuals and officials, compradors and "journalists," studied at the same schools, wrote in the same journals, met in similar salons, or attended the same military and administrative institutions, stretching between and connecting provincial cities. For the rise of the standardized class of technocrats, functionaries, and professionals, see Timothy

Mitchell, *Rule of Experts: Egypt, Techno-Politics, Modernity* (Berkeley: University of California Press, 2002). See also Michael Province, "Ottoman Modernity, Colonialism, and Insurgency in the Interwar Arab East," *International Journal of Middle East Studies* 43 (2011): 205–25.

6. Henry Ayrout, *The Egyptian Peasant*, trans. John Alden Williams (Cairo: American University Press, 2005), 62. For a discussion of how the Ottoman government viewed Lebanese as "pre-modern" and antithetical to the "Ottoman civilizing mission," see Ussama Makdisi, "Rethinking Ottoman Imperialism: Modernity, Violence, and the Cultural Logic of Ottoman Reform," in *The Empire in the City: Arab Provincial Capitals in the Late Ottoman Empire*, ed. Jens Hanssen (Beirut: Ergon Verlag Wurzburg, 2002), 43.

7. Rosalind Krauss, *The Originality of the Avant-Garde and Other Modernist Myths* (Cambridge, MA: MIT Press, 1986), 113. See also, for a discussion of Derrida's use of *mise en abyme*, Martin Jay, *Downcast Eyes: The Denigration of Vision in Twentieth Century French Thought* (Berkeley: University of California Press, 1993), 519.

8. Lacan, "What Is a Picture?," 106–7.

9. Derrida as quoted in Jay, *Downcast Eyes*, 521.

10. See Issam Nassar's pioneering "Familial Snapshots: Representing Palestine in the Work of the First Local Photographers," *History & Memory* 18, no. 2 (Fall/Winter 2006): 149.

11. Victor Burgin, "Looking at Photographs," in *Thinking Photography* (New York: Macmillan, 1982), 144.

12. Sigmund Freud, *The Interpretation of Dreams*, trans. A. A. Brill (1900; New York: Carlton House, 1931), 16.

13. Serene Husseini Shahid, "A Jerusalem Childhood: The Early Life of Serene Husseini," *Jerusalem Quarterly* 37 (2009): 8–9.

14. Ariella Azoulay, *The Civil Contract of Photography* (Cambridge, MA: MIT Press, 2012).

15. Geoffrey Batchen, *Burning with Desire: The Conception of Photography* (Cambridge, MA: MIT Press, 1999), 179.

16. Lacan introduced *point de capiton*, or quilting point, in his discussion of the cross-section between signified and signifier, or at least the disjuncture of this point in psychosis as exemplified by Freud's reading of Judge Schreber. See Jacques Lacan, *Seminar III: The Psychoses 1955–1956*, ed. Jacques Alain Miller, trans. Russel Grigg (New York: Norton, 1993), 258–70.

17. My analysis is inspired by Dipesh Chakrabarty, *Provincializing Europe: Postcolonial Thought and Historical Difference* (Princeton, NJ: Princeton University Press, 2000).

18. See Charlotte Jirousek, "The Transition to Mass Fashion System Dress in the Late Ottoman Empire," in *Consumption Studies and the History of the Ottoman Empire, 1550–1922: An Introduction*, ed. Donald Quataert (Albany: SUNY Press, 2000), 201–42.

19. See, for example, John Chalcroft, "The End of Guilds in Egypt: Restructuring Textiles in the Long Nineteenth Century," in *Crafts and Craftsmen in the Middle East: Fashioning the Individual in the Muslim Mediterranean*, ed. Randi Deguilhem and Suraiya Faroqhi (New York: Macmillan, 2005), 338–67. See also Claudia Kickinger, "Relations of Production and Social Conditions among Coppersmiths in Contemporary Cairo," in ibid., 285–307.

20. Issam Nassar, "Photography as a Source Material for Jerusalem's Social History," in *Transformed Landscapes: Essays on Palestine and the Middle East*, ed. Camille Mansour and Leila Fawaz (Cairo: American University of Cairo Press, 2009), 138. In the case of Palestinian studies, where the very existence of the Palestinian people has been the target of erasure, the immediacy that the manifest content offers is the first realm of defense as seen in Walid Khalidi, *Before Their Diaspora: A Photographic History of the Palestinians 1876–1948* (Washington DC: Institute for Palestine Studies, 1984).

21. See, for example, a special issue of the *International Journal of Middle Eastern Studies* 35, no. 1 (February 2003), dedicated to the rise of new forms of consumption and their relationship to new modes of production and surplus accumulation: Haris Exertzoglou, "The Cultural Uses of Consumption: Negotiating Class, Gender, and Nation in the Ottoman Urban Centers during the 19th Century," 77–101; Relli Shechter "Selling Luxury: The Rise of the Egyptian Cigarette and the Transformation of the Egyptian Tobacco Market, 1850–1914," 51–75; and Samer Shehata, "In the Basha's House: The Organizational Culture of Egyptian Public-Sector Enterprise," 103–32.

22. For a series of good articles on the social, cultural, and economic ravages incurred by communities throughout the Ottoman Empire owing to its introduction into the world capitalist system, see Huri Islamglu-Inan, ed., *The Ottoman Empire and the World Economy* (Cambridge: Cambridge University Press, 2004 [1987]). There are many good micro- and macrostudies regarding the Ottoman Empire, Southwest Asia, and Egypt's immersion into the world capitalist system. See Resat Kasabah's pioneering, *The Ottoman Empire and the World Economy* (Albany: SUNY Press, 1988); and Nelly Hanna and Raouf Abbas's valuable collection, *Society and Economy in Egypt and the Eastern Mediterranean 1600–1900* (New York: AUC Press, 2005).

23. Karl Marx, *Capital*, trans. Samuel Moore and Edward Aveling (New York: Appleton & Co., 1889), 48.

24. See *al-Muqtataf* 30 (1905): 452.

25. Fouad Debbas, *Des photographes à Beyrouth 1840–1918* (Paris: Marval, 2001), 49. Engin Özendes Çizgen also asserts this in *Photography in the Ottoman Empire 1839–1919* (Istanbul: Haset Kitabevi, 1987), 116.

26. Özendes Çizgen, *Photography in the Ottoman Empire*, 116–17; Debbas, *Des photographes à Beyrouth*, 49.

27. Ali Haydar Midhat, *The Life of Midhat Pasha* (London: John Murray, 1903), 166.

28. Ibid., 176–77.

29. Toby Dodge, *Inventing Iraq: The Failure of Nation-Building and a History Denied* (New York: Columbia University Press, 2003), 54.

30. Ibid., 54–56.

31. Charles Tripp, *History of Iraq* (Cambridge: Cambridge University Press, 2000), 15.

32. Suraiya Faroqhi, *Subjects of the Sultan: Culture and Daily Life in the Ottoman Empire* (London: I. B. Tauris, 2007), 285.

33. Mary Roberts, "The Limits of Circumscription," in *Photography's Orientalism: New Essays on Colonial Representation*, ed. Ali Behdad and Luke Gartlan (Los Angeles: Getty Research Institute, 2013), 58–59.

34. Faroqhi, *Subjects of the Sultan*, 285.

35. Fatma Muge Gocek, *Rise of the Bourgeoisie, Demise of Empire: Ottoman Westernization and Social Change* (Oxford: Oxford University Press, 1996), 42.

36. For a study of how this looked on a discursive level within a local context, see Michelle Campos, *Ottoman Brothers: Muslims, Christians, and Jews in Early Twentieth-Century Palestine* (Stanford, CA: Stanford University Press, 2012).

37. Midhat, *The Life of Midhat Pasha*, 47–48.

38. Ibid., 49.

39. Some *karakuz* exist in print. These shadow-plays are written in colloquial rhyming-prose. Weak on traditional-minded narrative and character development, they are hilarious, raunchy, and bawdy—if not also misogynist—usually involving scatological and sexual humor, revolving around plots where the characters are cheated, beaten, or tricked. See Jurji Zaidan, *Mudhakkirat Jurji Zaidan* (Beirut: Dar al-kitab al-jadid, 1968), 21.

40. Philip Sadgrove, "Ahmad Abu Khalil al-Qabbani," in *Essays in Arabic Literary Biography*, ed. Roger Allen, Joseph Lowry, and Devin Stewart (Wiesbaden: Otto Harrossowitz, 2010), 267–68.

41. Sulayman al-Bustani, ʾIbrah wa dhikra aw al-dawlah al-ʿUthmaniyah qabla al-dustur wa bʿad (Cairo: Maktabat al-akhbar, 1908), dedication.

42. Ibid., 5.

43. Albert Hourani, "Sulaiman al-Bustani and the *Iliad*," in *Islam and the European Thought* (Cambridge: Cambridge University Press, 1991), 69.

44. Shmuel Moreh, *Modern Arabic Poetry 1800–1970* (Leiden: Brill, 1976), 49.

45. Ibid., 54.

46. Stephen Sheehi, *Foundations of Modern Arab Identity* (Gainesville: University Press of Florida, 2004), 119–22.

47. For an example of the linguistic debates, see Abdulrazzak Patel, "Language Reform and Controversy in the *Nahda*: al-Shartuni's Position as a Grammarian in *Sahm*," *Journal of Semitic Studies* 55, no. 2 (Autumn 2010): 508–38. See also Adrian Gully, "Arabic Linguistic Issues and Controversies of the Nineteenth and Early Twentieth Centuries," *Journal of Semitic Studies* 42, no. 1 (Spring 1997): 77–120.

Chapter 8

1. Ibrahim Rifʿat Pasha as quoted in F. E. Peters, *The Hajj: The Muslim Pilgrimage to*

Mecca and the Holy Places (Princeton, NJ: Princeton University Press, 1994), xv.

2. These books are *Nabdhah fi istikshaf al-ard al-Hijaziyah min al-Wajh wa Yunbu' al-bahr ila al-Madinah al-Nabawiyah* [Window to the exploration of the land route in the Hijaz from al-Wajh and Yanbo to the Prophet's city] (Cairo: Matba't Arkan Harb al-Jihadiyah, AH 1293 [1877]), which appeared initially as articles in the "Egyptian Military Gazette," 1871; *Mash'al al-Mahmal* [Torch of the mahmal] (Cairo: Matba't Wadi al-nil, AH 1298 [1881]); *Kawkab al-Hajj fi safar al-mahmal baharan wa sirahu barran* [The star of the Hajj along the travels of the mahmal by land and sea] (Cairo: al-Matba'ah al-amiriyah bi-Bulaq, AH 1303 [1884]); and *Dalil al-Hajj lil-warid ila Mecca wal-Madinah li kull fajj* [A guide to the Hajj: Arriving in Mecca and Medina from any direction] (Cairo [Bulaq]: al-Matba'ah al-kubra al-amiriyah, AH 1313 [1896]). They are all republished in one volume, edited, introduced, and annotated by Muhammad Hammam Fakri, *Muhammad Sadiq Basha, al-Rihlat al-hijaziyah* [Muhammad Sadiq Pasha: Hijazi journeys] (Beirut: Badr lil-nashr wal-tawzi', 1999).

3. Originally in *Dalil al-Hajj*, and republished in Fakri, *Muhammad Sadiq Basha*, 259.

4. Sadiq's stamp is reproduced in Badr El-Hage, *Saudi Arabia: Caught in Time* (Reading, UK: Garnet, 1997), 17.

5. Omnia El Shakry notes that La Société Khédiviale de Géographie was also known as La Société Sultanieh de Géographie d'Égypte and La Société Royale de Géographie d'Égypte. See El Shakry, *The Great Social Laboratory: Subjects of Knowledge in Colonial and Postcolonial Egypt* (Stanford, CA: Stanford University Press, 2007), 231n13.

6. Ibid., 27. Since his death, the value of Muhammad Sadiq Bey's photographs has exponentially appreciated. One recently auctioned at Christie's in London for £144,000, while images from his 1880 Hajj were bought by the Saudi government in 1998 for more than US $2 million.

7. El-Hage, *Saudi Arabia*, 35. El-Hage's book was reproduced in Arabic, amending information that would later be incorrect, as well as adding new information regarding Muhammad Sadiq Bey and others. See Badr al-Hajj (Badr el-Hage), *Suwar min al-madi: al-Mamlakah al-'arabiyah al-sa'udiyah* (London: Riad El-Rayyes, 1989).

8. Claude W. Sui, "Pilgrimage to the Holy Sites of Islam and Early Photography," in *To the Holy Lands: Pilgrimage Centres from Mecca and Medina to Jerusalem*, ed. Alfred Wieczorek, Michael Tellenbeck, and Claude W. Sui (Mannheim: Reiss-Engelhorn Museum, 2008), 52.

9. Victor Burgin, "Looking at Photographs," in *Thinking Photography* (New York: Macmillan, 1982), 146.

10. Alan Mikhail, *Nature and Empire in Ottoman Egypt: An Environmental History* (Cambridge: Cambridge University Press, 2011), 113–22.

11. Sadiq Bey, in Fakri, *Muhammad Sadiq Basha*, 106.

12. Burgin, "Looking at Photographs," 146.

13. Shaun Marmon specifically refers to a portrait of Shawkat Pasha with a score of eunuchs, allegedly taken by Saleh Soubhy. I suspect, however, that Marmon misattributes the portrait's photographer because Soubhy used Sadiq Bey's photographs in *Pèlerinage à la Mecque et à Médine* (Cairo: Imprimerie Nationale, 1894). See Marmon, *Eunuchs and Sacred Boundaries in Islamic Society* (Princeton, NJ: Princeton University Press, 1995), 103–4.

14. Valeska Huber, *Channeling Mobilities: Migration and Globalization in the Suez Canal Region and Beyond: 1869–1914* (Cambridge: Cambridge University Press, 2013), 221–26.

15. Jacques Lacan, "The Split between the Eye and the Gaze," in *The Four Fundamental Concepts of Psychoanalysis* (New York: Norton, 1981), 75, 77. See also Rosalind Krauss, *The Optical Unconscious* (Cambridge, MA: MIT Press, 1994).

16. Lacan, "The Split between the Eye and the Gaze," 75.

17. The image is reproduced in el-Hage, *Saudi Arabia*, 32; and Sui, "Pilgrimage to the Holy Sites of Islam," 51.

18. Sui reproduces the images in "Pilgrimage to the Holy Sites of Islam," 51.

19. Ibid., 53.

20. In pondering these far too often ignored salient issues, one may look for assistance from F. E. Peters, *Mecca: A Literary History of the Muslim Holy Land* (Princeton, NJ: Princeton University Press, 1995); Madawi al-Rasheed, *Politics in an Arabian Oasis: The Rashidis of Saudi Arabia* (London: I. B. Taurus, 1991); Eve Troutt Powell, *A Different Shade of Colonialism: Egypt, Britain, and the Mastery of the Sudan* (Berkeley: University of California Press, 2003); and Marmon, *Eunuchs and Sacred Boundaries*.

21. For an example of an early portrait by an unknown photographer of Sadiq Bey wearing the loose fitting clothes of an effendi, see M. A. Mustafa Amer, "An Egyptian Explorer in Arabia in the Nineteenth Century," *Bulletin de la Société Royale de Géographie d'Égypte* 8 (July 1932): 29.

22. El-Hage, *Saudi Arabia*, 55–56.

23. For a pioneering discussion of Christiaan Snouck Hurgronje and 'Abd al-Ghaffar, see Sui, "Pilgrimage to the Holy Sites of Islam," 54–61; and el-Hage, *Saudi Arabia*, 40–47.

24. Jan Just Witkam translated two of these letters, which are reproduced in Sui, "Pilgrimage to the Holy Sites of Islam," 58–60.

25. C. Snouck Hurgronje, *Bilder Aus Mekka: Mit Kurzem Erläuterndem Texte* (Leiden: Brill, 1889); and Hurgronje, *Bilder Atlas zu Mekka* (The Hague: Martinus Nijhoff, 1888).

26. See "'Abdullah ibn Hussein" (plate 12) and "Aun er-Rafiq, Grossscherif von Mekka" (plate 7), in Snouck Hurgronje, *Bilder Atlas zu Mekka*; and Ali Asani and Carney Gavin, "Through the Lens of Mirza of Delhi: The Debbas Album of Early-Twentieth-Century Photographs of Pilgrimage Sites in Mecca and Medina," *Muqarnas* 15 (1998): 198n11.

27. Peters, *The Hajj*, xiv.

28. Asani and Gavin, "Through the Lens of Mirza of Delhi," 199n12. Originally found in *Mekka in the Latter Part of the 19th Century: Daily Life, Customs, and Learning of the Moslims* [sic] *of the East Indian Archipelago*, trans. J. H. Monahan (Leiden: E. J. Brill; London: Luzac and Co., 1931), 165.

29. Asani and Gavin, "Through the Lens of Mirza of Delhi," 199n12.

30. From Yasir Bakr, *Akhlaqiyat al-suwar al-sahafiyah* [Ethics of journalistic photographs], chap. 5, http://hekiattafihahgedan.blogspot.com/2012/03/blog-post_05.html, accessed February 24, 2013.

31. Al-Shaykh Muhammad Bisyuni quoted in Sambas Borneo, "Judgment of Hand-Painting and Photography" and reply from Rashid Rida in *al-Manar* 11 (AH 1326 [1908]): 277–78. Jamal Elias specifically uses this anecdote in the hadith to begin his conversation of Islam and art. See Jamal Elias's excellent *Aisha's Cushion: Religious Art, Perception, and Practice in Islam* (Cambridge, MA: Harvard University Press, 2012).

32. Rashid Rida, "The Capturing of Images and Photography," *al-Manar* 15 (AH 1330 [1912]): 904–5.

33. Yumna al-'Id, *Fann al-riwayah al-'arabiyah bayn khususiyat al-hikayah wa tamayuz al-khitab* (Beirut: Dar al-adab, 1998), 29.

34. Rida, "The Capturing of Images and Photography," 905.

35. Ibid.

36. Ibid., 903–4.

37. For a biography of Shaykh Muhammad Bakhit al-Muti'i, see Jakob Skovgaard-Petersen, *Defining Islam for the Egyptian State: Muftis and Fatwas of the Dar al-Ifta* (Leiden: Brill, 1997), 133–40.

38. Shaykh Muhammad Bakhit al-Muti'i, *al-Jawab al-shafi fi ibahat al-taswir al-futughrafi* [The Shafi reply regarding the legality of photography] (Cairo: Matba'ah al-khayriyah, Idarah al-Sayyid Muhammad 'Umar al-Khishab, n.d.), 3.

39. Ibid., 19–22.

40. 'Abd al-Rahman al-Kawakibi, *Tabai' al-istibdad wa masari' al-isti'bad* [The characteristics of despotism and the demise of enslavement] (N.p: Kalimat, n.d; originally published 1900), 7–8

41. Ibid., 11

42. The Holy Qur'an, Surat Saba', 34:13.

43. Ibrahim Rif'at Pasha, *Mir'at al-Haramayn aw al-rihlat al-hijaziyah wa al-Hajj wa mash'aruhu al-diniyah* [The mirror of the two sanctuaries; or, Hijazi journeys and the Hajj and its religious rituals] (Cairo: Matba'at Dar al-Kutub al-misriyah, AH 1344 [1925]).

44. While always formal, Ibrahim Rif'at Pasha, the consummate officer and Arab gentleman, tells of his many encounters with Hijazi and Najdi dignitaries and royalty, assuring his readers that he was always met with great hospitality and graciousness. Rif'at Pasha, *Mir'at al-Haramayn*, 38.

45. Joan M. Schwartz and James R. Ryan, "Introduction: Photography and the Geographical Imagination," in *Picturing Place: Photograph and the Geographic Imagination* (London: I. B. Tauris, 2003), 4.

46. Rif'at Pasha, *Mir'at al-Haramayn*, 93.

47. Ibid., 96.

48. Ibrahim Rif'at Pasha reproduces three short books that criticize the tyranny and corruption of al-Sharif 'Awn al-Rafiq. For example, Rif'at Pasha, *Mir'at al-Haramayn*, 275–79. Also, he provides two contrasting images. The first is a stately portrait, probably taken by Snouck Hurgronje or 'Abd al-Ghaffar, who also photographed the sharif. The second is of a more tired, elderly, retired man. See plates 318 and 37, respectively.

49. Rif'at Pasha, *Mir'at al-Haramayn*, 38.

50. Geoffrey Batchen, *Each Wild Idea: Writing, Photography, History* (Cambridge, MA: MIT Press, 1999), 60.

51. Sigmund Freud, "Uncanny," in *Art and Literature* (New York: Penguin, 1990), 361.

52. Ibid., 356.

53. Rosalind Krauss, *The Originality of the Avant-Garde and Other Modern Myths* (Cambridge, MA: MIT Press, 1986), 112.

54. Michel Foucault, *The Order of Things: An Archeology of the Human Sciences* (New York: Vintage, 1973), 6.

55. Jonathan Crary, *Techniques of the Observer: On Vision and Modernity in the Nineteenth Century* (Cambridge, MA: MIT Press, 1990), 4.

56. Badr el-Hage, *Saudi Arabia: Caught in Time* (London: Garnet, 1997), 38. This is an updated version of *Suwar min al-madi: al-Mamlakah al-'arabiyah al-sa'udiyah* (London: Riad El-Rayyes, 1989).

57. Muhammad 'Ali Sa'udi's accounts (especially his most detailed account in 1907–8) are summarized in truncated and extremely redacted form by Farid Kioumgi and Robert Graham, *A Photographer on the Hajj: The Travels of Muhammad 'Ali Effendi Sa'udi (1904–1908)* (Cairo: American University of Cairo Press, 2009).

58. Ibid., xvii.

59. Ibid., xii.

60. Ibid., xviii and 50.

61. See Jurji Zaidan's historical novel about the overthrow of Sultan Abdülhamid by Young Turk officers, *al-Inqilab al-'uthmani* (Cairo: Dar al-Halal, 1911); or Roger Allen's translation of Ibrahim al-Muwaylihi's *Ma Hunalik*, translated as *Spies, Scandals, and Sultans: Istanbul in the Twilight of the Ottoman Empire* (New York: Rowman and Littlefield, 2007).

62. Kioumgi and Graham, *A Photographer on the Hajj*, 34

63. Ibid., 38.

64. Ibid., 65.

65. Ibid., 5

66. Ibid., 50, 60.

67. Malevika Karlekar, *Re-visioning the Past: Early Photography in Bengal 1875–1915* (New Delhi: Oxford University Press, 2005), 8–9.

68. Walter Benjamin, "Little History of Photography," trans. Edmund Jephcott and Kingsley Shorter in *Walter Benjamin, Selected Writing, Vol. 2, 1927–1934*, ed. Michael Jennings, Howard Eiland, and Gary Smith (Cambridge, MA: Belknap Press, 1999), 508, 512. Karlekar, *Re-visioning the Past*, 9.

69. Suraiya Faroqhi, *Pilgrims and Sultans: The Hajj under the Ottomans* (London: I. B. Tauris, 1996).

70. For a pioneering and thorough discussion of the "public health" discourse and its relationship to the rise of Beirut as a municipality, see Jens Hanssen, *Fin de Siècle Beirut: The Making of an Ottoman Provincial Capital* (Oxford: Oxford University Press, 2005), 116–32.

71. Ibrahim Rif'at Pasha, *Mir'at al-Haramayn*, 114–16; see also the photograph of the lazaretto, plate 207, as well as group photographs of his detail.

72. Toufoul Abou-Hodeib, "Quarantine and Trade," *International Journal of Maritime History* 19, no. 2 (December 2007): 230.

73. Ibid., 231.

74. See also Birsen Bulmuş, *Plague, Quarantines, and Geopolitics in the Ottoman Empire* (Edinburgh: Edinburgh University Press, 2012).

75. Hanssen, *Fin de Siècle Beirut*, 105–9.

76. Susan Sontag, *On Photography* (New York: Macmillan, 1977), 7, 39.

77. Kioumgi and Graham, *A Photographer on the Hajj*, 13. The script seems to be overlaid on the negative but is inverse.

78. Ibid., e.g., 99, 104.

79. Ibid., 110.

80. The original is from Abd al-Halim Sahil, *Hajj Bait Allah* (Bombay: Khwaja Publishing House, 1968), 240, as quoted by Asani and Gavin, "Through the Lens of Mirza of Delhi," 182.

81. Asani and Gavin, "Through the Lens of Mirza of Delhi," 180.

82. Kioumgi and Graham, *A Photographer on the Hajj*, 17 and xviii.

83. Ibid., xi.

84. Ziad Fahmy, *Ordinary Egypt: Creating the Modern Nation through Popular Culture* (Stanford, CA: Stanford University Press, 2011), 85–86.

85. Kioumgi and Graham, *A Photographer on the Hajj*, 25.

86. Muhammad 'Abduh's portrait can be found in Philippe de Tarrazi, *Tarikh al-sahafah al-'arabiyah* (History of the Arabic press) (Beirut; al-Matba'ah al-'adabiyah, 1913), 1:287.

87. Ibid., 24.

88. Eugene Rogan, "Instant Communication: The Impact of the Telegraph on Ottoman Syria," in *The Syrian Land: Process of Integration and Fragmentation; Bilad al-Sham from the 18th to 20th Century*, ed. Thomas Philipp and Birgit Schabler (Stuttgart: Franz Steiner Verlag, 1998), 113–29.

89. Kioumgi and Graham, *A Photographer on the Hajj*, 54.

Epilogue

1. Written on the back of a portrait photograph of Suleiman Girby taken by Daoud Saboungi, Jaffa, ca. 1900, Blyth Collection, St. Antony College, Oxford.

2. Salama Musa, *The Education of Salama Musa* (Leiden: Brill, 1961), 44.

3. Ahmad Fahmi, "al-Funun al-jamilah: al-nabdhah al-thalithah; Fil-jimal wa fuwa'id al-funun al-jamilah," *al-Muqtataf* 11 (1886–87): 329–39.

4. See Yasir Bakr, *Akhlaqiyat al-suwar al-sahafiyah* [Ethics of journalistic photographs] (Cairo: Dar al-Kutub, 2012). See also the unsigned article, "al-Taswir wal-hafar,"[Photography and engraving] *Muqtataf* 65 (1924): 225.

5. Riad Shehata (Shahatah), *Kitab al-tawsir al-shamsi* [The photography book] (Cairo: N.p., 1912), 121. Shehata later wrote *al-Taswir wal-hafr: 'Ilmi wa'amali* [Photography and engraving: My knowledge and my work] (Cairo: Matba'at Misr, 1924).

6. Shehata, *Kitab al-tawsir al-shamsi*, 122.

7. Iskandar Makarius, the son of Shahin, wrote the first extensive review and analysis of the Kodak camera in Arabic. See Iskandar Makarius, "al-Taswir al-hadith: al-Film wal-Raqq" [Modern photography: Film and negative], *al-Muqtataf* 30 (1905): 225.

8. Shehata, *Kitab al-tawsir al-shamsi*, 124.

9. Ibid., 125.

10. Michel Fani has explored the Jesuit photographic project. See Michel Fani, *Une histoire de la photographie au Liban 1840–1944* (Beirut: Éditions de l'Escalier, 2005).

11. "Zinat al-bayt" [Decorating the home], in the column "Tadbir al-manzil" [Organizing the house], *al-Muqtataf* 6 (1881–82): 368.

12. "Quwa'id raskan fil-taswir," *al-Muqtataf* 11 (1886–87): 242.

INDEX

ILLUSTRATION CREDITS

1. Courtesy of Special Collections, Fine Arts Library, Harvard University
2. Courtesy of Gamil Sadek and Family, Ottawa
3. Courtesy of Michael Farrow and the Sadek Family
4. Courtesy of Aida Kawar Krikorian Collection, Arab Image Foundation, Beirut
5. Courtesy of Stephen Sheehi
6. Courtesy of Stephen Sheehi
7. Courtesy of Pierre de Gigord Collection, Getty Research Institute
8. Courtesy of the National Portrait Gallery, London
9. Courtesy of the National Portrait Gallery, London
10. Courtesy of the Library of Congress, Abdul Hamid II Collection, lot 9516, no. 11
11. Courtesy of Pierre de Gigord Collection, Getty Research Institute
12. Courtesy of Topkapi Museum Archives, Istanbul
13. Courtesy of the National Portrait Gallery, London
14. Courtesy of Stephen Sheehi
15. Courtesy of the Library of Congress, Abdul Hamid II Collection, lot 9525, no. 16
16. Courtesy of the Library of Congress, Abdul Hamid II Collection, lot 9525, no. 6
17. Courtesy of the Fouad Debbas Collection, Beirut
18. Courtesy of Fouad el-Khoury Collection, Arab Image Foundation
19. Courtesy of the Zaidan Foundation
20. Courtesy of Fouad el-Khoury Collection, Arab Image Foundation
21. Courtesy of the Lebanese National Archive
22. Viscount Philippe de Tarrazi, *Tarikh al-sahafah al-ʿarabiyah* (Beirut: al-Matbaʿah al-adabiyah, 1913), vol. 2
23. Courtesy of the Fouad Debbas Foundation
24. Viscount Philippe de Tarrazi, *Tarikh al-sahafah al-arabiyah* (Beirut: al-Matbaʿah al-adabiyah, 1913), 1:241
25. Courtesy of the Fouad Debbas Collection, Beirut
26. Fouad Debbas, *Des photographes à Beyrouth 1840–1918* (Paris: Marval, 2001), 46
27. Fouad Debbas, *Des photographes à Beyrouth 1840–1918* (Paris: Marval, 2001), 46
28. Louis Saboungi, *Diwan shiʿt al-Nahla al-manzhum fi khilal al-rihla* (Alexandria, 1901), 229
29. Courtesy of Özcan Geçer, Istanbul
30. Courtesy of Mohamed Ali Foundation (London), Abbas Hilmi II Collection, Durham

University Libraries
31. Courtesy of Stephen Sheehi
32. Courtesy of Stephen Sheehi
33. Courtesy of Stephen Sheehi
34. Yvonne Sursock Collection, Arab Image Foundation
35. Yvonne Sursock Collection, Arab Image Foundation
36. Viscount Philippe de Tarrazi, *Tarikh al-sahafah al-ʿarabiyah* (Beirut: al-Matbaʿah al-adabiyah, 1913), 1:136
37. *Aʿlam fi dhakirat Lubnan* (Beirut: Muʾassasat al-mahfuzat al-wataniyah, 2001), 39. Courtesy of the Lebanese National Archives
38. Jirjis Tannus ʿAwn al-Sadalani, *al-Durr al-maknun fil-sinaʿah wal-funun*, 3rd ed. (N.p.: Matbaʿat Amin Haniyah, 1924; originally published, Istanbul: Matbaʿah Jawaʾib, AH 1301 [1883]), 136
39. Courtesy of the Middle East Centre Archives, St. Antony College, University of Oxford
40. Eric and Edith Matson Photograph Collection, Library of Congress
41. Courtesy of the Library of the Institute for Palestine Studies, Wasif Jawhariyyeh Album, J 1/6-16
42. Courtesy of the Library of the Institute for Palestine Studies, Wasif Jawhariyyeh Album, J 1/18-40
43. Permission granted by Kamal Rebeiz, Beirut
44. Library of Congress, John D. Whiting Collection, American Colony Album, p. 9
45. Courtesy of Stephen Sheehi
46. Courtesy of the Library of the Institute for Palestine Studies, Library of the Institute for Palestine Studies, Wasif Jawhariyyeh Album, J 1/21-54
47. Courtesy of the Library of the Institute for Palestine Studies, Wasif Jawhariyyeh Album, J 1/48
48. Courtesy of the Library of the Institute for Palestine Studies Library of the Institute for Palestine Studies, Wasif Jawhariyyeh Album, J 1/44
49. Courtesy of the Zaidan Foundation
50. Courtesy of Michael Farrow and the Sadek Family
51. Courtesy of Stephen Sheehi
52. Courtesy of Stephen Sheehi
53. Courtesy of the Zaidan Foundation
54. Alfred Pharaon Collection, Arab Image Foundation
55. Permission granted by Kamal Rebeiz, Beirut

56. Courtesy of Michael Farrow and the Sadek Family
57. Courtesy of Stephen Sheehi
58. Courtesy of Stephen Sheehi
59. Library of Congress, John D. Whiting Collection, American Colony Album, p. 12
60. Courtesy of John Herbert Dudley Ryder, 5th Earl of Harrowby, National Portrait Gallery, London
61. Ali Haydar Midhat, *The Life of Midhat Pasha* (London: John Murray, 1903)
62. Sulayman al-Bustani, ʾIbrah wa dhikra aw al-dawlah al-ʿUthmaniyah qabla al-dustur wa bʿad (Cairo: Maktabat al-akhbar, 1908)
63. Courtesy of Claude W. Sui, Forum Internationale Photographie at the Reiss-Engelhorn-Museen, Mannheim
64. Courtesy of Claude W. Sui, Forum Internationale Photographie at the Reiss-Engelhorn-Museen, Mannheim
65. Courtesy of the Library of Congress
66. Ibrahim Rifʿat Pasha, *Mirʾat al-Haramayn aw al-rihlat al-hijaziyah wa al-Hajj wa mashʿaruhu al-diniyah* (Cairo: Matbaʿat Dar al-Kutub al-misriyah, 1925), frontispiece
67. Ibrahim Rifʿat Pasha, *Mirʾat al-Haramayn aw al-rihlat al-hijaziyah wa al-Hajj wa mashʿaruhu al-diniyah* (Cairo: Matbaʿat Dar al-Kutub al-misriyah, 1925), plate 21
68. Ibrahim Rifʿat Pasha, *Mirʾat al-Haramayn aw al-rihlat al-hijaziyah wa al-Hajj wa mashʿaruhu al-diniyah* (Cairo: Matbaʿat Dar al-Kutub al-misriyah, 1925), plate 232
69. Ibrahim Rifʿat Pasha, *Mirʾat al-Haramayn aw al-rihlat al-hijaziyah wa al-Hajj wa mashʿaruhu al-diniyah* (Cairo: Matbaʿat Dar al-Kutub al-misriyah, 1925), plate 318
70. Ibrahim Rifʿat Pasha, *Mirʾat al-Haramayn aw al-rihlat al-hijaziyah wa al-Hajj wa mashʿaruhu al-diniyah* (Cairo: Matbaʿat Dar al-Kutub al-misriyah, 1925), pls. 34, 35
71. Ibrahim Rifʿat Pasha, *Mirʾat al-Haramayn aw al-rihlat al-hijaziyah wa al-Hajj wa mashʿaruhu al-diniyah* (Cairo: Matbaʿat Dar al-Kutub al-misriyah, 1925), plate 36
72. Ibrahim Rifʿat Pasha, *Mirʾat al-Haramayn aw al-rihlat al-hijaziyah wa al-Hajj wa mashʿaruhu al-diniyah* (Cairo: Matbaʿat Dar al-Kutub al-misriyah, 1925), p. 321
73. Courtesy of the Estelle Blyth Collection, St. Antony College, University of Oxford
74. Courtesy of the Library of Congress
75. Courtesy of Stephen Sheehi
76. Courtesy of Mohsin Yammin Collection, Arab Image Foundation